Contents

Uncontrollable Beauty

Toward a New Aesthetics

Edited by Bill Beckley
with David Shapiro

ALLWORTH PRESS
NEW YORK

School of
VISUAL ARTS

AESTHETICS TODAY
Editorial Director: Bill Beckley

The Aesthetics Today series includes
Sticky Sublime, edited by Bill Beckley
Out of the Box, by Carter Ratcliff
Sculpture in the Age of Doubt, by Thomas McEvilley
Beauty and The Contemporary Sublime, by Jeremy Gilbert Rolfe
The End of The Art World, by Robert C. Morgan
Redeeming Art, by Donald Kuspit
Dialectic of Decadence, by Donald Kuspit

05 04 03 02 01 5 4 3 2 1

Published by Allworth Press
An imprint of Allworth Communications
10 East 23rd Street, New York, NY 10010

Copublished with the School of Visual Arts

Cover design by Douglas Designs, New York, NY
Cover photo © 1998 Bill Beckley
Book design by Sharp Des!gns, Lansing, MI

ISBN: 1-880559-90-0

Library of Congress Catalog Card Number: 98-70100

To

Silas Rhodes

and to

Tristan, Liam and Daniel

Introduction: Generosity and the Black Swan

BILL BECKLEY

> I saw
> a swan that had broken out of its cage,
> webbed feet clumsy on the cobblestones,
> white feathers dragging in the uneven ruts,
> and obstinately pecking at the drains,
> drenching its enormous wings in filth
> as if in its own lovely lake, crying
> "Where is the thunder, when will it rain?"[1]

Elsewhere in *Les fleurs du mal*, Baudelaire foreshadows Freud's criteria for civilization through beauty, order, and cleanliness.

> All is order there, and elegance,
> pleasure, peace, and opulence.

Freud concluded *Civilization and Its Discontents* with a note of optimism, even as fascism took hold in Europe and the future held little hope for Jews, "What the world needs is a little more Eros."

Datta, "to give," is one of three ways Eliot offers out of a dry, avaricious, and sexless landscape in the concluding section of *The Wasteland.* Beauty is generosity and reveals itself freely for it must be seen in order to exist. But we vacillate between self and giving, both as individuals and as a society.

Beauty joins grown-ups, like children, in play.

"*La beauté,*" said Louise Bourgeois, "*est la raison d'être.*"

* * *

A few years ago, I was reading John Ruskin and Walter Pater in my semiotics class. Both taught aesthetics at Oxford in the 1870s. They disagreed on many points, particularly on the *use* of beauty and its relationship to morality, though neither had any problem employing the word. I complained that the word was seldom used today.

Then Roberto Portillo, a graduate student from Mexico City, waved a little white book by Dave Hickey called *The Invisible Dragon: Four Essays on Beauty.* Walking home that evening, book in hand, I saw two lovers in a park near a church on Seventeenth Street: one pressed against the other, the other pressed against a tree, the tree traversed a purple sky.

In an earlier book, *The Sense of Beauty* (1896), Santayana wrote that if beauty is linked so strongly to the sexual drive, we do not need philosophy to defend it. If one wanted to produce a being with a great susceptibility to beauty, one could not invent an instrument better designed for that object than sex. If people didn't have to unite for the birth and rearing of each generation, they might retain their "savage independence." But sex endows the individual with a silent and powerful instinct, which carries each of us continually toward another.

I recommended Hickey's little book to my friend David Shapiro, with whom I share a similar aesthetic. Soon after, perusing an antiquarian bookstore on the fringe of Boston, I found an old anthology called *Philosophies of Beauty: From Socrates to Robert Bridges,* compiled by E. F. Carritt and published by Oxford University Press in 1931. It included writings by Plato, Aristotle, Aquinas, Hume, Baumgarten, Kant, Wordsworth, Ruskin, Pater, Nietzsche, Shelley, Santayana, Bergson, Croce, and several others.

With inspiration from *Philosophies of Beauty,* I felt it might be time for a new anthology on beauty. But if beauty had indeed been dropped from contemporary discourse, would there be enough to fill a book? I asked David to help in the search

and we were surprised at how much we found. Soon after, Peter Schjeldahl's piece derived from his "Notes on Beauty," published herein, appeared as the cover story for the *New York Times Magazine*. Disparaged for so long in intellectual circles, if not in the popular culture, seething beauty had suddenly resurfaced.

In organizing the book, David and I categorized the writings into three sections: Theory, Ownership, and Practice. The Theory section includes philosophies of beauty from some of today's most important art critics, poets, and philosophers. The oldest essay in this section, dated 1966, is by Meyer Schapiro on the concepts of perfection and unity of form and content. Arthur C. Danto's piece, on the relationship of beauty and morality, redefines for our time a question so close to eminent aestheticians of the nineteenth and early twentieth century like John Ruskin and Henri Bergson. Hubert Damisch contrasts Freud and Kant in the context of his book, *The Judgment of Paris*. The most recent works are by Robert C. Morgan, Marjorie Welish, and Carter Ratcliff, written specifically for this anthology.

The section we call Ownership encompasses an eloquent debate between Thomas McEvilley, then an editor of *Artforum*, William Rubin, director emeritus of the Museum of Modern Art, and Kirk Varnedoe, chief curator for painting and sculpture at the museum. The subject of the debate is the exhibition *"Primitivism" in Twentieth-Century Art: Affinity of the Tribal and the Modern* at the Museum of Modern Art, curated by Rubin and Varnedoe in 1984. In this exhibition, contemporary Western works of art were shown side by side with so-called primitive works.

One might ask why this material belongs in a book of essays on beauty. Its overt subject matter is not beauty. But in addressing the affinity artists of the Western world might have for the primitive, the debate cuts to the core of the question of consensus, the relativity of meaning, and the universality of beauty. With McEvilley's initial response to the show, "Doctor Lawyer Indian Chief," and the replies that followed in *Artforum* and *Art in America*, we have published what could be called rounds one, two, and three. It wouldn't be wrong to say that this was an early fight in the debate about modernism and postmodernism in the visual arts. In what may be the beginning of a fourth round, to be reserved hopefully for a new book, Rubin has recently completed a new introduction to the *"Primitivism"* catalogue, picking up where he left off in 1985. McEvilley insists that what Rubin, Varnedoe, and he are arguing are two views on beauty—his with a

small *b* as a value that is culturally conditioned and "characterized by disjunction and change," and Varnedoe's and Rubin's with a capital *B* involving "unchanging universals." Varnedoe recently retorted that "extreme relativists often think that the only thing not affected by deep bias and obfuscating blinders is their own viewpoint!" What one can feel most of all from these exchanges, both historical and recent, is the intensity of feeling the debate evoked and the absolutely fundamental importance all who were directly involved knew it had. In speaking to McEvilley, Rubin, and Varnedoe about publishing the articles and the subsequent responses, I could see that the debate has not cooled one bit. They seemed to feel it as keenly as if it had happened yesterday. For me, it was like stumbling into the O.K. Corral at High Noon, an experience I'll never regret.

The last section, Practice, begins with the psychologist James Hillman's essay "The Practice of Beauty." This easily could have been an introduction to the book itself, for it is a summary of how we arrived at the point of reconsidering beauty today. The writings that follow are from critics, poets, and two of our greatest artists, Louise Bourgeois and Agnes Martin, on the activity of making art. Donald Kuspit takes on the twentieth century's most controversial paintings, de Kooning's women, by defining beauty through vulgarity, and Julia Kristeva and Ariane Lopez-Huici discuss the aesthetics of men. John Hejduk describes the spirituality of a house through the humanity of architecture, and David Shapiro brings Mondrian's flowers out of the closet. I first saw the flower paintings in a show David curated at the Sidney Janis Gallery in 1991, but I know David has been obsessed with them since the early seventies because I remember him mentioning them when we first met. Even Mondrian's own theory rejected the flowers, and they remain transgressive still through their beauty and feminine refutation of the perpendicular. John Yau probes the enigma of Jasper Johns's method, and the "trap of looking," through examining Johns's sketchbook notes. Max Fierst, our youngest contributor, contrasts the way one approaches aesthetics through the personalities of his two aunts. I experience the same kind of vitality with a twenty-two-year-old poet like Max that I feel with Louise Bourgeois, who keeps getting younger every minute. I'll always remember the four hot Sunday afternoons in the late summer of 1997 that I spent with her.

> Que bâtir sur les coeurs est une chose sotte;
> Que tout craque, amour et beauté,

Jusqu'à ce que l'Oubli les jette dans sa hotte
Pour les rendre à l'Eternité![2]

* * *

I was a graduate student in Philadelphia at a time when there was a shift from the large, serious, retinal paintings that evolved through Pollock, Still, Newman, Frankenthaler, Noland, and Stella to the anti-aesthetic of Marcel Duchamp and the subversive poetry of dadaists like Tristan Tzara.

Tzara writes in an early manifesto:

Beauty and Truth in art don't exist; what interests me is the intensity of a personality, transposed directly and clearly into its work, man and his vitality, the angle from which he looks at the elements and the way he is able to rescue these ornamental words, feelings, and emotions, out of the basket of death.[3]

The question then, as with any new tendency, is, Were the dadaists against beauty or simply against old beauty? In their reaction against established forms of visual as well as social organization, the dadaists introduced new forms, chance arrangements, and humor to replace traditional elements of composition. In *Life Against Death*, Norman O. Brown compares making jokes to making art, and rightly argues their similarity both in the creative process and experience. Though largely neglected until the late sixties—a time when subversive concerns with regard to sexual and racial equality conspired to change society in a constructive way—the dadaist's anti-aesthetic, Marcel Duchamp's work in particular, took hold and blossomed into the conceptual movement.

After worshipping Frank Stella throughout my undergraduate days, a break in my own aesthetics occurred when my teacher Italo Scanga introduced me to Sol LeWitt, Marcia Tucker, and Bruce Nauman at recurrent barbecues in his backyard in Elkins Park. Bruce Nauman, a former student of Italo's, arrived one afternoon in an old black Citroën. He had nailed a little plaque onto a tree that said, "A Rose Has No Teeth," and Sol LeWitt buried a white cube in the ground. (I had never seen a Citroën before.) Sol suggested that I read Wittgenstein's *The Blue and the Brown Books.* Overnight, a rupture occurred in my aesthetics.

Two shows that included my work soon defined the conceptual movement: *Art of the Mind* (1969) in Oberlin, Ohio, and *The Information Show* (1972) at the

Museum of Modern Art in New York City. My piece in the earlier show was simply the title "My Ears Are Clogged," Masonite letters nailed to the wall. It was, perhaps, an incomplete surrender in the realm of the senses. I knew conceptualism had its limits. The employment of new mediums such as photography was expansive—why paint it if you can photograph it?—but conceptualism's denial of retinal pleasure seemed close to the puritanism of my hometown, from which I had just attempted to escape. Both the Amish fathers living in Virginsville and Joseph Kosuth, the spiritual leader of conceptualism here in New York, always wore black. In their anthem against painting as an object and as a commodity, conceptualists and Marxists were naïve, even hypocritical. A photograph is an object, it's just a little thinner than a painting.

Through language, we can make love, tell jokes, or we can preach. A tendency to the latter took over in the eighties when politically motivated artists became pious, as Jeremy Gilbert-Rolfe observes in his recent book, *Beyond Piety*. Musicians, even while evangelizing, as many rap artists do, still get off on harmony, dissonance, melody, and rhythm. For artists, the lure of the irrational lies, as Jacqueline Lichtenstein eloquently suggests, in color. Color is the element most conceptualists neglected.

As conceptualism turned to agitprop, lacking not only color but sensuality and humor, a new disease infiltrated bodily fluids, and it was everyone's worst nightmare. Perhaps we needed a postmodern update of the anti-aesthetic as an intellectual rationale to foster a fear of pleasure.

If there is a cloud lifting, a change in the wind now, we can attribute it to small progress with respect to that disease and to the long-leashed dragon of desire. We might also look among the scorpions and the hounds, the jackals, apes, and vultures—the beasts of Baudelaire's *Les fleurs du mal*. A beast inhabits that zoo that is "uglier and fouler than the rest, although the least flamboyant of the lot; the beast that would gladly undermine the earth and swallow all creation in a yawn." That beast is boredom.

* * *

We might blame Wittgenstein for *beauty*'s fall. Influential to conceptual artists in the sixties and seventies, he had little patience for questions like, What is beauty? In the summer of 1938, Wittgenstein devoted a lecture at Cambridge to the word. Meanings of words like *beauty* result from their use. *Beauty*, he pointed out, is

most often used as an interjection, similar to *Wow!* or rubbing one's stomach. When aesthetic judgments are made, aesthetic adjectives such as *beautiful* or *fine* hardly play any role at all. "The words you use are more akin to *right* and *correct* than to *beautiful* and *lovely*."

Dave Hickey attributes *beauty*'s disappearance to the progressive flattening of picture space. He writes in "Prom Night in Flatland," one of the four essays on beauty in *The Invisible Dragon,* that when flat pictorial space triumphed over the effeminacy of illusionist space, the "gender" of the work of art changed. It became masculine, impenetrable. Consequently, we replaced feminine descriptives like *beauty, harmony,* and *generosity* with masculine terms like *strength, singularity,* and *autonomy.*

If we could bring back John Ruskin, a passionate ecologist as well as an aesthetician (who would have loved proms), he might look at our contemporary landscape with its highways bludgeoning through hillsides and conclude that there simply isn't any beauty left. Torn between Cindy Crawford and Cindy Sherman, we might need to explain why we want to speak of beauty again. Is our project a nostalgia for a nineteenth-century phenomenon now supplanted by the political?

If beauty has resurfaced in contemporary discourse, some of the questions that Dr. Seuss raised in *Green Eggs and Ham* might be back too—to like it here or to like it there? If the *here* is in the eye of the beholder, the *there* is in the object. If beauty is in the eye of the beholder, is the capacity for perceiving beauty a result of the individual's culture or is it inherent? Is beauty something all human beings enjoy because we have the same basic faculties? If beauty is inherent in an object, this is very mysterious, even magical, very magical for the late twentieth century.

* * *

"For with this desire of physical beauty mingleth itself early the fear of death—the fear of death intensified by the desire for beauty." Walter Pater wrote these lines in the magical time of deep late romanticism. *The Child in the House* tells the story about the aesthetic awakening of a young boy. In another story about a young boy, Thomas Mann carried the affiliation of death and beauty into the early days of the twentieth century and likened beauty to disease. If, in *Death in Venice,* Aschenbach had not stayed in Venice to watch the beautiful Tadzio play on the beach, he wouldn't have eaten the "dead ripe" strawberries that brought the cholera to his

body. Was the cause of his death *cholera vibrio,* or should we attribute it to beauty?

A few months ago my two-year-old son caught the flu. He couldn't keep any liquids down. At the doctor's office, a nurse inadvertently threw his urine sample away. It was all the precious golden liquid we could gather in his severely dehydrated state. As the day passed, we tried to coax some more urine from him, but he just couldn't pee. He became uncharacteristically lethargic. At 7:30 we took him to the emergency ward. Only three other patients were there—a jaundiced man lying in a bed across the room, a dark-skinned man with delicate tortoise-shell glasses lying next to my son, and a woman who wrenched and convulsed at regular intervals. A team of doctors surrounded her.

After much fussing to find a vein in both his feet and in his arms, the doctor, a matronly woman in her thirties, finally plugged in the life-saving saline solution. For an hour or so, a surreal time measured by the drips of the liquid falling from the bottle into the tube and from the tube to his veins, I couldn't help but wonder about the other three people in the ward. The jaundiced man looked like he had all the symptoms of advanced AIDS. Like Aschenbach, had beauty brought him here? The man with the tortoise-shell glasses told me he was dying of cancer. I had no idea of the cause of the woman's convulsions.

In *Illness as Metaphor* and *AIDS as Metaphor,* Susan Sontag argues against placing metaphoric weight on disease. It gets in the way of proper treatment. I was sure the doctors were not considering beauty as part of any prognosis here. How would you treat it?

We have come a long way since the nineteenth century, passing even through Thomas Mann's continued association of beauty, desire, and disease in books like *Death in Venice, Doctor Faustus, Magic Mountain,* and *The Black Swan.* (The latter book is a poignant story of an older woman who believes her recent love for a young man has brought back her capacity to have children, only to find the blood from her womb is the result of a tumor.) Though there are so many passages in literature linking beauty and death, the following passage from *The Captive* by Marcel Proust is unique in that it does not suggest death as a punishment for desire, but poses beauty as a gift, generosity in the last moment of life. Read at the funeral of Meyer Schapiro, it is appropriate as an epitaph for the great aesthetician, and captures *an* essence of this book.

It describes the death of Bergotte, an art critic. The circumstances of his death began with an attack of uremia, which led to his being ordered to rest. (Uremia is

a disorder of the kidneys, an accumulation in the blood of the constituents normally eliminated by the urine, producing a toxic condition marked by headaches, gastric-intestinal disturbances, and vomiting.)

While convalescing, Bergotte is reminded by a fellow art critic of Vermeer's *View of Delft* in a local exhibition. Instead of resting, he has something to eat and goes to the exhibition to look for the painting, a picture he adores. He recalls "a little patch of yellow wall" painted so well—a beauty that is "sufficient in itself." When he gets there, he feels dizzy. Ignoring the other paintings in the exhibition, he comes to the Vermeer. He notices for the first time some small figures in blue, the pink sand, and finally "the precious substance"—the tiny patch of yellow wall. He fixes his gaze "like a child upon a butterfly" that it wants to catch. "That's how I should have written," he says. "My last books are too dry, I ought to have gone over them with a few layers of color, made my language precious in itself, like this little patch of yellow wall."[4]

He is unaware of the seriousness of his condition. In minutes he will die. "In a celestial pair of scales," Proust writes, "there appeared to him, weighing down one of the pans, his own life, while the other contained the little patch of wall so wonderfully painted in yellow. . . ."

Bergotte repeated to himself, "Little patch of yellow wall, with a sloping roof, little patch of yellow wall."

There is no reason inherent in the conditions of life on this earth, Proust continues, to oblige an artist to do over and over again a piece of work the admiration aroused by which will matter little to his "worm-eaten body," like the little patch of yellow wall painted with so much skill and refinement.

Such obligations, which have no sanction in our present life, seem to belong to a different world, a world based on kindness, scrupulousness, and generosity; a world entirely different from this one, which we leave in order to be born on this earth before, perhaps, returning there to live once again beneath the sway of those unknown laws, which we obeyed "because we bore their precepts in our hearts—those laws to which every profound work of the intellect brings us nearer and which are invisible only—if then!—to fools."

Proust pursues beauty through language that is various and eloquent. When a child simply says *nice* in a high-pitched voice, discovering and commenting on something for the first time, it is a similar pursuit. (If *nice* is not exactly *beautiful*, I respond in the way Robert Farris Thompson did when presented with the ques-

tion of why some cultures do not have a word for beauty, "Well, didn't anyone ever hear of synonyms?") Through exclamation, a child differentiates between fascinations and the rest of the world. A little patch of yellow wall. That's what is so interesting.

Arthur Danto wrote that in the Age of Indignation beauty may be in for a rather long exile. We wait for its return. There is a culture—only a handful remain—living on the small island of Obi, west of Borneo, east of Papua New Guinea, bounded by the Seram Sea. Coincidently, Obi is also the habitat of the violet bower bird, the only other animal that constructs solely for aesthetic motives. On the summer solstice in Obi, which is December 21, the inhabitants gather on the beach just before sunset. If the horizon is clear—sometimes for years it is not—the sun sets between two ancient palms and its rays fragment in their fronds bouncing off sprinkles of water that dance above the waves. This phenomenon is evidently pleasing to the eye.

There is only a small patch of yellow beach from which this is visible. Each year the people of the island come with beautifully woven blankets and wait in anticipation. If the ominous cigarlike clouds that are common at that time of year are present in the sky, it only increases their anticipation and their potential for joy or sadness. At the last moment, the clouds might block the sun in the midst of a beautiful sunset. But if the clouds hang just above the horizon, the sun will drop below them, between the fronds, and the sky will radiate for a moment with golden crystalline mist before the sun disappears altogether. They have a two syllable word for the anticipation of this event. Translated, the word means, roughly, "Prepare for beauty!"

In reading these essays and poems, I did not feel burdened by the weight of overdefinition or heavy-handed ideology. A most beautiful and otherwise reclusive actress once told me during an intermission between *Queen Christina* and *Camille*, "Never admit to a weakness." But I confess, the pretense for doing this book was not to identify a new doctrine or ideology, or to band together a new group of artists; it was to find a yes somewhere. It could be that every aesthetic choice is political. But it is equally possible that every political choice is ultimately aesthetic. What Nabokov says he remembered of *Lolita* after he wrote it is also what we remember of civilizations: the images.

You can actively seek beauty, as Wilde once told Whitman, "I cannot listen to anyone unless he attracts me by a charming style, or beauty of theme." Or you can

just let it happen, as Whitman responded to Wilde, "Why Oscar, it always seems to me that the fellow who makes a dead set of beauty by itself is in a bad way. My idea is that beauty is a result, not an abstraction."

Those were the days when beauty was self-evident, and, as Carter Ratcliff wrote, "the existence of people like us was inconceivable." In the dawn of the twenty-first century, when my son Tristan is old enough to read this, with friends as inconceivable to us as we must have been to Victorians, I hope he mislays this book and finds beauty for himself without guilt, in happiness for his own eyes, ears, and his nose. If along the way he encounters an anti-aesthetic as I did, may he greet it with a smile, then take a piss. Because if you are looking for beauty, it is with yellow relief, squatting or standing, fixed on the sky, fixed on the earth, that so often you find it.

Zumbah!

BILL BECKLEY
New York City
December 8, 1997

NOTES

1. Charles Baudelaire, from "Le Cygne," *Les fleurs du mal.*
2. Charles Baudelaire, from "Confession," *Les fleurs du mal.*
3. Tristan Tzara, *Seven Dada Manifestos and Lampisteries.*
4. This is not to imply that the production of beauty is always laborious. Andy Warhol recruited a couple of assistants to urinate on copper plates, and exhibited the beautiful oxidation.

Preface

DAVID SHAPIRO

Beauty, my dear Sir is not so much a quality of the object beheld, as an effect in
him who beholds it. . . . The most beautiful hand seen through the microscope
will appear horrible. . . . He who says that God has created the world so that it
might be beautiful is bound to adopt one of the two alternatives: either that God
created the world for the sake of men's pleasure and eyesight, or else that He cre-
ated men's pleasure and eyesight for the sake of the world.

—Spinoza, 1674

MEYER SCHAPIRO ONCE TOLD ME THAT DESPITE THE ENRAGED PURITANISM OF con-
ceptualism, he knew of no civilization that did not treasure the object. He often
began his courses by mentioning the blindness of certain critics to the arts of Asia,
and taught that one style has no victory over another. He hated false labels like
"postmodern," and championed the coexistence of a vital abstraction and realism
in his own generation. He had learned a subtle relativism from Riegl and yet
always included social fate in his nuanced sense of form's sensuousness.

It is not for nothing that Schapiro's critique of the very idea of perfection is
placed at the beginning of *Uncontrollable Beauty*. The beauty that emerges in these
pages has little in common with the monolithic ideals that long dominated aes-

thetics, only to be all but dropped from the discourse about art in the course of the twentieth century. After being cast out with the same zeal that it was once embraced, beauty is gradually reemerging without pretense to universalism, as a multifaceted and—as several of the contributors to this volume observe—*uncanny* quality that may be present or not in countless forms in any work of art.

Uncontrollable Beauty gathers writings by critics, philosophers, art historians, artists, and poets who have cared enough to sustain argument, alarm, and homage concerning the full intransigence of the aesthetic, and, particularly, its relevance to the discourse about art in our times. The selections do have a target, no doubt, in the colorblind and puritanical critiques that surround and "monitor desire." The book is animated by writers who have found their way past "the ruins of a formalism," and underlines artists such as Willem de Kooning, Jasper Johns, and Louise Bourgeois, who through a democratic vernacular have broken the taboos of the epoch.

I think of this book as a first chapter in a "Maxima Moralia" that rebukes those critics who would police our pleasures and the possibilities of the aesthetic in a dark time. I have tried over many years to assert an aesthetic pluralism that might be an analogue to the revolutionary perspectives of Herzen and his antidogmatic openings. All of this is perhaps a footnote to the pragmatic multiplicities celebrated by William James and his own true students, Wallace Stevens and Gertrude Stein. I regard the book as a part of a essentially unfinished project: an imaginary book on pluralism and the tragic costs of resistance to and repression of the aesthetic in our day—celebrating O'Hara's urbane joy, "Grace to be born and live as variously as possible."

Far from promoting a particular cadre of artists or a "new aestheticism," *Uncontrollable Beauty* hopes rather to give what Henry Michaux once told John Ashbery the surrealist group gave him: the great permission, in the sense of an army leave.

DAVID JOEL SHAPIRO

New York City

January 8, 1998

Le Livre est sur la table

JOHN ASHBERY

1

All beauty, resonance, integrity,
Exist by deprivation or logic
Of strange position. This being so,

We can only imagine a world in which a woman
Walks and wears her hair and knows
All that she does not know. Yet we know

What her breasts are. And we give fullness
To the dream. The table supports the book,
The plume leaps in the hand. But what

Dismal scene is this? The old man pouting
At a black cloud, the woman gone
Into the house, from which the wailing starts?

2

The young man places a bird-house
Against the blue sea. He walks away
And it remains. Now other

Men appear, but they live in boxes.
The sea protects them like a wall.
The gods worship a line-drawing

Of a woman, in the shadow of the sea
Which goes on writing. Are there
Collisions, communications on the shore

Or did all secrets vanish when
The woman left? Is the bird mentioned
In the waves' minutes, or did the land advance?

————————————————

I.
THEORY

On Perfection, Coherence, and Unity of Form and Content

MEYER SCHAPIRO

I

MY AIM IN THIS PAPER IS TO EXAMINE THE ASCRIPTION OF CERTAIN QUALITIES TO the work of art as a whole, the qualities of perfection, coherence, and unity of form and content, which are regarded as conditions of beauty. While rooted in an immediate intuition of the structure of the whole, the judgments of these qualities often change with continuing experience of the object. They are never fully confirmed, but are sometimes invalidated by a single new observation. As criteria of value they are not strict or indispensable; there are great works in which these qualities are lacking. Coherence, for example, will be found in many works that fail to move us, and a supreme work may contain incoherences. Order in art is like logic in science, a built-in demand, but not enough to give a work the distinction of greatness. There are dull and interesting orders, plain and beautiful ones, orders full of surprises and subtle relations, and orders that are pedestrian and banal.

II

The word *perfection* is often a rhetorical term expressing the beholder's feeling of rightness, his conviction that everything in the work is as it should be, that nothing can be changed without spoiling the whole. Our perception of a work, like our

perception of nature or self, is not exhaustive, however. We see only some parts and aspects; a second look will disclose much that was not seen before. We must not confuse the whole in a large aspect, coextensive with the boundaries of a work, and the whole as the totality of the work. Expert scrutiny will discern in the acknowledged masterpieces not only details that were defective when the artist produced them, but changes brought about by others who have repaired the work. Few old paintings are today in their original state. Even acute observers will often fail to notice these changes. A painting that has seemed complete and perfectly proportioned will, like Rembrandt's *Night Watch*, turn out to have lost a considerable part. In Homer's *Iliad*, numerous passages are later interpolations. Few visitors to the cathedral of Chartres can distinguish the original painted glass from the replacements made in the same windows in later and especially in modern times. The example of Chartres reminds us, too, that for the judgment of artistic greatness it is not necessary that a work be consistent in style or complete. Many architects, sculptors, and painters collaborated on this marvel. The varying capacities of these artists, their unlike styles, even their indifference to consistency with each other, have not kept generations of beholders from adoring this beautiful church as a supreme achievement. It is not a single work of art, but, like the Bible, a vast collection of works that we value as a single incomparable whole. If the Parthenon holds up artistically in its ruined state through the grandeur of its qualities in all that remains of the original, in Chartres we accept a whole in which very different conceptions of form have been juxtaposed. The two west towers, begun by two architects of the twelfth century, were completed at different times, one of them in the late Gothic period in a style that is opposed in principle to the rest of the façade. The great west portal, too, is not as it was originally designed; several sculptors of different temperament and capacity have worked together, and parts have been arbitrarily cut and displaced to adjust to a change in the construction.

Even where a single great artist has been responsible for a work, one can detect inconsistencies brought about by a new conception introduced in the course of work. So in the Sistine ceiling, Michelangelo has changed the scale of the figures in midpassage. One can recall other great works of literature, painting, and architecture that are incomplete or inconsistent in some respects. And one might entertain the thought that in the greatest works of all such incompleteness and inconsistency are evidences of the living process of the most serious and daring art which is rarely realized fully according to a fixed plan, but undergoes the contin-

gencies of a prolonged effort. Perfection, completeness, strict consistency are more likely in small works than in large. The greatest artists—Homer, Shakespeare, Michelangelo, Tolstoy—present us with works that are full of problematic features. Samuel Johnson, in considering Shakespeare, drew up a list of weaknesses that, taken alone, would justify dismissing as inferior any other writer in whose poems they occurred. The power of Shakespeare, recognized by Johnson, is manifest in the ability to hold us and satisfy us in spite of these imperfections. Arnold, reviewing Tolstoy's *Anna Karenina*, remarked that it was not a well-constructed story and was defective as a work of art. But then he added—as others have done since in speaking of Tolstoy—his novel is not art, but life itself.

It is clear from continued experience and close study of works that the judgment of perfection in art, as in nature, is a hypothesis, not a certitude established by an immediate intuition. It implies that a valued quality of the work of art, which has been experienced at one time, will be experienced as such in the future; and insofar as the judgment of perfection covers the character of the parts and their relation to the particular whole, it assumes that the quality found in parts already perceived and cited as examples of that perfection will be found in all other parts and aspects to be scrutinized in the future. There is, of course, the negative evidence from the absence of observable inconsistencies and weaknesses. But we have learned often enough how limited is our perception of such complex wholes as works of art. In a circle, a very tiny break or dent will arouse our attention. But in an object as complex as a novel, a building, a picture, a sonata, our impression of the whole is a resultant or summation in which some elements can be changed with little apparent difference to our sense of the whole; perception of such complexities is rapid and tolerant, isolating certain features and passing freely over others, and admitting much vagueness for the sake of the larger effects. We cannot hold in view more than a few parts or aspects, and we are directed by a past experience, an expectation and a habit of seeing, which is highly selective even in close scrutiny of an object intended for the fullest, most attentive perception. The capacity of an expert to discern in a familiar work unnoticed details and relationships that point to its retouching by others is therefore so astonishing. Here the sensibility of the expert, trained and set for such investigation, is like the power of the microscope to disclose in a work features beyond ordinary sensitive vision.

But even the experts are often blind or mistaken. To see the work as it is, to

know it in its fullness, is a goal of collective criticism extending over generations. This task is sustained by new points of view that make possible the revelation of significant features overlooked by previous observers. In all these successive judgments there is an appeal to the freshly seen structure and qualities of the work.

<div align="center">III</div>

What I have said about the fallibility of judgments of coherence and completeness applies also to judgments of incoherence and incompleteness. These are often guided by norms of style which are presented as universal requirements of art and inhibit recognition of order in works that violate new canons of form in that style. The norms are constantly justified in practice by perceptions—supposedly simple unprejudiced apprehensions of a quality—which are in fact directed by these norms. This is familiar enough from the charge of formlessness brought against modern works and especially the cubist paintings that were criticized later from another point of view as excessively concerned with form. It is clear that there are many kinds of order and our impression of order and orderliness is influenced by a model of the quality. For someone accustomed to classic design, symmetry and a legible balance are prerequisites of order. Distinctness of parts, clear grouping, definite axes are indispensable features of a well-ordered whole. This canon excludes the intricate, the unstable, the fused, the scattered, the broken, in composition; yet such qualities may belong to a whole in which we can discern regularities if we are disposed to them by another aesthetic. In the modern compositions with random elements and relations, as in the works of Mondrian and the early Kandinsky and more recent abstract painting, are many correspondences of form: The elements may all be rectilinear, of one color or restricted set of colors, and set on a pronounced common plane; however scattered they appear, these elements are a recognizable family of shapes with an obvious kinship; the density in neighboring fields is about the same or the differences are nicely balanced. In time one comes to distinguish among all the competing models of chaos those that have the firmness of finely coherent forms like the classic works of the past.

I may refer also to a striking medieval example of a long misjudged order, the Romanesque relief at Souillac, with the story of Theophilus, the Virgin, and the Devil. It had seemed to critical observers, sensitive to this style of art, an incoherent work, in spite of its clarity as an image. Its defect was explained by its incom-

pleteness, the result of a loss of parts when the large monumental relief was moved from its original place to the present position. Study of the jointing of the sculptured blocks of stone has shown that no part is missing; and a more attentive reading of the forms has disclosed a sustained relatedness in the forms, with many surprising accords of the supposedly disconnected and incomplete parts. It was the radical break with the expected traditional mode of hierarchic composition in this strange and powerful work that made observers feel it to be chaotic and incomplete.

<div style="text-align:center">

IV

</div>

I shall turn now to the unity of form and content, a more subtle and elusive concept. As a ground of value, it is sometimes understood as a pronounced correspondence of qualities of the forms to qualities and connotations of a represented theme—a stimulating kind of generalized onomatopoeia. So in a painting of violent action, many crossed, colliding, and broken forms, even among the stable accessories, and in a scene of rest, mainly horizontal shapes and considerable voids. It is the poetic ideal of a marriage of sound and sense.

This concept of unity must be distinguished from the theoretical idea that since all forms are expressive and the content of a work is the meaning of the forms both as representations and expressive structures, therefore content and form are one. In a representation, every shape and color is a constituting element of the content and not just a reinforcement. A picture would be a different image of its object and would have another meaning if its forms were changed in the slightest degree. So two portraits of the same person, done with different forms, are different in content, though identical in subject. It is the specific representation together with all the ideas and feelings properly evoked by it that makes the content. And where there is not representation, as in architecture and music and abstract painting, the relations and qualities of the forms, their expressive nature, in the context of the work's function, are the content or meaning of the work.

Conceived in this second way, the unity of form and content holds for all works, good and bad, and is no criterion of value. It is a sort of definition of art as well as of content, though it applies also to spoken language in which the physiognomic characteristics of speech are included with the intended message as part of the content. Unity in this indivisible oneness of form and content has another sense, it seems, than in the concepts of unity of form and unity of content, where

<div style="text-align:center">7</div>

distinguishable parts are judged to harmonize or to fit each other. What is expressed in this oneness of form and content need not, however, be unified in the sense of an inner accord; it is compatible with inconsistencies in the meanings themselves. To judge that a work possesses oneness of form and content it is not even necessary to contemplate it; the oneness follows from the definition of content in the work of art. The sense of the conjunction in "form and content" is not clear then; we do not know what it is that has been united with form as a distinguishable entity or quality in the work. It is different from saying that the content is the sum of the meanings—meanings given in the subject, the forms, and the functions of the work, with many different levels of connotation—a content unbounded rather than definite, and open to successive discovery rather than apprehended fully in a single moment of divination. The unity of form and content is then an accord of specifiable forms and meanings and may in certain works appear comprehensive enough to induce the conviction that everything in the work is stamped with this satisfying accord which is a ground of its beauty.

This judgment of an extensive unity is an interpretation, a hypothesis; there is no one perception or series of perceptions that make it complete and certain. Judgments of unity and perfection in art, as in nature, rest on a selecting vision, an unreflective and sometimes habitual choice of aspects, as in other engagements with complex fields. In attributing a unity of form and content to a work, we are free to abstract the aspect of forms and meanings that might coincide. It is not *the* form and *the* content that appear to us as one, but an aspect or part of each that we bring together because of analogy or expressive correspondence. Content and form are plural concepts that comprise many regions and many orders within the same work. The vagueness of the form-and-content usage is due to the failure to specify in which region the connection or the unity lies. In any work, form and meaning cover several layers and scales of structure, expression, and representation. Line, mass, space, color, dark-and-light constitute different orders in painting, as do words, actions, characters, and the large sequence of narrative in a play or story. Besides, within each of these aspects of the work are elements and characteristics that belong to the style of the time, others that are personal, and still others that are unique solutions for the particular work. To disengage these in their contribution to the content, even to interpret their expression, is beyond the power of an immediate apprehension of the whole.

In an extensive cycle of paintings—let us take Giotto's Paduan frescoes as an

example—each scene has a unique form that builds its distinct image; but all hold together through common forms and colors, though the subjects are different. It would be difficult to match this large order of the whole—given at once to the eye and confirmed by scrutiny of the recurrent elements and connections— with a summating expression and meaning found also in Giotto's conception of the story of Christ. But even if found, it would remain true that we can respond to one without grasping the other fully. If there is a common spiritual attitude in all these scenes, which we regard as a quality of the content, there is a particular form in each scene with features that are not distinctive for the governing spiritual attitude.

How far the unity of form and content is an ideal hypothesis, even a program, is clear from the fact that we often appreciate forms without attending seriously to their represented meanings; for certain works we could not begin to consider that unity with content since so little of the original meanings is available to us. There are few works of older art that are legible now as they were to their makers. Some of the greatest are still problematic in meaning and continue to engage the ingenuity of iconographers. To assume that the forms would necessarily acquire another aspect if we knew what they represented or what their deeper content was originally is only a guess, although there are examples of works restructured after a new interpretation of their meaning. It is unlikely that Titian's *Sacred and Profane Love* would change in artistic character and value if one of the alternative interpretations of its uncertain subject were adopted as certain.

After long study the content of the Sistine ceiling is less evident to us than the structure of the forms; to speak of a unity of form and content there is to pretend to a grasp that is still denied us. The uncertainty is not inherent in the untranslatability of artistic content into words, but in the difficulty of knowing fully enough the broad organizing ideas through which we can perceive the meanings as a unity embracing the subjects, the spheres of connotation, and numerous connections between otherwise isolated elements of representation.

For the painter each figure had a specific sense as well as many connotations, and his conception of the whole as a composition and many details of form were shaped by the need to make that sense visible. To ignore it and yet to speak of the unity of form and content is to strip the content of an essential core of meanings, and the work itself of a great part of its purpose. There is also the pictorial meaning of each figure as a form with a definite place and artistic function in the

appearance of the whole. This can be grasped without our knowing what the figure represents or symbolizes, what is its role in the story. The fact that we are still deeply moved by the undeciphered whole makes us wonder at a theory that regards the experience of forms as necessarily fused with that of content. Here the forms have become for us the main content of the work in a literal sense; they speak to us powerfully and we feel that we have perceived through them the force of the artist's creative powers, his imagination and conception of man, his style as a living person.

If, before Rembrandt's famous picture of *Man with a Knife,* a beholder is unable to say whether it's a portrait of a butcher or an assassin or of Saint Bartholomew who was martyred by a knife, he can still enjoy the painting as a beautiful harmony of light and shadow, color and brushwork, and appreciate the artist's power of making the figure visible as a complex human presence steeped in feeling and reverie; and all this without linking in a specific way the qualities of the painting to the attributes of an intended subject. In a portrait we need not know the identity of the person in order to admire the realization of individuality by painterly means. Yet for the artist that identity was essential. Certain expressive forms were conceived as uniquely adequate to a particular sitter with traits of character and a significance that we divine only incompletely from the portrait.

Seen as form, different works have a different explicitness of structure. In a novel, we often hardly attend to the form; in architecture, in music, in certain kinds of painting, and especially in short poems, the form is more evident and is an unmistakable physiognomy of the work. Who, after reading a novel by Tolstoy, can recall the form as distinctly as he can retell the story or find summarizing words for the thought and feeling that pervade the action? Surely there is an order, a pattern of narration, peculiarities of syntax and phrasing, contrasts and repetitions of language, of character and of plot, that build the whole in its large and intimate meanings. But we do not fix upon these as we read; the style, the form of narration, seems a transparent medium through which we experience the action itself and the feelings of the characters. But this is true also of inferior writing for the reader who is completely bemused by a story. What is relevant for the problem of unity of form and content as a value is that we do not speak of Tolstoy's form—even when we recognize it—as we do of his content. One may find in the remarkable transparency of the medium in Tolstoy's writing the same purity and sincerity as in the substance of his narrative, a confirmation of the oneness of his

art in at least certain aspects of form and content. Here again the unity would lie in a common quality rather than in an undecomposable resultant.

In practice, form and content are separable for the artist who, in advance of the work, possesses a form in the habit of his style that is available to many contents, and a conception of a subject or theme rich in meaning and open to varied treatment. In the process of realization, these separable components of his project are made to interact and in the finished work there arise unique qualities, both of form and meaning, as the offspring of this interaction, with many accords but also with qualities distinctive for each. The beautiful simple language of a writer in a complex story may be appreciated without being considered a property of the content.

The relation between forms and what they represent may be intimate or conventional, as in the beauty of a written or printed book as a work of calligraphic and typographic art. We admire the perfection of the script, the spacing of the page, the ornament, without ever referring to the meaning of the words. From the qualities of the page we cannot imagine the qualities of the text; and we know that this same artistic form can represent whatever text is committed to the calligrapher's art, which is, in general, indifferent to the sense of the script. But if this is regarded as a low order of art because of the shallowness of its content, limited to the expressive import of the melody of script, we shall also find in the same books miniature paintings of greater complexity that we contemplate with delight while ignoring most of their meanings—they are inaccessible to any but scholars and are often a riddle to them.

The concept of unity of form and content must contend with the fact that there are conventions of form that are independent of the subject and appear the same in a great variety of individual styles. In painting and sculpture, what is called the style of representation is a system of forms applied to varying themes. An example is the use of the black ground with red figures and the red ground with black figures in Greek vase painting, a highly characteristic and striking form. It would be hard to show that the choice of one or the other solution has much to do with the content of the painting, however broadly we interpret the latter. Themes of myth and everyday reality, the tragic and festive, the athletic and erotic, are represented alike with this contrast of figure and ground. Accepting the convention, artists of different style endow the basic form with qualities that might be connected with distinct features of a personal style and perhaps even with their individual conceptions of certain themes. But at least some character-

istics of the form are distinguishable from the specific content and even from the content considered as a domain of subjects with a typical set of meanings. Perhaps the convention contributes a quality of feeling, an archaic strength consonant with the robust objectivity of the representations. But even if I accepted this interpretation, I would not dare to say in advance that all the conventions and motifs in that art could be seen as fused with the meanings of an image in a consistent expression—even if I felt the painting to be perfect. On the other hand, to connect such a form as the black and red of figure and ground with a world-view implicit also in the choice and conception of a whole class of Greek subjects is to construct a special layer of meaning to which no explicit reference is found in the work. The Greek artist is not illustrating or presenting his worldview as he illustrates the mythical tales; but he is expressing it somewhat as the structure of a language, it is supposed, embodies in certain features attitudes prevalent in a culture and found also in some revealing utterances in a more explicit way. Yet it must be said that while the assumed connection between form and worldview is alluring to the imagination and as a hypothesis has become embedded in our perception of Greek objects until it has acquired for us the simplicity and self-evidence of a directly grasped meaning, the worldview is not a clear expressive feature of the work of art like the feeling of a painted smile or the contrast of black and red, but a complex and still uncertain interpretation.

Both concepts of unity—the perfect correspondence of separable forms and meanings and the concept of their indistinguishability—rest on an ideal of perception which may be compared with a mystic's experience of the oneness of the world or of God, a feeling of the pervasiveness of a single spiritual note or of an absolute consistency in diverse things. I do not believe that this attitude, with its sincere conviction of value, is favorable to the fullest experience of a work of art. It characterizes a moment or aspect, not the work as disclosed through attentive contemplation, which may also terminate in ecstasy. To see the work as it is one must be able to shift one's attitude in passing from part to part, from one aspect to another, and to enrich the whole progressively in successive perceptions.

I have argued that we do not see all of a work when we see it as a whole. We strive to see it as completely as possible and in a unifying way, though seeing is selective and limited. Critical seeing, aware of the incompleteness of perception, is explorative and dwells on details as well as on the large aspects that we call the whole. It takes into account others' seeing; it is a collective and cooperative seeing

and welcomes comparison of different perceptions and judgments. It also knows moments of sudden revelation and intense experience of unity and completeness which are shared in others' scrutiny.

Enter the Dragon:
On the Vernacular of Beauty

Dave Hickey

> It would be nice if sometime a man would come up to me on the street and say, "Hello, I'm the information man, and you have not said the word *yours* for thirteen minutes. You have not said the word *praise* for eighteen days, three hours, and nineteen minutes."
>
> —Edward Ruscha, *Information Man*

I WAS DRIFTING, DAYDREAMING REALLY, THROUGH THE WANING MOMENTS OF A panel discussion on the subject of "What's Happening Now," drawing cartoon daggers on a yellow pad and vaguely formulating strategies for avoiding punch and cookies, when I realized that I was being addressed from the audience. A lanky graduate student had risen to his feet and was soliciting my opinion as to what "the issue of the nineties" would be. Snatched from my reverie, I said, "Beauty," and then, more firmly, "The issue of the nineties will be *beauty*"—a total improvisatory goof—an off-the-wall, jump-start, free association that rose unbidden to my lips from God knows where. Or perhaps I was being ironic, wishing it so but not believing it likely? I don't know, but the total, uncomprehending silence that greeted this modest proposal lent it immediate credence for me. My interlocutor plopped back into his seat, exuding dismay, and, out of sheer perversity, I

15

resolved to follow beauty where it led into the silence. Improvising, I began updating Pater; I insisted that beauty is not a *thing*–"the beautiful" is a thing. In images, I intoned, beauty is the agency that causes visual pleasure in the beholder; and any theory of images that is not grounded in the pleasure of the beholder begs the question of their efficacy and dooms itself to inconsequence. This sounded provocative to me, but the audience continued to sit there, unprovoked, and *beauty* just hovered there, as well, a word without a language, quiet, amazing, and alien in that sleek, institutional space–like a pre-Raphaelite dragon aloft on its leather wings.

"If images don't *do* anything in this culture," I said, plunging on, "if they haven't *done* anything, then why are we sitting here in the twilight of the twentieth century talking about them? And if they only do things after we have talked about them, then *they* aren't doing them, *we* are. Therefore, if our criticism aspires to anything beyond soft-science, the efficacy of images must be the cause of criticism, and not its consequence–the subject of criticism and not its object. And this," I concluded rather grandly, "is why I direct your attention to the language of visual affect–to the rhetoric of how things look–to the iconography of desire–in a word, to *beauty*!"

I made a voilà gesture for punctuation, but to no avail. People were quietly filing out. My fellow panelists gazed into the dark reaches of the balcony or examined their cuticles. I was genuinely surprised. Admittedly, it was a goof. Beauty? Pleasure? Efficacy? Issues of the nineties? Admittedly outrageous. But it was an outrage worthy of a rejoinder–of a question or two, a nod, or at least a giggle. I had wandered into this *dead zone*, this silent abyss. I wasn't ready to leave it at that, but the moderator of our panel tapped on her microphone and said, "Well, I guess that's it, kids." So I never got off my parting shot. As we began breaking up, shuffling papers and patting our pockets, I felt a little sulky. (Swallowing a pithy allusion to Roland Barthes can do that.) And yet, I had no sooner walked out of the building and into the autumn evening than I was overcome by this strange Sherlock Holmesian elation. The game was afoot.

I had discovered something; or rather, I had put out my hand and discovered nothing–this vacancy that I needed to understand. I had assumed that from the beginning of the sixteenth century until just last week artists had been persistently and effectively employing the rough vernacular of pleasure and beauty to interrogate our totalizing concepts "the good" and "the beautiful"; and now this was over? Evidently. At any rate, its critical vocabulary seemed to have evaporated

overnight, and I found myself muttering detective questions like: Who wins? Who loses? *Qui bono?*—although I thought I knew the answer. Even so, for the next year or so, I assiduously trotted out "beauty" wherever I happened to be, with whomever I happened to be speaking. I canvassed artists and students, critics and curators, in public and in private—just to see what they would say. The results were disturbingly consistent, and not at all what I would have liked.

* * *

Simply put, if you broached the issue of beauty in the American art world of 1988, you could not incite a conversation about rhetoric—or efficacy, or pleasure, or politics, or even Bellini. You ignited a conversation about the market. That, at the time, was the "signified" of beauty. If you said "beauty," they would say, "The corruption of the market," and I would say, "The corruption of the *market*?!" After thirty years of frenetic empowerment, during which the venues for contemporary art in the United States had evolved from a tiny network of private galleries in New York into this vast, transcontinental sprawl of publicly funded, postmodern iceboxes? During which time the ranks of "art professionals" had swollen from a handful of dilettantes on the East Side of Manhattan into this massive civil service of Ph.D.s and M.F.A.s who administered a monolithic system of interlocking patronage, which, in its constituents, resembled nothing so much as that of France in the early nineteenth century? While powerful corporate, governmental, cultural, and academic constituencies vied for power and tax-free dollars, each with its own self-perpetuating agenda and none with any vested interest in the subversive potential of visual pleasure? Under *these* cultural conditions, artists across this nation were obsessing about the *market*?—fretting about a handful of picture merchants nibbling canapés on the Concorde?—blaming them for any work of art that did not incorporate raw plywood?

Under these cultural conditions, I would suggest, saying that "the market is corrupt" is like saying that the cancer patient has a hangnail. Yet the manifestations of this pervasive *idée fixe* remain everywhere present today, not least of all in the sudden evanescence of the market itself after thirty years of scorn for the intimacy of its transactions, but also in the radical discontinuity between serious criticism of contemporary art and that of historical art. At a time when easily 60 percent of historical criticism concerns itself with the influence of taste, patronage, and the canons of acceptability upon the images that a culture produces, the

bulk of contemporary criticism, in a miasma of hallucinatory denial, resolutely ignores the possibility that every form of refuge has its price, and satisfies itself with grousing about "the corruption of the market." The transactions of value enacted under the patronage of our new "nonprofit" institutions are exempted from this cultural critique, presumed to be untainted, redemptive, disinterested, taste free, and politically benign. Yeah, right.

During my informal canvass, I discovered that the "reasoning" behind this presumption is that art dealers "only care about how it looks," while the art professionals employed by our new institutions "really care about what it means." Which is easy enough to say. And yet, if this is, indeed, the case (and I think it is), I can't imagine any but the most demented naïf giddily abandoning an autocrat who monitors appearances for a bureaucrat who monitors desire. Nor can Michel Foucault, who makes a variation of this point in *Surveiller et punir*, and poses for us the choice that is really at issue here, between bureaucratic surveillance and autocratic punishment. Foucault opens his book with a grisly, antique text describing the lengthy public torture and ultimate execution of Damiens, the regicide; he then juxtaposes this cautionary spectacle of royal justice with the theory of reformative incarceration propounded by Jeremy Bentham in his "Panopticon."

Bentham's agenda, in contrast to the king's public savagery, is ostensibly benign. It reifies the benevolent passion for secret control that informs Chardin's pictorial practice, and, like Chardin, Bentham *cares*. He has no wish to punish the offender, merely to reconstitute the offender's desire under the sheltering discipline of perpetual, covert, societal surveillance in the paternal hope that, like a child, the offender will ultimately internalize that surveillance as a "conscience" and start controlling himself as a good citizen should. However, regardless of Bentham's ostensible benignity (and, in fact, because of it), Foucault argues that the king's cruel justice is ultimately more just—because the king does not care what we *mean*. The king demands from us the appearance of loyalty, the rituals of fealty, and, if these are not forthcoming, he destroys our bodies, leaving us our convictions to die with. Bentham's warden, on the other hand, demands our *souls*, and on the off chance that they are not forthcoming, or *cannot* come forth into social normality, he knows that we will punish ourselves, that we will have internalized his relentless surveillance in the form of self-destructive guilt.

These are the options that Foucault presents us; and I would suggest that, within the art community, the weight of the culture is so heavily on Bentham's

side that we are unable to see them as equally tainted. We are, I think, such obe-
dient children of the Panopticon, so devoted to care, and surveillance, and the
redeemable *souls* of things, that we have translated this complex, contemporary
option between the king's savage justice and Bentham's bureaucratic discipline
into a progressive, utopian choice between the "corrupt old market" and the
"brave new institution." Thus beauty has become associated with the "corrupt old
market" because art dealers, like Foucault's king, traffic in objects and appear-
ances. They value images that promise pleasure and excitement. Those that keep
their promise are admitted into the presence of the court; those that fail are sub-
ject to the "king's justice," which can be very cruel and autocratic indeed. But there
is another side to this coin, since art dealers are also like Foucault's king in that
they do not care "what it means." Thus radical content has traditionally flourished
under the auspices of this profound disinterest.

The liberal institution, however, is not so cavalier about appearances as the
market is about meaning. Like Jeremy Bentham's benevolent warden, the insti-
tution's curators hold a public trust. They must look carefully and genuinely care
about what artists "really" mean—and therefore they must, almost of necessity,
distrust appearances—distrust the very idea of appearances, and distrust most of all
the appearance of images that, by virtue of the pleasure they give, are efficacious
in their own right. The appeal of these images amounts to a kind of ingratitude,
since the entire project of the new institution has been to lift the cruel burden of
efficacy from the work of art and make it possible for artists to practice that "plain
honesty" of which no great artist has yet been capable, nor ever wished to be. Yet,
if we would expose the inner soul of things to extended public scrutiny, "sincere"
appearance is everything, and beauty is the bête noire of this agenda, the snake in
the garden. It steals the institution's power, seduces its congregation, and, in every
case, elicits the dismay of artists who have committed themselves to plain honesty
and the efficacy of the institution.

The arguments these artists mount to the detraction of beauty come down to
one simple gripe: *Beauty sells,* and although their complaints usually are couched
in the language of academic radicalism, they do not differ greatly from my grand-
mother's *haut bourgeois* prejudices against people "in trade" who get their names
"in the newspaper." Beautiful art *sells.* If it sells itself, it is an idolatrous commod-
ity; if it sells anything else, it is a seductive advertisement. Art is not idolatry, they
say, nor is it advertising, and I would agree—with the caveat that idolatry and

19

advertising are, indeed, art, and that the greatest works of art are always and inevitably a bit of both.

* * *

Finally, there are issues worth advancing in images worth admiring; and the truth is never "plain," nor appearances ever "sincere." To try to make them so is to neutralize the primary, gorgeous eccentricity of imagery in Western culture since the Reformation: the fact that it cannot be trusted, that imagery is always presumed to be proposing something contestable and controversial. This is the sheer, ebullient, slithering, dangerous fun of it. No image is presumed inviolable in our dance hall of visual politics, and all images are potentially powerful. Bad graphics topple good governments and occlude good ideas; good graphics sustain bad ones. The fluid nuancing of pleasure, power, and beauty is a serious, ongoing business in this culture and has been since the sixteenth century, when the dazzling rhetorical innovations of Renaissance picture making enabled artists to make speculative images of such authority that power might be successfully bestowed upon them, privately, by their beholders, rather than (or at least prior to) its being assigned by the institutions of church and state.

At this point, for the first time in history, the power of priestly and governmental bureaucracies to assign meaning to images began to erode, and the private encounter between the image and its beholder took on the potential of changing the public character of institutions. Images became mobile at this point, and irrevocably political—and henceforth, for more than four centuries subsequent to the rise of easel painting, images *argued* for things—for doctrines, rights, privileges, ideologies, territories, and reputations. For the duration of this period, a loose, protean collection of tropes and figures signifying "beauty" functioned as the *pathos* that recommended the *logos* and *ethos* of visual argumentation to our attention. It provided the image's single claim to being looked at—and to being believed. The task of these figures of beauty was to enfranchise the audience and acknowledge its power—to designate a territory of shared values between the image and its beholder and, then, in this territory, to argue the argument by valorizing the picture's problematic content. Without the urgent intention of reconstructing the beholder's view of things, the image had no reason to exist, nor any reason to be beautiful. Thus, the comfort of the familiar always bore with it the frisson of the exotic, and the effect of this conflation, ideally, was persuasive excitement—visual

pleasure. As Baudelaire says, "the beautiful is always strange," by which he means, of course, that it is always strangely familiar.

Thus Caravaggio, at the behest of his masters, would deploy the exquisite hieratic drama of the *Madonna of the Rosary* to lend visual appeal and corporeal authority to the embattled concept of the intercession of the priesthood–and would demonstrably succeed, not only in pleading his masters' case, but in imposing the urbane glamour of his own argument onto that doctrine. So today, as we stand before the *Madonna of the Rosary* in Vienna, we pay homage to a spectacular souvenir of successful visual litigation–an old warhorse put out to pasture–in this case, a thoroughbred. The image is quiet now; its argumentative frisson has been neutralized, and the issue itself drained of ideological urgency, leaving only the cosmetic superstructure of that antique argument just visible enough to be worshiped under the frayed pennants of "humane realism" and "transcendent formal values" by the proponents of visual repose.

Before we genuflect, however, we must ask ourselves if Caravaggio's "realism" would have been so trenchant, or his formal accomplishment so delicately spectacular, had his contemporary political agenda, under the critical pressure of a rival church, not seemed so urgent? And we must ask ourselves further if the painting would have even survived until Rubens bought it, had it not somehow expedited that agenda? I doubt it. We are a litigious civilization and we do not like losers. The history of beauty, like all history, tells the winner's tale; and that tale is told in the great mausoleums where images like Caravaggio's, having done their work in the world, are entombed–and where, even hanging in state, they provide us with a ravishing and poignant visual experience. One wonders, however, whether our standards for the pleasures of art are well founded in the glamorous *tristesse* we feel in the presence of these institutionalized warhorses, and whether contemporary images are really enhanced by being institutionalized in their infancy, whether there might be work in the world for them to do, as well.

For more than four centuries, the idea of "making it beautiful" has been the keystone of our cultural vernacular–the lover's machine gun and the prisoner's joy–the last redoubt of the disenfranchised and the single direct route from the image to the individual without a detour through church or state. Now, it seems, that lost generosity, like Banquo's ghost, is doomed to haunt our discourse about contemporary art–no longer required to recommend images to our attention or to insinuate them into the vernacular, and no longer even welcome to try. The

route from the image to the beholder now detours through an alternate institution ostensibly distinct from church and state. Even so, it is not hard to detect the aroma of Caravaggio's priests as one treads its gray wool carpets or cools one's heels in its arctic waiting rooms. One must suspect, I think, that we are being denied any direct appeal to beauty, for much the same reason that Caravaggio's supplicants were denied appeal to the Virgin: to sustain the jobs of bureaucrats. Caravaggio, at least, *shows* us the Virgin, in all her gorgeous autonomy, before instructing us not to look at her and redirecting our guilty eyes to that string of wooden beads hanging from the priest's fingers. The priests of the new church are not so generous. Beauty, in their domain, is altogether elsewhere, and we are left counting the beads and muttering the texts of academic sincerity.

<div align="center">* * *</div>

As luck would have it, while I was in the midst of my informal survey, the noisy controversy over exhibiting Robert Mapplethorpe's erotic photographs in public venues provided me with a set-piece demonstration of the issues–and, at first, I was optimistic, even enthusiastic. This uproar seemed to be one of those magic occasions when the private visual litigation that good art conducts might expand into the more efficacious litigation of public politics–and challenge some of the statutory restrictions on the conduct that Mapplethorpe's images celebrate. I was wrong. The American art community, at the apogee of its power and privilege, chose to play the ravaged virgin, to fling itself prostrate across the front pages of America and fairly dare the fascist heel to crush its outraged innocence.

Moreover, this community chose to ignore the specific issues raised by Mapplethorpe's photographs in favor of the "higher politics." It came out strenuously in defense of the status quo and all the perks and privileges it had acquired over the last thirty years, and did so under the tattered banner of "free expression"–a catchphrase that I presumed to have been largely discredited (and rightly so) by the feminist critique of images. After all, once a community acquiesces in the assumption that *some* images are certifiably toxic, this, more or less, "opens the door," as they say in the land of litigation.

And finally, hardly anyone considered for a moment what an incredible rhetorical *triumph* the entire affair signified. A single artist with a single group of images had somehow managed to overcome the aura of moral isolation, gentrification, and mystification that surrounds the practice of contemporary art in

this nation and directly threaten those in actual power with his celebration of marginality. It was a fine moment, I thought, and all the more so because it was the *celebration* and not the marginality that made these images dangerous. Simply, it was their rhetorical acuity, their direct enfranchisement of the secular beholder. It was, exactly, their beauty that had lit the charge—and, in this area, I think, you have to credit Senator Jesse Helms, who, in his antediluvian innocence, at least saw what was there, understood what Mapplethorpe was proposing, and took it, correctly, as a direct challenge to everything he believed in. The senator may not know anything about art, but rhetoric is his business, and he did not hesitate to respond to the challenge. As, one would hope, he had a right to. Art is either a democratic political instrument, or it is not.

So, it was not that men were making it in Mapplethorpe's images. At that time they were regularly portrayed doing so on the walls of private galleries and publicly funded "alternative" spaces all over the country. On account of the cult of plain honesty and sincere appearance, however, they were not portrayed as doing so *persuasively.* It was not that men were making it, then, but that Mapplethorpe was "making it beautiful." More precisely, he was appropriating a baroque vernacular of beauty that predated and, clearly, outperformed the puritanical canon of visual appeal espoused by the therapeutic institution. This canon presumes that we will look at art, however banal, because looking at art is, somehow, "good" for us, regardless and, ultimately, in spite or whatever specific "good" the individual work or artist might urgently propose to us.

This habit of subordinating the artist's "good" to the "higher politics of expression," of course, makes perfect sense in the mausoleums of antiquity, where it was born, and where we can hardly do otherwise—where it is, perhaps, "good" for us to look at the *Madonna of the Rosary* without blanching at its Counter-Reformation politics, because those politics are dead—and where it may be "good" for us, as well, to look at a Sir Thomas Lawrence portrait and "understand" his identification of romantic heroism with landed aristocracy. It is insane and morally ignorant, however, to confront the work or a living (and, at that time, dying) artist as we would the artifacts of lost Atlantis, with forgiving connoisseurship—to "appreciate" his passionate, partisan, and political celebrations of the American margin—and in so doing, refuse to engage their "content" or argue the arguments that deal so intimately with trust, pain, love, and the giving up of the self.

Yet this is exactly what was expected and desired, not by the government, but

by the art establishment. It was a matter of "free expression," and thus, the defense of the museum director prosecuted for exhibiting the images was conducted almost completely in terms of the redemptive nature of formal beauty and the critical nature of surveillance. The "sophisticated" beholder, the jury was told, responded to the elegance of the form regardless of the subject matter. Yet this beholder must be "brave" enough to look at "reality" and "understand" the sources of that formal beauty in the artist's tortured private pathology. If this sounds like the old patriarchal do-dah about transcendent formal values and humane realism, it is, with the additional fillip that, in the courts of Ohio, the sources of beauty are now taken to be, not the corruption of the market, but the corruption of the *artist*. So, clearly, all this litigation to establish Robert Mapplethorpe's "corruption" would have been unnecessary had his images somehow *acknowledged* that corruption, and thus qualified him for our forgiveness. But they did not.

There is no better proof of this, I think, than the fact that, while the Mapplethorpe controversy was raging, Francis Bacon's retrospective was packing them in at the Los Angeles County Museum of Art, and Joel-Peter Witkin was exhibiting in institutional serenity—because Bacon's and Witkin's images speak a language of symptoms that is profoundly tolerable to the status quo. They mystify Mapplethorpe's content, aestheticize it, personalize it, and ultimately further marginalize it as "artistic behavior," with signifiers that denote angst, guilt, and despair. It is not portrayal that destabilizes, it is *praise*. Nor is it criticism of centrality that changes the world. Critique of the mainstream ennobles the therapeutic institution's ostensible role as shadow government and disguises its unacknowledged mandate to neutralize dissent by first ghettoizing it, and then mystifying it. Confronted by images like Mapplethorpe's that, by virtue of their direct appeal to the beholder, disdain its umbrella of "care," the therapeutic institution is immediately disclosed for what it is: the moral junkyard of a pluralistic civilization.

Yet the vernacular of beauty, in its democratic appeal, remains a potent instrument for change in this civilization. Mapplethorpe uses it, as does Warhol, as does Ruscha, to engage individuals within and without the cultural ghetto in arguments about what is good and what is beautiful. And they do so without benefit of clergy, out in the street, out on the margin, where we might, if we are lucky, confront that information man with his reminder that we have not used the word *praise* for eighteen days, three hours, and nineteen minutes.

Beauty and Morality

ARTHUR C. DANTO

ROBERT MOTHERWELL'S ELEGIES TO THE SPANISH REPUBLIC, OF WHICH HE PAINTED *Number 172 (with Blood)* in 1990, is a good place to begin discussing whether there is a conflict between aesthetic excellence and what Richard Schiff designates as "sociopolitical discourse." The *Elegies,* Motherwell said, "reflect the internationalist in me, interested in the historical forces of the twentieth century, with strong feelings about the conflicting forces in it." I once drew a sustained comparison between the *Elegies* and the other great series of paintings by a modern American artist, Richard Diebenkorn's *Ocean Park* series. It is reasonably clear, though both these men are abstract painters, that Diebenkorn's inspiration is landscape and his paintings achieve their beauty by way of an internalization of the beauties of the natural world—of sea and sky and beach—but raised to a certain power, as is always true of an art which, in Hegel's thundering phrase, is "born of the spirit and born again." But it might be false to say that Motherwell's *Elegies* owe their beauty to some transfigured natural beauty: they may in fact transfigure terrible suffering instead, which it would be a mistake to view as beautiful at all. "How beautiful those mourning women are beside the shattered posts of their houses, against the morning sky" is not a morally permissible vision. But Motherwell's forms feel like the shawled shapelessness of bent women, alternating with, or set amidst, the ver-

25

ticals of shattered architectures. It is a stark, black-and-white setting, touched perhaps with ocher or crimson, and the reality must in some way be shattering. But the works are unquestionably beautiful, as befits the mood announced by their titles as *elegies,* which are part music and part poetry, whose language and cadence are constrained by the subject of death and loss and which express grief, whether the artist shares it or not. The *Elegies* express, in the most haunting forms and colors, rhythms and proportions, the death of a political reality, of a form of life, of hope institutionalized. Elegy fits one of the great human moods; it is a way of responding artistically to what cannot be endured or what can only be endured. Motherwell was medaled by the Spanish government, after the fall of Franco, for having sustained the only mood morally acceptable through the years of dictatorship, a kind of moral mission unmatched, I think, in twentieth-century art.

Elegies are artistic responses to events the natural emotional response to which is *sorrow,* which *Webster's* defines as "deep distress and regret (as over the loss of something loved)." I feel we understand too little about the psychology of loss to understand why the creation of beauty is so fitting as a way of marking it—why we bring flowers to the graveside, or to the funeral, or why music of a certain sort defines the mood of mourners. It is as though beauty were a kind of catalyst, transforming raw grief into tranquil sadness, almost, one might say, by putting the loss into a certain philosophical perspective. Kant famously and systematically connects the ascription of beauty to things that in fact please, but if and only if the pleasure can be universalized in a certain way: "The beautiful," he writes "is that which apart from concepts is represented as the object of a universal satisfaction." Kant does not especially speak of pain in his *Critique of Aesthetic Judgment,* but it strikes me that symmetry almost demands that there be a concept of beauty ascribed to objects that cause pain when the pain, too, can be universalized or philosophized, and so, though the death causes grief, causes as acute a pain in the survivor as the human being knows, since love is abruptly and irrevocably bereft of its object, the conjunction of pain with its universalization as mediated by beauty somehow is felt to be consoling through the consideration that death is universal, that, as the paradigm syllogism puts it, dryly and abstractly, all men are mortal. So the conjunction of beauty with the occasion of pain transforms the pain into a kind of muted pleasure. Everyone knows how pain distracts from pain—how we dig our fingernails into our palms to mute the agony of the toothache; here it is pleasure that mutes it, as caused by the music or the words or the cadences of

forms which make the occasion bearable because of the common lot. And the recognition of this may—must, given the ubiquity of the phenomenon—give the bereaved a certain strength in the recognition of his or her participation in the very meaning of what it is to be human. So the form of the elegy is philosophical and artistic at once: it gives a kind of meaning that is at once universal.

I will admit that it is not easy to extend this analysis to the *Elegies to the Spanish Republic*. Because these are elegies, they universalize through philosophization; but it is difficult to assimilate a political defeat to the mood of "queens have died young and fair." It makes it seem inevitable, the way death is, and this is not, I think, a perspective appropriate to political loss in, so to speak, zero-sum conflicts where, after all, somebody wins. And if this is unavailable, so is beauty. It is one thing when distant empires have collapsed, and all that remain are the ruins, the trunkless legs of Ozymandias, King of Kings, and the boastful legend is rendered instantly pathetic by the surrounding wastes and the thin desert winds. We do sentimentalize ruins, which is why they were so stirring to the temperament of the Romantics, who could stand below them and reflect on the transitoriness of glory. But we hardly can do this before raw wreckage, where the blackness is not so much the patination of age and nature, but the charred effect of fire and dried blood. Is the elegiac mood ever appropriate to so near a political catastrophe? Doesn't beauty distance it too abruptly? Have we a moral right to wax elegiac over something that was not all that inevitable or universal or necessary? Think, to bring it back to the individual death, to which beauty itself is the human response, when one feels that death was not inevitable (though death abstractly considered is): Suppose one's lover has died of AIDS, and one feels that something should or could have been done, one feels anger that it has not been done, one blames and accuses. Then beauty to which one is spontaneously moved also seems wrong, wrong because one is called upon to act (to "act up") and not to philosophize. Then that may translate back into the appropriate mood for the fall of the Spanish Republic, where elegy conflicts with the impulse to counteraction. (Of course, we then have to look at the dates: the first *Elegy* was done in 1948, whereas the Second Spanish Republic fell to Franco in 1939. Does this matter?)

This might be a criticism to which Motherwell's paintings are subject but to which Jenny Holzer's *Laments* would not be, as that work treats of death abstractly and almost disinterestedly. Kant's thesis is that the judgment of beauty is always disinterested: an object may be deemed beautiful only when it pleases "apart from

all interest." If this is so much as a possible analysis, then the question remains as to whether it is ever right to respond to an event so close by creating beauty, and hence whether beauty is appropriate when interest is morally prescribed. I shall return to this issue, so central in discussions of whether beauty is licit in art that is "engaged," as so much art today is; but my immediate concern is to stress that the beauty of Motherwell's *Elegies* is *internal* to the work. The paintings are not to be admired because they are beautiful, but because their being so is internally connected with the reference and the mood. The beauty is an ingredient in the content of the work, just as it is, in my view, with the cadences of sung or declaimed elegies.

I want to expand a bit on this idea of internal beauty, which has an incidental consequence of showing how the line is to be drawn between natural and artistic beauty. Hegel asserts straight off in his stupendous lectures on aesthetics that the beauty of art is higher than the beauty of nature: "The beauty of art," he writes, "is beauty born of the spirit and born again." People have queried the meaning of this "twice-born" characterization of artistic beauty. I think it must merely have to do with the fact that the beauty in the first instance is internal to the concept of the work in the artist's mind, and then enacted in the work itself, so born twice—first in the idea and then in the embodiment of the idea. Whatever the case, it will be valuable to consider some examples, of which I will cite two, each of which internalizes the phenomenon of beauty in a different way, both times differently from the way Motherwell's *Elegies* internalize it.

First, I want to describe the beauty in (not the beauty of!) a Tibetan tangka (scroll painting) of the late nineteenth century, which shows the death of the historical Buddha. The event takes place in an achingly beautiful garden, with green lawns under blue skies, rainbows fluttering like pennants, ornamental birds and plantings, amidst which the Buddha says his last farewells to grieving monks. The beauty of the day and of the place transfer their beauty to the work itself, which is beautiful in ways not typical of tangkas, which can be scary and menacing and repellent. But my sense is that this beauty *of* is subservient to the beauty *in* the work. The Buddha, of course, is calm, but the monks are not, which shows that they have as yet not internalized the message of disinterest, or detachment, which is the Buddha's central teaching. They still suffer because, on that theory, they are attached to him. So they have a very long path to tread indeed. They must learn to discipline the propensity to cathect. The Buddha, in this work, demonstrates

his enlightenment by the equanimity with which he faces death, taking leave of the world at its best and most beautiful—taking leave of *this,* which the artist arrays before the eyes of the viewer. Anyone, perhaps, can accept with equanimity the loss of a world gone bad and dark and hopeless: in those cases death is an escape, a way out. I once read, in a memoir of the French mystic Marie Bashkirtsev, the young woman's dying words to her mother: *"Maman, Maman, c'était pourtant si beau la vie."* That *pourtant* is a *cri de coeur* of one who had accepted intellectually the thought that the world is a poor place, which, in fact, her feelings contradicted. But this tangka shows us the world made beautiful by the fact of leaving it, which transcends the natural beauty, just as Hegel says. *This,* which we see before us, is what we must learn to distance if we wish to be free: So the work is an aesthetic apparatus for the strengthening of the muscles of detachment. "Detach yourself from this, and you are on your way to Buddhahood!" Here, in any case, beauty and death relate in a very different way from that in which they do in elegies, mainly, I suppose, because it is the doctrine of Buddhism that death is something that can be conquered, that it lies within our power to overcome it, and that the common philosophical lot of suffering need not be finally accepted.

A second example is at the antipodes of this. I want to consider certain of Robert Mapplethorpe's images that present the phallus to the viewer as if it were a very pricey product advertised in a magazine like *Vogue.* The images are of a kind to arouse envy and desire in the right sort of audience, and hence the internal beauty of the photography has a rhetorical function, the way the advertising photograph does. Nonetheless, such is the presumed mentality of the targeted audience and such the size of the phallus displayed in each that the object by itself, one might suppose, carries its own rhetoric of magnitude and its own erotic promises, even were the photographs to have been flat and descriptive and documentary. Indeed, we can imagine three photographs of the same phallused male body, one of which is merely documentary, one which uses the artifact of the documentary photograph to make a point about visual honesty, and then one of Mapplethorpe's images in which the whole vocabulary of the glamour shot is marshaled in order to confer on the subject merely shown in the first photograph an aura one would hardly have supposed required, but which, when present, contributes a meaning of its own. Mapplethorpe uses, in particular, backlighting and shadow as we find it in the standard Hollywood black-and-white, star-enhancing photograph, a language that is almost cosmetic in making the star seem beyond and outside the

ordinary human range. Stars already are that, being beautiful people in their own right, but with cosmetics in reality and light-and-shadow in photography, they become transformed into works of art almost, or at least what was suitably named "Matinee Idols." It is quite striking, when one reflects on it, that an artist as certain of the language of visual stardom as Warhol, should have altered the mode in which glamour is conferred upon a face: to be glamorous is to be presented in the mode of a Warhol portrait, regarding the beauty of which one must not be dogmatic one way or another, but in which the idiom of the silkscreened photograph overpainted and in some way blurred with a palette of greens and lavenders and lipstick red that is instantly identifiable as Warhol. Mapplethorpe was a far more conservative artist, appropriating the conventions of the fashion-and-Hollywood black and white to glamorize the phallus and, by indirection and synecdoche, the phallus-bearing body, almost always posed so as to render that feature of itself salient and enlarged, the way the well-endowed female star presses her shoulders forward to accentuate the visual definition of her breasts. Perhaps these pictures demonstrate, if I may use uncritically for a moment the feminist theory of the male gaze, what transpires when the male gaze takes the male rather than the female as its object. That they imply a male audience may just possibly be supported by the reflection that, according to an entry in a recent *Harper's Index*, the length of an erect penis according to males is ten inches and according to females, *four* inches. In any case, the paradigm of the celebrator and glamorizing phallus shot is Mapplethorpe's *Mark Stevens (Mr. 10½), 1976*, where the subject is arrayed, as if upon an altar, on the upper surface of a kind of podium, and the owner of the subject bends over it in his leather leggings. A vertical triangle at the left and a horizontal one at the right point to Mr. 10½, and the podium itself is haloed with the most intensely white light in the image. The figure itself is severely cropped—at the shoulder, at the back of the legs, at the knee, and at the elbow—as if Mark Stevens's identity *was* that of his penis. It is a frightening and dehumanizing image, but I offer it as a further example of internal beauty, where the beauty is yoked to the truth of the proposition visually projected in the image, as much so as with the tangka of the Buddha's death or Motherwell's *Elegies*.

Once we think of beauty as something "born of the spirit and born again," hence as something intended and then embodied in the work of art if the intention is fulfilled, hence, again, as something that has to be explained through whatever interpretation we give of the work of art, so that we are dealing with

something cognitive rather than merely aesthetic, then a painting—a work of art in general—can have an internal beauty and be a failure if, in fact, the beauty is inappropriate or unfitting. But that means there are works that are better off for not being beautiful, since they might be artistic failures if they were, so to speak, aesthetic successes—that is to say, inappropriately beautiful. With these, I suppose, nonbeauty too is "born of the spirit and born again." Serendipitously, I have come across an appreciation of a painting by the marginal Pre-Raphaelite Ford Madox Brown entitled *Work.* It depicts the laying of a sewer, and Dinah Birch, a Ruskin specialist, declares: "It is not beautiful. But that is part of Brown's point, for he was after qualities that counted for more than beauty. Its subject was carefully chosen. Brown knew that sewers mattered." They mattered because cholera mattered, and because adequate sanitation was a means of removing the threat of it. This was in mid-Victorian England, and Brown was particularly moved when he saw sewers being dug in Hampstead in 1852, and he realized that here was a subject suited to "the powers of an English painter." He worked on it for thirteen years. There will certainly have been aesthetes who reckoned sewage as an unfit subject for art, and one might have thought that the moony and dreamful Pre-Raphaelites would have been among them, given their general repudiation of the industrial landscape of the time and their thematization of the Middle Ages. The Pre-Raphaelite hero and heroine cannot easily be thought of as having to answer the calls of nature. To be sure, these artists did ideologize what they termed "visual truth," but there are, in fact, too many thematic decisions in *Work* not to suppose it to have been *composed,* and hence it is as dense with artifice as any of the academic works impugned by the Brotherhood. It is that which encourages us to accept Birch's thought that it was a decision on Brown's part not to make the work beautiful, that he would have fought beauty, and hence would have fought the implicit position that something is a fit subject for "the powers of an English painter" only when internal beauty is entailed by the rules of taste appropriate to art. And if she is right, the tacit theory is: this is not a beautiful painting because it treats of a subject more important than what is conventionally accepted as the subject of art, which entails the suitability of beauty. Were he really to have avoided artifice, Brown might have said: the truth is beautiful enough.

One cannot, when construing Brown's central work, refrain from thinking of *Fountain,* Duchamp's celebrated readymade of 1917, which so many of those in the circle around the Arenbergs—his patrons—insisted on aestheticizing, as if this

were his motive in selecting it and then displaying it—as an industrial form that bore certain strong affinities to the admired sculpture of Brancusi. Perhaps he did; perhaps it did; but if so it suggests, then, something about plumbing fixtures as such, where their formal beauty, if we may assume as much, was in the mode of celebration. The urinal proclaimed rather than disguised its function (it is not, for example, like a television set concealed in an antique armoire) at a time when plumbing itself was not something taken for granted, as it is today. In my building in New York, erected in 1912 by the Bernini of the Upper West Side, Gaetano Ajello, everything was meant to dramatize the difference between modern living and that still-nineteenth-century style of life of the brownstones only then being vacated, as people moved into multiple-unit dwellings such as mine. (The West Side was developed well before Park Avenue.) The architectural historian Christopher Gray pointed out to me that all the pipes and heating fixtures were exposed. There was no central heating—there may not have been much by way of plumbing in the brownstones—so the new tenants were proclaiming their change of lifestyle with features which, a generation later, would be buried in the walls. So pipes and porcelain would not be merely functional: They would exhibit their function as emblems. Duchamp himself said at one point that plumbing was the art of America, the urinal being then a literalization of this. But, in any case, its beauty, as I suppose it must have been, did not arise by way of an effort to deny or to repress excremental function, but to transfigure it in some way: The urinal is the point at which the human being interacts with the system that transports waste back into the natural world. Its whiteness is a metaphor for cleanliness. But this is something of a digression.

I want now to return to the consideration that, if beauty is internally connected to the content of a work, it can be a criticism of a work that it is beautiful when it is inappropriate for it to be so. A good case of this kind of criticism is in a review by Richard Dorment of John Richardson's *Life of Picasso*. "It now seems odd," Dorment writes,

> that for one moment Picasso thought that Puvis de Chavannes's decorative classicism might be an adequate conduit for the tragic emotions he sought to express in the series of paintings inspired by the syphilitic prostitutes in the Saint-Lazare prison, but he did. Many of his gorgeously maudlin paintings of these lonely figures shuffling across empty landscapes or huddled in the white moonlight are

fundamentally phoney because their seductive beauty is at odds with the genuine misery on which they are based.

* * *

I am uncertain of this assessment, simply because I am uncertain of its implications for Motherwell's *Elegies*. What artistic address *is* appropriate to the depiction of jailed prostitutes? A clear documentary style conveys one message, a depiction embodying rhetorical anger, another. Picasso need not have painted the whores at all, but it seemed a natural subject for someone who shared the late nineteenth century's sentimentalizing attitude toward such women, a kind of Baudelairean legacy. There can be little question that the sentimentalization of suffering gave a kind of market to such works—think of how moved audiences still are by cold, hunger, poverty, sickness, and death in *La Bohème*. Richardson writes, on the other hand, that "there is a hint of eroticism, even of sadism, to their portrayal." In a way, Picasso beautified the women because he relished the idea of a beautiful woman being caused to suffer. An ugly woman, or a woman rendered ugly by the harshness of her circumstances, blocks off the possibility of this perverted pleasure. Think, after all, of the history of depicting female victims, naked and chained to rocks, awaiting their rescuers. No one, presumably, would be interested in rescuing a hag, or a woman shown starved and emaciated. But this means that, by and large, beauty in the depiction of such victims comes in for a moral criticism connected not so much with "the gaze" as with the fact that the gazer takes pleasure in the agonies of a beautiful female. So Picasso's works from this period are not altogether phoney: They belong to a certain tradition, in which the use of beauty is perverse. Perhaps the right way to depict such victims, from a moral point of view, is to exclude any such pleasure and hence to exclude beauty in favor of documentation or indignation. In any case, it is important to recognize that, if this is true, then it is incorrect, on Dorment's part, to speak of Picasso learning "to do without the consolation of visual beauty." Beauty in such cases is not a consolation but a relish, a device for enhancing the appetite, for taking pleasure in the spectacle of suffering. Indeed, Richardson says that "Picasso would describe women with some relish as 'suffering machines.'" But that then raises the question of whether Picasso's subjects were not always victims of his style, of his imposing his will by rearranging their bodies to suit his appetite.

Against these considerations it is somewhat difficult to accept Dorment's

assessment that Picasso's eschewal of beauty "is what makes him an infinitely greater artist than Matisse," as if Matisse could not live without the "consolation." In truth, it would be very difficult to accept the claim that Matisse's *Blue Nude* is at all beautiful: she is fierce and powerful and sufficiently ugly so that voyeurism seems ruled out, let alone arousal—almost as if the ugliness were a sort of veil of modesty with which Matisse covered her nakedness. Still, there is justification, in general, for Dorment's claim, in that the world Matisse's works depict is a world of beauty, and the works themselves belong to the world they show. Matisse is absolutely coherent in this way, and a hedonist and voluptuary rather than a sadist: He has sought to create a world that excludes suffering and hence the pleasure that might be taken in it. His characteristic corpus has the aesthetic quality of a medieval garden—a garden of love—from whose precincts everything inconsistent with the atmosphere of beauty has been excluded. And to be in the presence of a Matisse is to look into that garden and to be in the presence of—an embodiment of—the spirit of the garden: a fragment of the earthly paradise. I am extremely hesitant, on the basis of this comparison, to see him as inferior to Picasso, let alone "infinitely" inferior, but Dorment's claim that he is so seems clearly based on some disapproval of beauty as an aesthetic quality to be at all sought after or used. As I see it, in his view beauty is a consolation, and consolation means mitigating the bitter truth, which it is morally more admirable to admit and to face than to deny. And to the degree that this represents the current attitude, it is not difficult to see what has happened to beauty in contemporary art. It is not art's business to console. If beauty is perceived as consolatory, then it is morally inconsistent with the indignation appropriate to an accusatory art.

Let us return to a work in the elegiac mode, and one, moreover, as with Motherwell's paintings, where the beauty seems internally linked to the attitude the artist undertakes to arouse toward the subject of the work, in this case the American dead in Vietnam memorialized in Maya Lin's astonishing work. The color, the way the work seems to reach out its wings to embrace the viewer, as if dead and living were folded together in an angelic embrace, almost unfailingly bring tears to the eyes of visitors to the site, and it will be interesting for future generations to see whether this does not continue to be the case, long after there are any of those left who call the fallen by the names that denote them on the surface of the work, or who remember the raw agony raised in the American breast

by the Vietnam conflict. At least it does this now, and what is astonishing is that this agony, which expressed itself in demonstrations, in flag burnings, in shouts and trashings, should have so suddenly been replaced with elegiac feeling. The interesting question is the degree to which the memorial itself was a catalyst in this change. The narrative of the memorial by the man who brought it about, Jan Scruggs, is called "To Heal a Nation," and I know of few cases other than the Vietnam Memorial where it is possible to suppose that a work of art in fact achieved such a consolatory and healing effect. Some may feel the wound should never have healed, that we should persist in a posture of rage, rage against a polity that did what we did in Vietnam. The memorial belongs to a perspective much broader, much more philosophical, a perspective which, as I said in connection with Motherwell, puts us above and outside the battle, seeing it from the perspective of eternity, as Spinoza phrases it. And there may be an essential conflict as to whether it is morally right to be philosophical about it in such a way. Is it morally right to be philosophical about the things that seem instead to call for action and change? To say, in connection with sexual aggression against women, that men will be men, as if that were an eternal truth? Or, to take another case, to use Christ's saying the poor we shall always have with us as an excuse for doing nothing about the homeless? If beauty in such cases is linked with being philosophical, there are clear arguments against the moral appropriateness of beauty.

But then there is a question of the appropriateness of art as well, for even if the art is not beautiful, art itself is already internally enough connected to philosophy so that simply making art at all, rather than acting directly where it is possible to act directly, raises questions of moral priority. Consider, in this light, the work by Chris Burden called *The Other Vietnam Memorial*, this one bearing the names of the Vietnamese fallen. Now, it would be wonderful if we as a nation could feel toward the enemy dead what we feel toward our own, but that requires a stance perhaps too philosophical to expect human beings who fight wars in the first place to take. The difficulty, nevertheless, with Chris Burden's piece is that it merely reminds us the enemy died as well, without in any interesting way acting upon our hearts. His work is not beautiful, and, in fact, it is difficult to say what aesthetic qualities it has. It, in any case, does not touch the heart. It consists of several wings attached, like those of a bulletin board, to a central pole. Each one holds a sheet of metal on which are etched, in letters too tiny to read without glasses,

the names of Vietnamese. These names as names mean nothing to us, as the individuals are generic and stereotyped, though doubtless there are those, unfortunately also generic and stereotypical for us, who loved and cared for and mourned the individual denoted by the name that is abstract for us. If Burden's piece were a model for a work to be built, on a large scale, then it is possible that that work would induce feelings the model barely enables us to foresee. But we could not stand in front of the names and read them if it were any larger, and my sense is that this is the work, rather than the model for the work. And my sense further is that the work is not a success: It does not activate any feeling to speak of toward its subject that we might not have had before, so that we walk away with a shrug, an "Oh yeah." It does not help the dead and it does not move the living, and in the end it seems merely a clever idea, almost a gimmick, a kind of moralizing toy. Everything about it as art is wrong, given its subject and its intentions. And because it fails as art, it fails morally, extenuated only by the presumed good intentions of the artist. It should not, if one is seriously interested in causing certain attitudes in viewers, stifle the very possibility of those attitudes.

That is always a danger in activist art, I am afraid. I can understand how the activist should wish to avoid beauty, simply because beauty induces the wrong perspective on whatever it is the activist wants something done about. A work meant to arouse concern about AIDS in the 1991 Whitney Biennial—*AIDS Timeline*—is a case in point. It was, one felt, deliberately scruffy, as if its message was: There is nothing beautiful about AIDS. It had the look of a junior high school project, sincere, jejune, callow. One felt almost more compassion for the artists than for the victims of the disease. They were moving in their earnestness, their fecklessness, their impotence. But they failed artistically if their aim was to enlist art as an ally in their campaign. I don't say it cannot be done, but trying and failing may be just measurably worse than not trying at all.

Ours, however, is an age of indignation, and the lesson just mentioned will take a while to learn if it is true. The lesson is that art has its limits as a moral arm. There are things it can do and things it cannot. It can do, one might say, what philosophy can do, and what beauty can do. But that may mean that philosophy, too, has its limits as a moral arm. There is something terribly deep in Hegel's thought about the bird of wisdom taking flight only with the falling of the dusk. What another philosopher called the Great Noontide, the time of day appropriate to

action and change, may not be appropriate either for philosophy or for art. It is the moment of interest, and Kant may just be right that interest and beauty are incompatible. Interest and art may be incompatible, but it is not easy to see that this is something the Age of Indignation can accept—it is, rather, something else to be indignant about. So beauty may be in for rather a long exile.

———————————

Beauty and the Contemporary Sublime

JEREMY GILBERT-ROLFE

IN THE ART WORLD, THE IDEA OF THE BEAUTIFUL IS ALWAYS THREATENING TO MAKE an appearance or a comeback, but in practice it tends always to be deferred. When not deferred, it's devalued so that references to the *merely* beautiful are common, but invocations of beauty unaccompanied by that adjective are scarce, and some might see a Freudian dimension in this deferring and diminishing of what's otherwise agreed to be at the center of the discourse.

If the contemporary art world is uncomfortable with beauty—a discomfort that seems to me to derive from its irreducibility to other forms of discourse—it finds comfort in the sublime for the opposite reason, and it is with this in mind that I want to see the relationship between beauty and the sublime as one between that which is attractive but irresponsible and that which, however negative its formulation may be, is always apprehended as the voice of responsibility because it's always attached to a serious idea.

This would complicate the sense in which the sublime has a differential relationship to beauty that makes them complements but not opposites. Derrida describes Kant as unable to keep the ideas apart because in defining the beautiful as that which is complete and may in that be framed, he seems to separate it from the sublime, which is for him by definition formless and unframeable; but this

raises the question of what forms and frames the formless so that one may see it. Moreover, the formless and limitless sublime can itself be opposed to a sublime made out of specificity and hardness, which, like Kant's, finds its first theoretical formulation in Longinus, and which Kant's contemporary Winckelmann saw as preceding the beautiful while being at the same time defined by its resistance to it. So one may say that the tradition of the sublime as seriousness comes in two versions that are inversions of each other.

I'm indebted in what I have to say about Winckelmann to Alex Pott's book about him, in which he proposes that Winckelmann offers a dialectical alternative to Burke's crudely oppositional theory of the sublime. Where Burke proposes that the sublime is straightforwardly masculine and beauty unambiguously feminine, Winckelmann advances a theory of exclusively male beauty—that is, which excludes the actually female—that obviates Burke's by recognizing that in order to attract, the sublime would have to have some of the properties described by Burke as feminine: "A male . . . body that . . . was nothing other than . . . (a)n aggressive display of . . . brute physical violence would all too easily appear ludicrous or repulsive rather than impressive and compelling."[1] For my part, I want to suggest a model in which the sublime is androgynous and beauty irreducibly feminine, although in a way quite unlike Burke's, not least insofar as the difference for me is not to be found between the active and the passive, but rather between the transitive and the intransitive. I'll suggest that the sublime is nowadays a technological sublime—a product of reason that is out of control and has in practice replaced its own ground with one of its own making, Heidegger's nightmare—and beauty a matter not only of the attractive but precisely of the glamorous, and, as such, anything but passive. I'm also suggesting that to think of the beautiful as glamorous is to make it into a secular concept, which could in that offer an escape from secularization instituted as an ideal.

* * *

Julia Kristeva once asked whether resistance to modern literature wasn't evidence of an obsession with meaning, and one might ask the same question about contemporary and modern art's resistance to beauty.[2] This is also the sense in which I am suggesting that beauty is found in that which does not exhibit the characteristics traditionally associated with the masculine, but is instead typically located within fragility and the delicate, and that it is in this that it places a limit on the

language of force to the extent that it resists being subsumed by what frames it. This resistance being only an effect created by its indifference to what is brought to it. The beautiful is powerless but always exceeds what frames it, and what always frames it is discourse.

* * *

For Winckelmann, the beautiful is at once the property of a particular style and, elsewhere and in general, a property or quality that is itself not a product of stylistic development.[3] Both ideas are useful here.

To take the last point first, he argues that while the arts develop in the sense of becoming more sophisticated or articulate, the beauty of early Syracusan coins surpasses those of later periods. So the beautiful may already be there, but one may lose it or have never had it.

At the same time, the beautiful as a style is something that comes after something else. Winckelmann sees the apex of Greek art as occupied by two styles that occur in rapid succession—so that the apex itself would have to be a zone of division, an imperceptible break. He calls one the high style and the other the beautiful style. Where the high style is characterized by a lack of refinement, the beautiful style is refined.[4] Where the high is hard, the beautiful flows.[5] Winckelmann thought that the beautiful style was what the Greeks did once they had surrendered their autonomy to Philip of Macedonia, which may or may not add to one's sense of the one as a style that is about authoritativeness and the other as one that is prepared to be seductive as well as instructive.

Winckelmann saw the high style as a struggle against the beautiful, that is, as an art made out of not falling into temptation, while he also saw the Laocoön, an example of the beautiful style, as "less purely ideal" than the art of the high style because of its beauty. So the high is characterized by its capacity for restraint, and the beautiful denied access to the purely ideal not on account of its own impurity, but because it won't restrain itself and become something else. It cannot be purely ideal because it's purely beautiful. This differential relationship between the high and the beautiful styles is then another version of that which exists between beauty and the sublime in Kant's formulation, but it reverses the order. In Kant, the sublime follows from the beautiful and is what the latter is not; in Winckelmann, beauty follows the sublime and amounts to a loss of sublimity.

So beauty finds itself surrounded: on the one side, an idea of restraint that

comes before the beautiful but is at the same time made out of refraining from becoming it while still knowing what it is; and, on the other, an idea of the not-beautiful made out of limitlessness. Furthermore, what surrounds beauty also reflects it. Kant divides beauty into two sorts: beauty not judged according to a predetermined order—which I interpret to mean not according to a principle of production—and beauty judged according to a predetermined concept, as in, "the beauty of man is dependent." The first kind of beauty sounds like the sublime as formlessness, the second is certainly reminiscent of the high rather than the beautiful style. So there are two kinds of beauty, and in certain respects they're rather like the two kinds of sublimity, except that the sublime is not beautiful: beauty that behaves like that which doesn't care about the beautiful, and beauty only realizable in that which restrains it and attaches it to a worthwhile idea. One notes that having to be attached to something would mean that beauty was not itself that thing, while the sublime is worthwhile and the worthwhile sublime.

Longinus, as Lyotard notes in an essay on Barnett Newman and the sublime, lists among his examples of the sublime the surprise provided by an erudite and sophisticated speaker using a coarse expression. In the Kant given us by Derrida, limitlessness plays a bigger role in the sublime than it does for Longinus, and roughness a smaller one. Roughness continues to play a part in the Kantian sublime, but no longer as a lack that has rhetorical force so much as a condition in itself, and therefore not really as roughness or incompletion, because one is no longer seeing the rough as something that could be potentially smooth or the incomplete as something that awaited completion.

I want to discuss Newman briefly here and, in doing so, to suggest that he formulated a version of a postmodern Kantian sublime that is no longer available at the end of the century as it was in the middle of it, when he made it up. It's no longer available because it's a sublime that still finds itself in nature, but it provides the terms for what seeks to find a way out of it.

I think Newman's paintings are clearly involved with the idea of limitlessness. They are certainly rough in this or that sense and present color without form, pointing in that to the possibility of formlessness, an emptiness that is at the same time full. Typically they do so through the indeterminacy—which Lyotard sees as Newman's theme—offered by red, which unlike yellow doesn't advance, unlike blue doesn't recede, but instead hovers in the middle ground. The model might be Matisse's *Red Studio*, where red holds together foreground and background, and

where the clock at the back reveals, in its unpainted face, the ground of the painting as a whole. In making the origin—the ground of the painting—also its culmination, what's at the center of the furthest recess made by the pictorial space, Matisse is quite Heideggerian in the way he makes the painting be a matter of the return of the origin at the end and as an end. This is not quite what happens in Newman, where there's no trace of the ground.

* * *

Newman painted his first, as they are called, zip painting, and most, but I think not all, the subsequent ones, by putting tape down over a color and leaving it there until the painting as a whole was finished, then removing it at the end. So the last mark is a removal that reveals the first, leaving traces of the buildup on the tape, which had covered the original color and which now gives an irregular edge to the stripe or zip. Therein, along with his generally very cavalier attitude to painting technique, lies the role of roughness in Newman.

Richard Schiff described Newman putting down first color and then tape as an act of subdivision, which at the same time engages the temporal by, as it were, dividing one duration by that which it replaced.[6] One could add to that the complication that comes from the different way one sees even the same thing if it's on the left or on the right. In any case, the stripe or zip is the provision of a third area between two others that are identical to one another and, in a sense, follow from the one from which they mutually differ. And though they look and are the same, the one thing we know for sure is that they don't run behind the stripe, because the stripe or zip is a sign of origin re-presented after a period in which it's been hidden, revealed at the end as an initiation.

Lyotard relates Newman's sublime to the temporal, itself an idea inherent in themes like limitlessness—which can't be spatialized, and, as such, is an invisibility apparent to vision but unrealizable by it—and it is in these terms that one could say that in Matisse, the painting begins with its ground, but in Newman, it begins with the stripe, which is what survives of a color first painted over the whole of the surface. The origin to which one is returned is not the ground of action, but an originary act meant to subsume that which preceded it, its ground. The sublimity of the act lies in its roughness and indeterminacy—the latter underscored in those paintings where Newman places the tape over wet paint—and thus it is that Newman can be discussed at length, and has been, without mention of beauty.

On the other hand, *Onement* is symmetrical, a property usually associated with beauty, and *Vir Heroicus Sublimis* is organized according to the golden section, the high style epitomized. So what is framing what? Certainly limitlessness is being presented in some way. As a red painting, *Vir Heroicus Sublimis* hovers like Matisse's *Red Studio*. But being a nonrepresentational painting and therefore ungrounded in representation—which is to say, the recognizable—it contains no extremities of near or far, so that indeterminacy means the loss of hierarchy, and movement must become something other than the possibility of movement between things. In both Matisse and Newman, red envelops as well as joins, but in Newman, the act of linking is the same thing as the act of holding apart, in a context where, unlike Matisse's, there never were any solids or voids because the stripes or zips function spatially, as fields of color. Their initial appearance as things suspended in or superimposed on the red is problematized by their dissolving into spaces, which is to say voids, when one actually looks *at* them.

* * *

In order to be sublime in the way that he said they were, Newman's paintings also had to be large, which could link him with the specifically American sublime theorized by Harold Bloom. This sublime would seem to be caught up in Protestantism's close relationship with the Old Testament, with a purposive creation, with law as logic, with the plainness of Jonathan Edwards—a severe and hard sublime predicated on questions of origin and boundlessness. Others have seen the New York painters of the fifties, Newman among them, as an American version of the German romantic sublime, an art concerned with the overwhelming and with the idea of destiny as an idea of acting out, a sublime severe but atmospheric and engulfing rather than hard and resistant.

In addition to these, the size and format of Newman's paintings could also invite comparison with a third sublime, not unrelated to Bloom's, which is the banal sublime of the propagandist painters of what was in the nineteenth century called America's manifest destiny. Large canvases containing honest settlers dwarfed by the vistas they are about to conquer, within at least one painting an angel in the sky goading them on, the awesomeness of the landscape mirrored in the awe with which the soon to be displaced indigenous population regards them. Such paintings employ a wide-screen format (the proportions of marine paintings applied to the Wild West) as does *Vir Heroicus Sublimis*, and while I am not sug-

gesting that Newman's work is continuous with that tradition (any more than I could subscribe to Robert Rosenblum's thesis that Rothko's paintings are Friedrich's without the trees and tiny figures), I want to see it as related to it through a kind of negation. Newman was interested in the art of Native Americans, a fascination he shared with Pollock (who, unlike Newman, was from the West), and in thinking of the role of limitlessness and indeterminacy in his work, I think of Newman's interest in a Native American dance in which the dancer places a pole in the ground and dances in response to it: an idea of mobility that can vary, be potentially limitless, on all sides, while retaining a constant center. As I think of this, I think also of Newman's expressed desire, eventually fulfilled I think, to go to the tundra, where one can turn around through 360 degrees and the horizon will remain constant and level. Again, limitlessness with a fixed center and also the idea of flattening, which I'll want to mention again.

One could say, then, that the theme of limitlessness offered in an earlier American sublime persists in Newman in some other way. What locates that sublime in Newman, anchors it, is a principle of origin and return. He finds a model for it, as nineteenth-century American art did not, in Native American culture as well as elsewhere, and in the American landscape at its most remote and most fragile. One of the elsewheres where he found the model was—as is well known and has been discussed at some length by Tom Hess and others—the Kabbalah. There Newman found, for example, the theme of the absent as a sign of immanent presence in the idea that before making the world, God had to make the space it would occupy, a theme not unconnected to ideas like manifest destiny or, in another sense, to the ideals of Puritans like Jonathan Edwards.

Newman's sublime, then, is one of limitlessness visualized within the terms of an activity that leaves no—or very little—trace of what was there before it but returns to what began it. This sounds quite American, and I think one can find in it the reasons why later painting would want to build on it without being able to preserve its assumptions. But nowadays the image of the tundra, which, as an idea of emptiness and freedom to move, inspired Newman, might be seen to have been replaced with the knowledge that invisibility itself, the air, is filled with electronic signals. An, as it were, geographical image of limitlessness has given way to a technological one. Immediacy—what Lyotard calls the enigma of the *Is it happening?*—is, in a sense, a technological convention, second nature to the computer and the

phone company, leaving the work of art to expand that immediacy into a gap of which one may be conscious.

A contemporary sublime might, then, have to engage an environment in which multiplicitous signification, that proliferation of systems that is the technological condition of late capitalism, is not only the norm but the model, and where the issues are not the incomplete and the rough, but the intersection of differences and repetition as difference. As Deleuze has pointed out, repetition precedes and makes possible the original. What makes it a repetition is also what prevents it from being one, it is in fact not that which it repeats.

* * *

Where Newman sought to visualize the invisible concept of spatial limitlessness in order to articulate a temporality conceived as a dialectic—the sublime as the fixed point and all other points—nonrepresentational painting might now find itself concerned with a sublime founded not in a relationship between beginning and end, and origin and potentiality, but instead imagined as an indefinitely decentered context of deferral, an androgynous sublime that collapses orders of priority—figure and field, surface and support, color and drawing—into one another to propose a temporality other than that of nature, a temporality of simultaneity and sameness, in the sense of painting as a body—a completeness—that is not so much a continuum as a combination of continua. The limitlessness that was, for Newman's generation, represented by an image of expansiveness is perhaps nowadays a limitlessness conceived as a process (a temporality) both deoriginated and without a destiny.

* * *

Beauty, on the other hand, is surely nothing of the sort. Along with Lyotard, Michael Fried and Steven Bann have also pursued the distinction—also eighteenth century in origin—between an art in which one looks at something and an art which would be about that act of looking, an art in which one could look at oneself looking. The first sounds like being attracted, the second like wondering what it means to be attracted. It could also be the difference between the irreducibly visible and that which had to be visualized. Act, process, and time are, after all, visible only as traces of what is essentially invisible. Beauty, in contradistinction, would have to be visible from the first. It was never other than visible, never

needed to be brought into view. Except, of course, when it had been suppressed. In this formulation, beauty would be that which cannot be reduced to its critique, to the sublime that is realized through critique and in the object of self-consciousness, in the self that finds itself in wondering about what it means to be or have a self.

If beauty exceeds critical adequacy, is counterproductive where the sublime is critically productive, then the Laocoön problem is not the problem of slackening, of a loss of seriousness and sublime ambition, it's that beauty is not critical nor a product of criticism, and, as such, can only undermine that regime of good sense that is criticism's search for meaning. Beauty, in being frivolous, and in that trivial and irrelevant, is always subversive because it's always a distraction from the worthwhile, which lets us know it's worthwhile by not being beautiful.

* * *

As such, beauty stands in opposition to the idea of productive thought and perhaps to the idea of production itself. This may be why advertising—technocapitalism's human face—is so dependent on beauty. It has to associate products with that which they implicitly cannot be and which is implicitly indifferent to them. Here one finds a very straightforward example of beauty's having to be feminine if it is to be irresponsible, if only by default. That the male can't detach itself from the principle of production is demonstrated by the fact that the male models used in advertising have, at some level, to look like nasty little businessmen, while female ones don't have to look as though they have any engagement in commerce whatsoever.[7]

Beauty places a limit on the principle of production because it changes but is always the same. Feminine beauty as it's conceived by the fashion industry, for example, changes body type every fifteen years or so but is always a matter of symmetry. When it's asymmetrical, that's because that's the game that it's playing with symmetry at that moment. As such, complete and thus a singularity, it seems that beauty must be feminine because there's nothing else for it to be. It's not androgynous because it's irreducible and complete, and it can't be male because it's not encumbered by anxieties about power. Norman Bryson has asked why, in an art form so preoccupied with proportion, the male genitalia in Greek sculpture should be so small. His answer is that their reduction obviates distracting comparison: "The gap between actuality and the imago is dealt with by reversing it so

that the idealized genitalia do not compete with the real thing; or, more precisely, they are made to compete—gap and disparity are presented—so that the spectator wins."[8]

In the next paragraph, in regard to a photograph of Arnold Schwarzenegger, Bryson talks about a comparably necessary sublimation of the genitalia in the bodybuilding aesthetic: "(T)o expose fully the bodybuilder's genitals is to leave behind the visual arena in which the activity is supposed to take place for an altogether different visual genre."[9]

Where the masculine seems unable to separate itself from the language of power, which obliges it to suspend sexuality in the service of an ideal—hardness and restraint as ideological imperatives—the feminine, fluid and unrestrained, could provide the possibility of a secularized beauty, which we know as the glamorous and which, in effect, suspends the idealisms of power—through the substitution of the thrill for the thought, arousal for contemplation—by virtue of its implicit powerlessness. The limit it places on theories of production is the same as the one that the intransitive places on the transitive, which is that the former is what the latter cannot become, in that beauty, the frivolous and not worthwhile, always has to be framed by something less than itself in the sense of being less complete, something that is always both supplement and in need of supplementation, something that is made out of the language of lack or absence or the need for completion—in short, the discursive as such.

* * *

This is the sense in which beauty leaves nothing for the work of art to do except to frame it, which it is prone to do in a way that makes it disappear, as art could be said generally to have done from the gray and brown roughness of Courbet onwards. Roughness perhaps assuring one of the presence of the sublime at its most masculine, while grayness, as Goethe pointed out, "is all theory," which beauty is not.[10] When it has sought to identify the act of looking with the idea of looking at something implicitly worth looking at, as in Matisse, we tend to see the activity as a certain sort of refusal of avant-gardism. In resisting beauty in favor of critique, avant-gardism proposes itself as a high style resisting its transformation into a beautiful style by remaining severe. Think of the argument against painting launched on behalf of minimalist sculpture in the sixties and the even more bizarre arguments for banality as a virtue that have

accompanied subsequent tendencies—arguments that recall Hegel's remark about no man being a hero to his valet, not because the man's not a hero, but because the valet's a valet.

* * *

The possibility of beauty's suppression, even when one allows for all works being by definition combinations of the beautiful and the sublime, has become even more acute now that the media associated with art are no longer the ones through which beauty conceives of itself. The eighteenth century was a world that imagined beauty in terms of sculpture and painting: flesh that had the translucency of marble; cosmetics that enhanced by means of a layering that covered the surface. White lead, the traditional ground of oil painting, was also the basis of facial makeup in Kant's lifetime. Once beauty employed the language of the traditional arts, but now it doesn't. It employs, instead, the language of photography. Makeup nowadays enhances not by covering, but by making the original more like it was than it ever was when left alone. Photography, made in an instant, developed in the dark, in a pool of poison, as a simultaneity, is like the beautiful in this property of always being all there at once. Unlike paintings, which are made bit by bit, over time, in the light, but also out of poisonous materials.

The condition of the photograph is one of simultaneity, flawlessness, intensification, and one grants that once these occur in painting they no longer function as they might elsewhere, because painting is itself serious by definition, which is to say, glamour inevitably acquires a critical status if found in a work of art. The word *glamour* was originally a Scottish corruption of the word *grammar*, which to them had magical power; so the glamorous is that which is magically articulated.[11] In such a situation, Matisse would once again emerge as a model. He, after all, used the colors of that season's fashions as a palette, making painting aspire to the language of the glamorous from the start.

Kant has been accused of telling us that a beautiful work of art is one that is of something beautiful and is beautifully made, but never telling us what that looks like. If he had, it might have gone elsewhere, like the unconscious fleeing the spot where Freud found it, driven by its exposure to take up a more secure residence in consciousness—where it feeds off the discourse that it makes possible. The question is not what does it look like at the moment? (you'll know when you see it), but where does one (expect to) find it, and why? One would also think of the lim-

pidity of Matisse's thin paint when recalling that it was Nietzsche who wrote: "Everything that is good is light, what is divine runs on delicate feet: first principle of my aesthetic." If the beautiful is always weightless, defying gravity, it is perhaps through those properties that painting can approach it. In our time, it does so by appropriating the surface of photography, the surface of painting itself having long since ceased to be a surface of any particular sort—as, for example, David Reed's work suggests—reaching out instead not, as one might expect, to all the other surfaces in the world, but to that other surface out of which the world now makes itself. There could, then, be a kind of painting that sought to embrace this condition and thus avail itself of the language of the glamorous, and a kind that found itself through rejecting it.

Consider two contemporary artists. Karin Sander makes works out of polishing walls, an art of intensification, then, of a ground ungrounded by emphasis. Maja Lisa Engelhardt makes paintings that invoke those of Newman's generation, an art made out of discontinuities that are nonetheless apprehended as mutually articulated. Both are antitechnological, handmade productions. One replaces or incorporates the ground by putting nothing there, the other by putting something there. I'd suggest that the one invokes Longinus's opposition of a living face to a dead face, the other the idea of roughness and provisionality as signs of the presence of the body. Both involve refusal—in Sander, intensification as a refusal to engage the ground as a difference, to undertake to improve it in the sense of changing it; in Engelhardt, a refusal of historical irreversibility, to accept that one may not do what seems to have been done before—and in this they set the terms in which beauty and the sublime may be seen to exist in a differential relationship that connects them, as categories, to the contemporary context.

The contemporary is a matter of unbroken continuity: above all the video image, hyperclear and without parts, constantly regenerated by an invisible movement, subdivisible at will into boxes, none of which can ever be materially different from one another; but also the computer, infinitely present information of which none is spatially manifest (like Bergson's memory). That is why a modernist style like futurism now seems so quaint. It presents an articulated world, a world of joints and limbs, pistons and pulleys, where ours is a world of blank mobility, of the dumb rather than the histrionic, mute power, machines with skins but not limbs: a space filled with blank and smooth surfaces. In art as in cosmetics, the exposure of layering characteristic of the modern is replaced in the

postmodern by a principle of intensification, the notion of duration by the idea of the instantaneous. Painting as temporality and accumulation is obliged to look to the photograph—to the technological, in other words—as the form that is always simultaneous and in that complete. Sander embraces it, while Engelhardt rejects it—but in a sense both address the same context of sublimity: In the one, the polished wall points to the irreducibility of the applied surface, a dumb and blank accumulation continuous with its support—as is a photograph with the paper it's on; in the other, to the irreducibility of painting as a series of acts, simultaneity as multiple temporalities, a handmade sublime made out of refraining from the look of the technological and, in that, evoking it.

* * *

One may say then that beauty as glamour—beauty concerned as the attractively unproductive—stands in a differential relationship to a "technosublime," a sublime found not in the forest but in the computer, not in the temporality of nature but in the simultaneity of the electronic. Beauty would, in this context, be flawless and blank, flawlessness being a prerequisite of the absence of lack, which is the breeding ground of the sublime as critique, and blankness a precondition of attractive indifference—the Byzantine Christ, the king's face, the face of the fashion model. The sublime as a technosublime would be limitlessness but not rough, and in that characterized by the terms I just associated with the beautiful, *flawless* and *blank*, a casing that tells one nothing about how the computer works, simultaneity and invisibility rather than process and visibly moving parts, the electronic as opposed to the mechanical. This would mean that the differential relationship between the sublime and beauty continued to be found in their tendency to share the same terms, and that beauty would continue to be surrounded by that which it was not. In this it would achieve, in art, a critical function by default. It would be that which prevented the sublime from becoming a religion made out of negative critique.

NOTES

1. Alex Potts, *Flesh and the Ideal.* (New Haven and London: Yale University Press, 1994), 117.

2. Julia Kristeva, *Desire in Language: A Semiotic Approach to Art and Literature,* ed. Leon S. Roudiez, trans. Thomas Gora, Alice Jardine, and Leon S. Roudiez (New York: Columbia University Press, 1980), 142.

3. Potts, op. cit., 88.

4. Potts, op. cit., 82.

5. Potts, op. cit., 83.

6. Richard Schiff, "Verbalizing Visual Time: Barnett Newman as Writer-Painter," lecture given at the International Association for Word and Image Studies conference, Carlton University, Ottawa, August 1993.

7. Gabrielle Jennings has pointed out to me that there is a corollary type, the ones who look feminine: long hair, makeup, high cheek bones, grungy sex appeal. When not anchored in the semiotics of brutality, the male reaches toward the feminine.

8. Norman Bryson, "Gericault and 'Masculinity,'" *Visual Culture, Images and Interpretations*, ed. Norman Bryson, Michael Ann Holly, and Keith Moxey (Hanover, New Hampshire: Wesleyan University Press, 1994), 235.

9. Ibid.

10. Charles A. Riley II, *Color Codes* (Hanover, New Hampshire: University Press of New England, 1995), 319.

11. I am indebted to Diane Stevenson for this bit of information and more than delighted that the word's origin should be in Scotland, a place not particularly widely associated with the concept in more recent history.

Notes on Beauty

PETER SCHJELDAHL

IN MY EXPERIENCE, AN ONSET OF BEAUTY COMBINES EXTREMES OF STIMULATION and relaxation. My mind is hyperalert. My body is at ease. Often I am aware of my shoulders coming down as unconscious muscular tension lets go. My mood soars. I have a conviction of goodness in all things. I feel that everything is going to be all right. Later I am pleasantly a little tired all over, as after swimming.

Mind and body become indivisible in beauty. Beauty teaches me that my brain is a physical organ and that "intelligence" is not limited to thought, but entails feeling and sensation, the whole organism in concert. Centrally involved is a subtle activity of hormonal excitation in or about the heart—the muscular organ, not a metaphor.

Beauty is a willing loss of mental control, surrendered to organic process that is momentarily under the direction of an exterior object. The object is not thought and felt about, exactly. It seems to use my capacities to think and feel itself.

Beauty is never pure for me. It is always mixed up with something else, some other quality or value—or story, even, in rudimentary forms of allegory, "moral," or "sentiment." Nothing in itself, beauty may be a mental solvent that dissolves something else, melting it into radiance.

Beauty invariably surprises me even when I am looking at what I assume

to be beautiful—a sunset, say, or a painting by Giovanni Bellini. There is always a touch of strangeness and novelty about it, an element that I did not expect. The element is usually very simple and overwhelming. In the sunset, I may identify something I never realized before about color; in the Bellini, something about mercy.

Sometimes the object of beauty is not just unexpected, but bizarre, with an aspect I initially consider odd or even ugly. Such experiences are revolutions of taste, insights into new or alien aesthetic categories. When I first "got" an Indian temple sculpture, it was as if my molecules were violently rearranged. Something similar happened when I first "got" a painting by Jackson Pollock, say, or Andy Warhol—any strongly innovative artist. As a rule, what had seemed most odd or ugly became the exact trigger of my exaltation.

An experience of beauty may be intense, leaving a permanent impression, or quite mild and soon all but forgotten. But it always resembles a conversion experience, the mind's joyful capitulation to a recovered or new belief. The merely attractive (pretty, glamorous) and merely pleasing (lovely, delectable) are not beauty, because they lack the element of belief and the feeling of awe that announces it.

The attractive or pleasing enhances the flow of my feelings. The beautiful halts the flow, which recommences in a changed direction.

Beauty entails a sense of the sacred. It surrounds something with an aura of inviolability, a taboo on violation. I am mightily attracted to the object while, by a countervailing and equal force of reverence, held back from it. I am stopped in my tracks, rooted to the spot. Beauty is a standoff.

Beauty has an equivocal relation with taste, which at best guides me to things I will like and at worst steers me away from things I might like if I gave them a chance. Taste may sharpen beauty by putting up an initial resistance to its object, making keener the moment when my intellect lays down its arms in surrender. Taste that is not regularly overridden forms a carapace, within which occurs spiritual asphyxiation. But to have no taste at all is to have retained nothing from aesthetic experience. Taste is residue of beauty.

In line with recent breakthroughs in neurological brain research, I fancy that one day the mental event that is an experience of beauty will be X-ray photographed. I predict that the photograph will show the brain lit up like a Christmas tree, with simultaneous firings of neurons in many parts of the brain,

though not very brightly. It will show a suddenly swelling diffused glow that wanes gradually.

* * *

There is something crazy about a culture in which the value of beauty becomes controversial. It is crazy not to celebrate whatever reconciles us to life. The craziness suggests either stubborn grievance—an unhappiness with life that turns people against notions of reconciliation to it—or benumbed insensibility. The two terms may be one.

"Beauty" versus beauty. Platitude versus phenomenon. Term of sentimental cant versus dictionary word in everyday use. I want to rescue for educated talk the vernacular sense of beauty from the historically freighted, abstract piety of "Beauty."

A dictionary says beauty is "the quality present in a thing or person that gives intense pleasure or deep satisfaction to the mind." Now, the idea of a "quality present in" external reality could use qualifying in this case. Overly confident identifying of experience with its object can foster rigid projections, such as "Beauty," that repulse the playful, exploratory, even skeptical vitality of aesthetic perception. Speech should distinguish beauty as a quality more volatile than, say, the color blue. The sky's reputation of being blue has never yet, that I know of, incited a rebellious conviction that it is orange. But anything's reputation of being beautiful is guaranteed to recommend itself to some as a theory, if not of the ugly, of the boring. To argue that beauty is real is unnecessary. To argue that it is interesting requires making room for the position that it is "all in the mind."

Meanwhile, can there be any possible problem with "intense pleasure or deep satisfaction to the mind"? I know those experiences, and I like them. I believe that others know and like them, too. For people without the comfort of religion, and even for many who are religious, the experiences may provide a large part of what makes life worth living. Any society that does not respect the reality of "intense pleasure and deep satisfaction to the mind" is a mean society. Respect for something begins with having a respectful name for it.

Many of us talk too little about our delights and accord other people's delights too little courtesy. This is especially so in these days of moralistic attack on things that make life tolerable for many: a cigarette and a drink, even, to ease someone's passage—perhaps also to shorten the passage, but that is no one else's business.

Beauty, too, is an intoxicant. So, too, is moralism, if moralizers would only admit it. Baudelaire said it best: "Always be drunk. Get drunk constantly—on wine, on poetry, or on virtue, as you prefer." Today many people drunk on virtue harass people who prefer wine or poetry. You can't argue with the harassers, of course. You can't argue with drunks.

No one is without experiences of beauty. "You can live three days without food," Baudelaire wrote. 'Without poetry, never." By poetry, I think he meant beauty in its thousand forms and tinctures, some of them common to all lives. "Fucking is the poetry of the masses," he said by way of amplification.

Moralizers take as their business the pronouncement of who gets to take pleasure when, where, how, and in what. The very word *pleasure* can be embattled now. I read an intellectual debate somewhere in which someone defended a respect for popular culture on the basis that it is pleasurable. To which someone else objected, "So is heroin." I suppose the objector meant that popular culture is an opiate of the people. He was one of those who think the people should not have opiates.

Socially invested "Beauty" has sins to answer for. (I recall a little usage lesson from my childhood: "Women are beautiful; men are handsome.") But the idea of beauty need not be imprisoned by its former uses. Indeed, the conviction of timelessness that is instilled by beauty recommends that the word constantly be shorn of period-and-place-specific connotations, even as it constantly takes on new ones.

The notion of anything being "timeless" is rationally absurd. But such is the lived sense of beauty, which Baudelaire identified as a flash point between the fleeting and the eternal. This is a healthy absurdity, which makes palpable the limits of thought's poky categories. Baudelaire stumbled upon it everywhere. In 1846, he noted the fashion of the black frock coat, whose "political virtues" as a symbol of democratic leveling were not inconsistent with its "poetic beauty, which is the expression of the public soul—an immense procession of undertakers' mourners, political mourners, mourners in love, bourgeois mourners. All of us are attending some funeral or other."

Anyone who cannot find an analogous poetry when surveying the parade of a contemporary street is an unfortunate person.

* * *

Do experiences of beauty today fall within the purview and function of art? Not necessarily, and certainly not all the time.

Forty or so years ago, J. L. Austin wrote that it was time for aesthetics to quit fretting about the single narrow quality of the beautiful. He recommended for study the dainty and the dumpy. Though without intending to be, he was prophetic. Since pop art, minimalism, arte povera, and conceptualism, artists have devoted themselves to all manner of aesthetic sensations exclusive of beauty—to the point where it seems vital to think about beauty again, though hardly to reduce the focus of the aesthetic back to beauty alone.

Loss of necessary connection between beauty and art seems another of the baleful effects of modern technology, which can simulate, so readily and in such abundance, experiences that once were hard to come by. Visual beauty has been escaping from visual art into movies, magazines, and other media, much as the poetic has escaped from contemporary poetry into popular songs and advertising.

Beauty's value as a profound comfort, a reconciliation with life, inevitably wanes when ordinary life is replete with comforts, notably including less frequent exposure to the ugly. The beautiful meant more before indoor plumbing.

Another reason for the progressive divorce of beauty from art is the institutional order that governs most activities involving art. Servants of this order, like minions of an established church, naturally try to rationalize their functions. They are temperamentally averse to irrational and, especially, indescribable phenomena. If I had what I believed was a mystical experience, probably the last person I would report it to would be a priest or pastor. Similarly, I do not discuss beauty with curators. It would only discomfit them and embarrass me.

* * *

Anyone can tolerate only so much beauty. Some years ago, a doctor in Florence announced his discovery of the "Stendhal Syndrome," named after the French writer. Stendhal had reported a kind of nervous breakdown after a spell of looking at masterpieces of Renaissance art. The doctor noted a regular occurrence of the same symptoms of disorientation—ranging, at the extreme, to hallucinations and fainting—in tourists referred to him as patients. For treatment, the doctor prescribed rest indoors with no exposure to art. It occurs to me that contemporary art is hygienic in this regard. I have never had the slightest touch of the Stendhal Syndrome at a Whitney Biennial.

Beauty is not to be recommended for borderline personalities. It is perhaps most to be recommended for those who, quite sane, most resist the notion of surrendering mental control, such as certain intellectuals who insult aesthetic rapture as "regressive." They should come off it. The self you lose to beauty is not gone. It returns refreshed. It does not make you less intelligent. It gives you something to be intelligent about.

Entirely idiosyncratic, perverse, or otherwise flawed experiences of beauty may be frequent. There is nothing "wrong" about them, and the distinction between them and "real" experiences of beauty is murky (requiring quotation marks). Unusual experiences may constitute a pool of mutations, most of them inconsequential, but some fated to alter decisively a familiar form. Of course, such alteration, like the distinction between familiar and mutant beauty, is moot unless a cultural sphere exists in which subjective experiences are openly revealed, compared, and debated.

An experience of beauty entirely specific to one person probably indicates that the person is insane.

<div align="center">* * *</div>

"Beauty is Truth, Truth Beauty"? That's easy. Truth is a dead stop in thought before a proposition that seems to obviate further questioning, and the satisfaction it brings is beautiful. Beauty is a melting away of uncertainty in a state of pleasure, which when recalled to the mind bears the imprimatur of truth. I do demur at Keats's capitalization. Truth and beauty are time-bound events. Truth exists only in the moment of the saying of a true thing, and beauty exists only in the moment of the recognition of a beautiful thing. Each ceases to exist a moment later, though leaving a trace.

Are there canons of beauty and truth? There are. Everybody has one, whether consciously or not. In social use, canons are conventionalized imaginary constructs of quality and value which, at both best and worst, are abstract rating games for adepts of this or that field of the mind. Battles over canons should be passionate and fun. Something is wrong if they are not fun. Usually the cause of the disagreeableness is a power struggle in disguise.

Nothing makes for worse art and more trivial politics simultaneously than *Kulturkampf*, a symbolic fight over symbols. Art is given misplaced concreteness as

the bearer of realities it is taken to symbolize. Politics becomes fanciful. Righteous blows are struck at air.

Quality. We need this word back, too. It has been abused by those who vest it with transcendent import, rendering it less a practical-minded rule of thumb than an incantation. Quality is a concept of humble and limited, but distinct, usefulness. It is the measure of something's soundness, its aptness for a purpose. I want a good-quality picture to hang on my wall and a good-quality wall to hang my picture on. I will be the judge of what sort of quality—or, better, what combination of qualities—is appropriate. I will be delighted to discuss my judgment with you, and you may enjoy the discussion, too, so long as I refrain from suggesting that my preference somehow puts you in the wrong.

In matters of quality, aptness is all. The best airplane is no match for the worst nail file when your nails want filing. Meanwhile, there is also an order of quality pertaining to purposes in themselves. It does not matter how well something is done if it is not worth doing, or if to do it is evil.

Much resistance to admitting the reality of beauty may be motivated by disappointment with beauty's failure to redeem the world. Experiences of beauty are sometimes attended by soaring hopes, such as that beauty must some day, or even immediately, heal humanity's wounds and rancors. It does no such thing, of course.

Much resistance to the reality of truth suggests a potential of truths that the resister fears.

Much resistance to the reality of quality, as a measure of fulfilled purpose, bespeaks the condition of people who either lack a sense of purpose or whose purposes must, by their nature, be dissembled.

Insensibility to beauty may be an index of misery. Or it may reflect wholehearted commitment to another value, such as justice, whose claims seem more urgent.

When politics is made the focus of art, beauty does not wait to be ousted from the process. Beauty deferentially withdraws, knowing its place. Beauty is not superfluous, not a luxury, but it is a necessity that waits upon the satisfaction of other necessities. It is a crowning satisfaction.

Contratemplates

Marjorie Welish

Before too many buildings on which polished marble and gilt bronze are lav-
ished, our pleasure in these appearances is more than counterbalanced by the
painful absence of esthetic purpose.

<div align="right">—Roger Fry, "Some Questions in Esthetics," 1926</div>

UNHELPFULLY, THE WORD BEAUTY IS UTTERED TRIVIALLY. LIKE GREAT OR BRILLIANT,
beauty comes to join other expressions noting preference, in temperament, per-
sonal taste, or sex appeal. More innocently, it is an honorific meaning "Yes!" and
calling forth no precise aesthetic concept. "Harmony!" "Sublimity!" "Radiance!"
are not what is meant when it is exclaimed: "That's beautiful!" or "That's great!"
or "That's brilliant!"—although all these concepts are of the utmost value in the
theories of art informing art history. An honorific-to-be-determined, the generic
enthusiasm might well be modified analytically to reflect the form, idea, or qual-
ity of the artwork that provokes the viewer to blurt out, "It's beautiful!" This is a
word that has come to mean nothing—or everything. The term *beauty* is devalued
because "liking things" means nothing within a study of art history informed by
cultural style and idea. The individual's idiosyncratic taste is irrelevant to culture.
From a cultural perspective, however, beauty may be assumed to permeate the cre-

ated world. Anthropologically, the word *beauty* designates a universal sense of the condition defining art: Under this designation, an artwork is an artifact of sentient thought valued by the culture and, as such, is beautiful. Art history seeks understanding of the artifacts culturally deemed beautiful, evaluation being a by-product of this understanding.

When not construed as entailed in the culture itself, and broadly taken for granted, beauty is a particular matter of worry for a certain corner of Europe. Having singled out the notion of the aesthetic for special attention, Alexander Gottlieb Baumgarten was intent to consider matters both of art and of beauty, although this distinction was soon lost. Subsequently, however, the notion of beauty is so linked to the eighteenth-century scheme of the sensation apprehended through a mental faculty for detecting sentience that *beauty*, per se, may be said to be a kind of jargon, a specialist's term.[1] Philosophically, *beauty* is a special and particular sign for a theory of art (already in decline and ceding to a theory of taste and then the aesthetic by the end of the eighteenth century, according to George Dickie).[2] What disguises its special status is that the word happens to be the same as the word adapted for general use. Semantic drift from register to register frequently goes unacknowledged.

Philosophically, aestheticians after Baumgarten often argued that the studies of aesthetics and beauty are synonymous, but this synonymy is contested. Occasionally relevant to a history of theories of art, beauty is a quality that may point to an aesthetic content, but it is only occasionally synonymous with a theory of art.

Problematic for some (and competing for the terminology), aesthetics as the study of beauty has drifted into confusion with aesthetics as the study of theories of art. Defined as the study of beauty, argues Noel Carroll, aesthetics should be distinguished from the theory of art. The reason that theories of art are reduced to beauty may be found in history, says Carroll. Since sunsets and other natural phenomena were initial instances under discussion, artworks then incorporated into the general discourse were compared confusingly with nature. Theories of aesthetics may, for the sake of expediency, be fused with theories of art as if "united in one field," argues Carroll, but they are, in substance, distinct pursuits.[3]

Aesthetics may then be coincident with the philosophy of art, wherein beauty has a cameo appearance. Dictionaries that currently define *aesthetics* as philosophy of art, mention the history of the term in its eighteenth-century canonical form,

yet pass on to consider aesthetics conceptually (as in the dictionary by Anthony Flew).[4] Philosophically, aesthetics largely concerns defining, or at least describing, theories of art. It also defines, interprets, and evaluates certain concepts intrinsic to art: Indeed, aesthetics is concept driven.

What is the concept of the art object, the concept of meaning, of intention, of representation—the pursuits of which have substantiated the claim of aesthetics to be classified as philosophy at all? Immediately relevant for us now is the short list of theories of art supplied by Flew, which, in his view, have been of form, of expression, and of symbol.

* * *

. . . and the hoarse music that the world, far behind us, hurls at our mother of beauty,—she recoils and rears up.

<div align="right">—Arthur Rimbaud, "Beauteous Being," 1874 (translated by Louise Varèse)</div>

Q: So, then, what do you do?
A: I am a boxer, a boxer once married to a ballerina.
Q: That's beautiful!
A: Yes. I thought it a beautiful combination.

<div align="right">—Conversation in the Cornelia Street Café, New York, circa 1980</div>

Aesthetics in the early twentieth century gained immeasurably by aggravating the idea of beauty. Vitality is broached as challenge to beauty, and, indeed, even today, many philosophers of art writing on aesthetics will use the word *expression* or *expressive*, or other forms of *expression*, to designate those artifacts of which the paradigm is no longer beauty, but vitality. Noteworthy, then, is an aesthetics driven to surfeit of energy, not decorum, the purpose of which is to undermine, or at least ignore, niceties in craft for the sake of either feeling or concept. Or putting it differently, craft is that which realizes the energy. Like the boxer married to the ballerina, beauty may manifest itself through an athleticism coincidently shared by unlikely antagonists, once gymnastics synthesizes these energies in sublimated discipline. At times, even the engagement or fateful combination embodied (a set of punches) is said to be beautiful.

Matisse is a curious case of a fauve whose colors are radiant but whose aesthetic is that of vitalism at odds with beauty. The two versions of *Le Luxe* exchange

classicizing proportion and measure for barbaric and orientalizing alternatives adapted from the East. By way of these alternatives to classicizing Greece (inadvertently forming an alliance with that Gothic tradition of Northern Europe long disallowed as a norm) comes the proposal by Matisse for an "expression": *Le Luxe II* (1907–08). A sketch, rather than a polished academic labor, *Le Luxe* solidifies the notion of spontaneity advanced in impressionism, yet this sketch observes nothing and does not represent nature: It presents itself. It presents itself as a design without repeating pattern, therefore as a design self-created, in line and color.

Differences exist between an aesthetic expression and stylistic expressionism, although they overlap. Both the philosophy of art and art history share in the rejection of description of natural fact. Posited by Croce as an intuition seized on, an insight prior to action that retains precognition even as it is performed and becomes sentient expression.[5] Not to be confused with any impulse, an expression registers an aesthetic content decidedly distinct in mind. A Crocean expression addresses the immediacy of sensation, and, as in Matisse, may mobilize the medium of expression—material paint, formal design—less to communicate a feeling than to confer palpable intensity on design in the spirited alternatives to classicizing beauty. Defiant of classicism, Matisse dares to propose an aestheticism, both nonderogatorily decadent and barbaric, from which the classical has been excluded.[6]

Expression derailed beauty in early Matisse, to accommodate non-European canons of proportion and measure, on one hand, and, on the other, to elevate form itself over pulchritude. How Matisse's aesthetic purged the decorative of its ingratiating aspect and put distance between painting and the commodity of painting is the remarkable achievement.[7] Were it not for the fame of Matisse himself, there would still be a hostile reception of his art: However physically portable, however they may be bought and sold, his early works are still not yet intellectual commodities.

* * *

The significance of the idea of the expressive for our purposes is that theories of art (aesthetics) may be distinguished from aesthetic notions of beauty even where formal and material contents are concerned. Even if modernity is said to privilege form over content—mistakenly, for the imitative realism of *subject matter* is the vanquished term—the meaning of the art depends on knowing which cultural

contents inform the form. The Nietzschean call to vitality is helpful, yet the primitivism of Matisse derives from different cultural artifacts than does that of Picasso: The norms of "beauty" differ from each, and the anticlassical expressivity in both *Le Luxe* and in Picasso's *Les Demoiselles d'Avignon* speaks to alternative notions of measure.

To gauge from writings on aesthetics in journals devoted to the subject, expressive theories of art displacing those of beauty are assumed to be still valid nearly a century after Croce. This assumption indicates several points. Aestheticians have not addressed developments in art beyond Kandinsky; or else they have assumed vitalism and the language of feeling to be the most legitimate of theories put forth. Or, underlining all discussions is the assumption that the cognitive and sentient expressions need to remain unmixed if art is to retain its place as a legitimate concern for philosophy. This is curious one hundred years after the age of Cézanne's "logic of sensations," the phenomenology of perception, and the influence of positivism on art; curious too, long after efforts in nonutilitarian engineering divided the constructivists from the utility-driven productivists, and Soviet ideology displaced the constructivists (whom, in the diaspora from Eastern Europe, brought a strong presence to England and France before and after World War I), that expressive theories of art are assumed by aestheticians to be dominant. Aesthetics of structure and function contesting each other for legitimacy play a crucial role in the ideology of modernity, however. Derived from the classical notion of forms "well adapted to their purpose" that in Socrates' argument usurps the place of sheer "good looks" in photogenic beauty, the ideal functionalism (of Le Corbusier and other masters of design) remains unaccounted for in, for instance, Flew's catalogue of indispensable aesthetic concepts.

Flew's own list is telling in this respect, for his concepts of aesthetics stop with expression. He does not bring theories of art up-to-date by adding function; nor is accommodation made for the agonistic strategies of high-modern aesthetics, or for the emergent idea of tactics that challenge strategic thought in aesthetics. Under pressure of relativism, as theories of knowledge had yielded to modes of use, the concept of the art object reconfigured itself and became process, not product, or became identified with methods instead of systems. (Flew's analytic approach to aesthetics keeps these potentialities at bay.)

Crucial in this regard is that philosophers employ the term *expression* much more broadly than do art historians. Philosophically speaking, if history seeks to

represent states of affairs as they are, art seeks to render matters as they might be: expression, then, covers all manner of interpretation. In this way, philosophy assumes *expression* as a shorthand for referring to the interpretive bias of art no matter what the style; art historians, meanwhile, reserve *expression* for a coherent culturally determined style. Expressionism is a period concept, even as expressivities of all kinds abound. Art historians acknowledge the romantic subjectivity that pulls the aesthetics of expressionism into alignment and distinguishes it from that which preceded it and that which followed, that is to say, from the preceding postimpressionism that presupposed perceptual analysis and method or from the subsequent advance of rationally inspired cubism—although all these are indeed aesthetic interpretations of the world.

* * *

To measure time they use the pendulum and they suppose by definition that all beats of the pendulum are of equal duration. But this is only a first approximation: the temperature, the resistance of the air, the barometric pressure, make the pace of the pendulum vary.

—Henri Poincaré, "The Measure of Time," The Value of Science, 1907 (translated by George Bruce Halstead)

Something
 has fallen in the corner
And the pendulum
has stopped

—Vincente Huidobro, "Tempest," 1920 (translated by Terry Hale)

An artist may be said to be doing philosophy if an artifact created concretizes an argument of meaning, of representation; and so certain artifacts, if not entire bodies of work, come to be considered significant. It is in this sense that aesthetics functions as critical theory. Critical consideration may be applied to beauty, yet also to art, nature, and imitation. This, assumed in eighteenth-century France to be true, may also be said to be presupposed by certain twentieth-century aestheticians and artists.[8]

The notorious instance of the cognitive artist remains Marcel Duchamp. Not a systematic thinker despite massive efforts in that direction, Duchamp did adopt the paradigm of aesthetics that put the mental construct first. If his readymades

seize and hold our attention, it is precisely because the objects so designated evince a compelling argument through and against aesthetics, not because they give plea- sure as lovely collectibles. In effect, the readymades appeal to a distinction between aesthetics and beauty, between Minerva and Venus, and opt for a critical disputation with the former about the nature of representation and much else. Whether art is an anti-rhetorical instantiation of an argument of some kind, or some other kind of knowledge, is also at issue in Duchamp's aesthetics. In dis- cussing the concept of aesthetics, let us note, meanwhile, that a strong paradox of Duchamp's art is that it made a fetish of the erotic while rarely, if ever, appealing to beauty. In this way, Duchamp can be said to have effectively proved his disdain for merely "retinal" artifacts.

Among the hoard of artifacts he produced, *Three Standard Stoppages*, 1913–14 does directly address the notion of beauty. Strings one-meter long, dropped from a height to produce an accidental set of curves, come to rest on canvas, the chance lines then fixed on glass as templates, at once extend and oppose the eighteenth- century canon of Hogarth's "Line of Beauty" as representing a universal standard: His continuous ratios of a line wrapped around a cone Hogarth dubbed "grace," and this rationalizing derivation of beauty gives a privileged place to the spiral.[9] (The vicissitudes of performing an experiment with handheld string together with the action of gravitational forces combine to yield "chance"—verified twice— put Duchamp's work in the domain of an empirical intervention rather than an occult event.)[10] *Three Standard Stoppages* is a thought experiment. Hardly ingrati- ating in itself, it is a work that refers to, rather than expresses, the notion of beauty. Yet, as a demonstration of an alternative to a known canon, *Three Standard Stoppages* does realize its own aesthetic countermeasure.

* * *

The significance of this is that, narrowly construed as sensuous appeal, beauty is far too literal-minded for the strategies at work in modernity. Beauty ingratiating the viewer is entertainment, designed from the outset for the trade only; beauty so construed is certainly largely irrelevant to art designated philosophically. The resistance to commerce in certain artifacts created under the auspices of moder- nity has now become a commonplace. What is interesting to suggest is that for- malism is not so monolithic in its approaches to aesthetic issues—not uncritical toward measure and proportion—as detractors would like to believe. At the very

least, certain works of modern art engage in interference patterns of cultural measure, so that competing codes of proportion "thicken the plot." (It can be argued that once Matisse naturalized his cultural codes of anticlassical vitality played against so-called classical beauty, his contribution to the history of art ceased.)

Of further significance is this. Referring to issues of form without resorting to formal beauty and issues of aesthetics as conceptual schema rather than affective intuitions, Duchamp raised issues crucial to the debate about the nature of the art object and of the imagination. It was his singular obsession to show that the aesthetics of perception was capable of yielding artifacts worthy of epistemology and, thereby, to prove that art is not inferior to thought.

Perhaps, then, the thought experiment of *Three Standard Stoppages* may be pressed into further use in directing our attention to the problem of taste. To save the standard of taste from being considered merely subjective, that is, to be found within oneself, the eighteenth-century philosopher David Hume hoped to establish a proof for a standard of taste found empirically to be objective by virtue of its being neutral. Cultivating the taste-less-ness that was his specialty, Duchamp might be said to advance not only so-called puerile bad taste but also blandness, and by these means to produce artifacts that evade the taste of connoisseurship. Whether his aesthetics of indifference took cognizance of the eighteenth-century theories compatible with his own, in Germany and France as well as in England, Duchamp's art seems illustrative of them. "True beauty should be like limpid water from the source itself," wrote Winckelmann, thinking of the Greeks (albeit transmitted secondhand through Roman casts), "the less flavor it has the more healthy it is considered."[11] Given this, it is even feasible that Duchamp devised *Three Standard Stoppages* as an instrument of the poetics of neoclassical objective taste made secondhand. Meanwhile, that his device points to the problem of fixing an objective standard as much as to the solution does not make his artifact less serious, less worthy, in form. That is to say, even as Duchamp's aesthetic of indifference exercised a willful misreading of the "disinterested attitude" characteristic of the desired aesthetic stance, the simulation of trial and error extends an attitude of indifference to outcomes.

At their best, both Matisse and Duchamp are exemplars of the strategic aesthetics that is the mark of modernity. Indeed, it is to the detriment of belated stylizations and weak pluralism that this strategic thinking can only result in mere application of taste[12]—or worse, weak rationalization for the loss of a style.[13] In his

day, Roger Fry despaired at the want of aesthetic purposiveness, although by 1926, when "Some Questions in Esthetics" was written, Fry had had the full advantage of witnessing firsthand the vindication of Cézanne's art and through it artistic purpose writ large. Compared with this postimpressionist logic, the immediate gratifications residing in the accumulated visual and tactile effects in Victorian edifices constitute neither a tectonic nor a theory—and so fail to qualify as art. Years later, a search for purpose may be found presupposed in the convocation of modern artists in 1952 at the Museum of Modern Art. The very proposal that dialogues between Ad Reinhardt and Hedda Sterne or Ad Reinhardt and Willem de Kooning (among the more memorable exchanges) could hash out differences of idea and critique in abstraction revealed the assumption that modern art is something with which to think. And when Alfred Barr, visionary founding director of the museum, urged the assembled artists to (in effect) drive a wedge in modernity by advancing another concept of style, he proved that engaged art which defeats his position is much more significant than the mere institutionalization of the abstract art he already knew. Barr acted on his words. In 1958, he purchased for the museum that antithetical statement in the form of a conceptual representation joining contrary systems of space: *Target with Four Faces* by Jasper Johns.

*　*　*

Theories of aesthetics are theories of art compelling to art history, as much as the other way around. Perverse in its hierarchy, perhaps, the history of art appropriates from philosophy what it requires, or what culture requires, for thought.

Adapted from philosophic aesthetics are theories of space. Conceptions of space traditionally organize the history of art in university courses because in the so-called formal concerns of space are understood to be embedded the rhetoric of mentality and culture. Art history tends to be plotted along these lines. Beauty as such is not mentioned but taken for granted as the culturally endorsed conception of space believed to be necessary (more than a formal structure, space as a schema for a world hypothesis that elaborates themes, genres, and ideology).

Concepts of space and time assumed by art history to be crucial to art, then, would be drawn from a Kantian notion of the mediating role of schemata between the idea and its sensible representation. Reliance on schemata is seen to be helpful in articulating the relation between actual and ideal notions at play in the imaginary world. The privileged place of landscape within the site of the artist's

studio is exploited as a key to understanding realism in Courbet's world hypothesis; the prevalence of the diagonal in suprematist compositions reveals a disposition toward physical aeronautical flight being construed metaphysically. Add to this Duchamp's spatiotemporal deformations; then a painting by Jackson Pollock, in which line in space is distributed evenly throughout. In this way, cultural presuppositions about space and time come to explicate and justify a notion of beauty, and culturally preconceived schema of time and space tend to establish meaning and significance in art-historical descriptions. Beauty, then, is taken for granted to have entered into these imaginary cultural constructions.[14]

And congruence between theories about space and time in art and space and time in world-making persists as a value. "What are called structures are slow processes of long duration," writes Ludwig von Bertalanffy from a cybernetic perspective, "functions are quick processes of short duration."[15] Beauty is conferred on a conception well done. In this sense of things, attributing beauty will extend to the artist's imaginative comprehension of his world: perceptual subtlety per se is inconsequential, if not irrelevant, then.

Duchamp maintains his controversial status of being one who does works both included in the library of art history and excluded from that library. Among other reasons, he is excluded on the grounds that his works are comments on art possessing insufficient formal interest.[16] On the other hand, Duchamp is included in the narrative of art history both on aesthetic and social grounds. An anti-aesthetic object may be eligible to be considered an artifact of vision whose craft is sufficient to its idea. Furthermore, the perfect functionlessness of the artist's artifacts might qualify as art—even readymades, which through intention designated a functionless aesthetic status on functional items. The sociological point to be made is that Duchamp started his career as a painter, so classifying him as an artist continued thereafter. Perhaps, then, the status of *Three Standard Stoppages* (fabricated the year that saw publication of Mallarmé's *Un coup de des*[17]) truly depends on defining aesthetics to include theories of art in which the nature of the art object, and such concepts as representation and intention, may be welcomed conceptual contents.

Now, the problematic status of this artifact by Duchamp is precisely what makes it a test case for beauty. As visual information about temporal processes becoming spatial templates of some sort, the stoppages are adequate for thought. They are adequate for an imagined comparison with French curves and "Lines of

Grace" and also in contrast with these ratios constructed from idealized curves, for Duchamp's curves are curves derived from contingency. And, in this sense, his contingent curves may even be compared to the contingencies of birth that render a human form what it is. To reject *Stoppages* or *Le Luxe* as works of art might require certain restrictive measures to be put on the rhetoric, such as a moratorium on the faculties of memory and imagination by which visual information on space and time is synthesized. The issue remains whether the form-giving process of thought, imagination, and interpretation of sensory information can be delimited, much less eliminated, from a criterion of beauty.

* * *

It is well known that modernity does not tolerate beauty at the expense of theories of the art object construed in dialogue with the culture, and so a work pleasing through the senses becomes a function of the history of ideas in the modern era. But since what is perceived empirically in 1874 is reconceived in 1890 to be rational, the vast stylistic difference between impressionism and postimpressionism should indicate that antithetical standards of beauty are being invoked. Similarly, fauve and dada impulses to confront beauty and redirect its ends are decided instances of diverging formal resistance. Meanwhile, with its gift of imagining the world along radical lines, the early twentieth century kept identifying paradigms and making the identification of paradigm and style just what might be found pleasing through the five senses. And so, the great paradigms of abstraction produced by Kandinsky, Malevich, and the team of Picasso-Braque are valued because they are paradigms, not because instances of anything like a "red sensation" present themselves.

NOTES

1. The history of aesthetics in Europe may feature a moment that institutionalizes the term and seeks special notice, but also coincident with this specialization is a consciousness of relative cultural context. Period mentality grasped aesthetics as international, and so initiated the practice of compiling anthologies of foreign literatures.

2. George Dickie, *Aesthetics* (The Bobbs-Merrill Company, Inc., 1971). Or, as Terry Eagleton remarks in considering Burke, morality was feminized under the sway of aesthetics: *The Ideology of the Aesthetic,*

1990. In contrast with Dickie's institutional approach to the subject, Eagleton's socialist approach finds much to say that is critical of the Left's disowning of aesthetics in retelling the specialized history of the aesthetic idea. His hope that the Left should realize an unembarrassed affiliation with aesthetics allows Eagleton to presuppose that the idea had been invented in the eighteenth century and did have its origins then. This is not the assumption of the essential relativism of Harold Osborne, whose *Aesthetics and Art Theory*, 1968, features Chinese aesthetics contrasted with Occidental aesthetics throughout. In consequence, Oriental aesthetics does not have to justify its set of values to accommodate Occidental rationale, and fifth-century aesthetics deriving from spirit is not written out of a history of sentient expression said to have its origins in eighteenth-century Europe.

3. Noel Caroll, "Beauty and the Genealogy of Art Theory," *Philosophical Forum*, XX, 4 (Summer 1991).

4. Anthony Flew, *A Dictionary of Philosophy*, 2d ed., (New York: St. Martin's Press, 1979).

5. Among the definitive moments for the switch from perceptual to affective contents in art is Delacroix's witnessing the exhibition of Constable's *View of the Stour near Dedham*, 1822, a perfected arrangement of pigment, the cruder sketches of which subject (*View of the Stour*, 1820) display not so much a human figure as red brushstrokes of no description: an event that prompted Delacroix to paint *The Death of Sardanapulus*, 1827, inspired in effect by the paradigm shift to romanticism that Constable had concretized.

6. Joseph Masheck in "Raw Art," *Modernities* (1993), argues the constant presence of ornament—not as mimetic design but as free play—in tribal arts: not invented by moderns nor projected on the "primitives" in false misreading of sources, the autotelic notion of the decorative is coextensive with the symbolic impulse from the start.

7. Once he naturalizes the proportions in order to ingratiate himself to the viewer, Matisse does then choose beauty in the sense of the art of pleasing.

8. Such is Warhol's concept of representation, as expounded by Arthur Danto.

9. Naïve though it may seem to fix a notion of beauty, Hogarth's impulse and the particular nature of his choice revisit the history of ideas in culture. Note the history of the theory of progressive time in history developed by George Kubler in his well-known *The Shape of Time*, 1963, according to which culture is cyclical, not linear, in its narrative.

10. The scientist impulse toward topological deformation motivates Duchamp as well. See Craig Adcock, *Marcel Duchamp's Notes from The Large Glass: An N-Dimensional Analysis* (Ann Arbor: University of Michigan, 1983). The point to be emphasized here is that Duchamp's empiricism corrects Hogarth's rationalism.

11. Cited by John Kemp in "Some Reflections on Watery Metaphor in Winckelmann, David, and Ingres," *The Burlington Magazine*, CX, 782 (May 1968).

12. The application of taste is tastefulness merely, and cannot substitute for aesthetic judgment. Beauty that obtains from the application of taste most often exposes an unfortunate want of knowledge about the theory of art that informed the paradigm. Eagleton vastly underestimates this possibility when he assumes that once the rules of taste are learned, application will yield excellent results. Tidy plantings do not constitute a garden, as anyone who has observed the stupefying substitution of exterior décor for the idea of the English or Japanese garden or the French model of a garden will attest. Not surprisingly, Alexander Pope satirized the picturesque garden gone awry through application without understanding.

13. So, when sectors of the art world protest against the death of painting with the "reason" that the practice of painting continues, this is ignorant of the grounds of discussion. The history of history is not the history of all practice—any more than all that happens in daily life enters the selective narrative given the cultural privilege we call history.

14. Mechanistic in this regard, art history is nonetheless contextual in promoting the broad cultural situation that informs a style.

15. Ludwig von Bertalanffy, *General Systems Theory* (New York: George Braziller, Inc., 1968).

16. Famously known for defining aesthetics as beauty, Monroe Beardsley argues this point.

17. Paul Valéry remembers when, in 1897, Mallarmé first showed him the finished poem, it seemed that the page held "thought in space."

A Sign of Beauty

For Michael Kirby (1931–1997)

Robert C. Morgan

To feel beauty is a better thing than to understand how we come to feel it.

—Santayana

In our transglobal informational age, ridden with the denial of qualitative judgments as to the meaning of culture, there is the perennial problem of the senses. It is as if the omnipresent glut of information has distorted our means of sensory intake. The reception of data—scientific, economic, cultural, and political—has become so overabundant as to suggest infinity. New combinations of data appear with each fraction of a second, information to be perpetually recycled and reordered into new paradigms. In such a virtual environment—one that exists hypothetically on a global scale, barring certain unexplained economic and political constraints—there are gnawing questions: What to do with the senses? How to give validity to our sensory experience? How to acknowledge the rightness of the senses as a perceptual filter in determining quality in works of art?

The answer to these questions, of course, relies heavily on the subjective principle, and on the confidence to assert qualitative judgments that exceed the rational constructions of the obvious. It is a type of intuition that is further dependent on the sublimation of a structural awareness of the language of form, and by

knowing form to declare beauty as its effect, a point expressed by the philosopher Santayana. Before the concepts of form and beauty can be defined operatively in relation to one another, particularly in the current situation, there is the problem of sensory input as it defines our experience of works of art. This definition is contingent on foregrounding some acknowledgment, if not a resolution, of the mind-body function.

Sensory Input and the Mind-Body Problem

There are a plethora of symptoms to suggest that we are living in a cultural moment that could be described as split between mind and body. As a globalized society, we have lost the connection between the two hemispheres. There is little external evidence to suggest that mind and body are cooperative, or that they neurologically depend on one another. The notion of mind-body interdependency has, for the time being, been suspended. The consciousness of a sensory balance appears lost. The capacity for synaptic charges instigated by the mind to inform the body or hormonal secretions from the body to chemically inform the mind has been scientifically known for several years, yet somehow the implications of this research do not appear conveniently suited to the present. Instead, we have come to exist in an antipodal culture in which obsessiveness of mind is positioned in relation to the fetishization of the body. (Is it any wonder that art and fashion have become virtually indistinguishable?)

Since Kuhn's *Structure of Scientific Revolutions* (1962), the physical and biological world has been viewed more or less in terms of a conceptual enterprise where every theory has a cause-and-effect relationship. The world is made from science, from rationality, from statistical memory. Theories are built upon theories. Metatheories try to account for the theoretical precepts of the past. Yet, the rush to theorize on the cultural level, as if culture were only a phenomenon relegated to the social sciences, may preclude more open frames of expression.

Culture, not science, is the repository of expressed human values. From a cultural point of view, the absence of a clear sense of intuition beyond the rational further precludes an accurate view of history. Without an accurate view of history, it is exceedingly difficult to gain an accurate view of culture in which qualitative significance plays a determining role. Without a clear dialectical understanding of historical time in relation to the cultural present, the role of sensory experience is considerably diminished.

Instead of sensory experience that is contingent upon the overlay of the synaptic mind-body function, we are left with the body as a fetish, as a primary focus of desire, as a scientific specimen depleted of historical and cultural significance. Within the rational confines of our postmodern condition, the body is given the status of commodity—a nonheroic mythic status, acquiescent to the commercial world of fashion. Where there is no evidence of qualitative significance, even on the most sublimated level, the role of beauty as a consequence of our sensory apparatus appears without force or authenticity. This loss signifies the repression of the subjective. In such cases, the body performs autonomously according to ritualized data, according to the input of software that makes it function. From a westernized cultural perspective, the concept of mind and body no longer operates as a conscious, unified organism. Instead, they are treated as separate functions, as discrete entities, divided between the computer and the gymnasium.

An interesting attempt to find an overlay between mind and body can be found in the recent digital architecture of the collaborative team Arakawa and Madeleine Gins, whose work *Reversible Destiny* was shown at the Guggenheim SoHo during the summer of 1997. These fantastic and chaotic spaces, consisting of broken planes, curvilinear surfaces, distortions in scale, and displacements between inside and outside, appear virtually uninhabitable. Their architectural hypothesis intends to bring the mind into focus with the body, a concept shared earlier by the sculptor Robert Morris. The question that Arakawa and Gins propose is to what extent can a revision of the concept of architectural space, through cybertechnology, restore sensory precognition.

What is significant about these cybergenerated projects, in spite of their totally fragmented impracticality, is how they represent the current cultural crisis to the extreme. Arakawa/Gins conceptually challenge the socioeconomic basis of our global "society" through ultra-amorphous deformalized architecture. The works are like playgrounds for the intellect that are not entirely without sensory appeal. A clear example would be their only realized architectural project to date, situated in Yoro Park in Gifu, Japan. The irregular terrain of the space allows the irregular and asymmetrical forms to meet and fall apart in relation to one's ambulatory movements. The continuity of the habitat is subverted at every turn. One is left with a sense of utter displacement, caught within the delirium of an unrecognizable fragmentation. The artists are ferreting out a means to bring architectural

space in closer contact with the body through a kind of sensory play. The illusory aspect of the work relates to its computer programming. It functions as a digital system, yet has limited applications in terms of actual mind-body involvement. The seduction of virtual time-space gives a convincing display of a virtual environment, but one that is highly self-conscious, reflecting a type of narcissistic indulgence. The architectural models, generated collectively by Arakawa and Gins, emphasize the fetishizing of the body through architecture. Yet, without a cohesive concept of mind-body interaction that can function in the practical world, there is only a pure aesthetics, a heightened sensory cognition, a fragmented utopia. There is little pragmatic application to the functional world. Beauty appears as an inverted romanticism, a lost horizon, a suspension of belief. On the other hand, this suspension of belief is consonant with the fragmentation of the present historical moment, a moment characterized as a period of high transition, or as Paul Virilio has articulated, a period infused with the pressures of speed.

Beauty as a Syntactical Sign

In the postmodern condition—a condition that some observers feel has already been usurped by an ever-expanding market economy and is therefore defunct—the question of beauty appears as a suspended entity, an imposed value system that is detached from any recognition of form. This is consistent with the poststructural notion that signs are in the process of losing their signifying power and are becoming detached from their referents. Put another way, signs exist in a state of suspension or flotation. There can be no assumption with regard to their predetermined meaning, as made clear in the architectural projects of Arakawa/Gins. Here the signs of habitation are fragmented presumably in order to augment the sensory experience of the body. The absence of the referent suggests that destiny is no longer a factor in the mind-body function. Without destiny, the body is liberated from the constraints of form and gravity and, therefore, is capable of moving through time and space as a kind of autonomous sensorial entity.

The argument that a sign can function interdependently, yet divorced from its referent, is essentially a poststructural argument. It is also a highly contingent one. It is contingent on accepting the fragmentation of the sign as no longer requiring a specific syntactical operation. In contrast to these more complex signifiers that are dependent on some form of syntactical structure, commercial

logos operate as fixed signs, virtually undaunted by their context. For example, Coca-Cola means the same in Atlanta as it does in Tokyo or Bombay or Buenos Aires. On the other hand, a concept as malleable and subjectively construed as beauty cannot exist as a fixed sign. Rather, beauty exists as a more open, syntactical sign without a predetermined aspect.

Paradoxically, the concept of beauty may no longer be absolute, as considered by Plato or Kant, but relative. This relativity, however, is contingent on the recognition of a form's conceptual understanding as much as on its aesthetic coherence. Yet its syntactical placement and contextual understanding are highly fragile. For example, a crushed car in a junkyard may not appear beautiful. However, when placed in an isolated context within a white gallery or museum, as in the recent César retrospective at the Jeu de Paume in Paris (summer 1997), the object is abstracted as material—compressed steel—and, for many observers, appears beautiful. One could make similar arguments in favor of Rauschenberg's *Bed* (1955), Tony Smith's steel cube, called *Die* (1962), or Warhol's *Campbell's Soup* (1962). Given the right context in what the critic Brian O'Doherty once called "the white cube," these works become astonishingly beautiful.

Beauty Cannot Be Imposed

The formal argument for beauty need not rely on the absolute or on a single monolithic criterion. When it does, the work tends toward aesthetic formalism. This definition of beauty is an exclusive one. To define beauty through the syntactical sign, it becomes necessary to rediscover the signifying power of the sign as existing between the formal and the conceptual. Without a formal basis, beauty can only exist as a surrogate form, as a fake. This is most often the condition of the commercial logo or any image that proliferates in reference to a product or ideology. Ultimately, such signs appropriate beauty as glamour, as signifiers of power, as conformist emblems, without any further structural or referential basis.

Yet, the structure of a sign that is understood as beautiful is one that is not solely dependent on its ideological semantics as is the case in commerce and in politics. While beauty appeals to the senses, it is not cosmetic; it is not a surface phenomenon. Beauty is a phenomenon that cannot be imposed. It is neither a quotational spectacle as in the work of Robert Longo nor a spectacular quotation as in the work of Matthew Barney. Put another way: To use spectacle in art is one thing; to make art into a spectacle is something else.

One cannot intend or predetermine beauty to be the condition of a work of art before the work exists; rather, beauty becomes a condition after the fact of the work—an aura that is received. Because beauty is not an absolute, but a syntactical sign, it exists as an *a posteriori* condition of aesthetic receivership, not as an *a priori* mode of determination. Beauty cannot be predestined. This is why works made with the *intent* of becoming commercial media cannot exist in the same context as art.

Beauty is fundamentally a sensory experience even if that experience is instigated through a conceptual form. It is possible to feel a coherent concept on a profound and intimate level whether or not the work exists in the form of an object. Though more difficult to obtain, due to its heightened degree of abstraction and its dependency on a thorough knowledge of art history, philosophy, and the processes of studio art, conceptual art cannot be excluded from the effects of beauty. There can be beauty in conceptual art just as there is beauty in romanticism or neoclassicism. While the criteria may be different, according to specific methods or materials, the knowledge of the structure in art is consistent.

Beauty is an aesthetic issue, but not only that. Since the publication of Croce's *Aesthetic* at the beginning of the twentieth century (English translation, 1909), aesthetics has moved beyond "the science of beauty" as its sole concern. With Duchamp's fanciful, nearly insouciant *objets trouvés*, known as readymades (1913–21), not only art, but aesthetics was revolutionized. Beauty became a condition of syntax; that is, how the form is understood and acculturated within a given time and space.

In the sixties came the struggle between the old and the new, between aesthetic formalism (modernism) and conceptual art. The synthesis is still in the process: How to expand a definition of aesthetics beyond "the science of beauty"? How to include the social and natural sciences, psychoanalysis, and gender and ethnic diversity as flexible parameters in the reception of a work of art? The new aesthetic functions like a matrix, where ideas and images from various disciplines enter into art, yet art must somehow attend to its own method within the scope of this abundant information. What separates us from Croce's world a century ago is our heightened degree of self-consciousness. Referring again to the problem of the mind-body split, it is this obsession with the self that ironically precludes beauty as a self-begetting act.

Beauty is not glamour. Most of what the media has to offer us is glamour.

Most of what the fashion world has to offer us is glamour. Most of what Hollywood has to offer us is glamour. Most of what the art world has to offer is glamour. Glamour, like the art world itself, is a highly fickle and comercially driven enterprise that contributes to what the late critic Lewis Mumford used to call "the humdrum." It appears and it disappears. What is "in" at one moment is suddenly "out" the next. It is about the persistence of longing. No one ever catches up to glamour. There is too much money at stake, too many investments. Glamour is about the external sign—the commercial logo—and has little to do with the inner-directed concerns of artists other than as subject matter for some expropriation of popular culture. Such examples can be found in works ranging from Man Ray to Ray Johnson, from Meret Oppenheim to Louise Bourgeois.

But the artist has to exist—to live—within a world that is mediated through glamour. The allure is constantly in the air. It is both omnipresent and omniscient. It carries the seduction of instant fame and success. It is the basis of the spectacle and the spectacle is about the cycle of repetition, the lack that confounds passivity, the utter abeyance of the affectation of desire. Beauty functions on another level. It cannot be predetermined by strategies of investment or by the sublimation of advertising. Beauty adheres to a structure or meaning that somehow coalesces with the material reality of existence. Because beauty is recognized through form and intuition, it requires preparation, time, and focus. The seventeenth-century mathematician Blaise Pascal spoke of intuition as a quality that emerges when logic has exhausted its limits, provided that the mind is alert to that moment. In this way, beauty is an intuition with an affinity to the hypothesis of Pascal. It is an intuitive structure, a recognition of form, that, as Santayana asserts, is finally unprovable given its relationship to the senses.

Beauty is an act of grace and is given neither to force or imposition. It is not an intent. It promises nothing.

Beauty is a felt concept that exists as a condition of receivership. It remains elusive in relation to the artist's intent. Beauty functions differently than intent even though intent is the structural basis from which the artist proceeds. For example, Kurt Schwitters's early collages (*Merzbilden*) consist of torn scraps—discarded papers, posters, receipts, tickets, labels, etc.—as a dada gesture with the intent of upsetting middle-class standards of taste. Today we perceive these collages not as indeterminate detritus or "junk," but as something that revolutionized aesthetics in the twentieth century. Arguably, Schwitters's collages, commensurate

with Duchamp's readymades, virtually redefine previous standards of beauty in twentieth-century modernism. Perhaps this is because these collages are not overdetermined; they simply proceed according to an intent.

Thus, beauty offers us something other than an intention. It offers us a sense of being connected to the world as mind is to body. In such moments, we come to understand beauty as a quality that goes beyond intention. In recalling a triptych by the contemporary Korean painter Moon Beum, beauty is less the condition of this abstract landscape than the effect that lingers long after the work has been seen. While experiencing art as a newly cognitive form, there is no contradiction in saying: "It is beautiful!" For beauty—as it arrives through the language of form and concept—is still the crown of aesthetics. One might conclude, then, that beauty springs from the subjectivity of one's sensory cognition when spurred by an aesthetic catalyst. Whether material as form or immaterial as concept, beauty declares itself to be the case in spite of all that has been spoken or said about it. Whereas language is the condition by which the work is selected, resolved, or understood, beauty is the effect by which it is sensed, transmitted, and, finally, remembered.

On Platonic Cosmetics

JACQUELINE LICHTENSTEIN

To vindicate the art of dress against the inept slanders
heaped on it by certain highly equivocal nature lovers.

—Charles Baudelaire, *Curiosités esthétiques*

So IT ALL BEGINS WITH PLATO—ALL THE TRADITION THAT BINDS THE LOT OF
rhetoric to that of painting and seals this alliance with the philosophically injuri-
ous emblem of a double condemnation. For it is from the vague necessity of a logic
that would apply to both that Plato proceeded to exclude the two arts—this logic
that is the essence of metaphysical reason and that even today determines most
discourse on the tangible realm and its images, on appearance and its artifices, and
thus, on pleasure and beauty.

We will explore this Platonic logic in its function as a paradigm throughout a
history continually marked by its decisive effects. Our point of view is external
and without hermeneutic aim; it does not claim to account for the internal work-
ings of philosophical thought or to restore Platonism to its true meaning and
define the nature of its principles. We intend, rather, to trace a path back to an ori-
gin whose meaning was assigned only after the fact, to identify, among the man-
ifold and often contradictory components, the possible matrix of this insensitive

discourse on the sensible realm that has come to characterize an entire philosophic tradition. We, of course, would not return to a way of reading that reduces the historic recurrence of themes to diverse figures of repetition, in order to show how an original system of thought remains ever active and ever the same. Historical analysis must assiduously avoid the pitfall of conceiving theoretical transformations in terms of influence, that is, of simply importing and reactivating concepts and themes that thus follow a linear path from one field to another. In the order of the rational, causality is often reverse; it is the children who lay claim to the ancestral paternity, weaving the weft of references whose meaning is found *a posteriori*.

But we must also avoid the opposite extreme, an equally dangerous pitfall. If the interpreter's relation to the body of texts depends on the goals of his reading, it must depend as well on all the possibilities that the texts offer, especially when the texts are philosophical. That a specific use is necessary does not automatically make it possible; the text must offer things that enable it to satisfy the reader's demands. To some extent, a philosophical system always sets the protocols of its readings, however far the readings may stray from the work's explicit intentions or literal content; to set the protocols is the philosopher's responsibility. This responsibility applies to Plato's writings perhaps more than to others' because of the structure he gave his work. For Plato integrated every possible diversion from his subject into his text, turning them into so many contradictions for dialectic analysis to refute. The interpreter is thus constrained to choosing, from among the sum of possible uses, one that fits with the demands stemming from conditions present in the text and with the actual presuppositions of his interpretation. Thus it seems not entirely unreasonable to ask Plato to account for the consequences that history draws from various aspects of his philosophy, to seek in Plato's texts the conditions that gave rise to misreadings and that fostered a particular use of Platonism in the domain of painting. Only within and through his texts can we understand why many classical writers and an entire school of theoreticians of the visual arts needed to take a stand against Plato.

* * *

Cosmetics: "A fraudulent, baseborn, slavish knave; it tricks us with padding and makeup and polish and clothes, so that people carry around beauty not their own to the neglect of the beauty properly theirs through gymnastics."[1]

This blunt definition is an essential point in the long analysis of the *Gorgias* in which Plato condemns as "ugly" all practices that aim for "what is pleasant, omitting what is best," ones he designates by the generic term of "flatteries." The target of this text is not painting, which is not mentioned, but rhetoric, whose sophistic falsity Plato demonstrates. But since the argument applies its criteria to all the simulacra of appearance, its general critique of flattery includes all the mimetic arts and, as we will see, particularly painting. Though omitted from the list of condemnable techniques of seduction, the visual arts still remain on it through a series of shifts that are never questioned and that are used again and again in later analyses of the two arts. Rhetoric will always be conceived as painting, and painting as rhetoric, as if the definition of one could be stated only in the metaphor of the other.

The analysis of the *Gorgias* is too well known to need a detailed rehearsal here.[2] It begins with a distinction among activities that aim at the good of the soul or at that of the body. In the first category are legislation and justice, parts of the art that Plato names "politics" and to which the simulacra of sophistry and rhetoric correspond. In the second he distinguishes medicine and gymnastics, which in their turn have the simulacra of cuisine and cosmetics. But curiously, unlike the first, this last category remains nameless, as Plato says he cannot "give you a single name for it." Thus, from the start and in all the modalities of its existence, the body has an ontological disadvantage that applies both to the effectiveness of a real activity and to the simulacra produced by a deceitful imitation. Even when they aim at the body's true good rather than its apparent good, the arts of the body resist any unification into a name and an essence. The body seems to function as a principle of theoretical dissolution, necessarily affecting all the activities it involves, as if the fundamental indetermination that characterizes it prohibited not only its determination but also the determination of everything that it concerns and supports. Even when disciplined by gymnastics and cared for by medicine, the body remains outside the metaphysical circle of denomination.

In this sense, the distinction among arts aimed at the real good and at simulacra meant only to flatter the senses does not have the same value when it applies to activities relating to the soul and to those of the body. Whereas in the first case it implies an ontological difference, in the second it simply corresponds to a shift among the possibilities present in the very nature of its object. Reduced to simulacra of its appearances, the body does not cease to be what it is; on the contrary.

It is never more itself than it is with external ornament and artifice, since it then manifests in all impunity the tangible powers that characterize its being. Where the body is concerned, flattery is not a lie but reveals, on the contrary, the truth of the body as appearance, the truth that appears when it is left to its own nature, away from the orthopedics of a control imposed by reason and maintained by gymnastics but instead given up to a dissolute activity whose only ends are seduction and pleasure. Whereas flattery alters the soul, it entirely corresponds to the inessential nature of the body. This mimetic activity that consists in passing itself off as the art whose mask it wears originates in all the aesthetic modalities of appearing. Such a practice, writes Plato, "I call it flattery, *and I say the thing is ugly and shameful*—this I direct to you, Polus—*because it shrewdly guesses at what is pleasant, omitting what is best.*"[3]

An entire tradition—tenacious, iconoclastic, and mutable in its form though monotonous in its bias—takes this definition as the model for its moral and aesthetic puritanism and as the constant implicit reference in its attack, filled with hate, fear, and discomfiture, against the pleasures of appearance and the charms of the tangible realm. Equating aesthetic and moral values, this definition of ugliness assures the triumph of metaphysics that thereby becomes the sole foundation and guarantee of beauty. In order to exist, beauty must henceforth exhibit its certificates of good moral and metaphysical conduct. No longer expected merely to please, it has been philosophically assigned its place: between the True and the Good.

Of course, Plato does not denounce as ugly all practices seeking to please but only those that do so without concern for betterment and thus that have no other end than pleasure itself. The ugly and guilty pleasure is one that does not follow the rules but obeys only its own movement. For it strays within the paradoxical autonomy of an illicit enjoyment that nothing can legitimatize.

It is no surprise that rhetoric and painting attempted throughout their histories to respond to this accusation. In withdrawing legitimacy from artifices of seduction that are not subject to the severe imperatives of morality, Plato definitively puts them in the position of having to justify themselves. All the difficulties raised here with regard to pleasure will reappear in exactly the same terms with regard to discourse and images, causing their practitioners to try, often desperately, always contradictorily, sometimes victoriously, to bring them within the sole limits authorized by philosophy.

Behind these responses, whether they take the form of illustrations, denegations, or attacks, remains the menacing shadow of this cosmetics whose definition weighs upon the whole history of the visual arts, this malevolent and deceitful *kosmètikè* that produces an illusion with the makeup of its colors. A whole category of practices undergoes the negative effects of this critique and finds itself rejected simply because it coincides with what this definition condemns: In the first place, all activities that resort to artifice to feign the truth and taint nature, all techniques of makeup, dyeing, and painting,[4] that is, all the ornamental, pleasurable arts—for the human form as for its surroundings, for the face as for the body, for discourse as for image. An entire tradition, of which we are the heirs, takes cosmetics to mark an original defect, to veil an ugliness always sensed beneath the virtuosity of masks, to signal an imperfection that art seeks to dissimulate. Moral puritanism and aesthetic austerity, along with resentment and an old, stubborn, and underhanded desire to equate drabness with beauty, thus make their righteous alliance and take delight in a constantly reiterated certainty: Only what is insipid, odorless, and colorless may be said to be true, beautiful, and good. Feeling themselves excluded from the pleasures of the simulacrum, truth lovers and defenders of nature—whatever their era, whether philosophers or orators, academics or clergy, painters or mathematicians, decorators or architects, and whatever their position with regard to Platonism—are in this sense the heirs of a metaphysical moral perspective that can see only a universe in black and white, stripped of adornments, washed of makeup, purged of all drugs that offend the mind and intoxicate the senses.[5] They always wish to shut perfume cabinets and paint sets to prevent the escape of all the practices that Plato designated as magic and maleficent from the pharmacy (*pharmakon*) where he wished to keep them—and from which, unfortunately, they never cease to break out, to spread and reach the universe of discourse and representation.[6]

Pharmacia, we recall, is a nymph, truly the quintessence of femininity. And to master the art of applying all the powders, creams, and lotions that are to this day called cosmetics, is it not necessary to be, or somehow to become, a woman? Or an actor? But this doubtless is the same thing; whoever knows for certain the sex of an actor? The Platonic definition of these cosmetics that produce an illusion through appearances and colors involves an entire domain of activities where women and actors often reign, yet the definition so perfectly applies to the art of painting that it seems to do so by particular intent, though never by name.

Painting is the cosmetic art par excellence and by definition, in which artifice exercises its seduction in the greatest autonomy with regard to reality and nature. Pictorial activity does not merely modify, embellish, or make up an already present reality whose insufficiency could be revealed if its ornaments were removed, like a woman without her makeup. Behind the layers of paint used by the painter to represent forms in a picture, nothing remains, just the stark whiteness of a canvas. No reality hides beneath the colors. If we are bent on finding a reality, we should look elsewhere, beside or outside the image but not beneath it, for painting hides or covers nothing. It does not present us with an illusory appearance but with the illusion of an appearance whose very substance is cosmetic. Unlike other forms of adornment, this one does not exceed reality by adding ornaments that mask its nature: it takes its place by offering an image whose nature is entirely exhausted in its appearance, a universe that is the pure illusory effect of an artifice.

In denaturalizing appearance, painting thus realizes the essence of ornament that consists in being without essence. It is like an adornment from which nature is absent, makeup whose coloring does not merely correct the faults of a face but invents its features and gives it a form, a garment that cannot be taken off without pulling off the skin, an originative metaphor. This image whose appearance is illusory and of which only the illusion is real, indeed has all the contradictory qualities of the *pharmakon*. This reality, which is not a thing or even the accessory of a thing, necessarily defies all the procedures of an argument ruled by the metaphysical principle of identity.

The task of the Platonic theory of mimesis is to tame this rebel image by assigning it an origin within the order of nature, that is, of truth. The idea of imitation restores the universe's coherence by subjecting painting to the philosophical conditions that fix the status of appearance as an image whose reality necessarily constitutes its reference. Conceived as an imitation, painting can be measured against its reference and judged according to the distance between it and its origin to which the mimetic definition of its nature has authorized this attachment. For Plato, as we know, painting is "three removes from nature,"[7] since painting imitates what is already but a pale imitation of the essence, namely, the mobile realities of perceptible appearance. Its images, says Socrates, are adequate to fool children or deranged men; even so, they must be viewed at a distance: "Well, we know this about the man who professes to be able, by a single form of skill, to produce all things, that when he creates with his pencil representations

bearing the same name as real things, he will be able to deceive the innocent minds of children, if he shows them his drawings at a distance, into thinking that he is capable of creating, in full reality, anything he chooses to make."[8]

From this operation of mimesis, or rather of mimetization, philosophy gains a twofold benefit, since it can link painting, as an image, to the referential order of reality while holding this image, as painting, at the greatest possible distance from its attributed origin. Locking painting into its referential function, Platonic mimesis naturalizes pictorial representations the better to deny their truth and legitimacy by contrast with the reality to which it refers them. Judged by a truth that by essence, or rather by lack of essence, is not theirs, painting's images necessarily carry a stigma that denies them consideration in and by themselves and shows them always, on the contrary, as lacking. Insofar as imitation must always be judged by an original reality, pictorial mimesis can never be the object of any recognition. Doubly deficient, not only by reference to intelligible reality but also by reference to the tangible world, it is neither true knowledge nor a technique of fabrication. Totally immersed in appearance, it lacks both foundation and utility since it does not even transform matter into a real product. It is nothing: the deceptive simulacrum of a pale copy, useless because it falls short of the real, and dangerous because it presumes to substitute for truth the illusion of its images.

The Platonic definition of mimesis and of the criteria determining its value sets the possible condition for a condemnation of painting whose necessary condition is the definition of painting as mimesis. Constructing its object to fit the interpretative grid and coincide with the fictitious reality of its evaluations, philosophical discourse invents an image of painting that justifies its own presuppositions and legitimates its condemnation. Thus defined, painting can always easily be rejected as a bad imitation in the name of the good imitation whose reality always constitutes the ultimate reference. Plato states very explicitly in the *Laws* that imitation should never be judged in terms of pleasure but only of truth: "A man's feeling of pleasure, or his erroneous belief, is never a proper standard by which to judge of any representation, and I will add, any proportionality. . . . In fact, we explained the rightness of a representation to lie in reproduction of the proportions and quality of the original."[9]

Obviously, this standard disqualifies pictorial imitation, which is necessarily incorrect from such a point of view. By definition, the standard can never be that of painting, which, Socrates notwithstanding, offers no analogy whatsoever with

a mathematical relation. Its resemblance, if there is a resemblance, unfurls its effects in a world of pure appearances; it tends not toward equality, but toward an illusion; its aim is not the intellectual rectitude of a true equation to nature, but the satisfaction brought by the sight of an image whose beauty lies in its artifices.

In rereading the familiar texts of Plato on pictorial imitation with an attempt at philosophical naïveté, we cannot help being struck by the inadequacy of the questions and by their denial of any justification for painting, which they treat as a defendant charged with trying to achieve something that it never intended in order to reproach it, in turn, for failing to do so. In choosing for its questions criteria that painting never claims to use, philosophical discourse draws painting onto its own ground, subjects it to its own mode of questioning, and turns the analysis to an entirely different object than the one that it claims to consider. Indeed, we need to put ourselves in philosophy's position to find any meaning in the problems it raises in the analysis of painting. From any other point of view, they appear surprisingly false: "A painter, we say, will paint us a cobbler, a carpenter, and other craftsmen, though he himself has no expertness in any of these arts, but nevertheless if he were a good painter, by exhibiting at a distance his picture of a carpenter he would deceive children and foolish men, and make them believe it to be a real carpenter."[10]

What painter ever claimed that he was able to work in wood or repair shoes? If we believe Plato's analysis, the painter wishes to produce a twofold illusion: to deceive us about the nature of his work and of his art, to have us believe that what we see are shoes and that he is a cobbler.[11] Few are so innocent or so lacking in common sense as to believe for any length of time in the real existence of painted figures and by the same token in the craft of their maker. No child is ever so well behaved or stupid as to stand still, captive, in the spot the painter chooses for him. There can be no doubt: These are truly the words of a philosopher. This painter who yearns to be a carpenter, this naïve child, this ignorant imbecile exist only in their author's metaphysical imagination.

Pictorial illusion is not intended to last but, on the contrary, to self-destruct at the very moment that its effects triumph, so as to provoke the admiration of those who, for an instant, were its victims. Painting is an imitation that needs to be perceived as such; it seeks to fool only as long as is necessary to establish the glory of the painter and the perfection of the picture, that is, just for an instant. We would have to be philosophers to think (or pretend to think) that a painter would want

to pass as a shoemaker and fool us about the nature of the shoes he draws on a wall or a canvas. No painter has ever tried this; it would make his recognition as a painter impossible. His goal is not to make us believe in the reality of his images. On the contrary; because we know that what we believed in is only an image—that is, since we no longer believe in it—we admire the painter for having succeeded in producing such an effect on us. And, obviously, this effect implies that we almost believed in it for a short time.

The way that painting has of playing with illusion, of being tricky with time, of making fun of the viewer, of upsetting all the mechanisms by which the usual game of identification unfolds, makes it suspect in philosophy's eyes. Its game respects neither the values nor the rules of philosophical discourse. It takes place outside all the divisions imposed by the distinction between true and false. Socrates is not mistaken when he states that "imitation is a form of play, not to be taken seriously."[12] Only with extreme effort can we apply the categories of philosophy to such an activity. The shift that Plato brings about, subjecting the matter of painting to a cognitive theory and a referential definition of the truth, is proof of this. By its absolute character, it reaches a level of difference that makes any compromise impossible.

Underlying the analyses of pictorial mimesis, and especially that in the tenth book of the *Republic,* is a strategic objective. Beyond painting, the larger target is sophistry. Making an equivalence, Plato authorizes a reversibility of judgments, condemning sophistry for its resemblance to painting, and painting by analogy with sophistry. Plato's approach to the problem of painting in these sections becomes clear when we take into account the necessities that this objective imposes on his discourse. Insofar as the problems raised by sophistry pertain to a theory of knowledge, painting can serve as an example only if it supports a proof of the conditions of true knowledge. The paradoxical and apparently inappropriate character of the questions that painting must answer comes merely from the character of the answers it must provide. To ensure that the conclusions drawn from the analysis of painting apply to the analysis of sophistry, the questioning must come exclusively, as Plato says in the *Laws,* from the point of view of truth and not of pleasure.

But this interpretation of his statements in terms of strategy does not fully account for their meaning and offers no justification for the means he chooses. Why indeed should he take this detour through the pictorial image to attack

sophistry, if not to accuse the latter on the basis of its "paintings"? Certainly, this discourse concerns sophistry, but first and foremost the aspect of it that resembles painting: the power of illusion whose painted images offer an exemplary representation. Only painting realizes the paradoxical essence of appearance, of meaning specific to the figure.

Thus, the painting-sophistry comparison follows a circular movement and inverts the positions of the two terms through a dialectic of appearance and reality that affects the very form it uses to state these terms and disturbs the very order in which we read them. Changing places, painting becomes the referential term for a comparison in which sophistry plays merely the secondary role of the term compared.

As we know, one strategy can harbor another or, more exactly, be a mere tactic used to conceal the real stakes of the true strategy. It can set a trap for the opponent who thinks he has frustrated all the text's plots, when in reality he has fallen into the net it wove for him. These treatments of pictorial mimesis do tell us something worthwhile about painting, but only on the condition that we not believe what they say, or, rather, that we see that the inadequacy of their approach expresses not the insufficiency of painting, but the impotence of philosophical analysis faced with an object that it knows eludes its grasp. If, as Socrates says, painting is child's play with nothing serious about it, are Plato's questions about pictorial mimesis to be taken literally as they always have been? Are they not also part of a game, a sort of parody of inquiry, affecting to be interested only in shoes when we know that painting is the subject at issue? If we do take Plato seriously, we wonder whether he believed the things he has Socrates say. Their inappropriate, even absurd, character is too blatant to be inadvertent; the way they approach the question is too false to escape irony. And it is irony, it seems to us, that we must take seriously here as suggesting the impossibility, for the philosopher, of adopting a position toward painting other than derision.

Whatever reservations we might have with regard to his philosophical positions, none can accuse Plato of failure to recognize the real power of images. The complexity of his strategy reveals, on the contrary, his measurement of how their power endangers truth. Plato knew very well, too well surely, that ornament was never simply ornament, a supplement added to the thing, whose excesses could be avoided by control of its use. He thought of it rather as a principle of perversion that held the germ of all dissolution since it wiped out all the differences upon

which philosophy established the authority of its realm. He had no illusions about the irreducible opposition that involves the philosophical foundations of discourse and aesthetic conditions of the image, in which mutually exclusive, and thus fundamentally irreconcilable, arguments confront each other. Otherwise, would he have taken such care to make it clear, in the *Laws*, that mimesis must *never* be judged in terms of pleasure? The violence of the prohibition and unconditional tone of the prescription betray an acute awareness of the risk to which truth would be exposed by the existence of common ground between reason and pleasure, as if any concession with regard to legitimating instances of representation would inevitably be fatal to philosophical discourse.

Only thus can we understand the very close, though often implicit, bond uniting the Platonic condemnation of pictorial activity and the critique of flattery, seduction, and pleasure. It justifies the analogy between painting and rhetoric, two modes of representation that are profoundly complicitous, since they seek the same effects. The comparison with sophistry is aimed at this fundamental complicity, and it is intended to destroy it. By grouping painters and rhetoricians with sophists, Plato could treat their respective activities as if they raised only questions of knowledge, pertaining to the discourse of science and truth, as if all the questions they raised belonged to metaphysics—that is, they were difficulties for which philosophy would account. Thus, he displaced the analysis to a totally foreign territory where it was to stay for centuries. The equation of painting and rhetoric with sophistry, by forcing us to think of these two modes of representation across the logical categories of truth, was to weigh considerably on the history of the visual and language arts. Painters and orators would be forever obliged to defend themselves against the charge of sophistry.

It is not in the analysis of truth that we must seek the reasons for the Platonic condemnation of painting, but in that of pleasure. The condemnation rests on two series of arguments, the first from the theory of mimesis and the second from the definition of persuasive discourse. Condemned because of the sophistic character of its imitation, painting is also rejected in the name of the rhetorical effects of its images. Only when the analysis turns to the rhetorical aspect of the problem does it reach painting's essence, which explains the power of its illusion and defines its seduction: the glimmer of its colors.

For to paint is, first and foremost, to color. Only an analysis in terms of rhetoric, that is, of effects, can account for its essence. We have always known that

painting, before it is an imitation, is a surface covered with lines and colors. Doubtless because of this fact, the idea of resemblance was invented to apply to these lines and colors the grid of an interpretation that allows us to master the image logically by bringing it down to the manageable dimensions of a reproduction of reality. Yet, color is not a unity of the same type as line. It is, first of all, a spot, the *macchia* whose secrets Leonardo da Vinci deciphered, an effect of the instant if not of chance, which the familiar story of Protogenes illustrates: unable to represent the foam at the nostrils of a dog that he was painting, he angrily threw his sponge at the canvas, staining it with a spot that instantly produced the pictorial effect he had so desperately sought. Unlike the line, which is already the result of a course taken and the start of a drawing, color is not the beginning of a figure; it is not homogeneous with drawing. It is not a sign, in the Platonic conception of the sign as a mimetic representation, maintaining a relation of resemblance with the things signified. For this reason, the theory of mimesis always comes up against the question of color. Considered in itself, color is pure ornament and does not resemble anything. Immense theoretical effort is required to apply to it the logical and ontological criteria of resemblance and truth, that is, of the sign.

By establishing an analogy among letters, lines, and colors, the twofold paradigm of writing and the portrait—the portrait as writing and writing as a portrait—restores the homogeneity among the various elements of a picture in favor of mimesis. By defining color as a sign, the sign as an image, the image as an inscription, the inscription as a portrait, Plato achieves the incredible feat of defining color as drawing.

This feat emerges in the highly complex analysis of the *Cratylus* that defines a name as the "imitation of things by means of syllables and letters"; in the same way, says Plato, painting imitates things by means of forms and colors. By reducing color to discrete units like the letters that make up names, the comparison imposes on painting a discursive model that makes possible a definition of painting as an image of the primary image of discourse. In order to define color as mimetic, it is necessary to equate drawing and painting; only thus will the analogy between painting and writing work:

> And further, primitive nouns may be compared to pictures, and in pictures you
> may either give all the appropriate colors (*chromata*) and figures, or you may not

give them all—some may be wanting—or there may be too many or too much of them. And he who gives all gives a perfect picture (*grammata*) or figure (*eikones*), and he who takes away or adds also gives a picture or figure but bad. . . . Returning to the image of the picture, I would ask how anyone could ever compose a picture which would be like anything at all, if there were not pigments (*pharmakeia*) in nature which resembled the things imitated, and out of which the picture is composed. No more could names ever resemble any actually existing thing, unless the original elements of which they are compounded bore some degree of resemblance to the objects of which the names are the imitation.[13]

Without stopping to analyze the various terms that designate painting here, we notice that color is named *pharmakeia* when nature provides it and *chromata* when it enters into the composition of a painting. Yet, *chromata* is a term that designates skin, the surface of the body, and flesh tones; it often occurs in the lexicon of painting, but also of dyeing. It is a color that shows in two senses—that is visible and that makes visible—analyzable in terms of colored sensation. It is also color as indissociable from a given form, as Socrates says in the *Meno*.[14] But color, because of its paradoxical nature as *pharmakon*, can also produce contrary effects. Excess in a color can interfere with vision, as excess of colors can, and block the perception of contours and the identification of forms. Mixed colors—what might be called a medley (itself a definition of painting)—dazzle the eye and set off a flash, blurring vision rather than illuminating it.

Confusion is always born of mixture. Plato demonstrates at length in the *Timaeus* that all colors stem from mixture, except the pure and colorless colors of black and white.[15] Between lack of color on the one hand and excess on the other, between transparency that produces no sensation at all and brilliance that brings tears to the eyes, black and white correspond to the two-way movement of contraction and dilation of the optical apparatus, *sunkrisis* and *diakrisis*. And there is red, an intermediary color, neither black nor white, neither transparent nor brilliant, a mixture certainly but not garish, a sort of spirit-color in the sense that Plato attributes to "spirit" in the *Symposium*, of a being falling in the middle and filling the interval, "holding the world together."[16] It is the color of blood.[17]

The flash set off by an overly violent dilation of the visual ray, the dazzle that blinds the gaze, the sparkle that obscures vision, correspond exactly to what Plato designates elsewhere as *poikiloi*. Whereas *chroma* is the name he gives to color, the

adjective *poikilos* describes all that is a medley; according to the Platonic logic, it embraces not only the mixture of colors but colors themselves, to the extent that all are mixtures except those two that are neither mixture nor color. This medley born of mixture is the color of color, since color exists only in a perceptible way and is recognizable as such only in its composite and plural nature as a quality. How, then, can we possibly give color a name, since a name necessarily implies the unity of an essence? Inasmuch as its being, if we can even use the term here, coincides entirely with the forms of its manifestations and the appearance of its modifications, the adjective that qualifies its effects designates it much more appropriately.[18] Color is but an effect of colors and that is why it is suspect to philosophers, the brilliance of its makeup and the charm of its luster giving it the formidable power of seduction that characterizes all that is *poikilos*.

Like the fox that is *poikilos*, like the snake and the octopus—and all animals that attract their prey with supple, changeable snares. Like the sophist whose "gaudy speeches" and "glistening words" (*poikiloi logoi*) seduce the listener with their ambiguity and deceiving sparkle.[19] Like the rhetorician who wins his audience's approval through the colors that adorn his argument. Like the painter who seizes the viewer with his enchanting *coloris*.[20] Sophists, rhetoricians, and painters are all three "creator[s] of phantoms," as Plato puts it, technicians of ornamentation and makeup.[21] These great masters of the lure are all masters of color.

Flattery, cosmetics, artifice, appearance . . . all the terms of this metaphorical chain linking the critique of painting, of sophistry, and of rhetoric, also qualify the effects of color as effects of seduction; they are the effects of illusion and pleasure. Essentially sophistic, color is also rhetorical, from the point of view of its effects: It is the figure of ornamentation and the ornament of figures. Within painting, color even lacks the excuse of being a metaphor, since the color of its artifices is but the artifice of its colors. For this reason, of all the activities that can be designated as *poikiloi*, painting is undoubtedly the most condemnable. Using matter as the means to produce its effects, painting produces from the tangible an appearance that offers the illusion of the tangible.

The painter is thus an even greater sophist than the rhetorician is, since the domain in which he applies his art is not language but matter, pure tangible appearance, of which he claims to offer a mimetic duplication that would be ridiculous if its colors did not make it dangerous by making it too pleasing. Language can always tell the truth and, in this sense, rhetoric simply perverts a

natural function of discourse that philosophy must be able to restore. Though the rhetorician and the philosopher fight for different stakes, they are on the same battlefield; the philosopher tries to gain—or regain—territory that he thinks the rhetorician, through craftiness and seduction, has appropriated illegitimately. And if the rhetorician is suspect, how much more so is the painter. It is hard to imagine a good use of painting, one that follows the demands of a discourse whose criteria by definition oppose the conditions that determine pictorial activity. A painter is first and foremost, as Plato says, "a grinder and mixer of multicolor drugs." If painting is a sophistic lie whose effects are similar to those of rhetoric, it must be so, above all, because painting is a form of cosmetics that draws on the same means as dyeing.

By implication, for an individual who claims to love only truth and to be interested only in essences, the only painting worth recognition should be colorless. That is to say, pointless.

What if Philostratus was right when he wrote that those who scorn painting scorn truth? Or Castiglione, when he affirmed (refuting Pascal and Kant in advance) that painting makes one love reality all the more? True, he was referring to women, claiming that the sight of their images in painting enhances the desire one has for their bodies in reality. Doubtless this is also why philosophers hardly heard him.

NOTES

1. Plato *Gorgias* 465B, in *The Dialogues of Plato*, trans. R. E. Allen (New Haven, 1984), 1:249–50.

2. If we find a rehearsal useful here, our purpose is to understand some of the readings the *Gorgias* has spawned. Thus we analyze only the elements of the Platonic text that were later borrowed, deformed, or contradicted by the theoreticians of rhetoric and painting.

3. Plato *Gorgias* 465A (emphasis mine).

4. The socially devaluating classification of painters with daubers and dyers during the Middle Ages, against which artists begin to rebel in the Renaissance, always seeks its justification in an argument borrowed from metaphysics. Any social history of arts and artists that ignores the weight of these purely philosophical categorizations cannot apprehend the nature and complexity of the debates over the social status of painting. See chapter 6 of *The Eloquence of Color– Rhetoric and Painting in the French Classical Age*, in which "On Platonic Cosmetics" was originally published.

5. A list of their names would be too long and could form another study. A single example, though, is that of Adolf Loos, who claims to show that the development of culture always involves a decrease in the importance attached to ornament: "We have vanquished ornament," he writes, "we have learned to do without it. A new century is coming in which the most beautiful promises will be fulfilled. Soon city streets will shine like great white walls. The city of the twentieth century will be dazzling and stark, like Zion, the holy city, the capital of the heavens." ("Ornement et crime," *Cahiers d'aujourd'hui* [June 1913].)

6. On this subject, see Jacques Derrida's analysis of the Platonic *pharmakon*, which, he writes, "transforms order into ornament, the cosmos into a cosmetic" ("Plato's Pharmacy," in *Dissemination,* trans. B. Johnson [Chicago, 1981], 142, 70 ff.).

7. Plato *Republic* 597E, trans. P. Shorey, in *The Collected Dialogues of Plato* (Princeton, 1961), 822.

8. Plato *Sophist* 234B, trans. F. M. Cornford, in *Collected Dialogues,* 977.

9. Plato *Laws* 667A–668B, trans. A. E. Taylor, in *Collected Dialogues,* 1264–65.

10. Plato *Republic* 598C, 822.

11. Much could be said of this example of shoes to which philosophers, from Plato to Heidegger and Derrida, seem particularly attached when they speak of painting! On this subject, see J. Rancière, *La Philosophie et ses pauvres* (Paris, 1983).

12. Plato *Republic* 602B, 827.

13. Plato *Cratylus* 431C–434A, trans. B. Jowett, in *Collected Dialogues,* 469–68. Jacques Derrida has written a beautiful analysis of this passage in *Dissemination,* 137 ff.

14. Plato *Meno* 75C, trans. R. E. Allen, in *Dialogues of Plato,* 156–57.

15. Plato *Timaeus* 67E–68A, trans. B. Jowett, in *Collected Dialogues,* 1191: "Wherefore we ought to term white that which dilates the visual ray, and the opposite of this black. There is also a swifter motion of a different sort of fire which strikes and dilates the ray of sight until it reaches the eyes, forcing a way through their passages and melting them, and eliciting from them a union of fire and water which we call tears, being itself an opposite fire which comes to them from an opposite direction— the inner fire flashes forth like lightning, and the outer finds a way in and is extinguished in the moisture, and all sorts of colors are generated by the mixture. This affection is termed dazzling, and the object which produces it is called bright and flashing."

16. Plato *Symposium* 202E, trans. T. Griffith (Berkeley, 1989).

17. Plato *Timaeus* 68B, 1191–92: "There is another sort of fire which is intermediate and which reaches and mingles with the moisture of the eye without flashing, and in this the fire, mingling with the ray of the moisture, produces a color like blood, to which we give the name of red."

18. The distinction between *chroma* and *poikilos* corresponds to two ways of speaking of color: as an essential quality (red) or as the quality of an effect (bright). This opposition spans the entire history of the-

ories of art, establishing a fundamental division between ways of thinking about color and painting. The seventeenth-century distinction between color and *coloris* and the opposition of Poussin to Rubens merely reiterate the *chroma-poikilos* dichotomy. See note 20 below and the discussion in part two (*The Eloquence of Color–Rhetoric and Painting in the French Classical Age*).

19. See M. Détienne and J.- P. Vernant, *Les Ruses de l'intelligence: La Métis des Grecs* (Paris, 1974), 47–48.

20. Because the distinction between *couleur* and *coloris* in French (like that between *color* and *colorito* in Italian) cannot be conveyed in English, the second term remains in French throughout. The definition and conceptual significance of this term will be amply illuminated by the text itself and require no further explanation here.

21. Plato *Republic* 599D, 824.

Freud with Kant? The Enigma of Pleasure

HUBERT DAMISCH

I HAVE ALREADY STATED THAT THIS READING OF FREUD, AND OF WHAT HE COULD have had to say about beauty, will be oriented and framed by his implicit reference to Kant's third *Critique,* more specifically to the analytic of the beautiful that opens its "Critique of Aesthetic Judgment." There is nothing in Freud's text that calls for this reference or explicitly justifies it.[1] In an attempt like this one to assess historically the passages in which Freud evokes the problem of beauty, other names also have some claim to consideration, beginning with that of the "divine Plato." Kant was certainly not the first to bring what Lacan called the "pleasure index" to bear on aesthetic matters, but his formulation of the question of the judgment of taste is echoed in Freud's text; these echoes are decidedly problematic, but I will undertake to amplify them, to set them reverberating, in hopes of revealing something that otherwise would have remained obscure.

First, the thesis consistently advanced by Freud that the object of the drive is, at least initially, of no importance, its only point of interest being its capacity to provide satisfaction (at least initially: the problem consisting in part of determining at what moment, under what conditions, in what context, as a result of what evolution, and in virtue of what displacement the object ceases being, as Lacan would have it, a matter of total indifference). Would we be justified in comparing

Freud's uncoupling of the question of beauty, insofar as it is derivative of the drive, from its object with the "Copernican revolution" operated by Kant with regard to the faculty of judging "beauty"? The analytic of the beautiful posits that the judgment of taste is not logical but aesthetic, with the latter term designating "that of which the determining principle can only be subjective": To decide whether something is beautiful or not, we do not relate the representation to the object by means of the understanding; rather, we relate it by means of the imagination to the subject and its feeling (*Gefühl*) of pleasure (*Lust*) or unpleasure (*Unlust*). It is a question of *affect:* While Diderot already maintained that beauty is relational, what counts for Kant is no longer the objective relation of representations among themselves but the subjective relation of representations to the feelings of pleasure or unpleasure accompanying them, feelings that designate nothing in the object itself but rather the positive or negative affect produced by its representation within the subject.

The parallel would make sense if the analytic of the beautiful did not explicitly exclude from satisfaction, from that *Wohlgefallen* crucial to the judgment of taste, all connotations of drive or libido as well as all links with the realm of desire. The paradox and enigma of what Kant terms "pure" pleasure begins here. Speaking of feelings of pleasure and unpleasure might be another way for Freud to designate the subject's "feeling of life," the *Lebensgefühl* that grounds the faculties of discrimination (*Unterscheidungsvermögen*) and judgment (*Beurteilungs vermögen*): If there is any such thing as this life feeling, it is and must be—insofar as it has anything to do with taste—independent of the faculty of desire (*Begehrungs vermögen*). In determining whether or not something is beautiful, the judging individual asks himself whether its representation gives him satisfaction, his "indifference" (*die Gleichgültigkeit*) being determined less by the object than by the subject itself, for whom it is not so much the object (or rather the latter's representation within him) that is a matter of indifference but its reality, the fact of its existing or not existing. As Kant himself said, in terms we would do well to remember, a judgment concerning beauty in which the slightest bias or interest (*das mindeste Interesse*) plays a role is decidedly partial (*sehr parteilich*) and cannot be considered a judgment of "pure" taste; to play the role of judge in matters of taste, one must first silence within oneself all desire, and be not the least bit (*im mindesten*) interested with regard to the object's existence but rather totally indifferent to it.[2]

So it is difficult to see, at first glance, what might be the meaning within a Freudian context of a "satisfaction" such as that posited by Kant as the basis of the judgment of taste: one that is "pure and disinterested"—disinterested to an extent inconsistent with the nature of the drive. For there to be a judgment of "pure" taste, the subject must pay no attention to the object and what he might think of it, heeding only the feeling of pleasure or unpleasure awakened in him by its inner representation. A work of art might well be, as Walter Benjamin maintained, a document of barbarism as much as of culture, and, to use Kant's example, a palace might bear simultaneous witness to the vanity of the great and to the exploitation of the working class; but Kant maintains that "such is not the subject at hand" (*nur davon ist jetzt nicht die Rede*): "The important thing in declaring an object beautiful and demonstrating that I have taste is not my relation to the existence of the object, but what I do with this representation within myself" (*was ich aus dieser Vorstellung in mir selbst mache*). The representation is related not to the object but to the subject. But what the latter "does" with it does not adhere to the register of knowledge, not even that through which the subject knows himself (*auch nicht zu demjenigen, wodurch sich das Subjekt selbst erkennt*): Judgments of taste convey nothing about the object in question, and they likewise tell us nothing about the pronouncing subject, except that the latter has—or does not have—taste, which is to say that he is capable of declaring an object "beautiful" on the sole basis of affect, of the satisfaction he derives from it.[3]

In Kant's view, where there is *Interesse,* whether positive or negative, there can be no "pure" judgments of taste, anymore than there can be *free* judgments of taste, freedom being paired here with purity and vice versa. Interest of any kind either presupposes or produces a need (*ein Bedürfnis*), and this precludes the pronouncement of judgments that are truly "free." The same holds for satisfaction deriving from the "graceful, lovely, delightful, enjoyable," etc., and generally for "everything pleasing to the senses in sensation." Whereas feeling (*das Gefühl*) must remain subjective and manifest itself in simple approval, in pure assent (*Beifall*), sensation, by contrast, corresponds to an objective representation that determines an inclination, a penchant (*eine Neigung*)—the sole criterion of the value of things being pleasure, in the sense of the enjoyment (*das Vergnügen*) they procure, or that they promise (*welches sie versprechen*). "Of that which is agreeable, we don't say 'I like it' (*es gefällt*) but 'it gratifies me' (*es vergnügt*)." *Annehmlichkeit ist Genuss:* "The agreeable is pleasure"; and pleasure (*jouissance*) goes beyond assent, implying use

or consumption. Gratification of this kind is so impure, so interested, that it will always induce a desire (*eine Begierde*) for objects of the same kind that are capable of providing analogous gratification. Beyond a certain point, when the enjoyment becomes most intimate, when it attains a certain level of creaturely pleasure (*das Geniessen . . . das ist das Wort, womit man das Innige des Vergnügens bezeichnet*), judgment of taste is no longer in question: those in search of such gratification willingly dispense with judgment.[4]

Roland Barthes has demonstrated that psychoanalysis provides us with a criterion for distinguishing pleasure from *jouissance*. Pleasure is verbally communicable while *jouissance* is not (Barthes cites Lacan on this point: "What one must bear in mind is that *jouissance* is forbidden to the speaker, or cannot be spoken except between the lines").[5] But we must go further, at least as regards pleasure—above all, that pure pleasure free of any taint of gratification, the one supposedly at the root of the judgment of taste. Jacques Derrida has grasped that the enigma posed by this pleasure must be assessed in light of what's in question, namely, the *discourse on the beautiful*—not only a discourse about the beautiful, but the discursivity inherent in the very structure of the beautiful.[6] Properly speaking, there is no "beauty" that isn't spoken, declared to be such in and by means of a discursive act, a judgment. I can have no pure pleasure insofar as I exist, only insofar as I can speak. Pure pleasure is inseparable from utterance: It is what makes me speak (judge), because the first condition (the *a priori* principle) of the judgment of taste stipulates that in this discursive act the pleasure must be posited as pure, *which is to say* (a phrase to be understood literally in this case, as the index of an enunciatory task) as a pleasure that's not a function of experience, but rather of pure affect—so pure that it can only be measured by its discursive effects (the affect is "to be spoken," and spoken in its function as a feeling of pleasure—"pure" pleasure).

The paradox here is that the affect seems to bracket the subject as much as the object—both the subject as empirical being and as desiring subject, man in both his reasoning and animal aspects. The enigma doesn't lie so much in its being a "pure" pleasure as in its link to feeling, to affect. How can we have a "feeling of life" so utterly unconnected to desire that the subject can properly pay no attention to the existence of an object whose representation is a source of pleasure for it? How can we have a pleasure in which gratification plays no part, when gratification designates pleasure's most intimate component? How can we have a

satisfaction in which—to use Kant's term—there is nothing "pathological," which is to say, nothing passive, a satisfaction that's not induced by a stimulus? How can we have an affect stripped of all accompanying emotion which, while pure, belongs to the register of activity (the free play of the faculties)? A pleasure, a satisfaction, an affect whose "purity" is commensurate with that of the judgment of taste, in discursive terms? If these questions have a bearing on the discursive element in the structure of the beautiful, they also concern the relation of pleasure, satisfaction, and affect to the very discursivity that produces them in all of their "purity," insofar as this latter is a condition of the judgment of taste.

Formulated in this way, these questions prompt a reconsideration of one of the most difficult passages in the analytic of the beautiful, section nine, where Kant investigates whether the feeling of pleasure precedes judgment (*die Beurteilung*) of the object or derives from it, the solution to this problem constituting for him the key to the critique of taste (*der Schlüssel zur Kritik des Geschmacks*). If pleasure comes first, it is reduced to a simple sensory gratification and is immediately dependent on the representation in which the object is *given*. To sensory taste (*Sinnesgeschmack*), which has a purely individual value, is opposed considered taste (*Reflexionsgeschmack*), which issues judgments with pretensions to universality: The very foundation of the judgment of taste, the condition of its subjective condition, is unanimity with regard to satisfaction (*die allgemeine Stimme, in Ansehung des Wohlfallens*), the universal communicability of this "mental state" (*die allgemeine Mitteilungsfähigkeit des Gemützustandes*), each individual considering that the satisfaction he experiences is rooted in something he can take for granted as being shared by everyone, and so can speak of beauty as if it were a property (*Eigenschaft*) or a structure (*Beschaffenheit*) of the object, something determined by a concept. Insofar as it is universally communicable, the "mental state" or *Gemützustand* is a thing of words. So a purely subjective (aesthetic) act of judgment logically precedes the pleasure induced by the object and provides the basis for the pleasure proceeding from the harmony of the powers or faculties of knowledge and their free play (free because not limited by a concept) in a representation. But the pleasure experienced in communicating, the interest (*Interesse*) inherent in sharing the state of mind that is its point of departure, is not sufficient to account for the judgment of taste in its most intimate manifestation, which is not intersubjective. However dependent on verbal expression it is and must be, beauty, like pleasure, even when

shared, is not a matter of consensus: In itself, independent of its relation to the feelings of the subject, it is nothing.[7]

It is principally in this respect that the analytic of the beautiful might seem to overlap with Freudian analysis, which tends to depict the subject as split, divided, separated from itself. What relation can possibly obtain between the attribution of beauty to the unconscious and the repression thanks to which the conscious subject is separated from a portion of its representations? The essential thing here is that, for Freud as for Kant, beauty is a matter of judgment, and "the beautiful" essentially has the value of a predicate. Kant does not investigate beauty in and for itself, but rather taste, defined as the power or faculty of discerning (*unterscheiden*) whether something is beautiful or not: the analytic of the judgment of taste should establish what is necessary to declare an object "beautiful" and clarify its source, its root, in the speaking subject. Likewise with Freud: Psychoanalysis, he feigns to avow, does not have much to say about beauty. But this is immediately to displace the question toward that of the attribution of beauty: The concept of "the beautiful" originally designated what was sexually stimulating, even though the genitals, however exciting to the eye, are rarely judged (*beurteilt*) to be beautiful. This prompts a question that might be formulated as follows: Is it "taste" that prohibits us from judging them to be "beautiful" and discourages their representation, which is declared to be "pornographic"? To reframe the question in Freudian terms: What is the relation between "taste" and repression—and between "the beautiful" and the repressed?

The displacement preliminary to the attribution of beauty is inextricable from the function here performed by negation (the genitals are not judged to be *beautiful*). This might well make us prick up our ears once we know that, for Freud, the capacity to make an impartial judgment (*die unparteilische Urteilsfällung*) as to whether a property does or doesn't belong to a thing depends on the creation of the symbol of negation, under whose cover thought acquires a semblance of independence with regard to the repression and achieves a kind of intellectual acceptance of the repressed.[8] Judgment goes in tandem with the repression for which it is a substitute: For judgments of taste to be possible, first of all the "organic repression" bearing on the genitals must be replaced by a judgment of denial or condemnation thanks to which a representation of the excitation they stimulate nonetheless rises to consciousness. Positive, approving judgments are predicated upon a double displacement, that of the genital organs onto so-called secondary

sexual characteristics, and that of the stimulus (*Reiz*) prompted by seeing them onto the "interest" awakened by these "charms" (*Reize*), which—it is worth repeating—are so-called because of "the particular quality of excitation whose cause, when it occurs in a sexual object, we designate as 'beauty'"—the discrepancy between the two meanings of the word *Reiz* being indicative of an evolution, perhaps even a history, belonging not only to the sexual object but also to the subject here constituting itself, discursively, by uttering an aesthetic judgment.

Thus Freud's text renews, within a perspective that is not critical but rather genetic, the question of the role of "discursivity" in the structure of the "beautiful." Judgment as such is a matter of the "ego"—which, under the cover of negation, sets itself apart from the unconscious even as it frees itself from the constraints of the pleasure principle. The judgment of taste in the Freudian sense is so paradoxical as to presuppose, in its capacity as *judgment*, the passage, by the ways and means of discourse, from a strictly subjective position in which the subject adheres to its internal representations—that of the pleasure-ego, the *Lust-Ich*—to an objective position—that of the *Real-Ich*, the reality-ego—from which a question arises as to the reality of these representations, of their correspondence to the external world. The paradox, which we have seen also finds its echo in visual art, resides in the fact that judgment of taste cannot be perfectly disinterested, even though it corresponds to a sublimation of the drive through withdrawal of its libidinal components. The very act of judging implies the reality principle's dominance over the pleasure principle, if only, as Freud says, as a way of serving it, of assuring its continued supremacy over the long term.[9]

<p style="text-align:center">* * *</p>

It would be absurd to maintain that the solution to the enigma of the judgment of taste is to be found in psychoanalysis. And yet this enigma is present and operating whenever the question of beauty arises in Freud's work—an enigma that, once again, must be understood in discursive terms. Kant's project was not genealogical but critical: He set out to build a bridge between understanding and reason by introducing judgment as a third term, a *Mittelglied*. Freud's project, by contrast, was psychoanalytic, and thus genetic. He set out to determine whence the very concept of "beauty" proceeded, or from what it derived. The paradox consists in the fact that this process or derivation is at the origin of, or, at any rate, contemporary with, the passage from nature to culture inherent in the acquisition of an

erect posture: The judgment of taste is predicated upon an initial displacement, a transfer of "interest" from sexual excitation to the realm of desire. And the origin of desire and emotion, and perhaps even of aesthetic judgment, is to be sought in the schism between the eye and the gaze. There can be no aesthetic emotion unless it declares itself as such in the form of a judgment; but this judgment, in turn, presupposes that, through the operations of desire, the "charms" of the object of amorous interest have overwhelmed or obscured the primary source of excitation, the possibility now presenting itself of a fixation on strictly scopic pleasure and, through this same means, of a diver-sion of the libido toward goals declared to be—as soon as they're designated "artistic"?—"more elevated."

Though the moment of passage from the one to the other is clearly marked in Freud's text, the opposition between nature and culture has no operative value: If we think, as psychoanalysis would have us do, in terms of derivation, or better yet of *sublation* (to use a Hegelian one), we soon realize the impossibility of precisely situating, if not the point of departure of the evolution in question, at least the threshold beyond which the passage from sexual excitation to judgment of taste becomes thinkable, as soon as it's allowed that something of the initial state must survive in even the most elaborately "sublimated" structures. Freud insists on this point from the very beginning of *Civilization and Its Discontents:* In the realm of psychology, primitive elements frequently survive alongside more advanced ones deriving from them, just as in animal evolution primitive characteristics tend to persist in subsequent stages of development.

The problem here doesn't concern the potential pathways to sublimation, to "idealization" of the drive, though it is perhaps worth stressing once more the necessarily discursive character of the process. The important question is the following: Can sublimation or "idealization," however diverted, lead to an aesthetic emotion of sufficient purity to satisfy Kant's criteria for the judgment of taste? Doubts begin to arise when we observe how fearlessly Freud associates in a single derivation the two terms Kant took such care to distinguish from one another: *beauty* and *charm.* Kant writes: "Taste needing a mixture of charms (*Reize*) and emotions to attain satisfaction will always be barbaric, all the more so if it makes these the standard of its approval."[10] If, as the third *Critique* would have it, beauty concerns form exclusively, then it would be a misunderstanding (*ein Missverstand*) to value over beauty a charm or attraction that enlivens a representation and makes it more vivid (color, for instance), in other words, to make it pass as itself

beauty when it is not integral to the representation but rather a mere addition, ornament, external trapping—or, to employ a Greek term used by Kant and recently given renewed currency by Derrida, a *parergon*.

It remains that, as Kant himself admitted, such misunderstandings often have "some basis in truth" (*etwas Wahres zum Grund*). Here again we must operate on the level of discourse: If indeed there is a misunderstanding, the only way to avoid it would be through rigorous conceptual definition; in which case the only judgments to qualify as pure judgments of taste would be those in which charm and emotion play no part and whose sole determining principle is form.[11] But Freud's thesis is, precisely, that it is impossible to anticipate the derivation of concepts. And isn't the "basis in truth" of which Kant speaks linked to the fact that if the beautiful, if "that which pleases," is meaningful only for man because he is endowed with reason, this same man is also an animal being and thus just as subject to the pull toward "gratification" as animals not endowed with reason? In Freud, it is beauty itself that is presented, at least initially, as a *supplement* ultimately intended to reinforce sexual excitation, to support and reinvigorate it despite the ever-present risk of deviation. The problem, again, is to discern whether sublimation can have as its aim beauty in itself, abstracted from any possible link with the sexual realm—a matter, as Kant would have said, of "conceptual rigor." For if, in the wake of the transition to an erect posture, the coprophilic component of the sexual drive is revealed to be incompatible with what we might call the "aesthetic exigencies" of our civilization, these developments concern only the superior forms of beauty, while the basic processes leading to amorous excitation remain essentially unchanged. "The excremental is all too intimately and inseparably bound up with the sexual; the position of the genitals—*inter urinas et faeces*—remains the decisive and unchangeable factor. One might say here, modifying a well-known saying of the great Napoleon, 'Anatomy is destiny' (*Die Anatomie ist das Schicksal*). The genitals themselves have not taken part in the development of the human body in the direction of beauty: They have remained animal, and thus love, too, has remained in essence (*im Grunde*) just as animal as it ever was."[12]

It was Kant's explicit intention to isolate the question of pleasure from that of desire. By contrast, Freud set out systematically to constitute desire as an autonomous energy by freeing it of any immediate dependence on gratification: According to his schema, desire is educable but the sexual drive is not. Excitation finding release in discharge does not always go hand in hand with desire, and vice

versa. We have seen how, for Freud, the institution of the family facilitates a transition from sexual behavior that is reflexive, and thus intermittent, to a desire capable of sustaining itself continuously to the extent that it manages to remain independent of the pleasure principle—at least partially, as in the case of the drive. This question encompasses the aesthetic realm: Art's participation in a psychic economy that is ultimately subject to the pleasure principle does not preclude the possibility of change in the regimes of pleasure, or in those of beauty.

What holds in the aesthetic realm also holds in that of ethics. In Freud's theoretical construct, the genesis of the ethical dimension is rooted precisely in desire itself, a thing's value being commensurate with its desirability.[13] The same could be said of the aesthetic dimension, with the following caveat: Here something analogous to a censor detaches itself from the energy of desire, such that the beautiful presents itself as an "ideal" opposed to the obscure root of beauty. This transformation of the energy of desire makes possible a conceptualization of the genesis of its repression: The ideal of beauty maintains a relation with that of human love that might seem paradoxical to the extent that the genitalization of desire stands in opposition to attraction to the secondary sexual characteristics, which are declared to be "beautiful." But the paradox is only apparent: beauty can sustain a relation with that which gives "body" to sexual desire only on condition of the partial drive's first being detoured away from the sexual "parts"—just as, it's tempting to add, "taste" itself detaches from its gustatory component to assume another, strictly discursive form of orality. Such are the detours of metonymy echoed by beauty even in the more perverse guises of the genitalization of desire, detours which, without the relationship necessarily being one of cause and effect, tend to discourage *judgments* that the genital organs are beautiful, however exciting the sight of them, and furthermore (as if the relation obtaining here between subjective and objective were identical to that between cause and effect) haven't *become* beautiful: if beauty is a matter of form, the *genitalia* belong—by a kind of necessity in which anatomy, figuring as destiny, also has a part to play, if not its word to say—to the realm of the unformed, *l'informe*. But the relation of the unformed to the formed is not one of simple substitution, nor is it one of unambiguous advance: The very mechanism of "sublimation" presupposes that the reign of the unformed will persist, as an undercurrent, *im Grunde*, throughout that of form.

NOTES

1. References to Kant are rare in Freud's work; they evidence his concern to clarify how the hypothesis of the unconscious might be substituted for that of the Kantian a priori by "going beyond" it and articulating it in genetic terms. Thus, spatiality is conceived of not as pure intuition but as deriving by projection from the extension of the psychic apparatus as such: "The psyche has extension but knows nothing about it" (cf. Freud, *Résultats, idées, problèmes*, vol. 2, 1921–38 [Paris, 1985], 288).

2. "Man muss nicht im mindesten für die Existenz der Sache eingenommen, sondern in diesem betracht ganz gleichgultig sein, um in Sachen des Geschmacks, den Richter zu spielen." See Immanuel Kant, *Kritik der Urteilskraft*, part 1, section 2 ("In order to play the judge in matters of taste, we must not be in the least biased in favor of the thing's existence but must be wholly indifferent about it." Immanuel Kant, *Critique of Judgment*, trans. Werner S. Pluhar [Indianapolis: Hackett Publishing Company, 1987], 46; hereafter cited as *Judgment*/Pluhar).

3. Ibid.

4. "Diejenigen, welche immer nur auf das Geniessen ausgehen . . . sich gerne alles Urteilens überheben." Ibid., section 3 (*Judgment*/Pluhar, 47–48).

5. Roland Barthes, *The Pleasure of the Text*, trans. Richard Miller (New York: Hill and Wang, 1975), 21; trans. altered.

6. Jacques Derrida, "Parergon," in *The Truth in Painting*, trans. Geoff Bennington and Ian McLeod (Chicago: University of Chicago Press, 1987), 48.

7. "Da doch Schönheit ohne Beziehung auf das Gefühl des Subjekts für sich nichts ist!" Kant, *Kritik*, part 1, section 9 (*Judgment*/Pluhar, 61–64).

8. Cf. Freud, "Formulierungen," in *Gesammelte Werke* (*GW*), vol. 8, 233 ("Formulations," in *Standard Edition* (*SE*), vol. 12, 221); and "Die Verneinung," in *GW*, vol. 14, 12 ("Negation," in *SE*, vol. 19, 235–36).

9. "In Wirklichkeit bedeutet die Ersetzung des Lustprinzips dutch das Realitätsprinzip keine Absetzung des Lustprinzips, sondern nur eine Sicherung desselben." See Freud, "Formulierungen," in *GW*, vol. 8, 235–36 ("Actually the substitution of the reality principle for the pleasure principle implies no deposing of the pleasure principle, but only a safeguarding of it." See "Formulations," in *SE*, vol. 12, 223).

10. Kant, *Kritik der Urteilskraft*, part 1, section 13 [*Judgment*/Pluhar, 68–69].

11. Ibid.

12. Freud, "Beiträge zur Psychologie des Liebeslebens. II. Über die allgemeinste Erniedrigung des Liebesiebens" (1912), in *GW*, vol. 8, 90 ("On the Universal Tendency to Debasement in the Sphere of Love (Contributions to the Psychology of Love II)," in *SE*, vol. II, 189).

13. Jacques Lacan, *Le Séminaire*, vol. 7, 11 (*Seminar*, vol. 7 [*The Ethics*][New York: W. W. Norton], 3).

Arousal by Image

David Freedberg

If the psychologist teaches us, "There are people who see," we can then ask him: "And what do you call 'people who see'?" The answer to that would have to be: "People who behave so and so under such-and-such circumstances."

—Wittgenstein, *Remarks on Colour,* I.88

Cette femme n'est pas une creature, c'est une creation.

—Frenhofer in the 1837 edition of Balzac's *Le chef d'oeuvre inconnu*

Cette femme n'est pas une creation, c'est une creature!

—Frenhofer in the 1831 periodical version of Balzac's *Le chef d'oeuvre inconnu*

WHAT IF EVERY CONSCIOUS ACT OF LOOKING WERE PART OF THE INTENTIONALITY of desire? And if the desire to gaze on representation were like the desire to gaze on the object: and the drive to do so, in the West at least, were masculine? What then would be the implications for the investigator of response?

Say the issue is one of possession: But is the reference then to possession of what is represented or of the representation itself? If we think that the range is simply signified and sign, then we play down the extent of the search for domi-

nation and possession. It is in this region that the gender orientation arises. If we concentrate on mere signifier, then we enter the realms of fetishism, and the semiotic range is inadequate. But why the centrality of possession? Because possession of what is imaged reveals the erotic basis of true understanding. The hermeneutic quest is always founded on the repression and perversion of desire; the objects of understanding are always bare. The long gaze fetishizes, and so too, unequivocally, does the handling of the object that signifies. All lingering over what is not the body itself, or plain understanding, is the attempt to eroticize that which is not replete with meaning. For example, the need to explicate form and to articulate the collocation of colors brings one closer to an acceptable pornography of discourse. But this is not to say that in shape, and form, and color, and in every way representation and represented seem, we do not find the precise locus of particular desire and particular response; or that every expression and every symptom of response is predicated, directly, stringently, and immutably, on how representation looks.

The problem, then, is to theorize a history that has become—if it was not always—the ideology of men. Nothing would now be served if the history were a partial one.[1] The first question of method is posed by a decision of the kind that acknowledges male conditioning (or the inescapability of the investigator's position at its present apex) in all talk of arousal by image. Say all viewing in the West has been through male eyes, because it has been largely through the eyes of males possessing or wishing to possess women. But can one, with such acknowledgment, dispense with the crucial aprioristic problems? To answer affirmatively would be too simple an answer—though by no means wholly illegitimate within the terms of response history.

In chapter 1,[2] I alluded to readings of pictures like Titian's *Venus of Urbino* and of prints like Hans Baldung Grien's *Holy Family with Saint Anne,* which were repressive because they evaded the more direct and immediate responses of which one might have assumed the people who wrote about them to have been capable. This was not to say that the readings were illegitimate; it was just that they took no account of response, except of the most remote and secondhand kind. Indeed, it may be that the present project should be to evolve notions of reading that implicate response rather more deeply than is customary. But, in fact, the project is simpler: It is to develop a mode of discourse about arousal by image that bears on the general relations between images and people, and on cognition—not on

conditioning. If we concluded that the only thing that could be said about the sexual responses postulated in the case of the picture known as the *Venus of Urbino* was that they were the product of male conditioning, male determining, and male possession, then the overall project would be threatened. But even that case, if admitted, would exemplify the issue of repression; for we could not thus explain the persistent and striking and wholly unnoticed avoidance of readings that excluded the centrality of those aspects of the image that pertained to sexuality. The matter is by no means just that of arousal; it is of the failure to see that grows from the acknowledgment of effectiveness. We repress as if in tacit but tormented denial of the potential and effectiveness of figuration.

A key issue in this book has been the fusion and elision of image and prototype. But when one deals with responses to images that seem to be not just images, but rather the bodies or objects or things they represent, then the problem of possession arises with great clarity. In this chapter, I do not intend, in any substantial or explicit sense, to speak of the inevitable *commodity* fetishism that arises with the need to possess either the picture itself or the picture of something—say, the picture of a bowl of fruit. I do, however, intend to speak of the arousal that may or may not proceed from attempted or imagined possession of the body in the picture, or even of the picture or sculpture itself. Arousal may proceed from the latter as well; but in all cases we should be aware of the drive to understanding, possession, and domination. The pivotal question is not whether understanding precedes possession, but whether we need to possess in order to understand at all. Not every stage may occur, and frustration is also likely to feature. When we reconsider the matter of fusion, and when we postulate possession as male, then the claim that all Western looking has been through male eyes makes a kind of sense that we may provisionally accept before volunteering the necessary and potentially adequate qualifiers.

The thread that runs from repression to fusion winds its way through the problem of live images. Here we find abundant exemplification of acquiescent and complicit or palpably resistant responses to images that are believed to be alive, or to be awesomely, unexpectedly, and miraculously like living bodies. Dead wood not only performed miraculously, in ways that ran exactly counter to what one might possibly have anticipated of its materiality, it also became vulnerable flesh; and it became sentient, emotional, and sympathetic. We saw images of the Virgin Mother of Christ come alive or offer their soft breasts to allay the wounds

of monks and sometimes nuns; and Saint Bernard (who wrote one of the greatest sustained commentaries on the most erotic book of the Bible, the Song of Songs) had a celebrated vision in which he received in his mouth a jet of milk from the breasts of a particular statue of the Mother and Bride of Christ with whom he, like umpteen others, identified the comely mistress of Solomon.

Now the psychosexual implications of most of this is clear. Indeed it seems especially easy so to judge the issue at the end of the twentieth century. The Virgin offered the most concentrated possible combination of motherhood and youthful sexuality. She was the fair sister and spouse of the Song of Songs, and the Mother who could turn the anger of a judgmental Son by reminding him of the breasts that nourished him in his infancy.[3] Everyone knew these iterated aspects of the Virgin, and so she naturally became the intense focus of the full gamut of sexual attention. The desire for sexual relations with females of this world was conveniently displaced onto her.[4] It would not be difficult to develop an analysis of all these manifestations of arousal by image in terms of the psychology and eristics of gender relations; but to phrase the issues in these ways is likely to appear anachronistic. We may compound anachronism by remaining attentive to our inability to express anything at all in this arena except in terms of the language of male dominance. But we cannot dispense with anachronism if we are to come closer to the terms of cognition. Thus we confront the old intellectualist divide: How can the historically and ethnographically responsible investigator declare anything at all without relinquishing the perfectly abundant but always culture-bound terms provided by the object of his investigation? The gender issue and the viciousness of the hermeneutic circle intersect at this very point. I will return to it later; but what further is at stake?

When we think of the example of images that come alive, we recall that the relationship with them always arose from concentrated gazing, from attentive prayer, and from sustained devotion of one kind or another—in other words, from plain fetishization of the painted or sculpted work. In many cases the image came alive because the beholder wanted it to do so. This intentionality provides full justification for a psychology of behavior in the presence of images; but what we must seek to achieve is the move from culture-bound psychology to a more general description of the forms of arousal that necessarily occur because the interaction is precisely with a figured object (and not—precisely—with some woman or man). And then the question must arise about the extent to which arousal is

dependent on what the image represents, or whether it proceeds from a specific form of seeking to grasp the consequences of figuring an object or of making a figure of it. In speaking of figuration here, I use the notion in its broadest sense; I absolutely do not imply anthropomorphic representation, except incidentally.

<div align="center">I</div>

"On the Sunday before Easter they brought the miracle-working icon of the Vladimirskaya Virgin from the Oransky Monastery to our town," recalls Gorky of his boyhood days (just before his apprenticeship to an icon painter),

> She'll probably cause my arms to wither for carrying her with dirty hands. I loved the Virgin . . . and when the time came to kiss her, I tremblingly pressed my lips to her mouth, not noticing how the grownups did it. Someone's strong arm hurled me into the corner by the door. . . . You simpleton! said my master in a mild rebuke. . . . For several days I waited like one condemned. First I had grasped the Virgin with dirty hands, then I had kissed her in the wrong way. . . . But apparently the Virgin forgave my involuntary sins.[5]

Gorky had responded to the image of the Virgin in the wrong way. He behaved to her—impetuously and immaturely—as if she were some mortal woman, of the kind he knew, and not as some divine unknowable being. To her and not to it. Gorky's "sin" consisted in acting spontaneously on that basis. The sin was *involuntary* (a crucial term in our present context) because of the overwhelming strength of his conditioning. We may suppose that he, like everyone else in his culture, was accustomed to think of the Virgin as the most beautiful of all women; and so, instead of wanting to kiss her chastely, he kissed her more intimately, even wantonly; or perhaps—to take the strongest element in the conditioning—as a mother. For that is what the Virgin endlessly was: the most beautiful of all women on earth and the ultimate exemplar of motherhood. Furthermore, the image was a miracle-working one: so she could come alive, she could be like flesh, she was fleshly and beautiful, and so she could impel the young Gorky thus to deliver his kiss. Let us briefly consider the further implications of his "involuntary" act.

Gorky was impelled to kiss the picture of the Virgin in the way he did because he had been conditioned to view women in a certain way, and especially women

<div align="center">117</div>

regarded as beautiful. But what is central in the whole action is that he could only thus be moved if he perceived that particular image of Our Lady of Vladimir as a particular mortal (and not as the Virgin generalized by the picture); and so he responded to it as if it were living and inclined to whatever passions—including sexual ones—that living forms normally induce. No claim is here being made for the kinds of images that are regarded as lifelike, nor do I make any tacit offer to help with determining what kinds of form are or are not capable of being regarded as that (for that must remain the task of a pure cognitive psychology). The only claim is that once images are regarded as lifelike, then we are liable to respond to them in the ways that we do to the living (or incline to do, or repress if we are not young and simple and full of ardor, like Gorky).

This is all very well; but say the argument is made that this sort of response is primarily—if not exclusively—male? The ontology of the religious picture argues otherwise, and so does the immense power of the kind of conditioning of which I have been speaking. Who is there in the Western world who could not point, first, to instances of response to the Virgin, Christ, or his saints that arise from grasping them as real (and therefore as mortals)? And second, who does not know that women respond in affective and sexual modes to beautiful Virgins and Magdalens too? In the absence of reports of the kind provided by Gorky, we cannot be quite as certain, it is true, about the possible responses of young girls to images of the Virgin; we do not know that they would yet have learned to kiss them in the wrong way. But just as we may *think* that they would not have handled the image with dirty hands either, so too we must acknowledge, first, the force of the stereotype that is wrong and, second, the extraordinary dominance of male ways of perceiving women, to such an extent that women as much as men may be roused by the sight of conventional beauty or conventionally seductive nakedness.

In any event, all this would be taken care of, analytically, by an adequate theory of male ways of looking or—better still—one based on the proposal that all looking in the West has precisely this gender orientation. It would certainly also cover with ease the neater cases such as the one recounted by Caesarius of Heisterbach, where the embrace of "Christ the Lord Jesus, who is the spouse of the whole Church, changed all the trouble of a nun, who was grievously tempted, to the greatest peace."[6] But when, with pictures like the *Venus of Urbino* or Manet's *Olympia,* or with the general representation of female bodies made visually avail-

able in ways that meet with prevailingly male conventions of eroticism, we find evidence of female enjoyment, too, the matter becomes more complicated. It is not just that the conventions become (or are) female, too. We may then have to provide a further theory of possession, where, say, the idea of male possession of the female body offers the possibility of female sexual arousal. But such a theory would be only partial. Aside from the element of argument from androgynity that it may or may not require, it would not incorporate any sense that to gaze on the representation itself (and not merely to imagine the body as present) partakes of the intentionality of desire—and not only the gaze, but the force of the combination of the act of looking and the insistent presence of figured image, the presence that cannot go away unless we turn away from it. It is the whole exchange that evokes, elicits, and is the very product of desire.

But we should not yet leave the problem of the relations between convention and arousal. Vasari tells the story of a Florentine citizen who one day went to the overclever puppet painter Toto del Nunziata and asked him for a Madonna which would be modest and not an incitement to desire. So Toto painted him one with a beard. Now it is true that Vasari goes on to tell of another man (a simpleton, according to Vasari) who asked Toto for "a crucifix for the summer;" whereupon he painted him one in breeches.[7] But the tale about the unlascivious Madonna has implications that go beyond that of a joke. First of all, it points to what we already know: that an image of the Virgin can be so attractive that it rouses desire. Second, it alerts us to the fear of such arousal—a fear (as we shall see) that does not simply arise from the need to keep profane and sacred apart. And third, it emphasizes, implicitly but with great and concise force, the power of conventionality in the evocation of arousal.

The Virgin, as everyone knew, was supposed to be a beautiful woman (from the earliest days of Christianity she had been likened to one); and she therefore had to be seen as such. The only way to show her, then, was against the prevailing standards applied to living women. But if one took as one's model the most beautiful women of the day, a woman who corresponded most closely to Solomon's bride, one could hardly be surprised by the allegation that the Virgin was too lascivious—at least in the eyes of the prudish and prurient. Furthermore, she is supposed to be ultimately and perfectly chaste; so how can we respond to her as such, when she is made to look like those to whom we are prone to respond in the very opposite of ways? Of course, the fact that we are encouraged by reli-

gion to adore and to love the Virgin played an additional role in the arousal of such feelings. As it is, we may have difficulty in distinguishing between erotic and spiritual love (and everyone would agree how perfectly this is illustrated by a sculpture such as Bernini's *Saint Teresa and the Angel* or his *Blessed Ludovica Albertoni*, for that matter)—but how nearly impossible to make that distinction is when the Virgin looks like a living model of beauty. The problem recurs countless times in the history of art.

So we admit the great force of convention in all this. We acknowledge the different sensitivities of different cultures. We recall that the Chinese were apparently revolted by the first images they saw of the crucified Christ, and that they took offense at the early missionaries' pictures of female saints, on the grounds of their excessively large feet.[8] We find other stories from still other cultures, such as one that comes from ancient Iran. A man was inflamed with passion by the figure of a female cupbearer (supposedly that of Shirin, the mistress of King Abarwiz) in the Grotto of Tâq i Bustân at the western end of the famous mountain of Bisutun, near Kirmanshahan; so its nose was struck off in order to prevent this from happening again.[9]

But convention does not seem an entirely sufficient category of explanation. It is problematic for at least two reasons. The first is that it does not adequately allay the suspicion, however much we acknowledge the patriarchality of our thinking, that some conventions are more widespread than others; and at what point does convention leave the particular and historical terms of context for the inclusive and embracing forms of cognition? When we read in a protocol of the Strasbourg archives for 25 April 1511 (not so long after the reported case of Toto del Nunziata) that the Council was concerned that "Jost, painter in the Oberstrasse," painted "scandalous pictures of the Virgin"; and that they decided they should send someone, knowledgeable in art, to go and look at the pictures; and that if he found that the pictures of the Virgin were painted scandalously and with bare breasts, Jost should be forbidden to do them[10]—when we read of such an incident, as we may of many others in the history of European art, we consult ourselves and can only conclude that either we fully accept the theory that all looking in the West is the expression of male desire (or the fear of it) or we make it culture-specific only if we embed it in some larger view. Then we proceed from diffident acknowledgment of context, site specificity, and the way in which conditioning is structured by particular convention to the more difficult task of induc-

ing a general but more liberating theory. One might attempt something along these lines (and we begin with the second difficulty incurred by the argument from convention):

However much one argued for the place of small feet in sexual contexts in China, or other anatomical features elsewhere, it would be futile wholly to argue away the psychosexual dimension of the bare female breast in all cultures, or of the exposed genitalia, male or female. The exact limits of the resonance of the breast in the psychopathology of everyday life may vary from one culture to another, but the limits are only somewhat variable, certainly not so much so that they never intersect. The same applies to its sexual resonance. For women, that resonance may or may not be different from men; but again—leaving aside the maternal and mothering aspect—we must postulate the kinds of arousal that may spring from female awareness of the sexual implications of the breast for men. And so, for particular kinds of exposure of the body—especially those that seem to make it available or open; or that set the beholder, teasingly, in search of the sexual organs.

It may, of course, be that the whole of Western representation (and, I suspect, most representation across the world) is patriarchally determined, since it is clear that female bodies are presented sexually considerably more frequently than male ones; but this does not affect the general position taken here at all. There are, of course, certain kinds of presentation of the male body that show the male sexual organ; and so sexual interest—or fear of it—may arise here, too. There is no reason to suggest that it was only in Catholic and Counter-Reformation Europe that cases such as the naked Christ Child would have caused anxiety; or naked satyrs and Hercules figures either—though there is no disputing that some people would have been more blasé than others. But the elements of sexuality that lie beneath sophisticated indifference should not be forgotten.

But even if all this were quite wrong, even if one were to insist that arousal could not enter into the case of pictures regarded as ugly (or representations of people regarded as ugly), and that ugliness was not only a matter of convention but also wholly relative—even so, that would not affect the more general course of this argument. Its aim is not to define precisely that which arouses and that which does not, or to set up appropriate rules and criteria for making such a distinction; it is to examine the historical evidence for actual response, and to assess the ways in which such evidence might illuminate the modes of cognition and the behavioral patterns that terminate in arousal by image. In order to do this, we need not

only to continue our pursuit of history, but also to consider more deeply the way in which the act of looking itself enters into the problem of arousal.

I have postulated that once we perceive the body as real and living (or once we wish to perceive it as real and living, or to reconstitute forms with some such result), we invest it with life and respond to it accordingly. When, *mutatis mutandis*, we find ourselves responding to an image as if it were real, it seems at that moment no mere signifier but the living signified itself. Then, once the body is perceived as real and living, we are also capable of being roused by it. The issue is not one of context, since to claim this much is not to attempt to achieve terms of definition for what is or is not seen to be lifelike, or real, or living in particular cultures or contexts. It is, rather, to suggest that there is a cognitive relation between looking and enlivening; and between looking hard, not turning away, concentrating, and enjoying, on the one hand, and possession and arousal, on the other. The argument from convention then becomes irrelevant in that it is insufficient, although it is evidently not wrong. It is, as I have claimed, only part of the story.

Kris and Kurz justly comment on the story of the sculpture of Shirin that it is "noteworthy in two respects; the statue was believed to be alive not only by the man who offered his love to it, but also by those who mutilated it to prevent others from falling in love with it," but we should not be misled into thinking it a tale about the convention-bound nature of sexual appeal.[11] It is much more than that. It provides still further demonstration of the way in which we acknowledge the response that arises from the perception of the body in the image, and of how, by disrupting the object of the fetishizing gaze, we may subvert desire. The point, of course, lies in the tautology that arousal by sight of picture is not simply a matter of arousal by sight of a particular alignment of features, or long legs, or slender neck, or large muscles, but precisely a matter of arousal by sight of picture.

II

Once we invoke convention and conditioning we must speak of horizons of expectation and thresholds of shame; we need to know the limits of what is both privately and socially acceptable in terms of picturing the sexual and the sensual.[12] Only then can we move to assessing the relations between arousal and individual perception of the transgression of boundaries and limits. As we know, these limits may sometimes be pushed far back, and sometimes move forward; as far as we know, individual arousal may depend both on a sense of substantial transgression

and only of being on its limits. In short, this approach to arousal seems almost wholly unamenable to analysis, because the social boundaries are so variable and the personal ones so idiosyncratic. But to search for anything more general forces one to fall back on specific instances from the past; even the psychologist who examined arousal by picture would need to analyze context and conditioning first—since his examples would wholly depend on the relations between beholder-context and representational convention.

These are the provisions we accept as we fall back, as indeed we must, on the historical cases. We accept them not only because they seem self-evident, but also because, in terms of the argument of this book, they are beside the point. Much more crucial, as with so much history writing, is the constant lack of authentic female voices. The construction of history has remained aggres-sively inattentive to—because willfully neglectful of—female report; and so it remains one of the essential structures of male power. But it may be possible to acknowledge all this and start coarsely in the hope that a bonus may nonethe-less accrue. In some instances one may even go a little beyond these needful provisos. Take the issue exemplified by a story in one of Girolamo Morlini's highly scurrilous novellas of 1520.[13] For once it has something to say about a specifically female response, even though it is told by a man and is plainly scopophilic, and even though it may be assumed to be predicated not only on a prevailing literary genre, but also on the assumption of male enjoyment of the disclosure of female arousal (Morlini's book makes special capital of this). We may read it wholly in that spirit too; but while the matter of the arousal that springs from looking must remain problematic and therefore problema-tized, there is a sense, here, in which the matter is altogether direct.

One evening a woman whose husband had gone away set out for church, as she mistook the light of the full moon for the breaking dawn. But when she came to the marketplace, with its statue of a nude man "intentum arcum habens," she was suddenly seized with a longing for her distant husband. Swiftly she made a pile of stones and climbed up to kiss the statue; but when she felt "erectus ille priapus" against her, she was so filled with passion that she removed her clothes and copulated with it. Her lust was so great that she could not remove herself, and so she remained clinging to the statue until the morn-ing crowds gathered to gape at her.[14]

This is all—must all have been—very titillating, especially for the male readers

for whom the tale was presumably intended. Indeed, there are several other details in Morlini's story which are still more explicit but are simply further evidence of the pornographic genre to which it belongs. Once again, however, the problem is not chiefly one of genre, nor indeed the further issue, however interesting, of the relation between fantasy and evocative presence. The problem remains general and not conventional.

A statue with a penis always offers this kind of potential. But the issue at stake is the degree of preparedness thus to engage it, or the degree of arousal that has proceeded not only from imagining and from fantasy about things unrelated to the object (say, here, the absent husband), but from the gaze, from the evocation of fantasy engendered by the object itself and by fetishization fed and heightened by looking. Before elaborating the case, let us look at two more instances that we may presume—or intuit—to have an application that extends beyond the confines of genre. The first is similarly direct, even though it masks its directness with a semisophisticated and disingenuously coy prurience. It comes from a part of Brantôme's *Vies des dames galantes* that belongs, in many respects, to the same literary genre as Morlini's novella. Its immediate literary context is an imaginary and thoroughly scatological conversation about the problems posed by the supposed fact that women desire large penises and men small vaginas. It also happens, incidentally but significantly, to underscore something of the sexual significance of the collection of antique statues amassed by François Ier and about which many art historians are still coy or evasive.

One day a "grande dame" at the court was looking and gazing at ("regardant et contemplant") the great bronze of the Hercules Farnese at Fontainebleau together with an "honneste gentilhomme." After commenting on the fact that the statue was well made, she noted a shortcoming. The proportions of his limbs were not quite right, because of the discrepancy between "son grand colosse de corps" and that part of him which corresponded so little to it. And the predictable dirty joke follows (women in those days were not so big, replies the gentleman).[15]

The case looks very trivial, and it seems wholly consistent with the slightly overheated fetishistic context of the Fontainebleau court. Here male fetishism and male fantasy brought forth pictures like the very many versions of Venus/Diane de Poitiers in the bath; and there are even some indications of the way in which female enjoyment of female nudity was exploited. The Estense emissary Teofilo Calcagnino tells of how François took the Duchesse d'Etampes

to look at a statue of Venus, to show her "come ella era di bel corpo perfettamente formata." She smiled, and turned and went to warm herself with the other ladies of the court; while the king, naturally, remained with his courtier to enjoy his statues—"al quanto a divisare di quelle figure."[16] The *sous-entendus* here are hardly bearable; but lines like these, just as those from Brantôme, have considerable indexical weight. They are also, for all their archness, unusually candid about plain responses to nude sculptures. None of this material should be dismissed as simply contextual or conventionalized.

It may be that we have an adequate context for the kinds of remark engendered by the famous bronze Hercules of Fontainebleau, as well as for the more than usual attention to female responses to naked form; but that would not take us very far in terms of the questions posed here. Nor would any attempt to subvert the historicity of sexual responses by reflecting, however troubledly, on the odd sense we have of a kinship between Bellifontainish responses and those that we immediately recognize as contemporary, or even our own. We do not at this stage need the phenomenological test. What we do need is an understanding of the full implications of the way in which talk of the kind we find in Brantôme (and reports of such talk) are legitimated by the fact that it is all about a statue, a work of art. One would hardly—certainly infrequently—talk about a real person in this way. The issue goes beyond one of simple decorum, and it has several correlates.

The first is that images arouse—or, in the broadest sense, elicit sexual interest—because of looking and gazing. Even with the trivial remark of Brantôme's "grande dame," the narrator stresses its origin "regardant et contemplant." The strong response is engendered by allowing the eye to linger over the surfaces of the object, to caress them lovingly, troubledly to traverse them, or visually to engage with its accidents. All this is emphatically no hypothesis from sight to touch; it is the initiation of the second correlate. Visual attention—the gaze, look, or stare—proceeds from the ontology of images in general; not just, as everyone knows, from art. But everyone knows, too, that with art we are more self-conscious in what we say about looking, or even in what we think about. Once we deal with art, we know we are not dealing with life; and so the third correlate is pure paradox. With the image that is not art, we can talk openly about sex and arousal. It allows us to do so frankly and in more or less full acknowledgment of the sublimation involved. Decadent bourgeois sophistication, say, tolerates talk about

pornographic imagery that it would never tolerate if the responses were directly implicated in life. But with the image that is art—say, that we recognize as art—we incline to denial. Such responses, we know, consciously and in our bones, detract from art. We can only talk about low-level imagery in these ways; if it really is art, especially great art, then we have to think of and speak of response in a different way. We do not fully acknowledge the sexual, or the sexual response. We talk about colors and form. If we suspect arousal, we deny it or—at best and most liberated—are mildly ashamed. This may be the pure paradox of looking, but there is—as so often—a further paradox. We have, clearly, to look more closely at the ways and implications of repression; but at the same time we realize fully the possibility that there is no arousal without repression. And when that does happen we may need rationalization.

For all the conventional aspect of the tale from Morlini, and for all the caveats we enter because of its genre and its patriarchal archness, it is unusually direct about arousal; and its chief actor (for whatever reasons) is female. When we turn back to antiquity (where, of course, we find the sources for all such stories), there is no shortage of accounts of young men who are aroused by images and overtly express their desire. The most famous case is that of the young man of Cnidos who was so roused by the famous Venus of that place that he stole there by night and copulated with the statue, leaving behind the actual traces of his lust.[17] So blatant (and oft-repeated) a case is of less relevance here than that of a woman who features in the Byzantine life of Saint Andrew the Fool.[18] In considering it, it is as well to remember how, not only in Byzantium, but throughout the Middle Ages and later, classical statues were suspect—not only because they were not Christian, but because their sensuality was the very mark of their pagan origin. The Byzantine lives of the saints are full of stories of hostility to statues that seemed to be unchaste or to be directly capable of rousing desire. They were too beautiful; they showed the body naked. These two elements together were too much, and they could thus arouse adulterous thought and action. But as we know even from other kinds of statues—and not only sensual ones—images such as those which came from Greece and Rome were effective and potentially active because they were believed to be inhabited by demons. Or they could be activated by specially magical processes (called *stoicheiosis*). This, it must always be remembered, provided the chief and most satisfactory rationale for the power of images. What it meant was that one could deprive images of their powers, within an acceptable

category of rationality, by magical means or—if this did not work, or if the demons were too strong—by breaking them. This is the context for our tale and the context for a particular kind of rationalization—and again we have something that is usefully and trenchantly indexical.

The problem was the husband: he was given to dissipation. But with the aid of a magician he was brought to heel. Unfortunately, the woman then started to have bad dreams. In some she saw herself pursued by Ethiopians and huge black dogs; in others she was standing in the Hippodrome, embracing the statues there—"urged," according to the chronicler, "by an impure desire of having intercourse with them." The saint was called in and he managed to drive the demons from the woman's head by expelling the demons of the statue. When Mango recounts this story in his excellent summary of Byzantine attitudes toward antique statuary, he notes, quite rightly, that "it is not surprising that the nude statues of the Hippodrome should have been inhabited by demons of concupiscence."[19]

The fact that the story is of a dream does not diminish its evidential status. If anything, by virtue of the unconsciousness of dreams, it indicates very clearly the response that easily elides image and prototype. And however common—say "normal"—it may have been to account for all powers of statues and pictures by the assumption of a demonic or magical presence, we are still dealing with one of the varieties of rationalizations.[20] Indeed, this applies not only to Byzantium, but to Greece and Rome as well—above all to the fourth to sixth centuries when Neoplatonic views and telestic functions combined, and where it could unexceptionably be claimed (as it regularly was) that the "reason" the image was alive was because it was inhabited by demons. But we too, now as then, incline to rationalization, especially in this broad area. The process has a twofold scope: first, the image that is, becomes, or seems alive; and second, the denial or defusing of the response that is sexual, in one way or another. The reasons for rationalization thus lie close to the center of what writers about art habitually, characteristically, and deliberately fail to acknowledge about art.

There are some cases where the actual sexual engagement is straightforward, as with the young man of Cnidos. The story is repeated in Lucian, in the *Greek Anthology,* and in several others.[21] It can be compared with tales in the comedian Alexis, and after him Philemon, which describe how a young man (this time of Samos) becomes enamored of a statue of a woman and shuts himself up with it,[22] or with Aelian's vignette of the youth who fell desperately in love with a statue on

the Prytaneion, not a statue of Venus or Eros, but of Fortune. He embraced and kissed it; he wanted to buy it, the City refused, and so all he could do was adorn it with ribbons and garlands.[23] The mistake, once again, would be to dismiss stories like these as clichés. While their repetition may seem to diminish the possibility of historical truth, it is just this repetition that emphasizes rather than impugns the cognitive relation between image and intentional beholder.

Then there are the cases where sexual interaction takes place in a vision or dream. They range from the woman and her problem with the statues in the Hippodrome to the later medieval instances where—for example—Bernard is confirmed in his faith by his vision of the lactating breast of a statue of the Virgin, and where the carnal temptations of monks and nuns are deflected by their all-too-sentient visions of the physical embrace of Christ or of statues of him. Here it may be worth expanding the summary of the case of the novice whose cancer was cured by the appearance of the Virgin, whom he knew from the image upon which he meditated in his cell. She took pity on him, appearing to him "plus blanche et plus fleurie que la fleur de l'aube espine . . . et la rosée de may"; she approached him, wiped his wounds with a towel whiter than snow, and without delay (as we have seen) "ella tira hors de son savoureux sain sa douce mamelle, et luy bouta dens la bouche, et puis en arousa routes ses playes."[24]

Of course this kind of language may itself be arousing, and one may wish to align it as a kind of religious and medieval equivalent of the sort of thing to be found in France under François Ier; but it still provides a sharp outline of some of the psychopathological motives that may underlie the need to invest an image with a life that is specifically capable of sexuality.[25] We may now pretend to be wiser and to see through the motivation, indeed the *raison d'être* of the story—just as we may insist on the significance of the psychological context of the Hippodrome case (the woman had the dreams because of jealousy of her husband's dissipation and because of the need for sublimation, etc.), and of Saint Bernard (denial of sexuality by contextualizing as conversion and the requisite chastity, etc.), and of the tormented monks and nuns (sex with Christ replacing the need for sex with someone of this world, etc.). But although it may be as well to remind oneself of the forms and varieties of rationalization, none of these "explanations" are needful here. The problem with the reminder is that greater wisdom (say, in identifying rationalization) does violence to the historical integrity of the deeds and events described—however much such violence may be

in the nature of every act of historical investigation. Be this as it may, the present significance of all such tales is rather simpler, and (in my belief) rather greater than all explanations along these lines imply.

III

Let us leave rationalization aside and take the cases as they come. The image seems to be or simply comes alive; and more or less overt sexual relations ensue. Or— *mutatis mutandis* again—the image gives rise to more or less sexual feelings; and so it can only be construed as living. Once we rationalize, we are on the borders of art; and with that we prefer to admit to other kinds of responses, preferably predicated on nothing too lively or, at best, on metaphors and similes of liveliness. The portrait "seems to" speak; the eyes "seem to" follow one round the room. It behaves "as if" it were alive. But a problem arises with beautiful images or, rather, with images for whose beauty the artist is evidently responsible. What happens when we see the image as beautiful, when we see it knowingly as image and not as body, when the stirrings have to do with nothing recognizably human—or even organic? That is the long-term question here; for the time being, one more example from the great body of medieval image lore may be considered.

It comes from a large group of variations, dating from the twelfth century, on the theme "Young Man Betrothed to a Statue."[26] The young man puts his marriage ring on the finger of a statue of Venus and then discovers that the statue takes him seriously: She prevents him from embracing his earthly bride. These stories are, in turn, to be related to those about the young man who similarly betroths himself to a statue of the Virgin (not just to the Virgin herself). When he goes to bed with his wife, the Virgin of the image comes between them and prevents their mortal embraces.[27] Of course, the Virgin's role as spouse of Christ was so well known that we can immediately identify the literary contamination, to say nothing of how easily that role could give rise to just this imagined intervention in a marriage bed.

As always, situations that seem perfectly plausible need rationalization; and this is exactly what one finds in this group of stories as well. The *Kaiserchronik* of around 1140–1150 tells that an herb was placed under the statue involved in order to make those who looked upon it fall in love with it. In the end, the statue was reconsecrated and dedicated to Saint Michael.[28] More often it is the ring that fulfills the crucial, almost talismanic function; and we think, just as in the

Kaiserchronik story, of *stoicheiosis* all over again. The act that enlivens the statue of the Venus or the Virgin is the giving of the ring; and that, even outside the realm of Freudian symbolism, is implicitly sexual (because it implies marriage, and therefore the marriage bed). The Virgins bend their fingers to receive the ring; they are therefore alive, and so they can come between the real lovers. Or—and how closely related this case is to the ones about temptation in the miracle legends—a young priest who is tempted by the flesh is commanded by the Pope to go to an altar where there is a beautifully painted picture of Saint Agnes, "ubi picta est Agnetis ymago formosa," and ask her hand in marriage. The image then stretches out its/her hand for the ring, and all the young man's temptation disappears.[29] It has, one may rightly say, been transferred to the picture. And so we have moved back from actual intercourse to what is, in effect, the subject of this chapter— arousal by image; and we move from making love in the newest sense to the broader, more old-fashioned sense.

Along with the many stories of the ring placed on the statue of the Virgin so popular from the thirteenth century on, the Saint Agnes account stands at the distant origins of the endless romantic tales in Eichendorff, in Merimée, in William Morris, and in many others about the situation of the bridegroom who is pursued by a jealous divinity on the finger of whose image he has slipped a marriage ring.[30] With this we embark on the whole topic of "Love by Sight of Image," as Stith Thompson entered it in his *Motif Index of Folk Literature*. His examples came from every continent, from Japan to the British Isles, from China to Finland, and from Iceland to Missouri, to say nothing of their occurrence in Indian and Arabic literatures.[31] The basic aspect of the topic is extremely close to that of the "Young Man Betrothed to a Statue"—someone falls in love with the image on a picture—only here the issue is even more crucial to the course of our investigation. The statue or picture is not used for overtly sexual purposes; there is no question, usually, of sexual intervention or sexual engagement. The question remains fundamentally one of looking—however much we may discern the projection of desire in feeling thus about a picture.[32]

This very last difficulty clarifies itself somewhat once we note the clear distinction within this body of tales. On the one hand, the image represents someone the beholder already knows; and this reinforces him or her in love, devotion, memory, and so on. On the other hand, men and women fall in love with the images of people they have not seen except on the image. Sometimes and

significantly they are moved to love by images of people who have not been seen before except in dreams; but this we must align with the first group. Into it falls Proteus's plea to Silvia in *The Two Gentlemen of Verona* (act 4, scene 2, lines 116–22):

> Madam: if your heart be so obdurate,
> Vouchsafe me yet your picture for my love,
> The picture that is hanging in your chamber;
> To that I'll speak, to that I'll sigh and weep;
> For since the substance of your perfect self
> Is else devoted, I am but a shadow;
> And to your shadow will I make true love.

For all the talk of shadows (which places these lines in one of the most venerable of all traditions of thought about imagery), the point, of course, is that Proteus says he wants to talk and weep to the image as if it were the real Silvia, neither image nor shadow.[33]

The equally typical verses penned by Leonardo Giustinian (1388–1446) almost two centuries earlier are more straightforward. He writes to his lover in a poem that begins, long before Marvell, with the perfectly standardized exhortation not to lose time: "Non perder, Donna, il dolce tempo c'hai/Deh non lassar diletto per durezza." After the usual sentiments about the impossibility of recovering lost time and the impermanence of beauty, the third stanza runs as follows:

> I have painted you on a small piece of card
> As if you were one of God's saints.
> When I rise in the sweet morning,
> I throw myself on my knees with desire.
> Thus I adore you, and then I say, O clear star
> When will you make my heart content?
> Next I kiss you and caress you tenderly;
> Then I go and take myself to Mass.[34]

And so he talks quite naturally to the image as if it were alive; he kisses and caresses it. The reference to God's saints may not be entirely nonchalant, not entirely a way of eulogizing the qualities of the lover. In a context like this, the

lover becomes as adorable as an image of a saint notoriously could be. It is as if the writer knows that the image can—almost idolatrously—be treated just as saints' images were, as if endowed with something magical, or, at any rate, with the presence that has so often been called magical.[35]

The second group takes us one step further away from such projections onto the image of desire for the person one already knows and wants. Again the variations are endless. The subject recurs many times in Arabic literature, particularly in the *Thousand and One Nights,* in the Turkish *Parrot Book,* in the *Tuti Nameh,* and in the epic poems of the twelfth-century Persian poet Nizami and the fifteenth-century Timurid poet Djami—to give only a few examples.[36] Men see an alluring representation of a woman in paintings and in books; filled with desire they set out to find her—often in charmingly complicated ways, as the genre requires. Thus, in the *Thousand and One Nights,* Ibrahim, the son of the Wazir of Egypt, stops at a bookseller on his way home from prayers. In one of the books he sees a picture of the most beautiful woman he can imagine. He pays a hundred dinars for it and falls to gazing upon it and weeping day and night, neither eating nor sleeping. He makes a desperate attempt to find her, the prototype of the image; but he discovers (as in many of these tales) that she is deeply hostile to men, "a virago of viragoes."[37] Women, too, cannot rest until they have found the living archetype of the handsome representation. So, for example, in the complex and intricate account of the role of pictures (and sculptures) in the love of Shirin and Khosrow in Nizami's *Khamseh,* Khosrow's confidante Shapur paints no less than three pictures of the Persian prince.[38] When Shirin sees the first one hanging from a tree in a hot and delightful meadow, she "holds it in her hands and gazes at the handsome Prince [whom she has never seen]. Her heart dissolves with joy and she embraces the portrait." But her handmaidens are afraid at her trembling, and in the kind of move that one could almost anticipate, they "destroy the image and burn rue to stop the spell. Only then does Shirin recover her senses." The next morning practically the same thing happens again, but now the maids do not even bring the picture to her. On the third day, Shapur makes yet another portrait. The Armenian princess catches sight of it, snatches it from the branch, and "worships it as if it were an idol. In its homage she drank wine, and with every sip she kissed the ground." And so she falls desperately and endlessly in love with Khosrow Parviz, whom, from early on, she was destined to marry.[39]

But the example of "Love by Sight of Image" that will come most readily to readers' minds is that of Tamino's aria in the first act of *The Magic Flute,* "Dies Bildnis ist bezaubernd schön." He begins:

> This portrait is bewitchingly beautiful,
> Such as no eyes have ever seen before.
> I feel how this divine image
> Fills my heart with a new stirring.
> This something I can scarcely name,
> Yet I feel it burning here like a fire.
> Can this sensation be love?
> O yes, it is love alone.
> If only I could find her
> O if only she just stood here before me!
> I would . . . I would warmly and purely . . .
> What would I do?
> Full of enchantment I would
> Press her to my ardent breast,
> And then she would eternally be mine!

The basic thematic structure of the aria could hardly be clearer; it is developed around the main elements of the theme we have been considering so far. But it also describes in extraordinary detail something of the mental movements that one can imagine accompanying the revelation of the picture. Tamino's heart is stirred, and then more powerfully so; he cannot name the emotion, he calls it love. Thus identified, the sentiment grows stronger; he moves from beautiful picture to the beautiful woman represented on it. Tamino is overwhelmed with a sense of her potential presence, her potential liveliness. He speaks of pressing her to his breast, and he wants to possess her forever.

There is one more telling aspect of these verses, and that is the reference to the picture as divine. Tamino himself calls it a *Götterbild,* but this is no idle trope. Both Mozart and Schikaneder knew in their bones that only a *Götterbild* could have such an effect and make the absent present; or induce such terrible desire, following veneration, for that which an image represented. But at the same time they knew that all images, once discovered or gazed upon with such attentiveness, par-

took of the quality of divine images. The ontology of the religious picture, as Hans-Georg Gadamer—like some new Sarastro—has reminded us, is exemplary for all pictures.

IV

I have strayed far from *looking, repression,* and *rationalization.* The moment has come to consider these terms more closely, but within the full embarrassment of their equivocal ideological implications and their awkwardness for the kind of history that is supposed to speak for itself.

What we learn most clearly from "Love by Sight of Image," and, indeed, from almost every one of the cases we have considered so far, is how the wish, the desire, and the need to make alive actually enlivens the dead image. It may be held that this is an inaccurate—or at least inadequate—way of saying that the desire to make what the image represents alive is what, in the end, makes it seem alive; or that by the projective act we bring forward the signified wholly to replace the sign (rather than, say, to fuse the signified and signifier). This refinement would possibly make the role of attentive beholder rather clearer and remove—rightly, it might be argued—the quality of liveliness from the ontology of the image. *Liveliness* in itself is a coarse term; its metaphorical aspect merges easily and closely with its literal one. But the coarseness may be useful and should alert us to the problem of seeking refinement in this area. We begin to see how the general and apparently vague formulation with which this paragraph opened may, in fact, be more revealing, once we realize that it may be profitable to dispense with semiosis as we consider the investment with life and liveliness. An even more radical step would be deliberately to eschew any attempt to distinguish between the transitive and intransitive senses of investment or—at best—to conceive of the problem of arousal in terms of the dialectic between its active and passive modes. Excessive emphasis on the active mode of investment is likely to lead into the dead end (into which all our examples may seem to head) where all arousal has to do with figuration. It may not; it may have as much to do with the cognition of correspondences between feeling and the liveliness of shape, form, contour, color, and surface. Taken *grosso modo,* such a formulation serves the relations between arousal and what is nonfigurative, too.

On the other hand, the danger with the approach adumbrated here is that it may seem to lead to mysticism or to absurdly sexist views of arousal. Toward the

very start of his introduction to *The Florentine Painters,* Berenson embarked on the outline of a now famous theory. The theory, such as it is, admittedly came after a statement about the Florentine preoccupation with figure painting; but the idea had and has much more general implications. As we follow it, we follow, too, a path of ideas that starts with a view of how the beholder invests the image with life; that then shows a sense of the dialectic at stake; and that ends, as so often with so much art history, utterly intransitively, though ostensibly predicated on the action of the painter and his or her activation of the object.

> Psychology has ascertained that sight alone gives us no accurate sense of the third dimension . . . although it remains true that every time our eyes recognize reality, we are, as a matter of fact, giving tactile values to retinal impressions. . . . [The painter] can accomplish his task only as we accomplish ours, by giving tactile values to retinal impressions. His first business, therefore, is to rouse the tactile sense, for I must have the illusion of being able to touch a figure . . . before I shall take it for granted as real, and let it affect me lastingly. It follows that the essential in the art of painting—as distinguished from the art of colouring—is somehow to stimulate our consciousness of tactile values, so that the picture shall have at least as much power as the object represented, to appeal to our tactile imagination. . . . [We] no longer find [Giotto's] paintings more than lifelike; but we still feel them to be intensely real in the sense that they powerfully appeal to our tactile imagination, thereby compelling us, as do all things that stimulate our sense of touch while they present themselves to our eyes, to take their existence for granted. And it is only when we can take for granted the existence of the object painted that it can begin to give us pleasure that is genuinely artistic, as separated from the interest we feel in symbols.[40]

And the passage goes on to discuss the matter of pleasure. It is true that for Berenson it is not—explicitly or in any sense—a matter of sexual pleasure; but the argument that relates tactility to the assumption of the existence of what is represented in the picture derives quite clearly from the kinds of tales we have been considering. This is to make no claim for the psychological validity of the Berensonian view; nor do I propose to test it. What is telling is the move that Berenson immediately makes to the "genuinely artistic," as becomes abundantly apparent in the next stages of his essay. For him it is precisely because of art that

we take greater pleasure in the object painted than in itself. Giotto's pictures were great—and ipso facto give greater pleasure—because they convey "a keener sense of reality, of lifelikeness than the objects themselves." The opportunity to consider the forms of arousal (even "pleasure" in the Berensonian sense) that are consequent on the internal life of the constitutive components of the painted or sculptured object (irrespective of whether they show organic figures) has been utterly lost. Instead it is art that gives life, arouses, and is pleasurable. Art becomes, mystically and slightly absurdly, "life-enhancing"; and because it is art, it will never descend from the vague and the mystical.

"Others," according to the *New York Times Magazine* on David Salle's pictures, "such as Philip Johnson, contend that 'sex should be in pictures—why not? That slight tumescence that you feel sometimes is part of seeing.'"[41] In sentiment as well as in tone, the statement is as much of our times as Berenson's were of the 1890s. On the face of it, it seems perfectly to encapsulate the position suggested at the beginning of this chapter: that desire is implicit in seeing and that (in the West at least) all looking is male (since "tumescence" in Johnson's statement can hardly be taken to be meant as anything but masculine). But the fact is that the tone of this claim is entirely characteristic of the prison-house of late twentieth-century talk about art. It appears to be open, candid, and free of repression; but in its glib dispassion, in the archness of the adverb that modifies "tumescence," and in the vagueness of "sex should be in pictures" (presumably good ones, as in Berenson), it passes by the very core of the disturbances that arise from the relations between looking and what is in the image. We have learned—just as Foucault has shown in his long meditation on the history of sexuality—to seem to talk about that which we cannot, or refuse to, talk about.[42]

V

Everyone knows the story of Pygmalion; by now it will have come to the mind of every reader of this book. It tells of how a sculptor falls in love with his creation, which then turns into a real being.[43] It seems so peculiarly apt for illustration that one can only wonder that its vogue—before the nineteenth century at least—was not greater. Then, in the nineteenth century, it also had its most important (and possibly most inventively interesting) literary influence, above all in the great stories of Balzac and Zola—*Le chef d'oeuvre inconnu* and *L'oeuvre*. The significant difference between the tales collected by Baum (where a dead image comes alive and

somehow interpolates itself between the main character and another living being) and the story of Pygmalion is that the protagonist is now the creator of the image himself; so the act of re-creation by love becomes the hallmark of the powers of artistic creation itself. But Ovid's account of Pygmalion and his statue provides so extraordinary a gloss on the stages in the enlivening of an image, and the substitution of living body for dead material, that it is worth pondering in almost all its compelling detail.

One should suspend, for a moment, the inclination to overpsychologize the opening of the tale as an explanation for what happens in the rest of it; rather, the whole should be read in the light of the other anecdotes and tales in this chapter.

When Pygmalion saw these women, living such wicked lives, he was revolted by the many faults which Nature had given to the female sex, and long lived a bachelor existence, without any wife, to share his home. With marvellous artistry he skillfully carved a snowy ivory statue. He made it lovelier than any woman born, and fell in love with his own creation. The statue had all the appearance of a real girl, so that it seemed to be alive, to want to move, did not modesty forbid. So cleverly did his art conceal its art. Pygmalion gazed in wonder, and in his heart there rose a passionate love for this image of a human form. Often he ran his hands over the work, feeling it to see whether it was flesh or ivory, and he would not yet admit that ivory was all it was.[44] He kissed the statue, and imagined that it kissed him back, spoke to it and embraced it, and thought he felt his fingers sink into the limbs he touched, so that he was afraid lest a bruise appear when he had pressed the flesh. Sometimes he addressed it in flattering speeches, sometimes brought the kind of presents that girls enjoy. . . . He dressed the limbs of his statue in woman's robes, and put rings on its fingers, long necklaces round its neck. Pearls hung from its ears, and chains were looped upon its breast. All this finery became the image well, but it was no less lovely naked. Pygmalion then placed the statue on a couch that was covered with cloths of Tyrian purple, laid its head to rest on soft down pillows, as if she could appreciate them and called it his bedfellow.

The festival of Venus . . . was now in progress when Pygmalion, having made his offering, stood by the altar and timidly prayed, saying "If you gods can give all things, may I have as my wife, I pray"—he did not dare to say "the ivory maiden," but finished, "one like the ivory maid." However golden Venus, present at her festival in person, understood what his prayers meant. . . . When

Pygmalion returned home, he made straight for the statue of the girl he loved, leaned over the couch, and kissed her. She seemed warm: he laid his lips on hers again, and touched her breast with his hands—at his touch the ivory lost its hardness and grew soft: his fingers made an imprint on the yielding surface, just as wax of Hymettus melts in the sun and, worked by men's fingers, is fashioned into many different shapes, and made fit for use by being used. The lover stood, amazed, afraid of being mistaken, his joy tempered with doubt, and again and again stroked the object of his prayers. It was a body; he could feel the veins as he pressed them with his thumb.[45]

We recognize almost every element in the tale, at least in its first part. The sculptor falls in love with the image; he wishes it to be alive. He speaks to it and hopes to be spoken to; he wants to possess the statue as if alive. With hope and great passion he wishes the statue to come alive, and it does. We may be tempted to read the tale in the light of Freudian psychology, say in terms of the initial description of Pygmalion's misogyny and celibacy, and thereby explain the whole course of events, from the carving of an unimaginably beautiful woman to using it first as a substitute body and then as a real one. But Ovid did not, of course, intend his tale as a psychological document in anything like this sense. It would be grossly fallacious to read it in terms of this sort of psychological reduction. On the other hand, his marvelously detailed description is utterly paradigmatic in its account of arousal by image.

It begins with repression (celibacy) and moves through sublimation in the form of artistic creativity. Repression follows again (it is only art, it is not real, it cannot be sexual). But creation implies life: The statue is not only lifelike, it comes alive by the very miracle of creation, and sexual liberation follows.

But note how intricately Ovid has managed to weave in the strands of art and looking. There could be no more gripping formulation of the repression that implies arousal and the need for possession. The statue is so beautiful that it threatens to come alive; it threatens no longer to be art, but life. Here is the final paradox. It *is* art; but, as Ovid puts it, "his art concealed its art." It had to do that, because once it came alive, it could no longer be art. It was art, because it "seemed to be" alive and—like all good art—to want to speak and move. But if it did that, one would be ashamed; and so it remained locked into its skillfully artistic but always artisanal matrix.

Then, however, Pygmalion stood back from it and "gazed at it in wonder." The phrase is Mary Innes's extremely deft translation of the Latin *miratur,* which at once combines exactly the two elements that constitute the fetishization of the object. Passion for it follows. Pygmalion kisses it; he decks it out. Finally he lays it on his bed, on the softest of pillows, and calls it his bedfellow—exactly as if it were alive. The poet makes it perfectly clear that Pygmalion expected the statue to feel the softness of the bed.

Then Pygmalion goes to the festival of Venus, and the miracle happens. Perhaps the most brilliant part of the passage is the description of the artist's self-consciousness about just what was happening in his thoughts as he prayed. He asks to have—to possess—as his wife the ivory statue itself; but he knows it is still art. He stops himself, just in time, and asks for one *like* the ivory statue. But Venus understands him, and the statue turns into a living being. It is no longer art but life; but it has been enlivened by looking, by a looking that could only have happened because of the beauty of the statue. The fetishization of the beautiful object follows, and the eager beholder is aroused. The great paradox and the great tragedy that lies in making the protagonist an artist is that the object he made was only beautiful because of his skills, because it was art; but as soon as it came alive, it was no longer a piece of art at all. It was indeed, and no less, the body itself.

The extraordinary thing about Ovid's Pygmalion passage is that it also adumbrates two deep fears: in the first place, that of the real body, and in the second, that of making an image come alive. The second is always a danger with artistic creativity. We are reminded again of the Islamic strictures against image making, where the artist suffers dire consequences for his ultimately fruitless (and temerarious) efforts to emulate God's own creativity—since it is only God who can make truly living images.[46] It is hard not to reflect on the irony of the repeated presence of stories such as those around the topic of "Love by Sight of Image" in a culture where the tradition (though, as we know, not the practice) evinced such grave misgivings about the portrayal of the living—to such an extent that Aisha, the ten-year-old wife of the Prophet, was only allowed to play with dolls on condition that they did not resemble people.[47] Indeed, there are several manuscripts of Nizami's *Khamseh,* where the faces of the protagonists and all the other figures are rendered without features. But the fear of making alive is, in the end, less difficult to grasp, since it is not hard to understand that we should want our creations to remain inert; it is we who should remain masters of what we make, and not have them

turn into phantoms that seem dangerously to be like ourselves, and therefore both equal and stronger. We must now proceed to the first fear, that of the body itself, because it attaches to one of the most fundamental fears of all images (namely, that they appeal to the senses), and because it forms the basis of the innumerable reservations that terminate in censorship.

EPIGRAPH

See Charles Rosen in the *New York Review of Books,* 17 December 1987, for a brilliant discussion of the implications of this and other changes in the various versions and editions of Balzac's story; and on the problem of romantic revision in general.

NOTES

1. For this reason, little would be served by outlining the long history of the use of pictures in private erotic contexts. From Tiberius's use of "the most lascivious pictures" in the rooms in which he held his orgies and his installation of Parrhasius's painting of Atlanta "gratifying Meleager with her mouth" (Suetonius, *Tiberius,* 43–44), the cases of the suggestive, therapeutic, and auxiliary use of images, both high and low, extend abundantly into the present—and everyone knows of them.

2. "Arousal by Image" was originally published as chapter 12 of *The Power of Images* (Chicago and London: University of Chicago Press, 1989).

3. See, for example, the text attributed to Germanos of Constantinople in ed. J. P. Migne, *Patrologia Graeca* (Paris, 1857–66), 98, col. 3999, and that by Arnaldus of Chartres, in ibid., 199, cols. 1725–26 (adapted in the *Speculum humanae salvationis,* cap. 12). J. B. Knipping, *Iconography of the Counter-Reformation in the Netherlands,* 2 vols. (Nieuwkoop and Leiden, 1974), 263–75 provides an extremely illuminating overview of the later material derived from basic texts like these.

4. Illustrated, perhaps, by stories about monks and novices such as those discussed in chapter 11, section 4 of *The Power of Images,* and in section 2 of this chapter.

5. M. Gorky, *My Apprenticeship,* trans. M. Wettlin (Moscow, 1932), 161–64.

6. Caesarius, *Dialogus,* dist. 8, cap. 16. Cf. chapter 11, section 4 in *The Power of Images.*

7. Vasari-Milanesi 4: 535–36 (in the *Life of the Ghirlandai*).

8. *The Travels and Controversies of Friar Domingo Navarrete, 1618-1686,* ed. J. S. Cummins (Cambridge, 1962), 1:162, n. 1. Cf. G. de Magalhaes, *A New History of China* (London, 1688), 103.

9. See P. Schwarz, *Iran in Mittelalter nach den arabischen Geographen* (Leipzig, 1921), 4:488, citing Kazwini and Ibn Rusta. For more on these Sassanid sculptures and their location, see W. Barthold, *An Historical*

Geography of Iran, trans. S. Soucek, ed. C. E. Bosworth (Princeton, 1984), 195-97. The story is also briefly referred to in [E. Kris and O. Kurz, *Legend, Myth and Magic in the Image of the Artist* (New Haven and London, 1979), 72.] Cf. the 1972 attack on Michelangelo's *Pietà* (discussed in chapter 14, section 6 of *The Power of Images*), where the nose seems to have been one of the particular targets.

10. Cited in C. Koch, "Über drei bildnisse Baldungs als künstlerische Dockumente von Beginn seines Spätstils," *Zeitschrift für Kunstwissenschaft* 5 (1975): 70, from H. Rott, *Quellen und Forschungen zur sud-westdeutschen und schweizerischen Kunstgeschichte*, 3, 1: *Der Oberrhein* (Stuttgart, 1935), 227.

11. Kris and Kurz 1979, 72.

12. As E. de Jongh did so brilliantly in his article on erotic symbolism and boundaries of shame in the Netherlands in the seventeenth century (E. De Jongh in *Simiolus* 3:22 [1968-69].

13. *Morlini novellae*, Joan Pasquet de Sallo (Naples, 1520). The edition used here is *Hieronymi Morlini Parthenopei, Novellae, Fabulae, Comoediae: Editio tertia, emendata et aucta* (Paris, 1855). See the "Avant-propos" here for a useful summary of the earlier editions, piratical and otherwise.

14. Morlini 1855 ed., 158-59.

15. Brantôme, *Vie des dames galantes*, in *Oeuvres*, ed. L. Lalanne (Paris, 1876) 9:580 (in the *Discours sur les femmes mariées, les vefves et les filles a sçavoir desquelles les unes sont plus chaudes a l'amour que les autres*).

16. Calcagnino's report was published in *Archivio Storico dell'Arte* 2 (1889): 377-78. See also S. Pressouyre, "Les fontes de Primatice à Fontainebleau," *Bulletin Monumental* 127 (1969): 230 for a brief reference.

17. For the sources, see note 21 below.

18. The date of the life is extremely problematic. The arguments range from the fifth or sixth century to the late tenth century. For the latter, see L. Rydén, "The Life of Andreas Salos," *Dumbarton Oaks Papers* 32 (1978), 129-55.

19. C. Mango, "Antique Statuary and the Byzantine Beholder," *Dumbarton Oaks Papers* 17 (1963), 60.

20. Mango (ibid., 56) notes that "whereas some Christian thinkers believed idols inanimate, the general opinion was that they were inhabited by maleficent demons" (while "conversely in the eyes of the fourth- century Neo-Platonists, idols were animated with divine presence"). The fullest source for the varieties of statue behavior—and for attitudes to them—is the eighth-century Constantinopolitan guide known as the *Parastaseis syntomoi chronikai* (now republished in the excellent 1984 edition by A. Cameron and J. Herrin). Mango describes it as being "on a low intellectual level." There may be some justice in the categorization, but its tone unmistakably reveals, yet again, a kind of devaluation of what is "low-level" and commonplace.

21. J. Overbeck, *Die antike Schriftquellen zur Geschiche der bildenden Künste bei den Griechen* (Leipzig, 1868), nos. 1227-45 and 1263; and J. T. Pollitt, *The Art of Greece 1400-43 B.C.* (Englewood Cliffs, NJ, 1965), 128-31. When Pliny, *Historia naturalis*, 36.20, refers to the story, he notes that there was another nude by Praxiteles in Parium on the Propontis, which was equally famous and also roused youthful desire, in the same way.

22. "Samos, they say, has had a case like this;/ The poor chap fell in love with a marble miss,/ and locked himself in the temple." This is the charming translation of the passage from Alexis provided by J. M. Edmonds, *The Fragments of Attic Comedy* (Leiden, 1959), 2:393, and taken from the section in Athenaeus, *Deipnosophists*, 13.605 ff. on falling in love with works of art. Athenaeus provides further details: the name of Alexis's play was *The Picture*; the young man was Cleisophus of Selymbria; and— according to Adaeus of Mitylene's book *On Sculptors*—the statue was the work of Ctesicles, possibly as Edmonds suggests, identical with the painter of Stratonice referred to in Pliny, *Historia naturalis*, 35.40.33. Cf. also Philemon 139, cited in Athenaeus *Deipnosophisti*, 13.606a (Edmonds 1961, 3:76-77); and Lucian, *Amores,*13.

23. Aelian, *Variae historiae,* 9.39 (in the section *De ridiculis et absurdis amoribus*).

24. Miélot 1928-29 ed., 126-27 (Paris, Bibliothèque Nationale, MS fr. 9198, fol. 124). Cf. Caesarius, *Libri VIII miraculorum,* lib. 3, cap. 23 (also discussed at the end of chapter 11, section 4 of *The Power of Images*).

25. It is no part of the aim of this book to make claims for the greater effectiveness of images over words, or vice versa. For the problematic of all such claims, see now the thoughtful analysis of the problem as a whole in W.J.T. Mitchell, *Iconography: Image, Text, Ideology* (Chicago and London, 1986).

26. The most useful compilation is still that provided by P. F. Baum "The Young Man Betrothed to a Statue," *Publications of the Modern Language Association* 34, 4 (1919): 523-79, who surveys both the primary and the secondary material; but some additional discussion is provided by Theodore Ziolkowski, *Disenchanted Images: A Literary Iconology* (Princeton, 1977).

27. Cf. Mussafia, *Studien.* I:962 (Paris, Bibliothèque Nationale, MS fr. 12593, no. 29). See also H. Focillon, *Le peintre des Miracles de Notre Dame* (Paris, 1950), x and text (from Paris, Bibliothèque Nationale, MS nouv. acq. fr. 24541, dating from the first half of the fourteenth century). But the story may be found in several further places in Gautier and is discussed on several occasions by Mussafia in his analysis of the manuscripts of the miracle legends. See, for example, A. Mussafia, *Über die von Gautier de Coincy benützte Quellen* (Denkschriften der Kaiserliche Akademie der Wissenschaften, Philosophicke-Historische Klasse, 44.1, Abh 1. 1896), 35-37 (relating to Gautier book I, miracle 12).

28. Baum 1919, 529-30. For the whole story, see Monumenta Germaniae Historica, Deutsche Chroniken, 1:319-23.

29. Baum 1919, 562, has the text, which comes from Bartholomew of Trent but was earlier reproduced in A. Graf, *Roma nella memoria del medio evo* (Turin, 1883), 2:402, n. 69 (also in the chapter in the *Legenda Aurea* on Saint Agnes).

30. Eichendorff, *Das Marmorbild* (1817-19), *Julian* (1853); Merimée, *Venus d'Ille* (1837); William Morris, *The Earthly Paradise* (1870). For a more recent treatment of the whole theme, along with a full expansion of the postmedieval treatments of the subject, see the chapter entitled "Venus and the Ring," in Ziolkowski, 1977, 18-77 (see note 26 above).

31. S. Thompson, *Motif Index of Folk Literature*, rev. and enl. ed. (Bloomington and London, 1975). See also Thompson's index in *Indiana University Studies* 21, nos. 103–6 (1934), and 22, nos. 108–10, s.v. "Love through sight of picture" (T.2.2) and "Love through sight of statue" (T.2.2.1).

32. Similar issues arise in the case of another, more overtly functional category of images. Everyone knows how, before the advent of photography, portraits were used by those who could afford such luxuries to assist in the selection of spouses. In Rubens's Marie de' Medici cycle, Henri IV casts an assessing eye at the somewhat glamorized portrait of Marie, though Holbein's great portrait of Christina of Denmark apparently moved Henry VIII less. In each case, reasons of state probably played more of a role in the outcome than anything to do with the way the portrait looked. But the case must be different with the pictures of courtesans and prostitutes. Some, of course, may simply have been intended to be the fond recording of the features of favorite mistresses, as, presumably, in the case of the well-known pictures by Palma Vecchio, Titian, and Paris Bordone, and the many instances in Andrea Vendramin's collection. But one can never be quite certain; nor can one be sure of the effects of the well-known Fontainebleau paintings supposedly of Diane de Poitiers had, or of the *Jocondes*, the half-length or partly nude versions of Leonardesque prototypes that figure so prominently in the inventories of the seventh-century bourgeoisie in Paris (see G. Wildenstein, "Le goût pour la peinture dans la bourgeoisie parisienne au début de la règne de Louis XIII," *Gazette des Beaux-Arts* 37, ser. 6 [1950]: 153–273). Indeed, with the latter pictures as well as with the illustrated catalogs of courtesans by Crispin de Passe, for example, and many of the pictures of prostitutes in the sixteenth- and seventeenth-century inventories, one wonders whether they should not be assigned a specific erotic function, along the lines of the *libidinis fomenta* described by Thomas Peacham in *The Gentleman's Exercise* of 1612 (though those, significantly, were in the round; cf. chapter 13, section 2, below). In any event, the potentiality of all such pictures seems to be perfectly illustrated by the theme "love through sight of picture," which I continue to discuss in the text. For further details of the kinds of courtesan picture discussed in this note, see the excellent brief review in A. Kettering, *The Dutch Arcadia: Pastoral Art and Its Audience in the Golden Age* (Montclair, N.J., 1983), esp. 51–55 and notes.

33. Cf. chapter 3, note 10 in *The Power of Images*, for a specific parallel from Leonardo, as well as the discussion of the general problem in chapter 11.

34. L. Giustinian, "Dagli Stramborci," in *Il Fiore della lirica Veneziana*, ed. M. Dazzi (Venice, 1956), 1:99.

35. For the further implications of the notion that the lover's image could be created idolatrously (as Julia insists in the very next stanza in the lines from Shakespeare), see also chapter 13, section 7, and note 70 in *The Power of Images*.

36. For others, see the useful but by no means complete survey by J. C. Bürgel, "'Dies Bildnis ist bezaubernd schön!' Zum Motiv 'Love through Sight of Picture' in der klassischen Literatur des islamischen Orients," in *Michael Stettler zum 70 Geburtstag . . . Porträtstudien* (Bern, 1983), 31–39.

37. "The Tale of Ibrahim and Jamilah" in *The Book of the Thousand Nights and a Night*, trans. Richard Burton (New York: 1934), 3415-40. What is significant about this tale is that Jamilah is hostile to men only because she had already fallen in love with Ibrahim—on the basis of *reports* about his beauty— and thus could not stand any other. Cf. my comments on Mitchell in chapter 13 of *The Power of Images*.

38. It is worth noting here Shapur's claim when he is first brought into the story: "When I draw a person's head," he asserts, "it moves; the bird whose wing I draw will fly" (cf. both chapter 5, section 1, and chapter 11, section 2; also chapter 10, note 91 in *The Power of Images*); and then follows the even greater cliché: "At portraiture, Shapur excelled; he could capture not only the likeness but the subject's very soul." This translation from P. J. Chelkowski, *Mirror of the Invisible World: Tales from the Khamseh of Nizami* (New York: 1975), 22-23.

39. Ibid., 23-24. On pages 46-47, Chelkowski gives a very useful commentary on the earlier versions of the story of Khosrow and Shirin by Khalid ibn Fayyaz, Ferdowsi, and Quatran, and assesses special characteristics of Nizami's great retelling.

40. B. Berenson, *The Florentine Painters of the Renaissance* (New York and London: 1896), 3-7.

41. P. Taylor, "How David Salle Mixes High Art and Trash," *New York Times Magazine* (11 January 1987): 28.

42. One difficulty is that when we locate the kind of perception attributed to Philip Johnson in the context of the wide availability of artworks in New York in the 1980s, and see its origins in pure male ideologies, we mitigate the truth that it hides. So, too, it is easy to contextualize elsewhere, and thereby retrieve other forms of evasiveness. On the face of it, one may find something appealing about the effort to corroborate past reports with present experience in Theodor Birt's lecture, six years after Berenson's Florentine introduction, on lay judgments about art in antiquity (*Laienurtheil über bildende Kunst bei den Alten: Ein Capitel zur antiken Aesthetik*. Rektoratsrede [Marburg, 1907]). "He who knows the Southerner," comments Birt, also offhandedly, "knows just how impressionable is his erotic fantasy." The assertion is given a footnote, as follows: "I myself have observed this phenomenon among young Neapolitans, as they stand before the Venuses from Pompeii in the Museo Borbonico." A good thing that they were young and Neapolitan! One could hardly wish for a clearer demonstration of the dangers of contextualization. Birt, being the rector of a German university, could naturally be more dispassionate in his responses; and one would not want to suspect his erotic fantasies of being too impressionable. In any case, they would not be relevant in this book at all. My reference to Foucault is, of course, to *Histoire de la sexualité*, vols. 1-3 (Paris, 1976-84).

43. For a parallel from the Persian *Book of Parrots*, in which four men share in the creation of a work of art which by their prayer becomes alive and then compels them all to fall in love with it, see Kris and Kurz 1979, 72, citing R. Schmidt's translation of the *Sukasaptati* (Munich, 1913), 149 ff.

44. Cf. the end of the opening section of Alberti, *De pictura*, book 2, which provides another kind of com-

ment on the transforming power of art over precious substances. Cited and discussed in chapter 3 of *The Power of Images*.

45. Ovid, *Metamorphoses,* 10, lines 243-89. I have only slightly modified the translation by Mary M. Innes in the Penguin Classics series (1955 et seq.).

46. Paret 1960, especially 38-41, has a number of the relevant texts from the Hadith.

47. A. Papodopoulo, *Islam and Muslim Art,* trans. R. E. Wolf (New York, 1979), 55-58, discusses those aspects of the Hadith that concern portraiture as well as the resistance to the imitation of animate beings in general. See also O. Grabar, *The Formation of Islamic Art* (New Haven and London, 1977), 75-104.

II.

OWNERSHIP

Doctor Lawyer Indian Chief: "Primitivism" in Twentieth-Century Art at the Museum of Modern Art in 1984

(ARTFORUM, NOVEMBER 1984)

THOMAS MCEVILLEY

SOMETHING, CLEARLY, IS AFOOT. RICHARD OLDENBURG, DIRECTOR OF THE Institution here, describes one of its publications and the exhibition it accompanies, both titled *"Primitivism" in Twentieth-Century Art: Affinity of the Tribal and the Modern*, as "among the most ambitious ever prepared by The Museum of Modern Art." "Over the years," he continues, "this Museum has produced several exhibitions and catalogues which have proved historically important and influential, changing the ways we view the works presented, answering some prior questions and posing new ones."[1] Indeed, this *is* an important event. It focuses on materials that bring with them the most deeply consequential issues of our time. And it illustrates, without consciously intending to, the parochial limitations of our world view and the almost autistic reflexivity of Western civilization's modes of relating to the culturally Other.

The exhibition, displaying 150 or so modern artworks with over 200 tribal objects, is thrilling in a number of ways. It is a tour de force of connoisseurship. Some say it is the best primitive show they have seen, some the best Eskimo show, the best Zairean show, the best Gauguin show, even, in a sense, the best Picasso show. The brilliant installation makes the vast display seem almost intimate and cozy, like a series of early modernist galleries; it feels curiously and deceptively

unlike the blockbuster it is. Still, the museum's claim that the exhibition is "the first ever to juxtapose modern and tribal objects in the light of informed art history"[2] is strangely strident. Only the ambiguous word *informed* keeps it from being ahistorical. It is true that the original research associated with this exhibition has come up with enormous amounts of detailed information, yet since at least 1938, when Robert Goldwater published his seminal book *Primitivism in Modern Painting*, the interested public has been "informed" on the general ideas involved.[3] For a generation at least, many sophisticated collectors of modern art have bought primitive works too, and have displayed them together. For five or so years after its opening in 1977, the Centre Pompidou in Paris exhibited, in the vicinity of its modern collections, about 100 tribal objects from the Musée de l'Homme. Though not actually intermingled with modern works, these were intended to illustrate relationships with them, and included, as does the present show, primitive objects owned by Picasso, Braque, and other early modernists. More recently, the exhibition of the Menil Collections in Paris's Grand Palais, in April, 1984, juxtaposed primitive and modern works (a Max Ernst with an African piece, Cézanne with Cycladic), and sometimes, as in the present exhibition, showed a modern artist's work in conjunction with primitive objects in his collection. The premise of this show, then, is not new or startling in the least. That is why we must ask why MoMA gives us primitivism now—and with such intense promotion and overwhelming mass of information. For the answer, one must introduce the director of the exhibition, and, incidentally, of the museum's Department of Painting and Sculpture, William Rubin.

One suspects that for Rubin the Museum of Modern Art has something of the appeal of church and country. It is a temple to be promoted and defended with a passionate devotion—the temple of formalist modernism. Rubin's great shows of Cézanne in 1977 and Picasso in 1980 were loving and brilliant paeans to a modernism that was like a transcendent Platonic ideal, self-validating, and, in turn, validating and invalidating other things. But like a lover who becomes overbearing or possessive, Rubin's love has a darker side. Consider what he did to Giorgio de Chirico: A major retrospective of the artist's work, in 1982, included virtually no works made after 1917—though the artist lived and worked for another half century. Only through 1917, in his earliest years as an artist, did de Chirico practice what Rubin regards as worth looking at. This was a case of the curator's will absolutely overriding the will of the artist and the found nature of the oeuvre. A

less obvious but similar exercise occurs in Rubin's massive book *Dada and Surrealist Art*[4]—a book not so much about dada and surrealism as against them. The dadaists, of course, and following them the surrealists, rejected any idea of objective aesthetic value and of formally self-validating art. They understood themselves as parts of another tradition that emphasized content, intellect, and social criticism. Yet Rubin treats the dada and surrealist works primarily as aesthetic objects, and uses them to demonstrate the opposite of what their makers intended. While trying to make anti-art, he argues, they made art. Writing in 1968, at a time when the residual influence of the two movements was threatening formalist hegemony, Rubin attempted to demonstrate the universality of aesthetic values by showing that you can't get away from them even if you try. Dada and surrealism were, in effect, tamed.

By the late seventies, the dogma of universal aesthetic feeling was again threatened. Under the influence of the Frankfurt thinkers, and of postmodern relativism, the absolutist view of formalist modernism was losing ground. Whereas its aesthetics had been seen as higher criteria by which other styles were to be judged, now, in quite respectable quarters, they began to appear as just another style. For a while, like Pre-Raphaelitism or the Ashcan school, they had served certain needs and exercised hegemony; those needs passing, their hegemony was passing also. But the collection of the Museum of Modern Art is predominantly based on the idea that formalist modernism will never pass, will never lose its self-validating power. Not a relative, conditioned thing, subject to transient causes and effects, it is to be above the web of natural and cultural change; this is its supposed essence. After several years of sustained attack, such a credo needs a defender and a new defense. How brilliant to attempt to revalidate classical modernist aesthetics by stepping outside their usual realm of discourse and bringing to bear upon them a vast, foreign sector of the world. By demonstrating that the "innocent" creativity of primitives naturally expresses a modernist aesthetic feeling, one may seem to have demonstrated, once again, that modernism itself is both innocent and universal.

"Primitivism" in Twentieth-Century Art is accompanied by a two-volume, seven-hundred-page catalogue, edited by Rubin, containing over one thousand illustrations and nineteen essays by fifteen eminent scholars.[5] It is here that the immense ideological web is woven. On the whole, Goldwater's book still reads better, but many of the essays here are beautiful scholarship, worked out in exquisite detail.

Jack Flam's essay on the fauves and Rubin's own one-hundred-page chapter on Picasso exemplify this strength. The investigation and reconstruction of events in the years from 1905 to 1908 recur in several of the essays; these years constitute a classic chronological problem for our culture, like the dating of the Linear B tablets. At the least, the catalogue refines and extends Goldwater's research (which clearly it is intended to supplant), while tilling the soil for a generation of doctoral theses on who saw what when. Its research has the value that all properly conducted scientific research has, and will be with us for a long time. In addition to this factual level, however, the catalogue has an ideological, value-saturated, and interpretive aspect. The long introductory essay by Rubin establishes a framework within which the other texts are all seen, perhaps unfortunately. (Some do take, at moments, an independent line.) Other ideologically activated areas are Rubin's preface, and the preface and closing chapter ("Contemporary Explorations") by Kirk Varnedoe, listed as "codirector" of the exhibition after "director" Rubin.

A quick way into the problems of the exhibition is, in fact, through Varnedoe's "Contemporary Explorations" section. The question of what is really contemporary is the least of the possible points of contention here, but the inclusion of great artists long dead, like Robert Smithson and Eva Hesse, does suggest inadequate sensitivity to the fact that art making is going on right now. One cannot help noting that none of the types of work that have emerged into the light during the last eight years or so is represented. Even the marvelous pieces included from the eighties, such as Richard Long's *River Avon Mud Circle,* are characteristic of late sixties and seventies work.

A more significant question is the unusual attention to women artists—Hesse, Jackie Winsor, Michelle Stuart, and, above all, Nancy Graves. Though welcome and justified, this focus accords oddly with the very low proportion of women in the show that preceded *"Primitivism"* at the new MoMA, *An International Survey of Recent Painting and Sculpture.* That show had a different curator, yet in general it seems that curators need a special reason to include a lot of women in a show—here, perhaps the association of women with primitivism, unconsciousness, and the earth, a gender cliché that may have seemed liberating ten years ago but may seem constricting ten years hence.

In the context of modern art, *primitivism* is a specific technical term: The word, placed in quotation marks in the show's title, designates modern work that alludes to tribal objects or in some way incorporates or expresses their influence.

Primitivism, in other words, is a quality of some modern artworks, not a quality of primitive works themselves. *Primitive,* in turn, designates the actual tribal objects, and can also be used of any work sharing the intentionality proper to those objects, which is not that of art but of shamanic vocation and its attendant psychology. Some contemporary primitivist work may also be called primitive; yet the works selected by Varnedoe are conspicuously nonprimitive primitivism. The works of Smithson and Hesse, for example, may involve allusion to primitive information, but they express a consciousness highly attuned to each move of Western civilization. Rubin and Varnedoe make it clear that they are concerned not with the primitive but with the primitivist—which is to say they ask only half the question.

There are, in fact, contemporary artists whose intentionalities involve falling away from Western civilization and literally forgetting its values. These are the primitive primitivists; they are edited out of the show and the book altogether. The farthest the museum is willing to go is Joseph Beuys. Varnedoe explicitly expresses a dread of the primitive, referring darkly to a certain body of recent primitivist work as "sinister," and noting that "the ideal of regression closer to nature is dangerously loaded," that such works bring up "uncomfortable questions about the ultimate content of all ideals that propose escape from the Western tradition into a primitive state."[6] The primitive, in other words, is to be censored out for the sake of Western civilization. The museum has evidently taken up a subject that it lacks the stomach to present in its raw realness or its real rawness. Where is the balance that would have been achieved by some attention to work like Eric Orr's quasi-shamanic objects involving human blood, hair, bone, and tooth, or Michael Tracy's fetishes of blood, hair, semen, and other taboo materials? The same exorcizing spirit dominates the schedule of live performances associated with the exhibition: Meredith Monk, Joan Jonas, and Steve Reich, for all their excellences, have little to do with the primitivist, and less with the primitive. Where are the performances of Hermann Nitsch, Paul McCarthy, Kim Jones, and Gina Pane? Varnedoe's dread of the primitive, of the dangerous beauty that attracted Matisse and Picasso and that continues to attract some contemporary artists today, results in an attempt to exorcize them, and to deny the presence, or anyway the appropriateness, of such feelings in Western humans.

Our closeness to the so-called contemporary work renders the incompleteness of the selection obvious. Is it possible that the classical modern works are chosen

with a similarly sterilizing eye? Was primitive primitivist work made in the first third of this century, and might it have entered this exhibition if the Western dread of the primitive had not already excluded it from the art history books? Georges Bataille, who was on the scene when primitive styles were being incorporated into European art as modern, described this trend already in 1928, as Rosalind Krauss points out in the catalogue's chapter on Giacometti. He saw the aestheticizing of primitive religious objects as a way for "the civilized Westerner . . . to maintain himself in a state of ignorance about the presence of violence within ancient religious practice."[7] Such a resistance, still dominant in this exhibition almost sixty years later, has led not only to a timid selection of contemporary works but to the exorcizing of the primitive works themselves, which, isolated from one another in the vitrines and under the great lights, seem tame and harmless. The blood is wiped off them. The darkness of the unconscious has fled. Their power, which is threatening and untamed when it is present, is far away. This, in turn, affects the more radical modern and contemporary works. If the primitive works are not seen in their full primitiveness, then any primitive feeling in modernist allusions to them is bleached out also. The reason for this difficulty with the truly contemporary and the truly primitive is that this exhibition is not concerned with either: The show is about classical modernism.

The fact that the primitive "looks like" the modern is interpreted as validating the modern by showing that its values are universal, while at the same time projecting it—and with it MoMA—into the future as a permanent canon. A counterview is possible: that primitivism on the contrary invalidates modernism by showing it to be derivative and subject to external causation. At one level, this show undertakes precisely to co-opt that question by answering it before it has really been asked, and by burying it under a mass of information. The first task Rubin and his colleagues attempt, then, is a chronological one. They devote obsessive attention to the rhetorical question, Did primitive influence precede the birth of modernism, or did it ingress afterward, as a confirmatory witness? It is hard to avoid the impression that this research was undertaken with the conclusion already in mind. The question is already begged in the title of the exhibition, which states not a hypothesis but a conclusion: *"Primitivism" in Twentieth-Century Art: Affinity of the Tribal and the Modern.*

The central chronological argument, stated repeatedly in the book, is that although the Trocadéro Museum (later the Musée de l'Homme) opened in Paris

in 1878, primitive influences did not appear in Parisian art until sometime in the period from 1905 to 1908. This thirty-year lag is held to show that the process of diffusion was not random or mechanical, but was based on a quasi-deliberate exercise of will or spirit on the part of early modern artists—in Rubin's words, an "elective affinity."[8] It was not enough, in other words, for the primitive images to be available; the European receptacle had to be ready to receive them. As far as chronology goes, the argument is sound, but there is more involved than that. What is in question is the idea of what constitutes readiness. Rubin suggests that the European artists were on the verge of producing forms similar to primitive ones on their own account—so positively ready to do so, in fact, that the influx of primitive objects was redundant. For obvious reasons, Rubin does not spell this claim out in so many words, yet he implies it continually. For example, he writes that "the changes in modern art at issue were already under way when vanguard artists first became aware of tribal art."[9] The changes at issue were of course the appearance of primitive-like forms. The claim is strangely improbable. If one thinks of Greco-Roman art, Renaissance art, and European art through the nineteenth century, there is nowhere any indication that this tradition could spawn such forms; at least, it never came close in its thousands of years. A countermodel to Rubin's might see readiness as comprising no more than a weariness with Western canons of representation and aesthetics, combined with the gradual advance, since the nineteenth century, of awareness of Oceanic and African culture. The phenomena of art nouveau (with its Egyptianizing tendencies) and *japonisme* filled the thirty-year gap and demonstrate the eagerness for non-Western input that was finally fulfilled with the primitive works. Readiness, in other words, may have been more passive than active.

Clearly, the organizers of this exhibition want to present modernism not as an appropriative act but as a creative one. They reasonably fear that their powerful show may have demonstrated the opposite—which is why the viewer's responses are so closely controlled, both by the book and, in the show itself, by the wall plaques. The ultimate reason behind the exhibition is to revalidate modernist aesthetic canons by suggesting that their freedom, innocence, universality, and objective value are proven by their "affinity" to the primitive. This theme has become a standard in dealing with primitivism; Goldwater also featured the term *affinities*, rather than a more neutral one like *similarities*.

A wall plaque within the exhibition informs us that there are three kinds of

relations between modern and primitive objects: First, "direct influence"; second, "coincidental resemblances"; third, "basic shared characteristics." This last category, referred to throughout the book as "affinities," is particularly presumptuous. In general, proofs of affinity are based on the argument that the kind of primitive work that seems to be echoed in the modern work is not recorded to have been in Europe at the time. Ernst's *Bird Head,* for example, bears a striking resemblance to a type of Tusyan mask from the upper Volta. But the resemblance, writes Rubin, "striking as it is, is fortuitous, and must therefore be accounted a simple affinity. *Bird Head* was sculpted in 1934, and no Tusyan masks appear to have arrived in Europe (nor were any reproduced) prior to World War II."[10] The fact that the resemblance is "fortuitous" would seem to put it in the category of coincidental resemblances. It is not evidence but desire that puts it in the "affinities" class, which is governed as a whole by selection through similarly wishful thinking. In fact, the Ernst piece cannot with certainty be excluded from the "direct influences" category either. The argument that no Tusyan masks were seen in Europe in 1934 has serious weaknesses. First of all, it is an attempt to prove a negative; it is what is called, among logical fallacies, an *argumentum ex silentio,* or argument from silence. All it establishes is that Rubin's researchers have not heard of any Tusyan masks in Europe at that time. The reverse argument, that the Ernst piece shows there were probably some around, is about as strong.

A similar argument attempts to establish "affinity" between Picasso and Kwakiutl craftspeople on the basis of a Kwakiutl split mask and the vertically divided face in *Girl before a Mirror,* 1932. For, says Rubin, "Picasso could almost certainly never have seen a sliced mask like the one we reproduce, but it nonetheless points up the affinity of his poetic thought to the mythic universals that the tribal objects illustrate."[11] The argument is weak on many grounds. First, Picasso had long been familiar with primitive art by 1932, and that general familiarity, more than any "universals," may account for his coming up with a primitive-like thing on his own. The same is true for Ernst and the *Bird Head.* Modern artists don't necessarily have to have seen an object exactly similar to one of their own for influence to exist. Anyway, the similarity between *Girl before a Mirror* and the "sliced" Kwakiutl mask is not really that strong. The mask shows a half head; the girl has a whole head with a line down the middle and different colors on each side. Rubin attempts to correct this weakness in the argument by noting that "Northwest Coast and Eskimo masks often divide integrally frontal faces more

conventionally into dark and light halves."[12] But most of the world's mythological iconographies have the image of the face with the dark and light halves. Picasso had surely encountered this common motif in a variety of forms—as the alchemical Androgyne, for example. There is, in other words, no particular reason to connect his *Girl before a Mirror* with Kwakiutl masks, except for the sake of the exhibition.

In addition to Rubin's reliance on the notoriously weak argument from silence, his "affinities" approach breaches the principle of economy, on which all science is based: that explanatory principles are to be kept to the smallest possible number (*entia non multiplicanda sunt praeter necessitatem*). The principle of economy does not, of course, mean keeping information to a minimum, but keeping to a minimum the number of interpretive ideas that one brings to bear on information. The point is that unnecessary principles will usually reflect the wishful thinking of the speaker, and amount to deceptive persuasive mechanisms. In the present case, ideas like "elective affinity," "mythic universals," and "affinity of poetic thought" are all *entia praeter necessitatem,* unnecessary explanatory principles. They enter the discourse from the wishful thinking of the speaker. An account lacking the ghost in the machine would be preferred. The question of influence or affinity involves much broader questions, such as the nature of diffusion processes and the relationship of modernist aesthetics to the Greco-Roman and Renaissance tradition. In cultural history, in general, diffusion processes are random and impersonal semiotic transactions. Images flow sideways, backwards, upside down. Cultural elements are appropriated from one context to another not only through spiritual affinities and creative selections, but through any kind of connection at all, no matter how left-handed or trivial.

The museum's decision to give us virtually no information about the tribal objects on display, to wrench them out of context, calling them to heel in the defense of formalist modernism, reflects the exclusion of the anthropological point of view. Unfortunately, art historians and anthropologists have not often worked well together; MoMA handles this problem by simply neglecting the anthropological side of things. No attempt is made to recover an emic, or inside, sense of what primitive aesthetics really were or are. The problem of the difference between the emic viewpoint—that of the tribal participant—and the etic one—that of the outside observer—is never really faced by these art historians, engrossed as they seem to be in the exercise of their particular expertise, the

tracing of stylistic relationships and chronologies. The anthropologist Marvin Harris explains the distinction:

> Emic operations have as their hallmark the elevation of the native informant to the status of ultimate judge of the adequacy of the observer's descriptions and analyses. The test of the adequacy of emic analyses is their ability to generate statements the native accepts as real, meaningful, or appropriate . . . Etic operations have as their hallmark the elevation of observers to the status of ultimate judges of the categories and concepts used in descriptions and analyses. The test of the adequacy of etic accounts is simply their ability to generate scientifically productive theories about the causes of sociocultural differences and similarities. Rather than employ concepts that are necessarily real, meaningful, and appropriate from the native point of view, the observer is free to use alien categories and rules derived from the data language of science.[13]

The point is that accurate or objective accounts can be given from either an emic or an etic point of view, but the distinction must be kept clear. If etic pretends to be emic, or emic to be etic, the account becomes confused, troubled, and misleading.

MoMA makes a plain and simple declaration that its approach will be etic. Materials in the press kit that paraphrase a passage of Rubin's introduction argue, "As our focus is on the modernists' experience of tribal art, and not on ethnological study, we have not included anthropological hypotheses regarding the religious or social purposes that originally surrounded these objects." Rubin similarly argues in his own voice that "the ethnologists' primary concern—the specific function and significance of each of these objects—is irrelevant to my topic, except insofar as these facts might have been known to the modern artists in question."[14] The point of view of Picasso and others, then, is to stand as an etic point of view, and is to be the only focus of MoMA's interest; emic information, such as attributions of motives to the tribal artists, is to be irrelevant.

This position is consistent in itself, but is not consistently acted on. In fact, it is violated constantly. It must be stressed that if the emic/etic question is to be neglected, then the intentions of the tribal craftsmen must be left neutral and undefined. But Rubin's argument constantly attributes intentions to the tribal craftsmen, intentions associated with modernist types of aesthetic feeling and

problem-solving attitudes. The very concept of "affinity," rather than mere "similarity," attributes to the tribal craftsmen feelings like those of the modernist artists, for what else does the distinction between affinities and accidental similarities mean? The claim that there is an "affinity of poetic spirit" between Picasso and the Kwakiutl who made the "sliced" mask attributes to the Kwakiutl poetic feelings like those of Picasso. The assertion that their use of "parallelisms and symmetries" demonstrates a "propinquity in spirit" between Jacques Lipchitz and a Dogon sculptor attributes to the Dogon a sensibility in general like that of Lipchitz. And so on. Rubin says that the "specific function and significance of each of these objects" is irrelevant—for example, what ceremony the object was used in, how it was used in the ceremony, and so on. The use of the word *each* here is tricky. It is true that Rubin ignores the specific function of each object, but it is also true that he attributes a general function to all the objects together, namely, the aesthetic function, the function of giving aesthetic satisfaction. In other words, the function of the modernist works is tacitly but constantly attributed to the primitive works. It is easy to see why no anthropologist was included in the team. Rubin has made highly inappropriate claims about the intentions of tribal cultures without letting them have their say, except through the mute presence of their unexplained religious objects, which are misleadingly presented as art objects. This attitude toward primitive objects is so habitual in our culture that one hardly notices the hidden assumptions until they are pointed out. Rubin follows Goldwater in holding that the objects themselves are proof of the formal decisions made, and that the formal decisions made are proof of the aesthetic sensibility involved. That this argument seems plausible, even attractive, to us is because we have the same emic view as Rubin and MoMA. But connections based merely on form can lead to skewed perceptions indeed. Consider from the following anthropological example what absurdities one can be led into by assuming that the look of things, without their meaning, is enough to go on:

> In New Guinea, in a remote native school taught by a local teacher, I watched a class carefully copy an arithmetic lesson from the blackboard. The teacher had written:
>
> $$4 + 1 = 7 \qquad 3 - 5 = 6 \qquad 2 + 5 = 9$$
>
> The students copied both his beautifully formed numerals and his errors.[16]

The idea that tribal craftsmen had aesthetic problem-solving ambitions comparable to those of modernist artists involves an attribution to them of a value like that which we put on individual creative originality. An anthropologist would warn us away from this presumption: "in preliterate cultures . . . culture is presented to its members as clichés, repeated over and over with only slight variation." "Such art isn't personal. It doesn't reflect the private point of view of an innovator. It's a corporate statement by a group."[17] Yet Rubin declares, again relying only on his sense of the objects, without ethnological support, that "the surviving works themselves attest that individual carvers had far more freedom in varying and developing these types than many commentators have assumed."[18] Surely Rubin knows that the lack of a history of primitive cultures rules out any judgment about how quickly they have changed or how long they took to develop their diversity. The inventiveness Rubin attributes to primitive craftsmen was probably a slow, communal inventiveness, not a matter of individual innovation. In prehistoric traditions, for example, several thousand years may be needed for the degree of innovation and change seen in a single decade of modernism. Rubin asserts formalist concerns for the tribal craftspeople "even though they had no concept for what such words mean."[19] Consider the particular value judgment underlying the conviction that the only thing primitives were doing that is worth our attention, their proof of "propinquity in spirit" with the white man, was something they weren't even aware of doing.

From a purely academic point of view, Rubin's project would be acceptable if its declared etic stance had been honestly and consistently acted out. What is at issue here, however, is more than a set of academic flaws in an argument, for in other than academic senses the etic stance is unacceptable anyway. Goldwater had made the formalist argument for tribal objects in the thirties; it was a reasonable enough case to make at the time. But why should it be replayed fifty years later, only with more information? The sacrifice of the wholeness of things to the cult of pure form is a dangerous habit of our culture. It amounts to a rejection of the wholeness of life. After fifty years of living with the dynamic relationship between primitive and modern objects, are we not ready yet to begin to understand the real intentions of the native traditions, to let those silenced cultures speak to us at last? An investigation that really did so would show us immensely more about the possibilities of life that Picasso and others vaguely sensed and were attracted to than does this endless discussion of the spiritual propinquity of usages of parallel lines.

It would show us more about the "world historical" importance of the relationship between primitive and modern and their ability to relate to one another without autistic self-absorption.

The complete omission of dates from the primitive works is perhaps one of the most troubling decisions. Are we looking at works from the fifties? (If so, are they modern art?) How do we know that some of these artists have not seen works by Picasso? One can foresee a doctoral thesis on Picasso postcards seen by Zairean artists before 1930. The museum dates the Western works, but leaves the primitive works childlike and Edenic in their lack of history. It is true that many of these objects cannot be dated precisely, but even knowing the century would help. I have no doubt that those responsible for this exhibition and book feel that it is a radical act to show how equal the primitives are to us, how civilized, how sensitive, how "inventive." Indeed, both Rubin and Varnedoe passionately declare this. But by their absolute repression of primitive context, meaning, content, and intention (the dates of the works, their functions, their religious or mythological connections, their environments), they have treated the primitives as less than human, less than cultural—as shadows of a culture, their selfhood, their Otherness, wrung out of them. All the curators want us to know about these tribal objects is where they came from, what they look like, who owns them, and how they fit the needs of the exhibition.

In their native contexts, these objects were invested with feelings of awe and dread, not of aesthetic ennoblement. They were seen usually in motion, at night, in closed dark spaces, by flickering torchlight. Their viewers were under the influence of ritual, communal identification feelings, and often alcohol or drugs; above all, they were activated by the presence within or among the objects themselves of the shaman, acting out the usually terrifying power represented by the mask or icon. What was at stake for the viewer was not aesthetic appreciation but loss of self in identification with and support of the shamanic performance.[20] The modernist works in the show serve completely different functions and were made to be perceived from a completely different stance. If you or I were a native tribal artisan or spectator walking through the halls of MoMA, we would see an entirely different show from the one we see as twentieth-century New Yorkers. We would see primarily not form, but content, and not art, but religion or magic.

Consider a reverse example in which Western cultural objects were systematically assimilated by primitives into quite a new functional role. In New Guinea

in the thirties, Western food containers were highly prized as clothing orna-
ments—a Kellogg's cereal box became a hat, a tin can ornamented a belt, and so
on. Passed down to us in photographs, the practice looks not only absurd but
pathetic. We know that the tribal people have done something so inappropriate
as to be absurd, and without even beginning to realize it. Our sense of the small-
ness and quirkiness of their world view encourages our sense of the larger scope
and greater clarity of ours. Yet the way Westerners have related to the primitive
objects that have floated through their consciousness would look to the tribal peo-
ples much the way their use of our food containers looks to us: They would per-
ceive at once that we had done something childishly inappropriate and ignorant,
and without even realizing it. Many primitive groups, when they have used an
object ritually (sometimes only once), desacralize it and discard it as garbage. We
then show it in our museums. In other words: Our garbage is their art, their
garbage is our art. Need I say more about the emic/etic distinction?

The need to co-opt difference into one's own dream of order, in which one
reigns supreme, is a tragic failing. Only fear of the Other forces one to deny its
Otherness. What we are talking about is a tribal superstition of Western civiliza-
tion: the Hegel-based conviction that one's own culture is riding the crucial time
line of history's self-realization. Rubin declares that tribal masterpieces "transcend
the particular lives and times of their makers";[21] Varnedoe similarly refers to "the
capacity of tribal art to transcend the intentions and conditions that first shaped
it."[22] The phrase might be restated: The capacity of tribal art to be appropriated out
of its own intentionality into mine.

As the crowning element of this misappropriation of other values comes
the subject of representation. Rubin distinguishes between European canons
of representation, which are held to represent by actual objective resemblance,
and the various primitive canons of representation, which are held to repre-
sent not by resemblance but by ideographic convention. Our representation,
in other words, corresponds to external reality; theirs is only in their minds.
But the belief that an objective representational system can be defined (and
that that system happens to be ours) is naïve and inherently contradictory. It
is worth noting that tribal peoples tend to feel that it is they who depict and
we who symbolize. Representation involves a beholder and thus has a subjec-
tive element. If someone says that A doesn't look like B to him or her, no coun-
terargument can prove that it does. All conventions of representation are

acculturated and relative; what a certain culture regards as representation is, for that culture, representation.

Rubin's love of modernism is based on the fact that it at last took Western art beyond mere illustration. When he says that the tribal artisans are not illustrating but conceptualizing, he evidently feels he is praising them for their modernity. In doing so, however, he altogether undercuts their reality system. By denying that tribal canons of representation actually represent anything, he is, in effect, denying that their view of the world is real. By doing them the favor of making them into modern artists, Rubin cuts reality from under their feet.

The myth of the continuity of Western art history is constructed out of acts of appropriation like those Rubin duplicates. The rediscovery of Greco-Roman works in the Renaissance is an important instance of this, for the way we relate to such art is also in a sense like wearing a cereal-box hat. The charioteer of Delphi, circa 470 B.C., for example, was seen totally differently in classical Greece from the way we now see him. He was not alone in that noble, self-sufficient serenity of transcendental angelic whiteness that we see. He was part of what to us would appear a grotesquely large sculptural group—the chariot, the four horses before it, the god Apollo in the chariot box, and whatever other attendants were around. All was painted realistically and must have looked more like a still from a movie than like what we call sculpture. Both Greco-Roman and primitive works, though fragmented and misunderstood, have been appropriated into our art history in order to validate the myth of its continuity and make it seem inevitable.

It is a belief in the linear continuity of the Western tradition that necessitates the claim that Western artists would have come up with primitive-like forms on their own, as a natural development. The purpose of such theorizing is to preclude major breaks in Western art history; its tradition is to remain intact, not pierced and violated by influence from outside the West. The desire to believe in the wholeness, integrity, and independence of the Western tradition has at its root the Hegelian art-historical myth (constructed by the critical historians Karl Schnaase, Alois Riegl, and Heinrich Wölfflin) that Western art history expresses the self-realizing tendency of Universal Spirit. (This is Rubin's vocabulary. He once declared, for example, that Pollock's paintings were "'world historical' in the Hegelian sense."[23]) When brought down to earth—that is, to recorded history—this view involves not only the conclusion that the shape and direction of modern art were not really affected by the discovery of primitive objects, but another

conclusion equally unlikely, that the shape and direction of European art were not really influenced by the discovery of Greco-Roman works in the Renaissance.

In fact, Western art history shows three great breaks: one when the population of Europe was changed by the so-called barbarian invasions in the late Roman Empire, which led to the transition from Greco-Roman to Christian art; the second with the Renaissance, the transition from Christian art to European art; the third at the beginning of the twentieth century, with the transition from European to modern art. Each of these breaks in tradition was associated with a deep infusion of foreign influence—respectively, Germanic, Byzantine, and African/Oceanic. To minimize these influences is to hold the Western tradition to be a kind of absolute, isolated in its purity. From that point of view, the adoption of primitive elements by early modernists is seen as a natural, indeed inevitable, inner development of the Western tradition. But the context of the time suggests otherwise. In the nineteenth century, the Western tradition in the arts (including literature) seemed to many to be inwardly exhausted. In 1873, Arthur Rimbaud proclaimed his barbarous Gallic ancestors who buttered their hair[24] and called for a disorientation of the patterns of sensibility. The feeling was not uncommon; many artists awaited a way of seeing that would amount simultaneously to an escape from habit and a discovery of fresh, vitalizing content. For there is no question that the turn-of-the-century fascination with archaic and primitive cultures was laden with content: Baudelaire, Rimbaud, Picasso, and Matisse were attracted, for example, by the open acknowledgment of the natural status of sex and death in these cultures. By repressing the aspect of content, the Other is tamed into mere pretty stuff to dress us up.

Of course, you can find lots of little things wrong with any big project if you just feel argumentative. But I am motivated by the feeling that something important is at issue here, something deeply, even tragically, wrong. In depressing starkness, *"Primitivism"* lays bare the way our cultural institutions relate to foreign cultures, revealing it as an ethnocentric subjectivity inflated to co-opt such cultures and their objects into itself. I am not complaining, as the Zuni Indians have, about having tribal objects in our museums. Nor am I complaining about the performing of valuable and impressive art-historical research on the travels of those objects through ateliers (though I am worried that it buries the real issues in an ocean of information). My real concern is that this exhibition shows Western egotism still as unbridled as in the centuries of colonialism and souvenirism. The museum pre-

tends to confront the Third World while really co-opting it and using it to con-solidate Western notions of quality and feelings of superiority.

Hamish Maxwell, chairman of Philip Morris, one of the sponsors of the exhi-bition, writes in the catalogue that his company operates in 170 "countries and ter-ritories," suggesting a purview comparable to that of the show. He continues, "We at Philip Morris have benefited from the contemporary art we have acquired and the exhibitions we have sponsored over the past quarter-century . . . They have stirred creative approaches throughout our company."[25] In the advertisement in the Sunday *New York Times* preceding the *"Primitivism"* opening, the Philip Morris logo is accompanied by the words, "It takes art to make a company great."

Well, it takes more than connoisseurship to make an exhibition great.

NOTES

1. Richard E. Oldenburg, "Foreword," in William Rubin, ed., *"Primitivism" in Twentieth-Century Art: Affinity of the Tribal and the Modern* (New York: Museum of Modern Art, 1984), viii.

2. The Museum of Modern Art, New York, press release no. 17, August 1984, for the exhibition *"Primitivism" in Twentieth-Century Art: Affinity of the Tribal and the Modern*, 1.

3. Revised and republished as Robert Goldwater, *Primitivism in Modern Art* (New York: Vintage Books, 1967). In 1933, 1935, 1941, and 1946, the Modern itself had exhibitions of archaic and primitive objects separately from its modern collections. René d'Harnoncourt, director of the museum for nineteen years, was an authority on the subject.

4. William Rubin, *Dada and Surrealist Art* (New York: Harry N. Abrams, 1968).

5. Two by Rubin, two by Kirk Varnedoe, two by Alan G. Wilkinson, and one each by Ezio Bassani, Christian F. Feest, Jack Flam, Sidney Flam, Sidney Geist, Donald E. Gordon, Rosalind Krauss, Jean Laude, Gail Levin, Evan Maurer, Jean-Louis Paudrat, Philippe Peltier, and Laura Rosenstock.

6. Kirk Varnedoe, "Contemporary Explorations," in Rubin, *"Primitivism,"* 662, 679, 681.

7. Rosalind Krauss, "Giacometti," in Rubin, *"Primitivism,"* 510.

8. William Rubin, "Modernist Primitivism: An Introduction," in Rubin, *"Primitivism,"* 11.

9. Ibid.

10. Ibid., 25.

11. Rubin, "Picasso," in Rubin, "Primitivism," 328–30.

12. Ibid., 328.

13. Marvin Harris, *Cultural Materialism: The Struggle for a Science of Culture* (New York: Vintage Books, 1980), 32.

14. Rubin, "Modernist Primitivism," in Rubin, *"Primitivism,"* 1.

15. Ibid., 51.

16. Edmund Carpenter, *Oh, What a Blow That Phantom Gave Me!* (New York: Holt, Rinehart and Winston, 1973), 54.

17. Ibid., 53, 56.

18. Rubin, "Modernist Primitivism," in Rubin, *"Primitivism,"* 5.

19. Ibid., 19.

20. This setting is directly based on ethnographers' descriptions. For example, Carpenter, note 16 above.

21. Rubin, "Modernist Primitivism," in Rubin, *"Primitivism,"* 73.

22. Kirk Varnedoe, preface, in Rubin, *"Primitivism,"* 5.

23. Cited in Peter Fuller, *Beyond the Crisis in Art* (London: Writers and Readers Publishing Cooperative Ltd., 1980), 98.

24. Arthur Rimbaud, *Une saison en enfer* (A Season in Hell), 1873, trans. Louise Varèse (New York: New Directions, 1961), 7.

25. Hamish Maxwell, in Rubin, *"Primitivism,"* vi.

On *"Doctor Lawyer Indian Chief:* 'Primitivism' in Twentieth-Century Art at the Museum of Modern Art in 1984"

(Artforum, February 1985)

Letters by William Rubin and Kirk Varnedoe

with a reply by Thomas McEvilley

To the Editor:

After years of work on an exhibition, a curator derives a certain satisfaction from a review that attempts to engage the basic issues of his show in a fair-minded way and on a high level of discourse. This is true even when the review is largely negative, as in the case of Thomas McEvilley's article on the Museum of Modern Art's *"Primitivism"* ["Doctor Lawyer Indian Chief," *Artforum*, November 1984]. Most analyses of exhibitions and their books fall away and are soon forgotten. McEvilley's could be one that becomes part of the history of the event it addresses. I hope, therefore, that he will take this extended commentary on his text at least somewhat as a compliment—an attempt to further thrash out and clarify some ideas and attitudes that mean much to both of us—and not as an exercise in logomachy. The questions McEvilley raises go far beyond the exhibition to the nature and motives of the Museum of Modern Art itself, and I appreciate the opportunity *Artforum* has given me to air some of these matters.

No project on the order of *"Primitivism" in Twentieth-Century Art* can work out entirely satisfactorily and wholly free of inconsistencies. Had we to do the book and show over again, there are some things I would surely do differently (I do not necessarily speak here for my colleague, Kirk Varnedoe, whose comments follow).

My auto-critique revolves largely around the definitions of "affinities," some of which, I think, could and should have been more sharply etched. I am, however, largely satisfied with the presentation of the main body of the show, the sections called "Concepts" and "History," both of which McEvilley attacked from a variety of angles. A few of his criticisms of these sections are well taken. I find, however, that notwithstanding his evidently good intentions, his review is interwoven with sufficient misconceptions, internal inconsistencies, and simple errors of fact that—given its seriousness—it should not go unchallenged.

At the outset, McEvilley has some very kind things to say about our show, among them that it was "thrilling" and "a tour de force of connoisseurship." As he proceeds, however, he describes the exhibition as operating in a kind of psychological, social, and historical void resulting from my supposed commitment to what he calls "formalist modernism." He concludes his text with the putdown that "it takes more than connoisseurship to make an exhibition great."

There is some kind of contradiction here. I'm not sure what McEvilley means by "connoisseurship," which—etymologically at least—implies far more than he presumably would wish to grant me. If I were wearing "formalist" blinders, could I really have chosen a great group of tribal works? Is their greatness not a function of their profound effectiveness on spiritual, poetic, and psychological—as well as on formal—levels? And do they not express, implicitly at least, societal values? Surely McEvilley does not believe that these qualities can be wholly separated from the objects' phenomenological (or plastic) configurations. Were not these affective factors necessarily, therefore, dimensions of my choices? While such components of the sculptures' expressiveness can be isolated for the purposes of discussion—indeed, the linear character of criticism virtually requires this—they cannot be separated from one another in the actual experience of the art.

McEvilley's repeated reproach that our show had no anthropological underpinning (of which more below) comes perilously close to suggesting that the tribal works, presented just in themselves, propose but a set of forms that communicate no "meaning" or "content." Picasso's remark, "all I need to know about Africa is in those [tribal] objects," was characteristic for him in its hyperbole; it was also flip. But it nevertheless embodied a crucial point, namely that Picasso felt (quite rightly, I believe) he could apprehend aspects of the spirit, values, and nature of African civilizations through their art. Indeed, while some of the observations he put into words were anthropologically wrong (e.g., his notion of "freedom" in

relation to tribal art—as I pointed out in our book), the sense of Africa he intuited through its sculpture rings truer today than does most anthropological writing of his day.

By reducing the virtues of our show to "connoisseurship," McEvilley also diminishes—if he does not entirely dismiss—what I hope art historians will consider a significant contribution to our discipline, one that revises many basic received ideas about primitivism. For McEvilley, our art history is largely an "overwhelming mass of information," and he concludes that "on the whole, [Robert] Goldwater's book [*Primitivism in Modern Painting*] still reads better." McEvilley suggests that the "general ideas" of our exhibition have been around since 1938 (the date of Goldwater's book) and points to instances in which other institutions (Centre Pompidou, Grand Palais) have purportedly provided at least limited prototypes for our project.

No one, I think, admires my late friend and colleague Robert Goldwater more than I. The preface to *"Primitivism" in Twentieth-Century Art* is devoted to expressing this admiration. The fact is, however, that the premises of our exhibition are very much at odds with many of his conclusions. If by "reads better" McEvilley is referring to Goldwater's lapidary literary style, I would be the first to cede the point. But in terms of substance, our conclusions are at odds with Goldwater's as regards a host of basic questions—about which only one or the other of us can be right. Hence, if we have not simply fallen on our faces as historians, we have done more than merely, as McEvilley would have it, "refine and extend" Goldwater's research.

Most of the reproductions in Goldwater's book were of modern works. Even in the revised and enlarged edition of 1967, only eight tribal works were illustrated, four of them paired visually with modern objects. None of the eight had belonged to modern artists and, so far as we know, only one of them was even in Europe in the days of the pioneer modernists. Our multiplication of juxtapositions illustrating proposed (and often provable) relationships between modern works and tribal objects in the artists' collections (or visible in museums they are known to have frequented) overturns one of Goldwater's basic principles, an insistence on the "extreme scarcity of the direct influence of primitive art forms" on twentieth-century art. Moreover, Goldwater made no allowance for what we have called "invisible" influences (as documented by the pairings of Picasso's *Guitar* and his Grebo mask, [Henry] Moore's *Upright Internal and External Forms*

and the British Museum's Malanggan, and [Marius] de Zayas's *Alfred Stieglitz* and the Pukapuka Soul-catcher). Nor did he connect the invention of collage, assemblage, and mixed media to the experience (Picasso's especially) of tribal art—or, indeed, treat most of the other topics taken up in the "Concepts" section of our exhibition. Finally, the artist's own words have undermined Goldwater's key assumption that Picasso's interest in tribal art was primarily formal. We are obliged to assign to Picasso's rediscovery of the "magical" roots and powers of art a more critical place in his development than we do any plastic or technical ideas he derived from tribal objects.

Contesting the museum's assertion that our exhibition is the "first ever to juxtapose modern and tribal objects in the light of informed art history," McEvilley cites two purported precedents: the Menil Collections exhibition last spring at the Grand Palais, which "juxtaposed primitive and modern works (a Max Ernst with an African piece, Cézanne with Cycladic) and sometimes, as in the [MoMA] exhibition, showed a modern artist's work in conjunction with primitive objects in his collection"; and the Centre Pompidou, which "exhibited, in the vicinity of its modern collections, about 100 tribal objects from the Musée de l'Homme." "Though not actually intermingled with modern works," McEvilley says of the hundred objects, they "were intended to illustrate relationships with them, and included, as does the [MoMA] show, primitive objects owned by Picasso, Braque, and other early modernists."

McEvilley's recollections here certainly don't jibe with mine or, as it turns out, with the facts. A rapid check reveals that (1) the two vitrines at the Centre Pompidou together never contained more than twenty or so objects; (2) none of them ever belonged to Picasso or Braque; (3) the objects in the Beaubourg vitrines could hardly have been intended to "illustrate relations" with modern art since they were chosen by Jean-Hubert Martin "without respect," as he says, "to historical or formal questions" from a group proposed by Francine Ndiaye of the Musée de l'Homme, who has only a glancing acquaintance with modern art, and whose mandate was to select such objects as would constitute an overview of African art; (4) the choice of African sculptures included many of types—and from tribal areas—totally unknown in France in the days of the "early modernists." As for the fascinating Menil show—which, in any case, took place after the writing of our book—my recollections (as confirmed by Dominique de Menil herself) are that (1) the tribal material was shown almost entirely in its own separate areas; (2)

contrary to McEvilley, no modern works were "shown in conjunction with prim-
itive objects from [the artists'] own collection[s]"; indeed, no tribal works from
the collections of important modernist artists were included anywhere in the
Menil collections show; (3) the juxtaposition of the Cézanne with a Cycladic
sculpture and the Ernst with an African work were determined by Mrs. de Menil's
"pleasure in seeing them together," and were not the demonstration of any his-
torical connection. Thus, the two supposedly precedent primitivist events pro-
posed by McEvilley were not instances of "informed art history"; they were not,
strictly speaking, instances of art history at all.

Why this determined effort on McEvilley's part to demonstrate that the
premises and content of our show were "not new"? The answer may be found in
one of the most remarkable rhetorical twists I have ever encountered. By con-
vincing his reader that our efforts are "not new," McEvilley feels licensed to ask
"why MoMA gives us primitivism now." The answer to this turns out to be his real
point, namely that the "temple of formalist modernism" is using the primitive to
"revalidate" the modernist movement in the face of "several years of sustained
attack," which supposedly led us to need a "new defense." "The ultimate reason
behind the exhibition," McEvilley insists, "is to revalidate modernist aesthetic
canons"—whatever *they* are. "How brilliant," he opines, "to attempt to revalidate
classical modernist aesthetics by stepping outside their usual realm of discourse
and bringing to bear upon them a vast, foreign sector of the world."

How brilliant, indeed. Brushed aside here is the real history of our show, and
the fact that it was an attempt to render explicit some art-historical concerns that
were implicit in MoMA exhibitions going back almost fifty years (*African Negro
Art*, 1936; *Indian Art of the United States*, 1941; *Arts of the South Seas*, 1946). No appar-
ent consideration was given to my conversations with Picasso of fifteen years ago,
which led me to conclude that the received art history of primitivism was pro-
foundly distorted and that the whole topic would have to be restudied, or to the
almost five years of the exhibition's actual integration (nor to the fact that if we
hadn't rebuilt the museum, the show would have taken place some years ago). By
sweeping aside both the real motivations for, and the chronology of, this show
(most of which is spelled out in our book), McEvilley could transform the nature
of the event, and with it the actually fortuitous fact that it takes place "now"
rather than some years ago, into an act of contemporary art politics.

For a man who, elsewhere in his text, shows a tremendous concern for the

logic of argumentation, McEvilley's motivating of me is astonishing. Putting himself inside my mind, he confidently discovers and asserts agendas of which I had never thought. Anyone who knows me will consider laughable the idea that I would think modernist art needs "revalidation." As I stroll through the galleries of the collection, the last thing in the world I imagine is that Cézanne, Picasso, Pollock *et alia* need to be authenticated by "primitives" or anyone else. It is not Rubin but McEvilley who thinks they need "revalidation"—and he conveniently projects onto me the strategies of his own art-political ways of thinking.

Perhaps the most persistent criticism in McEvilley's long article was directed to our omission of anthropological matter in relation to the tribal objects. He decries the fact that "no anthropologist was included in the team," with the result that the "wholeness" of the tribal objects is sacrificed to "the cult of pure form"; thus the show constitutes an act of "ethnocentric subjectivity inflated to co-opt [tribal] cultures and their objects . . . [showing that] Western egotism [is] still as unbridled as in the centuries of colonialism and souvenirism." "The museum pretends to confront the Third World while really co-opting it and using it to consolidate Western notions of quality and feelings of superiority." (Needless to say, had I really been concerned with Western "feelings of superiority," I would hardly have mounted a show, the very terms of which guaranteed that the tribal works would on average be superior to the modern ones.[1])

The museum, of course, had no intention of confronting tribal cultures, or even tribal objects as such (i.e., in their own terms), no less the whole Third World. To have done so would have hopelessly confused what the museum was, in fact, doing—namely, studying the reception of tribal objects by Western artists, the ethnocentricity of which history we ourselves described as manifest and accepted as given. But McEvilley won't let us have a show about that reception, which is, of course, precisely what *primitivism*—as opposed to *the primitive*—signifies. He wants the tribal objects presented in a wholly integral way (never spelled out) in which not even anthropological museums show them.

It isn't that McEvilley cannot understand our aims. Indeed, he quotes us saying: "As our focus is on the modernists' experience of tribal art . . . we have not included anthropological hypotheses regarding the religious or social purposes that originally surrounded these objects." And also that "the ethnologists' primary concern—the specific function and significance of each of these objects—is irrelevant to [our] topic, except insofar as these facts might have been known to the

modern artists in question." He might also have added our observations that primitivism "refers not to the tribal arts in themselves, but to the Western interest in and reaction to them" and that it was "an aspect of the history of Western art, not of tribal art."

"This position," McEvilley admits, "is consistent in itself." But he insists we are not entitled to it because we have "not consistently acted" on it. (What would have been *more inconsistent* with our position than the inclusion of precisely the anthropological information McEvilley calls for, about which the artists knew nothing?) Now, I don't doubt that given the breadth of our project, we have been guilty of some inconsistencies, although I do not agree that most of the examples McEvilley adduces—which have to do with the modes of functioning of tribal artists—*are*, in fact, inconsistencies (as we shall see below). But McEvilley seems not to understand the fact that *whatever the inconsistencies in execution* (and those he signals are in the book rather than the exhibition), *they do not by any twist of logic nullify the admitted consistency of our original perspective*. Even if we hadn't made those observations about tribal artists to which McEvilley objects, would *he* not still have wanted anthropological input? Wouldn't he still have objected that the tribal objects were decontextualized, that "the blood is wiped off them"?

Of course, the tribal objects in our show *are* decontextualized (as they are in the Metropolitan Museum of Art, or, even more relevantly, in anthropological museums as well). In fact, they are more than that; they are *recontextualized*, within the framework of Western art and culture. *And that is what our particular story is all about.* McEvilley simply refuses to accept the fact that our story is not about "the Other," but about ourselves. As I observed in my introductory chapter, "prior to the 1920s . . . at which time some Surrealists became *amateurs* of ethnology, artists did not generally know—nor evidently much care—about such [anthropological] matters." But as I also observed, the artists' lack of interest in or knowledge of the objects' religious purposes and functions did not mean that they were uninterested in "meanings." It was rather that "the meanings which concerned them were the ones that could be apprehended through the objects themselves." *This* is the real rub for, as we shall see, McEvilley refuses to accept that such meanings exist; indeed, that the tribal sculptures *are*, *in fact*, art.

Suppose we were to have taken McEvilley's advice and given an anthropological dimension to our show. What anthropology, whose anthropology should it have been? Should we have proposed the views of anthropologists of the

Trocadéro itself in Picasso's time, such as Maurice Delafosse, who interpreted African tribal art as an Egyptian derivation? Not only is the work of such anthropologists irrelevant to our subject because unknown to the modern artists, but it is wrong.[2] Even in our own day, there are an immense number of fundamental disagreements among anthropologists themselves, some of whom still credit the view, as does McEvilley, that there is no such thing as tribal art—only religious artifacts.

McEvilley appropriates the mantle and the voice of anthropology with far more certainty than is possessed by any professional anthropologist I have met. He constantly presumes to know and speak for the "intentionality" of long-dead tribal artists when, in fact, anthropology knows virtually nothing about them. He confidently puts himself into their minds in the same way he did into mine—and possibly with as little accuracy. Having granted the consistency of our perspective (at least in theory), he nevertheless states that by "their absolute repression of primitive context, meaning, content, and intention (the dates of the [tribal] works, their functions, their religious or mythological connections, their environments)," MoMA has "treated the primitives as less than human, less than cultural—as shadows of a culture, their selfhood, their Otherness, wrung out of them." Does McEvilley himself know how little is known about most of these tribal objects? Even had they been relevant, we would have had to face the fact that the specific functions and the religious or mythological significance of many, if not most, of the tribal objects in our show are unknown (and will probably never be known). And many of the meanings attributed to some of them by previous generations of anthropologists are being dismissed left and right.

Consider the question of dates, which McEvilley seems to think we have suppressed: "The complete omission of dates from the primitive works is perhaps one of the most troubling decisions," he writes, though he admits that "many of these objects cannot be dated precisely." In fact, *not a single one of them* in our show can be dated precisely, and precious few can be dated approximately. Even the small minority that were field-collected by anthropologists have only a *terminus ad quem;* one can only speculate as to how long they existed before collection. Most of the tribal objects in the show have little history, or dubious ones. Even the decision as to whether most of them are nineteenth- or twentieth-century objects is speculative, and usually made by historians of primitive art on a subjective rather than scientific basis. Far from being suppressed, the question of dates is not only

discussed in the book, but is summarized on a panel that is repeated three times in various places in the exhibition. I excerpt from our panel: "Since accurate dates are not known for most tribal art, no dates appear on the labels for tribal objects in this exhibition. These objects are often short-lived, in part because of their largely perishable materials, in part because they were not preserved after being desacralized. Hence, most of the fine tribal art preserved in the West dates from no earlier than the later nineteenth and early twentieth centuries, and represents the later phases of long-standing traditions."

Where dates of tribal objects *are* relevant to the history of primitivism, they are the dates at which artists could have seen them in museums (what Picasso, for example, could have seen in the Trocadéro in 1907) and at which they purchased the pieces in their collections. We have spent hundreds of hours researching these dates and, where discoverable and relevant, have given them.

As one who has probably spent far more time haunting anthropological museums than has McEvilley, I can assure him that in virtually no cases do their labels give more information on "context, meaning, content, and intention" than we do. Will McEvilley please tell me how he learns anything about the "religious or mythological connections" of the objects in the vitrines of Tervuren, the Musée de l'Homme, or the Völkerkunde museum in Berlin (whose "fine arts"–oriented installation surpasses that of the Metropolitan)? Do these objects have more "blood on them" than those at MoMA? To be sure, some anthropological museums provide short general text panels at the beginning of sections, but provide little or nothing on individual objects. Even these introductory panels are only possible because the material in their vitrines is geographically homogenous. Suppose—as demanded by McEvilley—we had wanted to provide "environment" for objects that came from over a hundred different cultures and societies, how could we have done it?

Does the presentation of tribal sculptures by themselves—the way great museums present all other cultures' sculpture from the Egyptian to the present—really imply treating their makers as "less than human, less than cultural"? Perhaps only if, like McEvilley, you consider the objects "not art, but religion or magic"—as if most of the world's sculpture *is not both art and religion at the same time*. Though this crucial fact gets lost in his fulminations against "formalist modernism," McEvilley *never accepts tribal sculptures as art*, nor their carvers as "artists"—or even "sculptors"; the latter remain relegated to the caste of "craftspeople." For McEvilley, the

mere assertion that these "craftspeople" were artists, not to say great artists, smacks of "co-option." I wonder how many of his readers who saw our show and stood before the monumental Nukuoro Island carving of the goddess Kave that introduces it, share McEvilley's conviction that what they were looking at was "not art."

Generations ago, anthropologists considered tribal sculptures only artifacts, and even Franz Boas held that their sculptors' function never exceeded the role of copying and the problems of craftsmanship. This assumption was partly based on the absence of a word for art in most tribal languages. But the same is true for the ancient Egyptians; yet that culture's painting and sculpture is not denied the status of art. Of course, the tribal sculptor, living in a religiocentric society made (the majority of) his objects in the spirit and to the purposes of religious practice and expression—which was also true of Egyptian and Christian medieval artists, among others. He also considered himself a craftsman—as did his Egyptian and Christian counterparts (the medieval painters were enrolled in the saddlers' guild for the simple reason that painting saddles was one of their primary duties). But no less than his Egyptian or Christian counterparts, the tribal sculptor was also an artist, and we have presented him as such—"misleadingly," according to McEvilley. In any event, the nineteenth-century prejudice that tribal peoples produced no art has today been given up by most anthropologists.

Underlining certain similarities in the work of tribal and modern artists does not mean, as McEvilley claims, that we have presented the tribal artist as a modern one; we present him as an artist *tout court*. According to McEvilley, "Rubin's argument constantly attributes intentions to the tribal craftsmen, intentions associated with modernist types of aesthetic feeling and problem-solving attitudes." This is simply not so. I did, of course, attribute to tribal sculptors the need to make aesthetic decisions, but that is because they functioned—among other things—as artists. The kind of questions I saw them confronting in terms of their ideographic language (which, McEvilley notwithstanding, did not invent itself)—a problem such as "how to make a nose"—could only be described as "modernist . . . problem-solving" by someone with McEvilley's skewed perspective. All art involves some sort of problem solving, whether it happens self-consciously or not. And in attributing to tribal sculptors an aesthetic instinct, which the anthropologist Robert Lowie (and, since him, many other anthropologists) have considered a common denominator of all mankind, I have simply chosen to believe those

anthropologists whose views seem to me to accord with my experience of the sculptural objects themselves. McEvilley has chosen others, and we will have to agree to disagree. In terms of primitivism, however, it doesn't matter one whit *which* anthropologists you follow inasmuch as the modern artists understood and acted upon the tribal objects *as art.*

I believe that it is McEvilley, not MoMA, who treats the tribal peoples as "less than human, less than cultural" by denying their cultures the fact of their art and their great artists. (He attributes the diversity and range of tribal art, which is considerable even within certain individual tribal units, to something he calls "communal inventiveness"—a process I leave the reader to try imagining.) He has a lot to say about MoMA's presumed inability to appreciate the Otherness of the Other (which was more than evident to me *in tribal objects* long before I began reading anthropologists on primitive art). It is, indeed, exceedingly difficult to dissociate ourselves from Western values and ways of thinking sufficiently to truly appreciate the Otherness of Third World peoples, as contemporary anthropologists are trying especially hard to do. But this was not what our show was about. Nor, in regard to this Otherness, does McEvilley have any monopoly on virtue, since many leading anthropologists disagree sharply with his ideas.

It should also be remembered that there is another, negative "Otherness" that is at issue for us in the West. This is the view that the Other is lazy, unintelligent, fit only for *travail de nègre* and, above all, uncultured. Most early anthropology is shot through with such prejudices, and the respect and admiration we find for tribal peoples on the part of Picasso and Matisse in the first decade of the century were not—with rare exceptions—to characterize anthropology until after World War II. If the peoples of the world are to get along with each other, they will not only have to appreciate their respective "Otherness," they will have to recognize their common humanity. Some of us still do not think Schiller's hope that *"alle Menschen werden Brüder"* is tainted by co-option. By denying the manifest genius of tribal artists, McEvilley excludes whole peoples from this cultural commonality.

WILLIAM RUBIN

The Museum of Modern Art, New York City

NOTES

1. Many critics and visitors to the exhibition noted that the quality of the tribal works was, taken as a whole, higher than that of the modern works. This was accepted in advance as an inevitable result of the premises of the exhibition. Except for those tribal works that were in artists' collections, or those museum objects which had had a direct historical relation to the work of individual modern artists (and the two together constituted a minority), the tribal works I chose were all—by my lights—the best of their types I could find during many years of study in public and private collections all over the world. Unlike the modern art, these profited from unfamiliarity. The modern works were, by definition, limited to artists involved with primitivism; hence, not only were many great modern artists not represented, but others who *were* in the exhibition (Brancusi, for example) were, for historical reasons, represented by objects that were not necessarily their very best. (Some artists were not as well represented as they should have been because loans were unobtainable; Matisse's great and highly relevant *Blue Nude* and *Madame Matisse*, could not, for example, be borrowed.)

 Not surprisingly, only the greatest of modern artists, such as Picasso and Brancusi, could hold their own against the best tribal artists. Nobody, I think, considers that Picasso and Brancusi suffered in the comparison. That some other artists did was inevitable. Needless to say, I did not look upon the exhibition as a contest of quality, a *mano a mano* between tribal and modern artists, and I could have easily stacked the cards in either direction. I knew that our public was far more familiar with great modern art than with great tribal art, and was at pains to emphasize the latter. The only review of the show that came to grips with this particular issue, analyzed it, and understood it properly, was "Rubin's Primitives" by Allen Wardwell, which appeared in the November *Art World*.

2. I do not mean here to imply that everything Delafosse and his early twentieth-century colleagues wrote about African art was wrong—although to read the critiques of them by contemporary anthropologists one could conclude that very little of what they said was right. There was, however, one anthropologist writing early in the century whose work, as Lydia Gasman has insisted, is interesting to consider in connection with Picasso's ideas about tribal art, and that is Marcel Mauss. Though Gasman is wrong in thinking that Picasso might have read Mauss's 1903–04 essay on magic (Picasso did not read anthropological texts, and his French in 1907 would not have been up to it in any case), Mauss's ideas parallel those of Picasso, participate in the same zeitgeist. It is interesting to consider this in the light of McEvilley's view of Goldwater's book, a great part of which is devoted to a review of anthropological ideas; ironically, the one group of anthropologists Goldwater does *not* deal with is precisely, as Gasman observes, the French school of Mauss and his followers.

To the Editor:

In his criticisms of my contributions to the *"Primitivism"* exhibition, Thomas McEvilley is occasionally sloppy (he thinks I wrote two chapters in the book; I wrote three). He is also selectively forgetful, as when he chidingly suggests that an outdated "earth-mother" notion motivated my selection of contemporary women artists. This ignores the part of my essay that explicitly denounces this very cliché, at length (pp. 680–81); yet McEvilley must know the passage, for he elsewhere quotes from it as evidence of my censorship of primitivism's deeper truths! Also, he generally overestimates my contributions, by supposing my handling of the contemporary sections in both show and book can be taken as centrally representative of the exhibition's conception; whereas, in fact, these contemporary sections were later add-ons, organized (as should be expected, given their content) on significantly differing premises. But let all this pass—I'm glad to be associated with the show, and to confront the substantive issues McEvilley raises in his serious and impassioned review.

McEvilley accuses me of writing on primitivism in a "value-saturated, interpretive" way. He is absolutely right: My essays, and particularly the contemporary essay with which he takes special issue, do have this character, and were intended to make those values and interpretations very evident. His opposing views also have this character—what he would term an "ideological" aspect—but I am afraid he is less forthright in declaring, or perhaps less clear in understanding, their implications. Often, in fact, it seems to me that he is more deeply guilty of the very mistakes he attributes to William Rubin and to me.

He holds that the artists I selected, and the issues I raised, did not confront primitivism's "raw realness, or its real rawness." He admires instead contemporary artists "whose intentionalities [a word he favors as a substitute for the simpler

intentions] involve falling away from Western civilization and literally forgetting its values." Their work is not just better primitivism, but fully *primitive,* he says, because it shares "the intentionality proper to [tribal] objects." Yet these attitudes McEvilley admires are quintessentially modern and Western, involving goals that obviously could never have been held by tribal artists—who by definition never had civilized Western values to forget. McEvilley's semantic abuse of the already beleaguered term *primitive* is the least of his confusions here. He blames Rubin and me for supposedly attributing modern Western intentions to tribal artists, and opines that "The need to co-opt difference into ones own dream of order . . . is a tragic failing. Only fear of the Other forces one to deny its Otherness." Yet when he attributes *tribal* intentions to *modern* artists, Otherness vanishes in a more global identity of purpose than we would ever suggest, or believe possible, between creators in vastly different cultures. McEvilley thus seems unwittingly to reinforce the very prejudice of Western superiority he claims to reject. In his account, contemporary artists can know all about primitive motives, and subsume them within their more complex projects; but the primitive may not be credited with harboring any analogue of modern ways of thinking.

What, one should ask, constitutes this global notion of tribal purposes about which McEvilley seems so clairvoyant—this idea of an essential "intentionality" that for him embraces Senufo and Sepik, Polynesian and Punu alike? The definition is never fully spelled out, but the traces can be found in a constellation of effects he evokes. Primitive creation involves for him "violence" in religious practice, "awe and dread," objects drenched in blood, seen in "closed dark spaces, by flickering torchlight," and a "terrifying power" of the "darkness of the unconscious." In short, his is a deeply romantic vision—latently more than a little racist—whose rather limited terms seem more appropriate to the generation of Joseph Conrad, or to a particularly unreconstructed Freudian, than to a 1980s understanding of the variety and complexity of social and mental life in tribal societies.

Imagining the power of tribal art exclusively in these terms, McEvilley seems to see only one legitimate avenue for its contact with modern art: the domain of psychodrama and the expression of the dark unconscious. He accuses me by contrast of a "dread of the primitive, of the dangerous beauty that attracted Matisse and Picasso and that continues to attract some contemporary artists today." As instances of this ongoing tradition, he cites Hermann Nitsch, Paul McCarthy,

Kim Jones, and Gina Pane. It would seem that the pairing of Matisse and Picasso might already suggest that there is a wide range of modern primitivist responses that matches the wide range of tribal art. And no matter how deep one's respect for Nitsch et al., it is peculiar praise to hold them up as the true legatees of Matisse. If "dread" is what keeps me from constructing this kind of genealogy for primitivism, may I continue to live in fear.

McEvilley claims that I timidly avoid facing up to the kind of primitivism he prefers, and even "deny [its] presence." This is false, and misinforms his readers. My "Contemporary Explorations" chapter explicitly and pointedly considers views such as those he holds, and primitivizing art of the kind he admires. I don't deny these notions of the primitive exist, or that numerous contemporary artists believe in them sincerely. I do argue, however (in ways better examined in the essay itself), that there are other valid ways of thinking about the primitive that inspire other serious artists, and I explain why, in the end, I find these latter more rewarding and stimulating. I try to explain, moreover, that the strain of romantic, expressionist primitivism McEvilley favors, with its fantasies of total escape and forgetting, has disturbing undercurrents that are ultimately authoritarian in their implications.

My essay examines different ways interchanges between modern and tribal art have worked, and stresses that the two spheres have points of contact in the mind as well as in the gut—minimalism and cubism are points of departure, or zones of affinity, as valid as angst-torn expressionism. Tribal art, in my view, can inspire not only violence and dark dread (a response which, as Rubin explains at length in the book, is often based on misconceptions of tribal life and misunderstandings of tribal forms), but also wit, fantasy, and sophisticated complexity—many tribal objects project, in fact, a classic sense of dignity and serene repose. Modern culture, in turn, provides not simply encumbering values that need forgetting, but also powerful new ways of insight into the variety of tribal creation. This view is indeed "value-saturated and interpretive"; it is intended to be so, and declares itself as such. McEvilley, on the other hand, who believes that modern artists can willfully acquire the "intentionality" of their tribal counterparts, may similarly dream that there is some other way—presumably his own—in which a reading of primitivism and of the primitive can involve no such shaping premises.

One panacea he recommends is scrupulous attention to intention and context. Berating Rubin and me for excluding anthropological data from the exhibi-

tion labels for tribal objects, he seems to be arguing that proper awareness of original intentions will save us from the imperialist sin of misreading primitive art in our own terms. As I believe he demonstrates, however, construals of intention are every bit as problematic and value laden as other forms of "appropriation" from tribal sources. But I do not mean by this to damn appropriation per se—only to ask McEvilley to rethink some false divisions he's setting up. He suggests that my extolling "the capacity of tribal art to transcend the intentions and conditions that first shaped it" should be restated as "the capacity of tribal art to be appropriated out of its own intentionality into mine." I would be happy enough with the paraphrase, if I thought McEvilley understood what he was saying. For someone so committed to an idea of the power of the unconscious, and its communication across the barriers of time and culture, a nostalgic devotion to the notion of an inviolate, ultimately controlling intention seems curious and inconsistent. In fact, even without appeal to unconscious factors, it is plain to see that no act or object, by Shakespeare or a Yoruba carver, would have any broad or long cultural impact if its meaning or potential consequence were totally constrained by its founding motivations (which are finally unknowable in any event). As modern literary theory has driven home repeatedly, there is no validity in a model of knowledge based on the ideal of a privileged reading of an original determining intention. All art, culture, and communication functions by "appropriations" from one context to another. McEvilley and the artists he admires appropriate the primitive to their purposes just as certainly as I do. Between our two appropriations, the question is not which is pure—neither is or can be—but which is barren and which fertile, which is liberal and open-ended and which, in McEvilley's own terms, is a "rejection of the wholeness of life."

Unhappy with the exhibition's decontextualization of tribal objects, McEvilley offers what he seems to think is an ultimately damning image in riposte: a parallel but reverse decontextualization, where the Western object (in this case a food container) is adopted by New Guinea tribesmen as a clothing ornament. McEvilley concludes that our museum showing tribal objects is as ludicrous as the natives wearing Kellogg's boxes. On the contrary, though, the ability to see art value where others see only garbage (as, for example, in cubist collage, or [Robert] Rauschenberg) is to my mind a kind of receptivity, and creative intelligence, that is well worth respecting and thinking about. Specifically, the tribal use of Western discards is a potentially fascinating phenomenon, of which

McEvilley has chosen a relatively uninteresting instance. He ignores the more telling examples of this kind of bricolage that we included in the exhibition: a striking Guere mask made from bullet casings, or an exceptional fetish fashioned around a bottle of Suze liqueur. By acts of appropriation, disregarding the functions the Western objects originally fulfilled, the tribesmen saw new possibilities for the discards and gave them new life and meaning. I agree with McEvilley that it's fair to draw a parallel between this activity and the modern Western attention to the formerly neglected power of tribal objects. But his reading of the situation ascribes naïve stupidity to the natives and deluded venality to the Westerner, while mine would stress the common potential for invention, for expansion of cultural limitations, and for communication, that makes both actions compellingly and positively human.

KIRK VARNEDOE

Institute of Fine Arts, New York University, New York

———

THOMAS MCEVILLEY REPLIES:

I'm the one who barked these grouchy bears out of the woods, so I guess I have to listen to their howling and gnashing of teeth. In a sense it's a chance in a lifetime. We rarely see these bears out in the open—especially the big one. The angry bears, rising from what they must have thought was a well-deserved sleep, are after me. But they are shoddy arguers. Helpless in the face of issues which their replies indicate they barely understand—and then only in a nineteenth-century kind of way—they have adopted the courtroom strategy of discrediting the witness rather than responding to his testimony. They have attempted to undermine the readers' confidence in me by claiming inaccuracies in my text.

Let's consider this charge of inaccuracies. Varnedoe leads off with a daring revelation of a typographical error—how feeble, to attempt to discredit me on the grounds that a sprite of the typesetting or proofreading realms, after the finished,

correct text had left my hands, didn't pick up the fact that three had been changed to two—a common sort of scribal error—deep in a footnote. The thing to notice is not that there is a typo—because that happens—but that this scholar and curator, with a month to comb the text, could find nothing more important to criticize in the introduction of his reply than a typographical error in a footnote. Rubin shows a more ambitious version of the discrediting strategy: He wants to bury my readers' faith and my criticisms deep in an atmosphere of manufactured doubt. He begins his reply, understandably, by distancing himself from Varnedoe's "Contemporary Explorations" section of the show; he specifies the parts of the show that he is pleased with (the "Concepts" and "History" sections) and makes no mention of Varnedoe's unfortunate venture into the contemporary. He goes on to expressions of his familiar Picassoism, then defends the two-volume book that accompanies the exhibition from my statement that it merely refines and extends the research of Robert Goldwater. "But in terms of substance, our con-clusions," he says, "are at odds with Goldwater's as regards a host of basic ques-tions." Those familiar with Goldwater's book will recognize that this is a gross overstatement. The lines and themes of research are Goldwater's, the terminol-ogy is Goldwater's; what is at issue where they differ, as in Rubin's insistence that Goldwater did not recognize as many examples of direct influence as does Rubin's team, is just the gathering of more information.

The strategy underlying Rubin's approach, I suspect, is both to weaken the readers' confidence in me and to attempt to bog me down in answering petty dis-agreements, in the hopes that I will never fight through to the issues themselves—since those are the challenges Rubin wishes to avoid. I must drag the reader through a certain amount of this petty bickering about details, both in order to clear the reader's mind of manufactured doubt about the integrity of my article, and to illustrate Rubin's method of debate. Here's the sentence that is meant to lean the readers back in their chairs, distancing them from me once and for all: "His review," Rubin writes, "is interwoven with sufficient misconceptions, inter-nal inconsistencies, and simple errors of fact that—given its seriousness—it should not go unchallenged." The charge of these supposed factual errors centers around a paragraph in which I demonstrated with a few obvious examples—and I could have used others—that the practice of regarding and exhibiting primitive and modern works together was not really new to this show, as one might be led to believe by the claims and promotion around the show, despite its qualifier, "in the

light of informed art history." Rubin professes to find my statements about recent earlier exhibitions to be nests of inaccuracies. First is my statement that the Centre Pompidou, for several years beginning in the late seventies, "exhibited, in the vicinity of its modern collections, about 100 tribal objects from the Musée de l'Homme," some of them owned by early modernist artists including Braque and Picasso, with the intention of illustrating relationships with the modern works in the Beaubourg collection. In reply, Rubin attacks first my number, one hundred. Citing the authority of Jean-Hubert Martin, who was at the time a Beaubourg curator and in charge of the loans from the Musée de l'Homme, he declares: "(1) the two vitrines at the Centre Pompidou together never contained more than twenty or so objects." But in conversation with me subsequent to his conversation with Rubin, Martin stated that each vitrine—not both together—held twenty or twenty-five objects, bringing the total to forty or fifty at any one time. And there is more than meets the eye hidden in Rubin's unobtrusive little word *never*. Why doesn't he just say (however mistakenly) that the vitrines did not hold more than twenty objects? Because he is repressing the fact or doesn't know that the objects in these vitrines were changed, since more objects had been borrowed from the Musée de l'Homme than the vitrines would hold. *Never* means not at any one time, and has nothing whatever to do with the total over a period of time. No listing of the total number of objects has been located, but Beaubourg curator Jean-Yves Mock, whose memory provided my original estimate of one hundred, still says that figure is not unreasonable.

Next, Rubin denies that any of the objects in the Beaubourg vitrines had ever been owned by Braque or Picasso. In fact, at the writing of my article, one of the authorities on this subject had ventured the opposite opinion, yet, finally, it seems this point must remain moot, in light of the fact, acknowledged by Rubin, that no exact listing of the objects has been found. Still, the fact that some of the objects there belonged to early modernist artists is acknowledged by all. Rubin goes on to say that these objects "could hardly have been intended to 'illustrate relations' with modern art since they were chosen by Jean-Hubert Martin 'without respect,'" as he says, 'to historical or formal questions. . . .'" In clarifying this point to me, Martin said otherwise: The primary purpose of the installation was to open viewers' eyes to non-Western ways of seeing, he remarked, but added, "Of course it was also to remind people, without specific historical scholarship, that the painters in Paris at that time [early in the century] were aware of primitive art." Indeed,

unless one were trying to point out a relation of some type, why else would one exhibit primitive works in a museum specifically dedicated to *l'art moderne?*

Rubin's second set of claims of inaccuracies focuses on my remark that the exhibition of the Menil collections, *La rime et la raison*, at Paris's Grand Palais in the spring of 1984 "juxtaposed primitive and modern works (a Max Ernst with an African piece, Cézanne with Cycladic) and sometimes, as in the [MoMA] exhibition, showed a modern artist's work in conjunction with primitive objects in his collection." I am going to quote Rubin on this point, minor as it is, in order to demonstrate the more clearly his method. Again he numbers his points as if stacking up an inexorable case against me. He writes: "(1) the tribal material was shown almost entirely in its own separate areas." Again, note the unobtrusive little word, in this case *almost*. The fact Rubin can neither growl away nor live with is that the tribal objects were not shown *entirely* in their own separate area. That was my point, and he concedes it while pretending to deny it. Yes, the Ernst was shown with an African piece; yes, the Cézanne was shown with a Cycladic piece; and so on, through examples I have not mentioned. Rubin goes on: "(2) contrary to McEvilley, no modern works were 'shown in conjunction with primitive objects from [the artists'] own collection[s].'" Yet there is a plain statement in the catalogue, by Walter Hopps, curator of the exhibition, discussing the mixing of primitive and modern objects, in which he notes, "Ainsi, dans la section des surréalistes, on trouve, à coté de leurs oeuvres, des objets leur ayant appartenus" (thus, in the section on the surrealists, beside their own works one finds objects that belonged to them). These include, for example, Eskimo masks, of which "plusieurs furent acquises . . . par des surréalistes français établis à New York" (several were bought . . . by French surrealists living in New York).

His next point is no stronger: "(3) the juxtaposition of the Cézanne with a Cycladic sculpture and the Ernst with an African mask were determined by Mrs. de Menil's 'pleasure in seeing them together,' and were *not* the demonstration of any historical connection." Here again, the unobtrusive little element, in this case the italicizing of *not* directs the reader away from the point. The point is that Rubin has acceded completely to my statement, while again pretending to reject it. He has had to agree that the Cézanne was shown with the Cycladic piece, the Ernst with an African, and so on. To distract attention from that fact he attempts to shift the readers' attention to the last part of the sentence through the emphasis. Of course, the works were "*not* the demonstration of any historical connec-

tion." I never for a moment said they were. I am being corrected on statements I never made. Here again is the key catalogue passage from that show, on which my statements were in part based.

Ici l'art primitif est représenté à égalité avec l'art occidental; l'art occidental le plus ancien est juxtaposé avec l'art le plus moderne. Les affinités ne sont pas chronologiques, elles sont conceptuelles, iconographiques et formelles, destinées à suggérer les correspondances profondes entre les valeurs esthétiques et spirituelles de peuples et de temps fort divers. Ainsi, dans la section des surréalistes, on trouve, à coté de leurs oeuvres, des objets leur ayant appartenus. Dans la même esprit, quelques oeuvres modernes sont exposées au milieu d'objets archaïques ou traditionnels.

(Here, primitive art is represented equally with Western art; the oldest Western art is juxtaposed with the most modern. The affinities are not chronological but conceptual, iconographic, and formal; they are intended to suggest the deep correspondences between the aesthetic and spiritual values of very different peoples and times. Thus, in the section on the surrealists, beside their own works one finds objects that belonged to them. In the same spirit, several modern works are shown among ancient or traditional objects.)

Hopps goes on to mention the Ernst with the African piece, and so on. Rubin attempts to reduce the importance of the Menil show, along with the Beaubourg installation, saying they are "not instances of 'informed art history'"; he even goes so intemperately far as to say, "they were not, strictly speaking, instances of art history at all." And why not, in the case of the Menil show? His reason is that the juxtapositions under discussion "were determined by Mrs. de Menil's 'pleasure in seeing them together.'" Now, to say that the pleasure of the eye of a sensitive and long-trained collector is not automatically an exercise of informed art history is already somewhat questionable. The collection itself is an act of "informed art history," and the Menil show was the quintessential demonstration of collectorly connoisseurship's long habit of mingling the modern and the primitive. When Rubin declares that because objects were juxtaposed merely for the pleasure of seeing them together, the show is disqualified as informed art history, doesn't he realize that he is damning his own show too? Why, for example, was

Picasso's *Girl Before a Mirror* shown with the Kwakiutl mask—even on the cover of the catalogue and a poster for the show, as if this juxtaposition were the essence of it all? As I demonstrated in the article, there was absolutely no reason whatever to show these particular two pieces together except Rubin's "pleasure in seeing them together." Indeed, the greater part of his show was made up of that pleasure and his indulgence in it.

The careful way Rubin's and Varnedoe's letters are constructed is to give the impression that many factual inaccuracies have been found in my text. Rubin, for example, makes his remark about inaccuracies, then goes on for several paragraphs about matters of critical dispute that have nothing to do with claims of factual error. This blurring of the distinction between factual error and critical dispute is a basic method in both letters. If we pause and count up the inaccuracies they have found, we see that Rubin has found none, and Varnedoe has come up with a typographical error in a footnote. That is all. Enough with the distracting fog of these tactics. Rubin's achievement was not, surely, in originating the idea of juxtaposing primitive and modern objects, nor in being the first to act it out, but in doing it more extensively than his predecessors had—in fact, too extensively, considering that certain of his juxtapositions are meaningless.

It is in their treatment of the real issues that these men reveal, I think, a poverty of intellect. I am serious when I say that they seem to have brought only nineteenth-century ways of thinking, nineteenth-century minds, to bear on the discussion. Very near the beginning of his statement, Rubin takes refuge in references to "my conversations with Picasso," a tactic that amounts, throughout his text, to the fallacy called the appeal to authority. In an obvious appeal to authority, Rubin defends himself from my belief that more information should have been given about the primitive works by quoting Picasso's remark, "all I need to know about Africa is in those [tribal] objects." Rubin comments, "Picasso felt (quite rightly, I believe) he could apprehend aspects of the spirit, values, and nature of African civilizations through their art." But Picasso's remark could just as clearly mean, "all I need to know about Africa is how these objects look," for that is indeed all you get from just looking at them: how they look. Later, Rubin, quoting himself, says that the meanings that concerned modern primitivists "'were the ones that could be apprehended through the objects themselves.' *This*," he goes on, "is the real rub for, as we shall see, McEvilley refuses to accept that such meanings exist." Here Rubin is relying on an implied claim to universal

sameness of aesthetic feeling, an out-of-date piece of Platonic lore that has no ground in evidence whatever. The surprising thing is that Rubin evidently has no inkling of cultural conditioning and what it does to one's eyes. The meanings that we read directly from tribal objects are highly unlikely to be the ones the tribal image makers intended; they will predominantly be the ones that our own cultural conditioning has ingrained in us. To say, as he does, that one can derive the intended emic content merely by looking at the tribal works is to say that we need no study of ethnology at all, no struggle with the emic-etic problem—in short, no attempt to understand the tribal images and image makers on their own terms; our own terms, he is saying, must be universal, evidently just because they are ours. This is in fact the principle on which his show and book are based. That, after reading my article, he fails to perceive the simple and basic point of cultural relativity indicates how deep is his resistance to it and how unquestioning is his commitment to the claim of the universal supremacy of Western cultural values.

In another defense against my charge that the realities of the tribal works were actually repressed in both the *"Primitivism"* show and, above all, the book, Rubin says that the museum was "studying the reception of tribal objects by Western artists." "But," he laments, "McEvilley won't let us have a show about that reception, which is, of course, precisely what *primitivism*—as opposed to *the primitive*—signifies." This is, of course, not strictly true. I said that I would be far happier with the show (and book) than I am if they had truly limited themselves to the reception; the problem is that both the show and the book (especially Rubin's introductory essay) attribute motives to the primitive as well as to the primitivist—in fact, the same motives—making them (what else?) like us. It is primarily in his category of "affinities" that he attributes to the tribal image makers this and that modern Western aesthetic feeling and ambition, ignoring their own expressions of their feelings and ambitions. Rubin shows a strange immunity to criticism here. He refers to his "auto-critique," which would feature improvements in his "affinities" category; yet his categories were one of the leading subjects of my article and he has nowhere replied to my criticism of them, except vaguely to imply that he is privately improving them.

Throughout Rubin's letter, he resorts to the childish tactic of throwing my accusations back at me (*"You* are"—"No, *you* are"—this is Varnedoe's reflex too), rather than answering them. He says, for example, that McEvilley "constantly presumes to know and speak for the 'intentionality' of long-dead tribal

artists . . . He confidently puts himself into their minds. . . ." In fact, I have attributed no motives to the tribal image makers, except to deny, on the soundest of anthropological, linguistic, and psychological grounds, that the motives he attributes to them apply. When Rubin claims that "many leading anthropologists disagree sharply with [McEvilley's] ideas," he is suggesting again that I presented some definition of tribal Otherness. Of course I did not; I criticized Rubin's definition, since his idea of Otherness is simply to make it look like oneself. And for his part, Varnedoe writes, "[McEvilley] seems to be arguing that proper awareness of original intentions will save us from the imperialist sin of misreading primitive art in our own terms." Yes, that is to an extent what I mean, and I direct the reader's attention to the somewhat mocking tone of the phrase "imperialist sin." Like a Westerner of the nineteenth century, Varnedoe cannot take the question of an imperialistic sin at all seriously, though to many it virtually leaps off the walls of the exhibition. A prominent non-Western artist, for example, hearing the show praised, said, "No; we don't want to be their mascots."

Both Rubin and Varnedoe claim that the absence, in both the show and the book, of information about the attitudes of the people who made, used, and understood these objects is justified by our lack of knowledge of such attitudes. "Construals of intention are every bit as problematic and value laden as other forms of 'appropriation' from tribal sources," says Varnedoe; and Rubin asks, "Does McEvilley himself know how little is known about most of these tribal objects?" They suggest, in other words, that since we cannot know what these things were made for, we are justified in projecting our own fantasies onto them. Rubin asks, "Will McEvilley please tell me how he learns anything about the 'religious or mythological connections' of the objects in the vitrines of Tervuren, the Musée de l'Homme, or the Völkerkunde museum in Berlin . . . ?" Why, I'd be glad to. I would suggest, first of all, more attention to the relevant ethnologic literature (yes, it is there) and, above all, to the history of religion. Of course there are many problems in the anthropological literature and many blind places in our knowledge of tribal attitudes, but, in fact, the one area where there is rather abundant knowledge is that of ritual practices, which is the major area relevant to the works in the exhibition. To illustrate the sometimes difficult types of content that primitive images might have, I might even be so bold as to suggest my own monograph on some Indus Valley icons, published in *RES*, journal of the Peabody Museum of Harvard University and of the

Laboratoire d'Ethnologie of the University of Paris. I would be glad to provide further reading lists.

Both Rubin and Varnedoe seem determinedly innocent of serious attention to the question of how primitive cultures develop and change. In prehistoric art, for example, thousands of years may be needed for a small development in image making. The situation is very likely the same in more recent tribal cultures. This I referred to as "communal inventiveness," which Rubin describes as "a process I [Rubin] leave the reader to try imagining." Well, one might for example try imagining the American automobile industry, where stylistic change arises through a communal development, or again look at a shelf full of books and contemplate the changes in book design over the last hundred years, or, again, the design changes of utilitarian objects like household goods and cigarette lighters, all of which change in essentially communal ways. The evidence is that tribal images were regarded as utilitarian objects by their makers and users, and that their design changes would better be compared with those of our utilitarian objects than with the originality-obsessed Western practice of art.

When Rubin says that I want "the tribal objects presented in a wholly integral way (never spelled out) in which not even anthropological museums show them," he is being disingenuous. Rubin claims that I "demanded" "'environments'" in the installation; no such demand occurs in my article. I want the objects written about without attributing our motives to their makers. I want writing and exhibiting that are as clean as possible of ego projections. That is all. In response to my request for more information about the tribal objects, Rubin and Varnedoe claim that they cannot be dated and, somehow, need not be dated. Yet anyone who opens a scholarly book on primitive objects, or who visits anthropological museums (and by the way, I'll put my hours in them against Rubin's any day), will see that at least approximate dates are usually given for the works. The fact that these dates are reconstructed by scholars does not in the least invalidate them, as Rubin claims; *all* dates are reconstructed by scholars. The fact that these reconstructions will change as the available evidence changes does not mean we should ignore them; it means that at any time we must use the best possible scholarly approximation, with an understanding that it is less than absolute. Without dates, how do we know that we are dealing with what Rubin calls "long-dead tribal artists"? One very good reason for including dates in this show—one brought up in my article and conveniently ignored by both Rubin and Varnedoe—is that it is absolutely

certain that tribal image making since the nineteenth century has been increasingly influenced by Western arts and crafts. The distinction between ethnic and tourist arts is all important.[1] As soon as a market began to exist for tribal objects, their character changed. If the objects in the show are all genuine, that is, pre-market, or pretourist works, then they were used in ritual ways as I described in the article; if they were not so used, then they are the products of tourist industries. In other words, the omission of dates amounts to another hidden tactic for avoiding the confrontation with the actual uses of these objects in their tribal settings. One could almost believe that Rubin would rather show tourist works, since they were never used in ways that Western eyes have trouble facing.

Let's consider the tribal object that Rubin uses in an attempt to suggest that my approach is opposed to aesthetic feeling and appreciation—the large Nukuoro Island figure that introduces the exhibition. Rubin identifies this figure as "the goddess Kave," and says no more. By mentioning the mythological title, Rubin gets one foot into the ethnology of the piece, but never puts the other in. And why not? Brian Brake, James McNeish, and David Simmons, in their book *Art of the Pacific,* show the same icon of Kave and note that she was a goddess to whom human sacrifices were offered.[2] Rubin has, in other words, invoked the very positive feelings that Greek mythology and related traditions have instilled in us toward the idea of a "goddess," in connection with a figure that should have very different associations. If he was going to name her at all, he should have told us not only who but *what* she is. The other way would have been simply to present the icon as an object, with no references to goddesses and myth-names at all. Let me put the point clearly: *If* the Kave icon is authentic, then it was used in its own culture for human sacrifices rather than for aesthetic enjoyment; if, on the other hand, it was never bloodied by human sacrifice, then it is probably not authentic, but a tourist work.

Rubin focuses very extensively on the fact that I raised questions about calling tribal objects artworks plain and simple. He says that to me the tribal objects are "not art, but religion or magic." This fragment of a quotation from my article eliminates context and attributes to me a point I made about a hypothetical tribal observer. What I actually wrote was this: "If you or I were a native tribal artisan or spectator walking through the halls of MoMA, we would see an entirely different show from the one we see as twentieth-century New Yorkers. We would see primarily not form, but content, and not art, but religion or magic."

The statement, by the way, is correct beyond a doubt. I have not, in other words, denied these objects any status by questioning the way their wholeness is fragmented and repressed as they are appropriated into Rubin's art realm. The question ultimately is not whether these things are or are not art (an essentially barren question of linguistic usage), or whether they should or should not be regarded as art; the real issue is how these men regard art and its relationship to the world, to history, to culture, to civilization. This is not exclusively a question about so-called civilized versus so-called primitive cultures. It is a question about the critics' or curators' willful ego-projections onto the objects. (How Rubin represented the works of the dadaists and surrealists in an earlier book is a similar case.) The problem with calling the tribal objects art merely through their design similarity to modern art is precisely that this tactic amounts to a rejection of the intentions of the makers and an imposition on them of foreign intentions that would not have made sense to them.

Varnedoe replies to my desire that the tribal image maker's intentionality be attended to by claiming that "modern literary theory has driven home repeatedly [the idea that] there is no validity in a model of knowledge based on the ideal of a privileged reading of an original determining intention." By "modern literary theory" he seems to mean the formulation by W. K. Wimsatt and Monroe Beardsley, in the forties, of the idea of the intentional fallacy. Of course, an artist's statements cannot be allowed utterly to control the interpretation of his or her work, but neither can they be ignored. In any case, the idea of the intentional fallacy is wrongly brought up by Varnedoe here; it does not apply to my argument. I am talking about the fact that cultural objects arise in cultural contexts, and that within that larger context—in which the particular maker's personal and specific intentions are merely a detail within a larger whole—they are communally understood in certain ways which, for that culture, constitute the reality of the object. Varnedoe's invocation of the intentional fallacy springs from his misunderstanding of the difference between the word *intention*, which refers to an individual's intention and is what the intentional fallacy is about, and *intentionality*, which is a larger world-constituting type of understanding having always communal resonances. The whole-cloth nineteenth-centuryism of Varnedoe's thought is revealed in a display of comedic ignorance. He quotes me as using the term *intentionalities* and notes parenthetically that this is "a word [McEvilley] favors as a substitute for the simpler *intentions.*" He evidently doesn't recognize that *intentionality* is a tech-

nical term in the philosophy of Edmund Husserl and in the whole phenomeno-logical movement. I used the word *intentionalities* rather than the very different word *intentions* to indicate that, like linguistic philosophy, phenomenology also would give us insight into the problems at issue here—to indicate that I was dis-cussing the way that one's cultural horizon, like one's language, both shapes the mind and constitutes the world it relates to. Twentieth-century ways of thinking like linguistic philosophy and phenomenology have tried precisely to pry us loose from the unremitting colonialistic egotism of our nineteenth-century ways. Varnedoe remains silent in the face of such arguments, evidently not recognizing the terminologies. Both he and Rubin even use quotation marks around *inten-tionality* as if to suggest that it is some monstrous, affected coinage of mine. The anthropological linguists Edward Sapir and Benjamin Lee Whorf have argued very influentially that if a people's language does not permit the expression of a certain concept, then there can be no reason at all for saying that people have that concept. This fact has been experimentally confirmed in a number of ways.[3] Now, in light of that, can there be any justification for ignoring the fact that the lan-guages of the tribal cultures whose objects were seen at MoMA utterly lacked words or even circumlocutions that could express what we mean by art? It is a simple fact, both on linguistic and on ethnological grounds, that the makers and users of the tribal objects in the MoMA show did not regard them at all as we regard our art. Why then should our concept prevail over theirs in discussions of their objects? Is it not merely arrogance to bring in our term from outside, on all the tribal objects we like, as if we knew what they were? Is it not in fact a dead end to show no curiosity about attitudes different from our own?

The making of objects whose only or primary function is pure contempla-tion and aesthetic appreciation is, in Western cultural history, peculiar to ancient Greek culture and its descendants and offshoots, including us. Something similar, but by no means identical, arose in T'ang-dynasty China. Most of the world's cultures did not know of this activity until they came into contact with the European stream of influence. What we call art, in other words, as opposed to functional types of image making and craftsmanship, is not an etic or objective and universal phenomenon.

Rubin, noting that tribal peoples lack a word for art, remarks, "But the same is true for the ancient Egyptians; yet that culture's painting and sculpture is not denied the status of art." The fact is that most of what we regard as Egyptian art-

works the Egyptians themselves understood as functional objects within the very practical activity of funerary magic. To us, the activity of making something art prominently involves the act of displaying it or reporting on it to others. But virtually every object in the great Egyptian Museum at Cairo was made to be buried underground and hidden from human eyes and from human knowledge forever; nor is there anywhere in the abundant Egyptian literature any hint that ghosts or gods or anyone else were intended to take aesthetic pleasure in these objects in the way we do. The reasons why they were so gorgeously designed and crafted, then, remain a mystery that it should be our concern to penetrate rather than to avoid with an easy term. We could honestly say that these things are funerary objects, and then go on to say that we like to look at our artworks next to their funerary objects. But instead we co-opt the whole cultural reality of these objects into our language game, so that we can use a word we feel at home with, regardless of the fact that it has a very limited and partial application to them. Rubin and Varnedoe are implicitly declaring that everything native to these non-Western cultures is unimportant next to our mania for calling their spoons and things art. The tribal person, in other words, has no dignity in terms of his or her own aspirations and concepts. Our conviction that we understand these things properly by calling them art, even that we elevate them by giving them that name, necessarily implies that the people who made them and the people for whom they were made did not understand them properly—a bizarrely skewed claim. It is to avoid such atrocities of thinking that I suggest we begin to loosen up our habit of believing that we honor those objects by conferring on them our revered concept "art."

"McEvilley," says Rubin, "simply refuses to accept the fact that our story is not about 'the Other,' but about ourselves." In fact, my point is the opposite. What is at issue is not simply a matter of attempting to understand other cultures; it is a matter of attempting to understand ourselves. By forcing other cultures into our own familiar modes of naming and feeling, we rob them of the power to reveal ourselves by our Otherness from them, we rob them of the power to show us our limitations and to suggest possible ways to grow beyond those limits.

Rubin shows no awareness of the complexity of the question, "Is it art?" In a very important sense, that question is meaningless until completed with some such phrase as "Is it art to you, or to me, or to that person there?" This phenomenological aspect relates, again, to the linguistic. The rule of usage as the arbiter of meaning was the fundamental insight of twentieth-century linguistic thought,

the center of the work of both Ferdinand de Saussure and Ludwig Wittgenstein—the insight that there was no necessary relation between word and thing. As Saussure said, the connection between the signifier and the signified is arbitrary, governed merely by usage. In Wittgensteinian terms, to be art simply means to be called art. The question is not, "Is it art?" but, "Is it called art?" In this sense, for the figure of the goddess Kave, for example, the answer is double: no, for its makers and the people of the culture in which it was made, it is not art; and yes, for us who call it art, it is art. It is art by our redesignation of it as such; it is art in the same way that unhewn stones brought into a gallery by Robert Smithson were made art by the act of so designating them.

Finally, I think it is clear that Rubin's emphasis on the question, "Is it art?" involves a serious misreading of my article. I did not say the tribal objects were not art, but that there were several senses in which something might be called art, and that some of these clearly don't apply to the tribal objects. Neglecting the complexities of the question altogether, Rubin asks, in effect, why did McEvilley question the practice of calling these things art and nothing more, and the only answer he can imagine is this: McEvilley must think it's not good enough to be art!

He then, most regrettably, takes this drastic misreading to the limit. "Most early anthropology," says Rubin, "is shot through with such prejudices!" as "the view that the Other is lazy, unintelligent, fit only for *travail de nègre* and, above all, uncultured." How easy this blatant reversal of my argument makes it to deal with me. But it gets even worse than that. "I wonder," Rubin asks gravely, "how many of his readers who saw our show and stood before the monumental Nukuoro Island carving of the goddess Kave that introduces it, share McEvilley's conviction that what they were looking at was 'not art.'" He has, in other words, simply struck up the national anthem of the kingdom of aesthetic feeling, as if I alone were saying that these objects are not noble, spiritual, and great. In fact, I am saying something quite different—that these objects fall outside the categories of our language, that this is the great freedom they offer us, and that a vast opportunity is lost when we force them into one of the categories of our known language with its familiar and limited horizon or intentionality. But note that along with me, Rubin has excluded, without a glance at them or a feeling for them, the Nukuoro Islanders themselves, who, supposedly "like McEvilley," think that the Kave figure is "not art"—not because it is of insufficient formal beauty to be called art, but because, for all its magnificent formal beauty,

like a mountain or an automobile, it happens to be something else. Rubin thinks he is doing the Nukuoro Islanders a favor because he is saying that they are like him; but what if they don't want to be like him? He should face the facts of what the Nukuoro Islanders themselves did before that figure of Kave to which he sings the anthem of aesthetic feeling.

In terms of the affirmation or denial of the art identity of tribal works, three periods of history must be distinguished. There was the period prior to the scholarship of Franz Boas, when primitive objects were denied the status of art as if it were an honor that they did not deserve, as if they were just not good enough to be called art. Then came a second phase in which tribal objects such as those in the show were thought to be formally and intellectually "good enough" to be called art and the habit arose of so calling them. More recently, the possibility has arisen of a third phase, which anthropologists are finding the way into now, when one may begin to look at the tribal objects from the point of view of their own culture and to realize that, whatever they are, they fall in between the categories on our grid. In other words, it is not the objects that are inadequate but our conceptual grasp of them. My skepticism about the act of bestowing the word *art* in these and certain other contexts is a phase-three rather than phase-one attitude. I think this is obvious to anyone who reads the article. I must not, of course, be misconstrued as meaning that there should be no museums of primitive art, or courses in primitive art, or studies of the relationships between these objects and ours, and so on. The objects in question are of such great interest that one delights in studying and regarding them, and in so doing, the temptation to relate them to things that look like them from our own culture is easily submitted to. But I suggest that the phase-three act must be different from the phase-two act of aesthetic appreciation that we are all so good at and comfortable with. What we must learn is to see a doubleness, the two aspects at once, simultaneously feeling these objects as art, which is our way of appreciation, and maintaining a sharp and constant awareness of the fact that the people of their own culture did not so feel them. This keen awareness of cultural relativity and of the arbitrariness of one's own horizon is simply the necessary step in maturation for our culture—and a step necessary for the safety of the whole world.

Finally, I must deal with the cheapest of Rubin's and Varnedoe's tactics against me, their presentation of me as an ideologue because I speak of subjects besides formal similarities. Rubin says I have transformed the event into "an act of con-

temporary art politics," and refers to my "art-political ways of thinking." He is practicing the familiar tactic of dismissing criticism by calling it "political"; what I performed was an act of criticism, not an act of politics. Rubin's accusations of political motivation are paralleled by Varnedoe's claim that I am a person interested in violence and the darkness of the unconscious, echoed by Rubin's repeated quotation of a phrase in which, thinking, for example, of the human sacrifices to Kave, I used the word *blood*. This is really low argumentation. They have attributed to my personal tastes the qualities of certain religious practices that I denounced them for ignoring and censoring. There is no doubt whatever that the religious practices associated with those ritual objects were characterized by what we would call violence, and that many of the objects in the show, if they are genuine, were used in conjunction with sacrifices and ritual bloodshed. I asserted that these men, by editing out the facts, misrepresent the objects. Their replies suggest that because I would not edit out the real qualities of the religious rites involved, I must have a ghoulish attraction to blood and violence. In their view, it seems, an accurate and realistic description of traditional ritual practices would be unhealthy; a totally misleading and censored version like theirs, on the other hand, is supposedly the product of a healthier mind. This is what I meant by saying that they shouldn't have dealt with the topic at all: If they feel that the realities of the topic have to be censored out on moralizing grounds, then they manifestly are not the right people to have treated the topic in the first place. Their assumption that to face the topic squarely would somehow show bad character reveals an appalling lack of scholarly integrity. They are forgetting that scholarship (including art history) is a type of science. I felt that the context of blood was necessary to confront *because it was factually there.* Rubin's and Varnedoe's belief that Western civilization and its ethic are served by ignoring the realities of the topic shows an absolute lack of understanding of the difficult responsibility of science to face up to all the facts, not just the easy ones.

But these letters, of course, get even worse than that, for example the part where Rubin slops Mom, country, apple pie, and German slogans all over me. It's his grand peroration, where he goes for nothing less than a destruction of the idea of my humanity. You remember: "If the peoples of the world," he intones somberly, "are to get along with each other, they will not only have to appreciate their respective 'Otherness'"—note the quotation marks: Here again is something he doesn't really think exists— "they will have to recognize their common human-

ity." (Wow!) "Some of us," he says, "still do not think Schiller's hope that *alle Menschen werden Brüder* is tainted by co-option. By denying the manifest genius of tribal artists, McEvilley excludes whole peoples from this cultural commonality." But I have not of course for a moment denied the genius of tribal peoples; I have suggested that it might be saner and more interesting to try to appreciate their genius in as many of its own terms as we can, and that it is, to an extent, possible to find those terms out. So why don't we try to do it? As far as excluding people from "this cultural commonality," I seriously question whether what the peoples of the Third World need is the kind of Western imposed "commonality" implied by a German slogan that is more about forcing people to be one's brothers than about becoming theirs. I, and I think they too, want out of that sick dream. It sounds too much like a Leni Riefenstahl film to me, all the peoples of the world trudging along together hollering out the Ode to Joy. That Rubin would introduce such a completely gratuitous and sophistic *argumentum ad hominem*, one so ungrounded in argumentation, is disgraceful, and a disgrace that our readers will have seen he shares with his collaborator, whose only tactics are sophistic reversals, *ad hominem* arguments, and empty denials. In response, for example, to my claim that his "Contemporary Explorations" section was dominated by the earth-mother view of the female, he asserts that he denied that association in his essay; well, deny it he might, but the fact remains that that is what he did in the exhibition. Both men in effect say, "don't watch what I actually do, just listen to my claims about what I do."

I gave the *"Primitivism" in Twentieth-Century Art* exhibition reasoned criticism, and Rubin and Varnedoe gave me back rhetorical tricks. I gave them historical and philosophical arguments and they met not one of them, not one, dear reader, because they *could not*. They are bad bears indeed, and I am going to bark them back into the forest now as I barked them out some months ago so we could look at them. I did not think they would look as bad as they do. I expected worthier adversaries.

NOTES

1. See, for example, Nelson H. H. Graburn, ed., *Ethnic and Tourist Arts* (Berkeley: University of California Press, 1976).

2. Brian Brake, James McNeish, and David Simmons, *Art of the Pacific* (New York: Harry N. Abrams, Inc., 1980), 132.

3. See, for example, B. Berlin and P. Kay, *Basic Color Terms* (Berkeley and Los Angeles: University of California Press, 1970); A. Capell, *Studies in Socio-Linguistics* (Hawthorne, N.Y.: Mouton, 1966); and R. Brown and E. Lenneborg, "A Study in Language and Cognition," in S. Saporta, ed., *Psycholinguistics* (New York: Holt, Rinehart & Winston, 1961).

On "Doctor Lawyer Indian Chief": Part II

(ARTFORUM, MAY 1985)

A LETTER BY WILLIAM RUBIN

WITH A REPLY BY THOMAS MCEVILLEY

TO THE EDITOR:

Under normal circumstances I would not trouble *Artforum*'s readers with a continuation of the exchange between myself and Thomas McEvilley on the *"Primitivism" in Twentieth-Century Art* exhibition at the Museum of Modern Art ["Doctor Lawyer Indian Chief," November 1984; "Letters," February 1985]. However, there are important issues that have been obscured in this fray, and these need clarifying. Thus I ask the reader to rise above the intemperate tone of McEvilley's "final word" and to—dare I say?—please bear with me.

In places, McEvilley and I argue past each other, creating differences where I hope we might, in time, agree. But there is no mistaking the huge gap in opinion that separates us. McEvilley's disgust with the history of Western colonialism—a history I deplore as much as he does—unfortunately leads him to the kind of indiscriminate extremism where Schiller becomes a sloganeer comparable to Hitler's pet filmmaker, and where we are asked to admire most of those contemporary artists who somehow have the gift of "literally forgetting [Western civilization's] values." McEvilley is surely not alone in his anti-Western position—but he is surely right if he senses that these are not the positions of the organizers of the exhibition. It is no wonder that he finds so much to criticize in the show and, as

I took the trouble to suggest at the beginning of this exchange, anyone interested in these issues can only be impressed by the sincerity and intensity of his response.

But there is obviously one tradition of Western thought that McEvilley admires—at least, so one would gather from his eagerness to cite experimental evidence and his appeal to scientific method in art history—and that is the Western practice of scholarly and scientific inquiry, which rests ultimately on the tradition of critical dialogue. I more than share McEvilley's enthusiasm for this tradition, and, as any student of my writings will know, I have in the past found such exchanges—many of them stemming from disagreements at least as great as that between McEvilley and myself—to be immensely profitable and stimulating.

I had hoped that the exchange between McEvilley and myself would continue that tradition. But in order for such exchanges to be productive, it is necessary that the intellectual basis of critical discussion not be undermined. In the history of rational inquiry, it has generally been thought unproductive to attack what you take to be your opponent's motives rather than his arguments—and particularly unproductive to attribute to him sinister or conspiratorial motives. Nor does it advance the discussion to appeal to discredited or, worse, unnamed authorities. And it is fatally destructive to the nature of discourse—however much it may appeal in the heat of intellectual contest, and even on what may seem to be a minor point—to fabricate evidence rather than admit error.

Anyone who has taken the trouble to read my writings or attend my lectures will be as unable as I am to recognize McEvilley's portrait of me as a kind of high priest who insures the mysterious "canons" of what McEvilley calls "formalist modernism" and who dwells in "the temple of formalist modernism" on Fifty-third Street, where the "cult of pure form" is unashamedly practiced according to the "dogma of universal aesthetic feeling." I suppose that I should be flattered to be mistaken for this Druid, since he is obviously quite a guy. (He will do *anything*—including mounting exhibitions that co-opt entirely unrelated art—in order to "revalidate modernist aesthetic canons.") But then (I surmise) he has some unattractive traits, too: According to McEvilley, he is always ready to abandon a colleague when it seems convenient. Thus, McEvilley writes that Rubin "begins his reply, understandably, by distancing himself from [Kirk] Varnedoe's 'Contemporary Explorations' section of the show." My remark about not speaking for my colleague did no more, of course, than recognize that, as Varnedoe was appending his own letter, I considered him more than able to speak for himself.

Lest there be any doubt whatever in McEvilley's mind, I very much like Varnedoe's selections for "Contemporary Explorations," as I did his entirely persuasive letter outlining the principles behind them. Above and beyond inevitable differences in judgment—indeed, in part because of them—Varnedoe's particular contributions to all parts of the show were critical to its success.

Alas, all those who will now haunt the galleries of the museum hoping for a glimpse of the Dark Lord of Modernism will be sadly disappointed. My own ambitions are much more modest than those McEvilley imagines for me. In all my work I have never thought to "validate" modernism; I am only trying to understand it. Nor can I fathom what McEvilley means when he says, citing our show of the late work of Cézanne, that modernism is "self-validating." Is it that it doesn't have to be approved by the party or the church? Or McEvilley? And how does Cézanne's art go on "validating and invalidating other things"? What does it "invalidate"? What has been suppressed from MoMA's twentieth-century collection because "invalidated" by Cézanne? And is modernism "above the web of . . . cultural change," as McEvilley claims? What better example of the way it is not than primitivism itself? The very year of Cézanne's memorial exhibition, artists presumably "validated" by him, Picasso and Braque, began to study tribal art, which Cézanne would surely never have considered "valid."[1]

It is my supposed fixation with something called "pure form" (a meaningless phrase I have never used nor would think of using[2]) that, according to McEvilley, has left me entirely uninterested in the historical context of any art. I, on the other hand, would never have become an art historian were I not committed to the belief that the fullest understanding of art objects requires that we know as much as we possibly can about the cultures from which they came. It is precisely *because* I am concerned with historical context that I virtually omitted anthropological information from the exhibition—richly stimulating though I find it—where it could only have misled the viewer about the actual intellectual context and content of modernist primitivism, which, after all, was the subject of our show. It is simply a fact that (with but rare exceptions, beginning only around 1930) the cultural and historical context of twentieth-century primitivism did not include anthropological information; it was totally irrelevant to the pioneer modernists' reaction to tribal objects.

The rare instances when modernist artists possessed some ethnological information were noted in our book. However, the problem with even these anthro-

pological "facts" is that they usually turned out to be fictions—i.e., theories discredited by later anthropologists. Let me give a classic example. Michel Leiris was one of many ethnologists I consulted several times in preparing our show. A member of the Dakar-Djibouti mission of 1931–33, he is an expert on the collection of the Musée de l'Homme, a great writer, and was long a close friend of Picasso. He told me that, by the thirties, Picasso would certainly have heard that the big-nose Baga (Guinea) Nimba figures and masks were a sort of "goddess of fertility"—the way many collectors and dealers in African art still refer to them.[3] This merited being brought into the discussion because Picasso owned two such figures and a giant mask (which stood in the entrance of his château), and the big-nose busts of Marie-Thérèse Walter he sculpted at that time (and her image in *Girl before a Mirror*) associate *her* with a kind of fertility goddess.

Today, however, the anthropologist Leon Siroto, a specialist in West African art, will tell you that the Baga figures have nothing demonstrable to do with a "goddess of fertility" and that, even for the mask, such an interpretation is inadequate ("fertility" is only one of its possible aspects) and misleading (because the very word *goddess* is Eurocentric and wrongly applied in the case at hand to African cult symbols). So had we presented these tribal objects from the perspective of today's anthropology, we would have had to explain that on this rare occasion when a modern artist actually knew something about "primitive context, meaning, [or] content," *what* he knew was essentially a fiction. I can imagine the visitors reeling out of the galleries after attempting to digest such dual-track information. That the operative fictions of modernist primitivism were in fact Eurocentric was, of course, something we had accepted, indeed, insisted upon from the start. The whole history of modernist primitivism, at least until very recently, took place within the context of Eurocentric assumptions, and it cannot be recounted or understood outside those terms—certainly not within the ex post facto framework of today's advanced anthropology.

Similar strictures apply to the problem of providing dates for tribal works. Our omission of individual dates for the tribal objects, which we had described as mostly from the later nineteenth and early twentieth centuries, was seen by McEvilley as "another hidden tactic for avoiding the confrontation with the actual uses of these objects in their tribal setting"—as if the latter ethnological concerns were relevant, or had ever been our purpose. Moreover, not a single tribal object in our show *can* be dated "precisely," and precious few can even be dated

approximately. Where tribal objects *are* given dates by scholars, such dates are almost always of the exceedingly elastic order of those attributed to a handful of objects in the Menil family collection catalogue (where many of the African objects are totally undated and only six of the forty-four Oceanic objects are given even approximate dates). As in this catalogue, the most focused dates scholars normally proffer for these objects are of the order of "nineteenth century," "nineteenth to twentieth centuries," and "twentieth century." As "twentieth century" could apply equally to objects made yesterday and those that predate the modernists' discovery of tribal art, it is obvious that this or other vague dates are useless for the study of primitivism. Far more important—indeed, crucial—for the study of primitivism was the question of the dates at which objects could have been seen in the West, a subject to which we devoted an immense and unprecedented scholarly effort. (McEvilley's claim that in "anthropological museums . . . at least approximate dates are usually given for the works" is simply untrue. In the African section of the Musée de l'Homme in Paris—as I took the trouble to reconfirm on a recent visit—*not one* of the labels for any of the hundreds of objects contains even an approximate date. The same thing is true for the tribal objects in the African and Oceanic galleries of the American Museum of Natural History— among other ethnological museums.)

Of course, in the largest sense there *are* "anthropological" issues at stake throughout the show, in that it deals with human artifacts and was always intended to raise larger questions about the nature of human creativity. Here there is room for rich and profitable debate between McEvilley and myself, as there is, indeed, room for such debate between art historians and anthropologists, as well as, of course, among anthropologists themselves. (It was precisely in order to welcome and further such debate that we invited a group of distinguished anthropologists and historians of primitive art to join us in a day of intellectual exchange about the exhibition, in early November.) It is, of course, a basic assumption of the exhibition that when we talk about the tribal objects as art or sculpture, we are saying something perfectly sensible and meaningful. McEvilley refuses to accept this position, and embraces instead a radical form of cultural relativism. In support of this position, he dogmatically cites various kinds of evidence from art history, anthropology, and anthropological linguistics.

Now, I do not pretend to be anything of an expert on either anthropological or linguistic issues. Nor do I imagine that such immensely rich and complicated

issues can be sorted out in this kind of exchange (though I would think it not impossible that some real progress might still be made). I can only envy McEvilley's authority in art history, anthropology, linguistics, phenomenology, and literary theory, and sympathize with his need to mock the comedic ignorance of those less accomplished than he. Alas, as but a poor art historian, I can only hope that after a professional lifetime in this field I know something about *it*, at least. And yet, when I come to consider McEvilley's art-historical citations, I am often really startled. For example, in order to cut through a supposed "myth of the continuity of Western art history" (another sacred dogma of mine, which somehow I had previously been unaware I held), McEvilley asks us to consider that "the charioteer of Delphi, circa 470 B.C., for example, was seen totally [sic] differently in classical Greece from the way we see him now. He was not alone in that noble, self-sufficient serenity of transcendental angelic whiteness that we see." Perhaps I should take it less amiss to find my own ideas being transformed beyond recognition by McEvilley, when I discover that he can also somehow transform this familiar monument of introductory art history from a bronze into a marble.

I am afraid that almost all of McEvilley's art-historical assertions come from the same quarry as the marble charioteer. I had pointed out that the Egyptians produced art, although they had no word for it. McEvilley counters this by saying that "what we regard as Egyptian artworks the Egyptians themselves understood as functional objects within the very practical activity of funerary magic. . . . virtually every object in the great Egyptian Museum at Cairo was made to be buried underground and hidden from human eyes and human knowledge forever. . . . the reasons why their [painting, sculpture, and decorated objects] were so gorgeously designed and crafted, then, remains a mystery. . . ." Only to McEvilley. McEvilley seems to be crossing his fingers and hoping that none of his readers has been to the Egyptian Museum, where, contrary to his assertion, there are a great many objects not intended "to be buried underground."[4] Some of the objects in royal tombs were, in fact, the very ones previously used in palaces. Moreover, anyone who visits Karnak or a variety of other sites can still see a great deal of Egyptian painting and sculpture that was intended to be seen in the light of day. Indeed, the tomb paintings, sculptures, and objects were *not* (as Leo Steinberg said to me of this passage in McEvilley's reply) put underground to be hidden from human eyes forever. "They were designed," he observed, "to be enjoyed, both functionally and aesthetically by human eyes in an assured afterlife precisely forever. McEvilley is

simply projecting his own skepticism about the afterlife upon the ancient Egyptians." Or—may I add?—"appropriating their intentionality into his."

In defense of his astonishing concept of "communal inventiveness" as a description of the process of change in tribal art, McEvilley cites "the American automobile industry, where stylistic change arises through a communal development, . . . or, again, the design changes of utilitarian objects like household goods and cigarette lighters. . . ." Yet, as any beginning student in the history of industrial design knows, the development of design objects—including automobiles and cigarette lighters—has been very much the consequence of individual inspirations by gifted designers. At the same time, all Western art might be considered "communal" insofar as its development depends on the sharing of ideas within artists' communities.

McEvilley's record in art-historical citation, therefore, makes me a little uneasy about the unassailable truth of the anthropological and linguistic evidence he calls on so confidently. And, indeed, a little digging in the library suggests that these assertions are not, shall we say, unproblematic. In his attempt to demonstrate that objects in the show were used for human sacrifice and ritual bloodshed, McEvilley claims to quote a secondary text on the Nukuoro Island Kave figure to the effect that "she was a goddess to whom human sacrifices were offered." In fact, the authors had said only that she is "reputed to have had human sacrifices offered to her."[5] Going back to the primary scholarly source on the Kave,[6] we discover that this story of human sacrifice derives entirely from nineteenth-century travelers' tales, a genre known for its Grand Guignol exaggerations. As Susan Vogel, director of the Center for African Art, New York, observes, "hardly any of the African objects in the show ever had blood on them, and, in those few exceptions, it was always chicken blood, not human blood."[7] McEvilley tries to qualify his statement by saying that the objects in the show "were used in conjunction with" sacrifices, but this is equally true of classical Greek art, which also functioned "in conjunction with sacrifices and ritual bloodshed," as when animals were sacrificed on the altar-derived triple steps of the Parthenon. This is not to suggest, of course, that Greek and African rites were the same; but it does demonstrate that McEvilley's attempt to show that tribal objects cannot be considered "art" in the Western sense because they were sometimes used in conjunction with sacrificial activities is simply unfounded.

Then we come to McEvilley's claim that the "point of cultural relativism" can

be upheld by the work of the linguists Edward Sapir and Benjamin Lee Whorf, whose theories of linguistic relativism have "been experimentally confirmed in a number of ways." I was puzzled to read that this was so, since the thesis, as I understood it—that people don't have something if they don't have a word for it—seemed to be falsified many times in my own modest experience as a multilingual. The French, for instance, have no word for design (in recent years they have taken to using the English word, pronounced in the English manner)—and yet who would claim that there was no design in France? I have since been pleased to learn that my own commonsense argument was in fact a key point in a famous debunking article about the Whorfian hypothesis by the eminent linguist Joshua Fishman.[8] (That is, Fishman pointed out that the claim that we have to have a single word for a thing in order to have the concept is absurd; some languages may need many words to make the same point that in others can be made with one, but that does not mean that the language determines the conceptual structures.) Moreover, McEvilley's assertion that the tribal peoples "lacked . . . even circumlocutions that could express what we mean by art" is simply false. The Africans can and do use numerous "circumlocutions," for they possess many words—such as *balance, evenness, to make beautiful*—that they use to describe the character of their art, and there is a notable literature on this subject.[9]

On the whole question of whether or not primitive objects can be called art, the simplest position seems to be this: No culture's art is similar to another's in every sense; all art is something Other. But since it is made by human beings, its Otherness is a matter of degree. If we are to call an object art, it must involve some aesthetic ordering of its materials to nonpractical, expressive purposes—whatever magic or religious ends it may also have. This either is the case with tribal sculpture or it is not; and if it is—as seems to me painfully obvious[10]—then it is perfectly appropriate to call it art, though we may choose to call it many other things as well.

We now come to the question of the truth of McEvilley's claims about various other exhibitions that were supposed to have made ours old hat. I have very little appetite for this debate, since such questions of priority normally hold no interest for me at all.[11] But McEvilley insisted, and presumably continues to insist, that our show was mounted not for its stated purpose but rather in order to "revalidate classical modernist aesthetics." This theory, in turn, rested syllogistically on a set of "facts" purportedly proving that our exhibition was "not new" and that, therefore, it must have some other, secret agenda. The necessity of contesting

McEvilley's "facts," therefore, lay less in their intrinsic importance than in their role in *his* reasoning—though it is worth getting the record straight in any event.

Rather than concede mistakes in the face of my critique, McEvilley returned with "proofs" designed to show the errors were mine. ("If we pause and count up the inaccuracies they have found, we see that Rubin has found none. . . ."). The slippery nature of his reply, however, has shifted the issue to the more significant and telling area of scholarly honesty. Take the question of the content of the Beaubourg vitrines. "Rubin," he writes,

> denies that any of the objects in the Beaubourg vitrines had ever been owned by Braque or Picasso. In fact, at the writing of my article, one of the authorities on this subject had ventured the opposite opinion, yet finally it seems this point must remain moot, in the light of the fact, acknowledged by Rubin, that no exact listing of the objects has been found. Still, the fact that some of the objects there belonged to early modernist artists is acknowledged by all.

For a man who accuses me of "the fallacy called the appeal to authority" because I cite Picasso on Picasso's own views about primitive objects, the reference to an unnamed "authority" in the above passage is extraordinary. I wonder if this "authority" is not an invention of McEvilley for, so far as I know, I am alone in having made a study of Picasso's and Braque's tribal objects and their various locations. Let McEvilley refute me by naming his "authority" and describing the bona fides that entitle him or her to an opinion on this specialized subject.[12] More importantly, however, there is nothing at all "moot" about this question. There *cannot* have been any of Braque's or Picasso's tribal sculptures in the Beaubourg vitrines since there are none in the collection of the Musée de l'Homme, which provided Beaubourg with the objects. Thus the issue of a supposedly lost "listing" is irrelevant. Nor did I ever "acknowledge," as McEvilley claims, that no such list had been found. *I never mentioned any list.* Moreover, I always assumed that the Musée de l'Homme had such a list; it does, and I now have a copy of it.[13] Finally, "the fact that some of the objects [in the Beaubourg vitrines] belonged to early modernist artists" is *not* "acknowledged by all," as McEvilley claims. It was not "acknowledged" by me, nor has it been, so far as I know, by *anyone* except McEvilley. And with good reason, for none of the objects lent by the Musée de l'Homme ever belonged to a modern artist.[14]

Now let us turn to the Menil family show, where McEvilley attempts to prove he is right about its role as a precedent for our exhibition by pointing to

> a plain statement in the catalogue, by Walter Hopps, curator of the exhibition, discussing the mixing of primitive and modern objects, in which [Hopps] notes, "Ainsi, dans la section des surréalistes, on trouve, à côté de leurs oeuvres, des objets leur ayant appartenus" (thus, in the section on the surrealists, beside their own works one finds objects that belonged to them). These include, for example, Eskimo masks, of which "plusieurs furent acquises . . . par des surréalistes français établis à New York" (several were bought . . . by French surrealists living in New York). [Ellipses McEvilley's.]

All of this would seem pretty convincing—unless you had seen the Menil show (which McEvilley, to judge from what he says, evidently did not), or unless you had at hand the catalogue, *La rime et la raison,* from which McEvilley has mis-appropriated his "facts." In the latter case you would see that Hopps's sentence about "objects that belonged to [the surrealists]," though slightly ambiguous because poorly translated, is *not* located, as McEvilley claims, in a discussion about the "mixing of primitive and modern objects." And if you had seen the show, you would have known that the "objects" to which Hopps was, in fact, referring were not tribal sculptures at all but bibelots, exotica, and memorabilia; the few tribal sculptures in those areas were *not* from artist's collections, *nor did Walter Hopps ever say they were.*[15] But that's not all. The last part of McEvilley's paragraph cites Eskimo masks in the Menil show as examples of tribal objects supposedly owned by surrealists, an assertion elaborated with a quotation seemingly continued from Hopps's text. But this passage ("several were bought . . .") is by another author, occurs 339 pages later in the Menil catalogue, *and does not refer to the Eskimo masks in the show.*[16] Is this the scholarship that "is a type of science"?

William Rubin

The Museum of Modern Art, New York

NOTES

1. Cézanne was so deeply attached to the tradition of Renaissance and post-Renaissance painting, with its emphasis on visual perception and on sculptural plasticity, that he derisively dismissed Gauguin's mature style as "Chinese painting." One can hardly imagine his having accepted the far more conceptual and ideographic stylizations of tribal art.

2. I have, of course, used the term *pure painting*, but only and always as a translation of French terms, as in *Dada and Surrealist Art* (New York: Harry N. Abrams, Inc., 1968), 15: ". . . its less absolutist explorations led indeed to a revival of 'poetic painting' (*peinture-poésie* as opposed to *peinture-peinture*,or 'pure painting,' as it is spoken of in the modern French tradition)," and p. 150: ". . . thus the collective appellation *peinture-poésie*, or poetic painting, as opposed to *peinture-pure*, or *peinture-peinture* (by which advanced abstraction was sometimes known in France)."

3. This is not meant to imply that Leiris himself subscribes to such a description, only that he said it was common coin in the thirties among amateurs of what was then universally called *art nègre*, and that Picasso would have heard of it.

4. Remembering a good deal of large sculpture from my visit to that museum, I checked with the Egyptologists at the Metropolitan Museum of Art, who suggested that something less than one-fourth of what is visible of this immense and as yet not fully catalogued collection would be material *not* taken from tombs. Thus, tomb material could hardly be said to comprise "virtually every object" there.

5. Brian Brake [photographs], James McNeish [conversations], and David Simmons [commentary], *Art of the Pacific*, (New York: Harry N. Abrams, Inc., 1980). See Simmons's note for catalogue #78.

6. Janet Davidson, "A Wooden Image from Nukuoro in the Auckland Museum," *Journal of the Polynesian Society* (March 1968). There we discover that the suggestion of human sacrifice was hearsay reported by traders, among them the donor, Mr. Cousens, whose statement was published in an Auckland newspaper in 1878. The newspaper says that it "cannot say" if the statement was "well founded," and observes: "It [the sculpture] is very rude, but it is for this reason a proof of the barbarous and primitive worship in the islands." (Cf. also note 7.)

7. As the making of sculptures was, for the African artist, a primarily religious function, he often—as Vogel notes—sacrificed a chicken before beginning a piece.

 In Africa, human sacrifice, except in the kingdoms of Dahomey and Benin, was always very rare, reserved for major ritual occasions. "Human sacrifice is a difficult subject on which to find unbiased information," writes Vogel. "Early visitors to Africa—missionaries or representatives of the colonial powers—had every reason to make their constituents in Europe believe that the Africans whom they encountered were benighted savages, badly in need of conversion or policing. They tended to exaggerate the prevalence of human sacrifice." ("Rapacious Birds and Severed Heads: Early Nigerian Bronze Rings," Art Institute of Chicago Centennial Lectures, *Museum Studies X*, 1983, 330-57.)

8. Joshua Fishman, "A Systematization of the Whorfian Hypothesis," *Behavioral Science*, v. 5, 1960–61, 323; cf. also Elizabeth Rosche, "Linguistic Relativity," in Albert Silverstein, ed., *Human Communication: Theoretical Explorations* (New York: Halsted Press, 1974).

9. As, for example, Robert Farris Thompson, "Yoruba Artistic Criticism," *The Traditional Artist in African Societies*, ed. Warren L. d'Azevedo (Bloomington: Indiana University Press, 1973) and Susan M. Vogel, "Baule and Yoruba Art Criticism: A Comparison," *The Visual Arts: Plastic and Graphic*, ed. Justine M. Cordwell (Hawthorne, N.Y.: Mouton Publishers, 1979).

10. How else to explain—among other stylistic variations—the obvious changes within established types made by single sculptors, such as the innovations of the Buli Master or the Master of Ogol? Such differences alter the aesthetic expressiveness of the object, but cannot be explained by practical cult necessities; nor do they reflect any change in iconography.

11. MoMA had never claimed that *"Primitivism"* was the first show anywhere in which tribal objects from artists' collections had been juxtaposed with their work, only that it was the first to deal with the subject in depth and "in the light of informed art history." A small exhibition had taken place in Berlin many years ago, in which some objects belonging to German expressionist artists were shown with their work. Our show was the first to do this with tribal art belonging to all major European and American primitivists.

12. McEvilley cites two curators, Jean-Yves Mock and Jean-Hubert Martin, on other aspects of the Beaubourg vitrines. Neither, I am certain, would claim the slightest expertise on the subject of tribal art in general, nor the tribal art collections of modern artists in particular.

13. This list, and the accompanying information, for both of which I am indebted to Francine Ndiaye, confirms my statement that a number of the tribal objects at Beaubourg were from regions and were of types—as well as accessioned at dates—that would have made it impossible for them to be seen by Paris modernists. The list shows both McEvilley and me to have been in error about the number of objects involved. Beaubourg received sixty-five, not one hundred, objects, of which thirteen were returned almost immediately. There is no record of how many of the remaining fifty-two objects were shown at any one time, although it is clearly more than I had remembered.

14. The only possible exception to what I have been saying about the Beaubourg vitrines, and a very unlikely one, concerns a Fang mask bequeathed to the Centre Pompidou by the widow of André Derain, which may have been shown for a short time after its arrival at Beaubourg in the African vitrine. Jean-Hubert Martin thinks this is possible, but is not sure. The *fiche* for the object indicates that it was not shown at all. It was an object we searched for during a period of years, never coming upon it at Beaubourg. Through an agent for the late Mme. Derain's estate we finally discovered that it had been given to Beaubourg. Even in the unlikely event that this Derain-owned object were to have been shown for a short time, it would fall far short of confirming that "some of the objects there belonged to early modern artists."

15. See *La rime et la raison* (Paris: Editions de la Réunion des Musées nationaux, 1984), 16 and passim.

16. The quotation in the second part of McEvilley's paragraph is from the catalogue notes on the Kuskokwim masks of the nineteenth century. None of the catalogue notes are individually signed, but all were by the experts who wrote the introductory texts on the geographical area involved, as McEvilley should well have been aware. On page 355, Edmund Carpenter, writing of the Menil family Eskimo masks, says that they come from a group of thirty-two pieces purchased at the beginning of the century by George Heye. *Of this group,* he notes, "many were later acquired by French surrealists established in New York." He does not refer in the quoted phrase to the Menil masks, which—as he has reconfirmed to me—never belonged to surrealist artists.

Thomas McEvilley replies:

Boy, is the big bear mad at me. (Where's the little bear hiding anyway?) Swatting at facts that pester him like bee stings, once again William Rubin has dropped the honey into the department of fact-checking to make a really exciting afternoon of it. Once again his charges of factual inaccuracy are empty. It's all strangely familiar.

Eighteen years ago in the pages of *Artforum,* Rubin published a series of articles on Jackson Pollock. In April 1967, after the second piece came out, Harold Rosenberg wrote to the editors objecting to what he felt was Rubin's misrepresentation of his famous article on action painting. Rubin, of course, responded to Rosenberg—the correspondence ran two rounds—and began his answer with the phrase, "Looking beyond the disputatious tone of Mr. Rosenberg's letter. . . ." Now he begins by asking the reader "to rise above the intemperate tone of McEvilley's 'final word.'" (I don't believe in the concept of a "final word," by the way.) In the second round of the exchange, Rosenberg noted that Rubin "dislikes myth but doesn't mind basing his argument on gossip." To this day, Rubin relies on private conversations more than on published authority. "Every paragraph in his reply," wrote Rosenberg then, ". . . contains misstatements of fact. I haven't the patience (nor will the reader) to deal with more than a few examples." There

is a certain graciousness in Rosenberg's refusal to tax the reader's patience by slogging through the mud of Rubin's factual claims. I am going to make the other choice, however, and walk with the reader into the woods of those claims in order to show their emptiness. (Anyway, I am developing patience at bear-hunting.)

Back then, interestingly, Rosenberg noted, before dealing with "something nasty" from Rubin, that he was not going to go into Rubin's "weird manners." This question of "weird manners" is important in the present case because a certain type of so-called gentlemanly manners is in fact nothing but a sanctimonious method for dismissing anyone or anything (such as primitive objects, or me, or any other conscientious objector) that has not been tamed and sterilized to the point of displaying similar weird manners. In the introduction to his current reply to me, Rubin calls my tone toward him and the little bear "intemperate." Yet the reader of our first exchange of letters has seen that Kirk Varnedoe, Rubin's colleague and apparently also one of these old-school gentlemen, indulging his respect for "manners" and rhetorical twists, labeled me a "racist" for not liking his and Rubin's treatment of primitive objects. And the other gentleman, Rubin, described me in terms that amount to calling me an enemy of mankind. This it was that elicited my "intemperate" response.

In the present letter, Rubin berates me for "the kind of indiscriminate extremism where Schiller becomes a sloganeer comparable to Hitler's pet filmmaker. . . ." But I didn't say that Schiller was like Leni Riefenstahl—I said that Rubin's application of Schiller's words to a discussion of the Third World sounded too much like a Riefenstahl film. Schiller was a fundamental part of German high school education in the nineteenth and early twentieth centuries—the educational system that so prominently produced genocide. (Riefenstahl's progression from celebrating Hitlerism in *Triumph of the Will* to photographing tribal Africans as decorative objects out of their social and cultural context is not uninteresting in this regard.) For this reason I regarded it as insensitive to look to Schiller for a model and a motto on how to relate to the Third World. Rubin calls my raw nerve on this subject "indiscriminate extremism." "McEvilley is surely not alone," he says, "in his anti-Western position—but he is surely right if he senses that these are not the positions of the organizers of the exhibition. It is no wonder he finds so much to criticize. . . ." To dislike his show is anti-Western: what nonsense. We've heard that tone before. Rubin thinks that to oppose his will is to oppose Western civilization.

In fact, my whole point is to oppose the ossification and sterilization of Western civilization. This debate is about art. Objects are powerful transitional devices within and between cultures. The way one culture's objects are treated in the context of another culture is a kind of conduct of foreign affairs. Rubin treated the primitive objects as if they had nothing to do with any living societies except ours, as if they were pretty objects and no more, there for us to do with as we like. It's time to go beyond. Art has; why haven't the curators of this show?

"It is precisely *because* I am concerned with historical context," Rubin writes to me,

> that I virtually omitted anthropological information from the exhibition—richly stimulating though I find it—where it could only have misled the viewer about the actual intellectual context and content of modernist primitivism, which, after all, was the subject of our show. It is simply a fact that (with but rare exceptions, beginning only around 1930) the cultural and historical context of twentieth-century primitivism did not include anthropological information; it was totally irrelevant to the pioneer modernists' reaction to tribal objects.

Rubin, in essence, insists that modernist primitivism is something that applies only to the "pioneer modernists"; in other words, that the subject of the show was limited to pioneer modernist primitivism. On purely scholarly grounds, the show would have been more coherent if he had in fact limited it to pioneer modernism, or, rather, to pioneer modernist primitivism. His argument for the irrelevance of ethnology would then be more defensible, though it would still raise unpleasant questions. But really the exhibition went far beyond this, as his appetite for a blockbuster show engorged more and more of the art of our century into its vitrines. Without even counting Varnedoe's "Contemporary Explorations" section, about a third of the modern works in the show were made after 1930, the date at which Rubin says conceptual awareness of ethnology began among Western artists. If Varnedoe's section is included, the figure rises to about 40 percent. Many of the important works in Rubin's section of the show are from the period between 1940 and 1979, a time in which we learned an increasing amount about primitive culture. Lucas Samaras is represented with a work from 1962, Arman with a work from 1973, Italo Scanga with a work from 1979. Rubin's argument for the irrelevance of anthropological information is directly contradicted by the way he went

beyond the stated premise of his show—perhaps dimly sensing the hidden coun-termessage that underlay it, which is that this exhibition is not about 1906 but about an attitude in 1984, the moment in which it opened. If he'd given these more contemporary works the same loving attention he gave to the pioneer mod-ernists, Rubin would have had to realize how relevant ethnographic information is to the question of influence and affinity in the more recent works. But the truth of the matter is that these contemporary artists are subsumed as appendages to the pioneer modernists, much as the works from traditional societies are subsumed as their footnotes. This does not speak optimistically for the life of contemporary painting and sculpture in the Museum of Modern Art.

When Rubin and I began corresponding, he asked me to realize that the show was "not about 'the Other,' but about ourselves." He meant, I suppose, that it was about Picasso, André Derain, and others, who are, if not us, in our past. To really be about *us*, the show would have to be about the evolution in our relationship to the Other. And it is, but only in a negative way. A century or so ago, Western societies generally regarded people of so-called primitive societies as less than human. In cultural terms this meant anyone outside the Greco-Roman diffu-sion stream; we could not recognize as civilization, or in fact as culture, any-thing that lacked that imprint. Then, early in this century, we entered a phase in which instead of dreading the non–Greco-Roman as absolutely Other, we tamed it by assimilating such parts of it as we could believe to be really like our-selves in deep, underlying ways more fundamental than the Greco-Roman imprint. The easiest assimilation, since it was based on immediately perceivable similarities in design, was to move objects from ethnological to art museums. This was a great and necessary step: from regarding the Other as having no self, we came to regard it as having a relationship to our most advanced creative selves. But at this point the projections—cognitive, interpretive, evaluative—still seemed to go exclusively from us to them.

Unfortunately this is where Rubin's show stops—yet his exhibition encom-passes the twentieth century up until the seventies. And although the museum has stood still on this question, the world around it has changed. Intellectual investigation has entered a third phase in which it has become increasingly clear that the distinction between learning about oneself and learning about the Other is false: The self cannot be known without reference to an Other, and vice versa. This project of civilization could have unfolded in *"Primitivism" in Twentieth-*

Century Art in many ways. Robert Farris Thompson, for example, in research recently begun, has taken Picasso and Amedeo Modigliani reproductions to Africa and recorded the impressions of them given by priests and priestesses of traditional religions of Africa. This may be one way to learn what kinds of "affinities," in a deeper sense, exist between our art and theirs; this may be one way we can extend the project beyond the limits of design similarities; this may be one way we can even begin—dare I say it—to think about influence in reverse. The great thing to realize, the great necessity, is that we are at a moment when distinctions between "us" and "them" are rapidly wasting away. There are no untouched tribal cultures anymore, even ours—or perhaps this show indicated that we are the most untouched of all.

Isn't it time to remind ourselves that more is at issue here than passageways detouring off passageways and seeming always to be avoiding something? At the beginning of this debate I raised certain questions about the primitive objects included in the show. I asked, were they intended as art by their makers? Were they called art? Were they treated as art by the people for whom they were made? What was it about them that made our early modernist artists go for them in such a big way? And why did other early modernists, like Duchamp, receive an opposite message from them? When I asked such questions the bears replied that I was denying to these works and to their makers a status that they were supposedly seeking. This was indeed the point: I suggested they were seeking something quite different, which might also be what people like Picasso were seeking in them. As I contemplated the way they had been ripped from their meanings and hung in mix 'n' match on our walls in New York, resonances came up of an ancient violence far worse than the ritual violence in the history of the objects themselves. Pliny the Younger tells of Carthaginian sailors who entered sub-Saharan Africa by way of a river that after a while went by an island. On the island they saw dark hairy things that moved like people. Going ashore they chased them and captured three wild women. But the women were untamable so they killed them, skinned them, and took the skins back to Carthage, where they were exhibited in the temple, hanging on the wall—like the objects in the show under discussion.

But as lifeless and helpless as these objects lay upon the Modern's walls, still they mutely questioned all who saw them about what they were doing there and how they fit into our designs, and, in a really quiet way, how we fit into theirs. They were, you might say, early ambassadors from the Third World. They held us

in a mutual gaze in their questioning. Why, they asked, did we think we knew them? What was it about ourselves that made us want them? They asked us to think again about all these things.

In terms of the twentieth-century discourse on art, the question whether or not a thing is art can appear in several different forms. (1) There is the formalist mode: Does it look like the things that we are used to calling art? This mode emphasizes the element of design above all others. One problem with this form of the question is that it can lead only to the identification of more of the same. (2) Then there is the linguistic mode of the question, most prominently in a Wittgensteinian form: Is it *called* art? This form relates to the practical matter of what you would do to find out what art was if you didn't already think you knew—that is, ask someone whom you thought likely to know to show you or tell you which things are called art. You would find that there was no common "look" to the range of things so called, which means that this mode and the first are already in conflict. (3) The linguistic form of the question verges into an intentional form: Is it intended as art, that is, is it regarded as art by its maker and by the people he or she made it for? Minimalism made this mode very common: On entering a gallery one might find an ambiguity about which objects in the room were artworks and which were construction materials. In usage this mode is probably as common as the looks-like-it mode, though they also are in conflict, that is, they designate sets that may overlap but are different. (4) Closely related to this is a functionalist mode: Is it contextualized as art, that is, treated like art in the context of its society? For example, is it exhibited, is it overtly appreciated for formal values, and so on? (5) A social-functionalist mode—Was it made by an artist?—is also common in the discourse of the last generation or so: Andy Warhol and others answered the question, Why is it art? by saying, well, it was made by an artist, and that would make it art. Since the conventions of usage are arbitrary, we can agree among ourselves to call things art on the basis of any one or more of these criteria. But we should be careful always to know on just what basis we are using the word, and also to know how many of the modes of definition do and do not apply in a certain case.

In his current letter, Rubin offers the following definition of art: "if we are to call an object art, it must involve some aesthetic ordering of its materials to nonpractical, expressive purposes. . . ." In this definition, the first mode, design similarity, which appears as "aesthetic ordering," is combined with the third mode,

artistic intention, which appears as "nonpractical expressive purposes." Yet the tribal objects in the *"Pritimivism"* show qualify as "art" only on the first of the five points, similarity of design. This elementary clumsiness about the most basic of art questions is the source of the problems in Rubin's show. For the so-called primitive objects might look like art, but were not intended as art. Having made his decision, Rubin was forced either to abandon expressive intent as a necessary part of his definition or to falsely insist that primitive art arises from intentions that we would recognize as "nonpractical expressive purposes." Hence the necessity for the "affinities" category, and the rejection of "communal inventiveness."

He has been so easily led into this problem by his primary emphasis on design similarity as the criterion of art. Yet in terms of twentieth-century art history, this is the least useful of all the modes of definition. Duchamp's readymades would not qualify. Nor would a conceptual art piece employing only language, which clearly does not look like art; yet it is called art, it was intended as art, it is treated as art, and it was made by an artist. Quotational art is a direct mockery of the looks-like-it formula. Furthermore, the criterion of "look" does not allow for innovation. If that criterion had retained its hold on the late nineteenth-century mind as firmly as it has on Rubin's and Varnedoe's, modern art would never have happened. Modern art arose primarily out of the other four modes of the question.

Roy Sieber, writing on "The Aesthetics of Traditional African Art," describes what I think happened in the MoMA primitivism show. "Admiration in isolation," he wrote,

> easily leads to misunderstanding, and African art, its functions only vaguely apprehended, has fallen prey to the taste of the twentieth century. While noting the vitality and strength of purpose that pervade it, its admirers misread conservatism for spontaneity and commitment to style for freedom. . . . Such adulation springs from a Western aesthetic rooted in a romantic love for exotic precocity, and, perhaps inevitably, has developed into fashionable cliché taste.

Sieber describes the function of object and image making in African societies as "intensely practical," having to do with the magical obtaining of "wealth, prestige, health, children, wives," and so on.

In my last letter I suggested that it was relevant in terms of the intentionality of the "primitive" works that the languages of their makers lacked a word for "art."

I cited the idea advocated by Benjamin Lee Whorf that the semantic structure of a language, that is, the system of concepts enunciated in its dictionary, is partly formative of cognitive and behavioral patterns. In reply, Rubin says he is "pleased to learn that my own common sense argument was in fact a key point in a famous debunking article about the Whorfian hypothesis by the eminent linguist Joshua Fishman." Well, I know the article and I have an incredible report for the reader. Fishman is not, in the first place, "debunking" the Whorfian hypothesis; he conceives himself to be among the many people constructively working on it. Secondly, he affirms that the presence or absence of a word in a language's lexicon is cognitively significant, and thirdly, he cites some of the same research on color perception I cited.

I had gone so far as to say that the languages of Africa and Oceania even lacked circumlocutions that could express what we mean by the word *art*. What I meant essentially was that these cultures—*by definition*—are those that have not been swept up in the diffusion stream of Greco-Roman culture and hence do not have the specialized concepts peculiar to that stream. Rubin replies that African tribal peoples do have terms to discuss art. But in fact, as the anthropologist Daniel J. Crowley remarks in the essay "An African Aesthetic," these terms discuss only craftsmanship. As others have pointed out, for example, terms meaning "smoothing of the surface" are very prominent in African tribal object discourse, but there are none for compositional factors, or for such Western aesthetic concepts as disinterested contemplation or functionlessness. "New masks were preferred to old because they have the stronger power that comes with youth," Crowley says. What's at issue in such decision making is magical power, not aesthetic power.

"Each artist," Crowley goes on, "considers (or says he considers) his own work superior to all others except that of his own teacher." This is the custom of the magician, or shaman, whose own magic must be claimed the best, except that it depends on his or her master's magic, which therefore must be even better. Finally, Crowley remarks that in African attitudes toward art, "the stress on technical skill rather than on personal expression parallels the value systems of Western craftsmen such as carpenters and joiners." One anthropologist seeking to find the names of makers of masks found it very difficult even when the maker was local, because no one ever thought of who made them, just of who owned them. This is the way we relate to goods like automobiles or hand-knit sweaters. It

is of course true that there is a degree of personal variation in African sculpture and that investigators like William Fagg and Robert Farris Thompson have managed to distinguish works of individual artists. "But the marks of identity," as Edmund Carpenter writes, "turn out to be details of craftsmanship or minor stylistic innovations. This is not self-expression. Carvers merely interpret traditional designs the way actors interpret parts." "Questions of 'creativity' and 'self-expression,'" Carpenter notes, ". . . belong to literate traditions. The labels just do not apply to preliteracy." The point that Rubin finds difficult to confront, but which we must, is that although purely in the design sense tribal ritual objects are obviously like our modern art, still they were not made in anything like the mind-set that we call self-expression. The point is that the production of beautiful objects can be carried out without any of the high-art feelings that we associate with it. This should hint to us vastly different available understandings of our own activity.

My purpose is not, of course, to deprecate the non-Western works—it could only seem that way to one who took our values as absolute—but to reassert their selfhood, and let them be themselves. Our cultural mind-set associates art so strongly with concepts like self-expression that it is difficult for us to confront cultural objects that conform to our sense of beauty but do not arise from anything like our mood of self-expression. What Rubin did was work the material as he would, which, as it turned out, was in his own likeness. What he and countless others have found in the primitive objects is the type of aesthetic decisions they are familiar with; they find an account of the type they would give—because of course they *are* giving it. They find themselves. The question that we must face is whether our so-called etic, international, quasi-objective, scientific point of view is not just another emic or tribal point of view—just our own tribal attitudes and values inflatedly projected into an absolute (an etic norm), much as any tribal member does with the myth of his or her tribe. What awaits us if we take this step may be an experience of ourselves so far gone in mystery as to be unimaginable now.

In an interview in the *New York Times* of February 20, ostensibly about a new position at the museum for a contemporary curator, Rubin discussed the criticism *"Primitivism" in Twentieth-Century Art* has received. "A lot of people are grinding their own political axes," he said, "and while I'm not blaming them for that—gung ho, let them do it!—I ask only that they get their facts straight." I think most of us did. Significant critiques were offered by a number of critics, among them Arthur

Danto, who focused on the show's philosophical presuppositions in the *Nation,* and Cynthia Nadelman, who dismantled some of its art-historical connections for *ARTnews.* Both these authors regarded substantial numbers of Rubin's juxtapositions of modern and primitive works as "meaningless." Michael Peppiatt attacked several of Rubin's assertions of influence. According to a story in the January 1985 *Art & Auction, Connaissance des Arts,* the magazine Peppiatt wrote for, refused to publish Rubin's and Varnedoe's replies on various grounds, including content, length, and the inclusion of color photographs. The situation, judging from the *Art & Auction* story, became deeply embroiled, with strong feelings on both sides. "Here I spent five years on the exhibition," Rubin is quoted as saying, "I broke my back to make observations in scholarly ways, and some fellow used the show as an excuse to say we presented suppositions as facts." Rubin, according to *Art & Auction,* threatened a lawsuit against *Connaissance,* and the president of the company that publishes the French magazine, Dimitry Jodidio, complained that ". . . Rubin has commanded his side to sue, if required . . . We can't work with Rubin now—a pity." In the end, no lawsuit was brought, and the main points of Rubin's and Varnedoe's letters were published by another French magazine, *Art Press,* in December. Later *Connaissance des Arts* agreed to publish another letter by Rubin, with no illustrations, in their March issue. There's a lot riding on this, you see. In the *New York Times* interview, Rubin said that Hilton Kramer and I were "firing at each other through the medium of the exhibition. My attitude about it is, a pox on both your houses." In fact, neither Kramer nor I mentioned each other. Rubin seems to feel that he is invisible in the center.

Rubin refers to the "success" of the exhibition that Danto called "stupendously misconceived." One is forced to wonder what success means to him. Is it the turnstile? The blockbuster? The approval of a nonspecialized press? The problem with this is that the museum should have its sights set much higher than entertainment. It should be an institution that would lead the way into a serious cultural future, yet its idea of success seems to have more to do with resisting change, and with a hobbyist enthusiasm for the past. Rubin presented a value system that had been firmly in place for sixty years as if it were a terrific new discovery. This is a holding action against the future, and against art's tendency to make a living advance into it rather than ride in on a morgue table surrounded by the scent of formaldehyde.

In Rubin's latest letter, the claim of the show's success is framed as an endorse-

ment of Varnedoe. "Lest there be any doubt whatever in McEvilley's mind, I very much like Varnedoe's selections for 'Contemporary Explorations' . . . Varnedoe's particular contributions to *all* parts of the show were critical to its success." I would say it another way: Varnedoe's failure was critical to the failure of the show, to its failure to address the real issue, which is the present—and the contemporary was specifically his job. The Modern's failure to confront the primitive is directly connected to its failure to confront the contemporary. This linkage seemed implicit in the *Times* article, where criticism of the museum's hibernation through contemporary painting and sculpture was edited together with the criticisms the *"Primitivism"* show received. Varnedoe's input was both antiprimitive and anticontemporary. About a third of the works included were by dead artists. The truly contemporary, like the truly primitive, wasn't clean enough for Varnedoe. It has the unpredictability of life upon it, and this exhibition, in the grip of a cliché of the classic, veered with an unstoppable impetus toward the cult of permanence, eternity, and the past. Like a gentleman of the old guard, Varnedoe edited out of the contemporary section anything that too conspicuously lacked "weird manners." In his catalogue essay, he even wrote about his selections as ethically motivated toward sustaining Western institutions, as if Western civilization were so weak and nonadaptive that it would not have a chance in a confrontation. But this is ossification. Cultures do not grow by resisting changes.

A vision very much like Varnedoe's in his choices for his section of the show was seen ten years ago in a show called *Primitive Presence in the Seventies* at the Vassar College Art Gallery, which Carter Ratcliff wrote about in the November 1975 *Artforum* in an article called "On Contemporary Primitivism." These were conceptually the same shows: Both emphasized women, especially Nancy Graves, and the ranges of types of work were similar—Ree Morton's pieces of wood on the floor in the earlier show, Richard Long's stones at the Modern; Salvatore Scarpitta's *Fish Sled* instead of Michael Singer's *First Gate,* and so on. I am not saying that these artworks are alike in themselves or in their makers' intentions, but I am discussing the curatorial use that can be made of them by exploiting design. Faced with the whole challenge of the present and the future, the shock is that Varnedoe came up with a conception no fresher than one curated by undergraduates at Vassar ten years ago. His approach to art—and Rubin's, too—is similar to that of Australian aboriginal shamans who would bury power objects in the ground, or hide them in caves; as long as they remained buried, the aborigines

believed, the end of the world was postponed. The ritual functioned as reassurance about the endurance of their traditions. If we look at ourselves the way we look at them, we can see something similar. We segregate artworks away in places dedicated to maintaining a sense of permanence on every level. The older works that have survived into the present through being buried in museums reassure us that our traditions are intact. The younger works more recently buried derive from the example of the older ones the assurance that they, too, will survive into a distant future—and with them, it is implied, the traditions that produced them. The primitivism show was a kind of ritual, which transpired in a magical atmosphere of complete control. Viewers were bullied through by an exceptionally manipulative and interfering system of wall plaques. As with the canned tours at places like Disneyland or Graceland, the viewer's mind was not offered an inch of space to move in.

The Museum of Modern Art has given us a nineteenth-century model on the most pressing issues of the about-to-dawn twenty-first century. In this generation, tribal points of view are being shed: Roland Kirk plays the didgeridoo in Texas while Mozart's Susanna sings from a radio in the outback. Today, any artist can be stylistically primitive or stylistically modern. To perpetuate, on the basis of differences in look, the distinction obtained a century ago is to commit a blindness worse than that of the eye. There is no longer much justification for the distinction; today, primitive and modern are elements in a single vocabulary. In the emerging global information moment, classical Yoruba tradition will take its place beside classical Greek tradition, primitivist modernism beside modernist primitivism. This is the great and epochal subject that Rubin and Varnedoe so willfully missed. We no longer live in a separate world. Our tribal view of art history as primarily or exclusively European or Eurocentric will become increasingly harmful as it cuts us off from the emerging Third World and isolates us from the global culture that already is in its early stages. We must have values that can include the rest of the world when the moment comes—and the moment is upon us. Civilization transcends geography, and if history holds one person in this global village, it holds another. In fact, if one of us is privileged over the other in art-historical terms, it is the so-called primitive object makers, through whose legacy we got our last big ride outside our own point of view, and called it modern art.

Getting Down

The debater who will relate only to facts is not unlike the formalist who will relate only to shapes and colors. Rubin says he argues with my statements of fact because my conclusions are based on them; yet he never touches a point with significant content, but only numbers and details that cannot alter the outcome one way or the other. I am confident of my facts, but Rubin's attitude goes beyond them; it is symptomatic of the whole lost opportunity of this exhibition, which commissioned a team of scholars to seek out details of fact without ever using the information to address larger questions about the subject. Facts need a surrounding framework of ideas to make them meaningful, and their situations are never static. The frameworks have to be constantly revised as social needs change, and the facts have to be constantly revised as the state of the evidence changes. These remarks are not in reference to Rubin's letters to me but to his larger confusion between facts and growing knowledge. He notes, for example, that the pioneer modernists sometimes held mistaken ethnological views about the objects they were relating to, and he condescendingly contemplates "the visitors reeling out of the galleries after attempting to digest such dual-track information." But it would not be very hard to explain, say, that the modernist artist thought such and such an object was used in a fertility rite when in fact it was used in a healing rite. The visitor might have considered with interest whether that view did or did not appear in the work, and how different or the same the primitive object looked under the different interpretations, and so on. Some actual thought and questioning might have gone on. Rubin's apparent assumption of the visitors' lack of intelligence precludes this.

Hibernation can be a productive method—one can go into solitude and come back with understanding—or it can cloud the mind with dreams of scrambled facts, of fabricated evidence and marble charioteers. "The charioteer of Delphi," I wrote, "circa 470 B.C., for example, was seen totally differently in classical Greece from the way we now see him. He was not alone in that noble, self-sufficient serenity of transcendental angelic whiteness that we see." The word *marble* is Rubin's, not mine, and comes up in his claim that I misreported the classical bronze as a marble work—after which he exercises his wit against me by referring to "the marble charioteer." Rubin never deals with the question of why I brought the charioteer up in the first place. My point was about the manipulation of the object through its context; we now see the work alone on a pedestal in a white

room in the Delphi archaeological museum, in the typical kind of installation with which we relate to works from other cultures or times by isolating them so that they are available to receive our projections. The charioteer is decontextualized in this artificial white atmosphere and made meaningless in terms of its native context, function, and intention. I drew the analogy in my initial article as a criticism of the installation of the primitive works at MoMA, where, similarly, fragments of complex pieces were isolated in such a way as to render them meaningless in their own terms, as if indeed they had no terms of their own. Rubin chose to ignore this issue, as well as others that related to the example of the charioteer, and instead to argue a point of physical detail that would not have affected the argument in any way even if he had gotten it right.

Rubin's dispute over the goddess Kave is on no higher a level. I said the goddess had human sacrifices offered to her; no, he says, she was only *reputed* to have had human sacrifices offered to her. But the practice of human sacrifice is always known by report, which is to say, repute. This is a tactic Rubin employs repeatedly: He checks out one of my statements, finds that I was right, then pretends to have found otherwise by focusing on something like the word *reputed,* which does not materially change the evidence in the case in question. The reports of human sacrifice in Oceanic religious practice go far beyond empty travelers' tales. Any study of ritual practices in the area in the nineteenth century (and for that matter, well into the twentieth) will confirm it.

At this point in his argument, Rubin makes an interesting transition. He appeals to the authority of Susan Vogel, of the Center for African [not Oceanic] Art, who observes, "hardly any of the African [not Oceanic] objects in the show ever had blood on them, and, in those few exceptions, it was always chicken blood, not human blood." To begin with, I did not claim that human sacrifices had been offered to any African pieces. Rubin's calling in of an Africa authority on a question in Oceanic art, his not even addressing the question at hand, is indicative of his unconscious politics toward these objects, which he makes use of as he will. He goes on to say that "McEvilley tries to qualify his statement by saying that the objects in the show 'were used in conjunction with' sacrifices." The locution "tries to qualify" is odd here: I *did* qualify the statement. Does he suppose that I meant that the statues were used to club victims to death, the masks used to smother them? I wrote, "Many of the objects in the show, if they are genuine, were used in conjunction with sacrifices and ritual bloodshed."

Vogel clearly confirms this for the African works. Rubin has hidden in a footnote the crucial statement: "As the making of sculptures was, for the African artist, a primarily religious function, he often—as Vogel notes—sacrificed a chicken before beginning a piece." In other words, the pieces were involved in bloodletting from their very beginning as a matter of course; their later careers would add to it. In the same footnote, Rubin goes on to acknowledge that human sacrifice was performed in Africa on major ritual occasions and more frequently "in the kingdoms of Dahomey and Benin." His authority, though having nothing to do with the Kave question at all, has inadvertently confirmed my larger point.

Farther up in his text, Rubin notes that "classical Greek art . . . also functioned 'in conjunction with' sacrifices and ritual bloodshed . . . McEvilley's attempt to show that tribal objects cannot be considered 'art' in the Western sense because they were sometimes used in conjunction with sacrificial activities is simply unfounded." But he has missed the point. The ancient Greek and tribal African situations were not the same in this respect. Many of the objects from Bronze Age Greece that are now in our museums were anonymously made ritual and tomb objects, as in traditional societies around the world, including Africa and Oceania. But around 600 B.C. this situation was visibly changed. Greek artists began self-consciously to sign their works and to use them for nonritual display; soon picture galleries came into existence. This is really when art in our full sense of the word began. In the classical period of Greek culture to which Rubin is referring, there were residual sacrificial rites in connection with sacred architecture, but there was also a self-conscious practice of making artworks intended for self-expression and aesthetic appreciation and nothing else. The ritual environment in which some classical Greek artworks found themselves was not their raison d'être, as it was in traditional African and Oceanic societies. (Today some self-conscious artworks are sited in ritual locations—the Roman Catholic mass, for example, with its symbolic sacrifice of flesh and blood, is sometimes performed in the Rothko Chapel—but this does not make them primarily ritual objects.)

The general obsession with numbers in these replies from MoMA is getting comic. Varnedoe was after me about a number in a footnote, Rubin about a number in the text. Can't they read words? Rubin, in the current letter, refers to the forty-four Oceanic objects in the Menil show when really it seems to be forty-five. Isn't it dumb of me to even bother bringing that up? The jackpot number that really set this debate cooking is one hundred, a figure I mentioned in the original

article. In addressing "McEvilley's claims about various other exhibitions that were supposed to have made ours old hat," Rubin insists, "I have very little appetite for this debate, since such questions of priority normally hold no interest for me at all." The body language of that sentence as well as all the PR around his show—not to speak of his effort to deny the importance of the many other exhibitions—say the opposite.

In my article in November, in an effort to pick a fairly recent example of these earlier exhibitions, I wrote: "For five years or so after its opening in 1977, the Centre Pompidou in Paris exhibited, in the vicinity of its modern collections, about 100 tribal objects from the Musée de l'Homme. Though not actually intermingled with modern works, these were intended to illustrate relations with them. . . ." Rubin replied, citing Jean-Hubert Martin, that "the two vitrines at the Centre Pompidou together never contained more than twenty or so objects." I then replied, "But in conversation with me subsequent to his conversation with Rubin, Martin stated that each vitrine—not both together—held twenty or twenty-five objects, bringing the total to forty or fifty at any one time. . . . No listing of the total number of objects has been located, but Beaubourg curator Jean-Yves Mock, whose memory provided my original estimate of one hundred, still says that figure is not unreasonable." Now, in his latest letter, Rubin mentions that he has nudged the Musée de l'Homme into finding the list and, in the usually unread footnotes, that the number was actually sixty-five. (Rubin remarks in his footnote that thirteen pieces were returned to the Musée de l'Homme "almost immediately"; in my original inquiry I was told that the vitrines, immediately after the installation, looked overcrowded, resulting in the removal of some pieces. I assume that these were the objects returned.) I am glad Rubin had the power to unearth the original list; I didn't. But I could have said the vitrines contained "a number" of primitive objects and made the point. My number was the number given in our checking and it is still closer to the mark than Rubin's original twenty.

In the article I went on to say, because this is what I had heard in my fact-checking, that some of the objects in the vitrines had belonged to early modernist artists including Picasso and Braque. Three months later, on the same subject, I wrote in my reply to Rubin's first letter: "Next, Rubin denies that any of the objects in the Beaubourg vitrines had ever been owned by Braque or Picasso. In fact, at the writing of my article, one of the authorities on this subject [i.e., the vitrines] had ventured the opposite opinion, yet, finally, it seems this point must

remain moot, in light of the fact, acknowledged by Rubin, that no exact listing of the objects has been found." In his current letter, Rubin places great emphasis on my use of an unnamed authority and on my statement about the list. He naïvely equates my reference to an unnamed source with the logical fallacy *argumentum ad auctoritatem,* the appeal to authority, though the two rhetorical moments have nothing to do with one another. In fact they are opposite: The point of the appeal to authority is that the name of the source is what carries the power to convince; I repressed the name of my source to protect him from the underlying power situation of this debate.

As for the list, Jean-Hubert Martin, then of the Beaubourg, told me that though it was probably extant, its whereabouts were uncertain. Rubin declares, with odd, hysterical emphasis, *"I never mentioned any list."* But the fact that he had not seen a list was tacitly acknowledged by several elements in his argument. He spoke, for example, of his recollections, then referred to a "rapid check" of the facts. Now the question is, a rapid check of what? If he was checking the list, then he had it and was being misleading about the number twenty, which I knew from Martin and Mock to be definitely too low. If he was checking the memories of informants, then he did not have the list. I was giving him the benefit of the doubt; perhaps I was being too generous. Now that he says he has the list, Rubin makes a bald denial ("none of the objects lent by the Musée de l'Homme ever belonged to a modern artist"), and then, in a footnote, takes it back and acknowledges that there may have been at least one such case as I claimed. Someone with lots of spare time and no hobbies might undertake to analyze and publish the list and clear the matter up.

Of course, I brought up the vitrines in the first place to illustrate the point that the practice of exhibiting so-called primitive works either with modern works or in their milieu was nothing new or unusual. The case was sound, and Rubin hid among the numbers to evade it. But it should be emphasized that there is no ambiguity whatever about this. Rubin's primitivist hat is indeed an old one; it's the amount of surrounding research that's new, what they call the "light of informed art history." One could go on naming earlier shows that exhibited primitive art in the milieu of modern art till the bears come out of the caves and say they're sorry. Rubin's essayists in the catalogue are well aware that the practice began early in modernist primitivism itself. (Even Rubin, nudged by my article, acknowledged some of them in his first letter.) Alfred Stieglitz showed African wood carvings at

the Gallery 291 in 1914. In 1915, modern and primitive works were shown together at the Modern Gallery in New York. In 1933, the Museum of Modern Art showed *American Sources of Modern Art (Aztec, Maya, Inca)*; in 1935, *African Negro Art*; and in 1941, *Indian Art of the United States,* curated by René d'Harnoncourt. A key precursor, one that had special status in the background of Rubin's show—but that he chose not to mention in his letter—occurred in 1967. In that year, the Musée de l'Homme held a major exhibition called *Arts primitifs dans les ateliers d'artistes.* Here, according to the Musée de l'Homme catalogue (I did not see the exhibition), were exhibited primitive art objects that had been in the collections of Braque, Picasso, Derain, Matisse, Max Ernst, Jacques Lipchitz, Vlaminck, Henry Moore, and dozens of other modern artists. Here were the fantastic photographs that moved so many at MoMA of Picasso in his studio with a variety of tribal objects in 1909, and, above all, of Braque in 1911, playing an accordion in front of a wall with a Fang mask on it. And on and on.

Ultimately, Rubin is so obsessed with the idea that his exhibition had no precedents that he makes my comments in regard to the Menil-collection exhibition, *La rime et la raison,* the linchpin or rhetorical climax of his letter. I did not see the show. I was not writing about artworks in themselves but only about the record of what had been exhibited, and this record is available through the extensive catalogue. There is of course no requirement of firsthand viewing for scholars who are writing about the record of things. I have written about Plato without ever having seen him. Astronomers write about the stars without visiting them; physicists write about things too little or too big to see. Present-day writers on the Armory show write about it from the published record, not from having seen it. The press release on the Menil-collection show clearly suggests that it paralleled the MoMA project in its main lines. It said, for example, that "the show tracks the ideas early twentieth-century artists found in primitive art, and the relation of these works to successive, linked waves of European and American art movements: Cubism, Surrealism, Abstract Expressionism, and Minimalism." In addition, I saw in the catalogue several references to the mixing of primitive and modern objects. This is what I wrote about it in my initial article: "More recently, the exhibition of the Menil Collections in Paris's Grand Palais, in April 1984, juxtaposed primitive and modern works (a Max Ernst with an African piece, Cézanne with Cycladic), and sometimes, as in the present exhibition, showed a modern

artist's work in conjunction with primitive objects in his collection. The premise of this show, then, is not new or startling in the least."

I want to remind the reader that in his first letter Rubin listed three objections to those remarks. I replied. In the current letter he has abandoned two of his objections and focused everything on the statement that the exhibition "sometimes showed a modern artist's work in conjunction with primitive objects in his collection." In that regard I depended on certain indications in the catalogue. There was, for example, a statement by Walter Hopps in the introductory essay that "in the section on the surrealists, beside their own works one finds objects that belonged to them." The question now is, what kind of objects? The statement appears among sentences on the mixing of primitive art and modern art, and I understood, on the basis of context and of the inference contained in the word *ainsi,* or "thus," that this sentence was on the same topic. Rubin first objects that "Hopps's sentence about 'objects that belonged to [the surrealists],' though slightly ambiguous because poorly translated, is not located, as McEvilley claims, in a discussion about the 'mixing of primitive and modern objects.'" The reader will have to read the Hopps passage to see what I see:

> Ici l'art primitif est représenté à égalité avec l'art occidental; l'art occidental le plus ancien est juxtaposé avec l'art le plus moderne. Les affinités ne sont pas chronologiques, elles sont conceptuelles, iconographiques et formelles, destinées à suggérer les correspondances profondes entre les valeurs esthétiques et spirituelles de peuples et de temps fort divers. Ainsi, dans la section des surréalistes, on trouve, à côté de leurs oeuvres, des objets leur avant appartenus. Dans le même esprit, quelques oeuvres modernes sont exposées au milieu d'objets archaïques ou traditionnels.

> (Here, primitive art is presented equally with Western art; the oldest Western art is juxtaposed with the most modern. The affinities are not chronological but conceptual, iconographic, and formal; they are intended to suggest the deep correspondences between the aesthetic and spiritual values of very different peoples and times. Thus, *in the section on the surrealists, beside their own works one finds objects that belonged to them.* In the same spirit, several modern works are shown among ancient or traditional objects.) [My italics on the English.]

Perusing the catalogue in search of more information on those objects, I found, in the "Catalogue" section proper, after several hundred pages of pictures with occasional introductory paragraphs, pictures of some Kuskokwim Eskimo masks, with the following passage introducing them:

> Ces masques étaient portés à l'occasion de danses et de cérémonies liées à l'invo-cation du monde des esprits. L'artiste qui réalisa les pièces 292 à 294 les vit d'abord "apparues en rêve." Il exécuta ensuite seize pairs d'objets. La série complète, trente-deux pièces, fut achetée au début du siècle par un Américain, George Heye, et plusieurs furent acquises ultérieurement par des surréalistes français établis à New York.

> (These masks were worn on the occasion of dances and ceremonies linked to the invocation of the spirit world. The artist who made pieces 292 to 294 first saw them "appearing in dream." He then executed sixteen pairs of objects. The complete series, thirty-two pieces, was bought at the start of the century by an American, George Heye, and several were later bought by French surrealists living in New York.)

At this point I had found two references in the catalogue to things owned by surrealist artists (a third, more general statement was consistent with these): One statement said that they were in the show, the other that they were Kuskokwim masks. The first statement was by Walter Hopps; the second was unsigned. Compressing for space, I wrote the following: "'Ainsi, dans la section des surréal-istes, on trouve, à côté de leurs oeuvres, des objets leur ayant appartenus' (*thus*, in the section on the surrealists, beside their own works one finds objects that belonged to them). These include, for example, Eskimo masks, of which 'plusieurs furent acquises . . . par des surréalistes français établis à New York' (several were bought . . . by French surrealists living in New York)."

Rubin says in reply, at the very end of his second letter, that if you held the Menil catalogue in your hands

> you would see that Hopps's sentence about "objects that belonged to [the surre-alists]," though slightly ambiguous because poorly translated, is *not* located, as McEvilley claims, in a discussion about the "mixing of primitive and modern

objects." And if you had seen the show, you would have known that the "objects" to which Hopps was, in fact, referring were not tribal sculptures at all but bibelots, exotica, and memorabilia; the few tribal sculptures in those areas were *not* from artists' collections, *nor did Walter Hopps ever say they were*.[15] But that's not all. The last part of McEvilley's paragraph cites Eskimo masks in the Menil show as examples of tribal objects supposedly owned by surrealists, an assertion elaborated with a quotation seemingly continued from Hopps's text. But this passage ("several were bought . . .") is by another author, occurs 339 pages later in the Menil catalogue, and does *not refer to the Eskimo masks in the show*.[16] Is this the scholarship that "is a type of science"?

There are six objections here. The first, about the context speaking of mixing, I have discussed, and the second, about the appearance in the show of objects belonging to surrealists, too. The third point—that the second quote seems to continue the first—is empty, and suggests that the bear has a punctuation problem. The two French quotations are enclosed in separate sets of quotation marks, indicating that they are not continuous. Fourth point: the second quote was unattributed; as Rubin agrees, in the catalogue it was unsigned. Fifth point: the 339 pages that intervened between the two passages were almost entirely filled with pictures; in any case, if the same subject is discussed in separated passages, one must quote separated passages. Rubin's sixth and crowning point, the culmination of his letter, is that the passage about masks owned by surrealists *does not refer to the Eskimo masks in the show*." There he has a footnote, and the footnote refers to a private conversation as his proof. I relied on the published record and believe that in my method there was no error.

The question of whether the dates of the non-Western works should have been included either in the show or the catalogue or both may seem at first glance sterile and merely factual, but I think it is not; it points to hidden presuppositions of great moment. In the article that began this debate, I objected that by omitting dates from the non-Western works in both the show and the book, Rubin was presenting their makers and their cultures as really "primitive," that is, outside of history—as, really, less than human. He was acting out a presupposition that had a great deal in common with the Conquistadors' belief that Amerindians did not have souls, and he was doing so ultimately for the same purpose—to justify taking over in the one case their bodies and in the other their cultural objects. I wrote:

"Anyone who opens a scholarly book on primitive objects, or who visits anthropological museums . . . will see that at least approximate dates are usually given for the works." In his citation of this passage, Rubin conveniently omits my reference to books and deals only with the question of whether museums put dates on their vitrines. Earlier on in his current letter, he says that "we had described [the tribal objects in the show] as mostly from the later nineteenth and early twentieth centuries. . . ." He is evidently referring to a wall plaque in the exhibition. But the checklist of the exhibition says nothing about the dates of the primitive objects, though of course it dates all the modern objects. Clearly the information belongs there, for starters. Wherever it is in the book (if indeed it is anywhere), it hasn't jumped out at me. In any case, it is inadequate. Rubin's unconscious politics toward the primitive objects are coming out again; lumping them all together is not something he would do for the museum's Picassos.

In my claim that the policy of most museums is to give such dates as are available, I granted that precise dates are usually not available. Rubin, in reply, acts as if I had demanded precise dates for everything, and states that often only centuries are known, as if to show me that my request was ridiculous; yet I had specifically written: "even knowing the century would help." "*Not one* of the labels for any of the hundreds of objects [in the African section of the Musée de l'Homme]," Rubin insists, "contains even an approximate date. The same thing is true for the tribal objects in the African and Oceanic galleries of the American Museum of Natural History—among other ethnological museums."

Well, the story certainly does not end there. Is Rubin really unaware that the Musée de l'Homme does in fact give such dates as are available in its most widely distributed catalogue, *Chefs d'oeuvre de musée de l'homme* (Paris: Musée de l'Homme, 1965)? Is he really unaware that the Metropolitan Museum of Art in New York gives available dates in its primitive collection? And that the Field Museum of Natural History in Chicago does also? He refers lightly to "other ethnological museums"—too lightly, I'm afraid. The general catalogue of the Museum für Völkerkunde in Vienna gives dates such as "*vor 1879*" (before 1879) or "*Frühes 19. Jahrhundert*" (early nineteenth century) when they are available. The Berlin Museum für Völkerkunde, in a catalogue of West African masks, gives available dates. The Linden-Museum in Stuttgart, in a catalogue of objects from Cameroon, gives dates such as "collected . . . in Bali, 1905." The catalogue of Indonesian and Melanesian works in the Collection Barbier Müller (Geneva, 1977) gives dates.

The catalogue *Exotische Kunst im Rautenstrauch-Joest Museum* (Cologne, 1967) provides such dates as are available. The Museum of Primitive Art in Rimini, in its general catalogue, edited by Delfino Rialto, gives available dates. The Museum of Primitive Art in New York, in a catalogue of the primitive works in the John and Dominique de Menil collection edited by Robert Goldwater himself in 1962, gave available dates such as "before 1896." Douglas Newton, when director of this museum, gave dates in their general catalogue, *Primitive Art Masterpieces, 1974*. As chairman of the department of primitive art at the Metropolitan Museum, Newton included dates "when known" in the catalogue *The Nelson A. Rockefeller Collection: Masterpieces of Primitive Art, 1978*. The catalogue *Traditional Art of Africa, Oceania, and the Americas,* published by the Fine Arts Museum of San Francisco in 1973, gives dates such as "collected before 1900" when they are available. The catalogue of *The George G. Frelinghuysen Collection at UCLA,* 1968, gives, when they are known, such dates as "made in the nineteenth century." Cottie Burland, in *Gods and Demons in Primitive Art,* 1973, gives dates such as "Collected by Dr. Emil Holub c. 1860," "Possibly mid-nineteenth century Tsimshian work," and "Made by Tlingit Indians in the mid-nineteenth century"; and Henry John Drewal, in the catalogue *African Artistry: Technique and Aesthetics in Yoruba Sculpture,* 1980, gives dates such as "probably by Akiode (died 1936)" and "possibly by Oniyide (died 1947)." A recent book by Werner Gillon titled *A Short History of African Art,* 1984, proposes correctly that it is time to begin regarding non-Western objects within the context of history.

Rubin employs a reverse form of argument when he writes of the Menil catalogue, as if disproving me, that "many of the African objects are totally undated and only six of the forty-four [sic] Oceanic objects are given even approximate dates." But the point is the opposite of what he implies: It is that the catalogue in question does give available dates. I could go on. Rubin claimed there was a general practice not to give dates; clearly he is wrong. But it is not difficult to guess why Rubin did not want individual dates in his show. Consider the pink Sulka mask that adorned the cover of *Artforum* in which my initial article appeared, and which was one of the really prepossessing objects in the show. In the 1975 edition of Helen Gardner's *Art Through the Ages,* it is dated "1900–1910." Picasso's *Les Demoiselles d'Avignon,* in the museum's collection, is dated 1907. The fact the exhibition was at pains to conceal from the nonexpert public is that "the primitive and the modern," as anthropologist Remo Guidieri wrote, "are contemporaries."

And yet this contemporaneity is, finally, the most interesting fact of all. Is 1910 in Africa or Oceania a different year from 1910 in Europe? Is history only for us? Why are the object makers of Africa and Oceania invisible to us except in this degraded, anonymous, dateless, timeless, childish, ahistorical role as pedestals for—guess what—*our* art? To push them into the nursery of childish timelessness while researching every tiniest detail of the chronology of the grand Europeans is grotesque.

There is an inner contradiction to this attitude that recontextualizes primitive ritual objects as art in the Museum of Modern Art and then leaves them anonymous and dateless: Our Western idea of art is premised both on the maker as a self and on the historical progression of the works. I suggested that Rubin had enunciated no clear criteria for using the tribal objects the way we use our artworks, and that he did not want to think about the complexities of their transpositions. I had claimed that "virtually every object" in the Egyptian Museum in Cairo had been intentionally buried underground away from all human eyes, and that this showed something fundamentally different in intention from our intentions about art. Rubin attempts to rebut me, saying, "contrary to [McEvilley's] assertion, there are [in the Egyptian Museum] a great many objects not 'intended to be buried underground.'" He has a footnote number on this, and the footnote says the following: "I checked with the Egyptologists at the Metropolitan Museum of Art, who suggested that something less than one-fourth of what is visible of this immense and as yet not fully catalogued collection would be material *not* taken from tombs. Thus, tomb material could hardly be said to comprise 'virtually every object' there." The information itself is hidden in those sentences. Less than one-fourth of the objects, Rubin learned, were not taken from tombs; it follows then that more than three-fourths were taken from tombs. More than three-fourths, of course, means something between three-fourths and all of the objects. The range is conservative and an actual count, I think, would come in at around 90 percent. In any case, saying more than three-fourths is very much the same as saying virtually all. Again Rubin has confirmed my original statement. He found that I was right, pretended that he had found otherwise, and hid the real information in a footnote. (Rubin treats the footnotes like a burial area away from all human eyes.)

The red herring of whether some temple sculpture and painting was meant to be seen in the light of day makes no significant difference in the issue; in ancient Egypt, both temple and palace were hieratic settings in which the works in ques-

tion functioned magically, as they did in tombs. It is known that the Egyptians themselves regarded their sculpture and painting (as for that matter their architecture in durable materials) as functional magical objects, and expressed no consciously articulated aesthetic propositions about them. I trust it's clear that I'm not saying that they're not pretty. To me, as to many Western Moderns, they have a powerful, even an uncanny, aesthetic appeal. Indirectly, by way of the Greeks, the Egyptian canon of proportion and harmony trained our eyes, and can still be felt resonating behind Renaissance and modern European art.

The second element in Rubin's Egyptian reply is his report of a personal conversation with Leo Steinberg. My quarrel is not with Steinberg, and one wonders why Rubin does not cite a published authority on Egyptology. In any case, the speaker of these remarks acknowledges that the Egyptian works were mostly buried underground—this really is an undeniable fact—but goes on to say about the buried objects that "they were designed to be enjoyed both functionally and aesthetically by human eyes in an assured afterlife precisely forever." The words "and aesthetically" are without a basis in evidence. To begin with, I hope it is clear that the speaker is referring to dead human eyes. The speaker means that after the works were deliberately buried behind the most elaborate obstacles, they were meant to be enjoyed "both functionally and aesthetically" by corpses or ghosts. I wonder if the speaker would care to cite documents for the aesthetic pleasures of the dead. I repeat that as far as I know there is not a scrap of evidence in extant Egyptian literature for the idea that ghosts or gods in the tomb were meant to take an explicitly aesthetic pleasure from these objects. In fact, there is no more articulation of aesthetic propositions in ancient Egyptian literature than in African and Oceanic tribal discourse; the category of aesthetics, as we know it, had not yet dawned and cannot be called a part of the intention behind the work, except in the same unconscious way that Rubin and others attributed to the African and Oceanic works in the show—that is, by the same Eurocentric projection of our feelings and intentions into their works, despite the fact that all the evidence shows their work to have arisen from quite different intentions. One wonders why Rubin doesn't tell us what the Egyptologists he consulted (and whom he does not name) had to say on this point, rather than suddenly ignoring them and going to a Western-art historian for opinions about Egyptian questions. For the absence of evidence in the literature is not the worst of it: Anyone who had reviewed the material from the tombs themselves in detail

would know better. Some of the highly ornamented objects, for example, were found in animal cemeteries. Were they meant to be enjoyed aesthetically by dead crocodiles, vultures, and jackals? Furthermore, the only important tomb whose original contents we know in detail is Tutankhamen's, and the speaker should note that it contained far more stuff than it could hold in exhibition. The magnificent objects that we admired in the museum show were not originally arranged for aesthetic appreciation: They were stacked on top of one another as in a closet or a storeroom. (The partial ancient robbery does not alter this fact.) They were there, in other words, because their magical presence was necessary, not because anyone would be looking at them.

Finally, the speaker chides me for supposedly ignoring the fact that the Egyptians believed in an afterlife, and that therefore the idea of aesthetic appreciation in the afterlife would have seemed less than comical to them. But the speaker seems to feel that the Egyptian view of the afterlife involved the mummy living forever in the tomb, enjoying its goods. There are traces in the Egyptian literature of such a rudimentary belief system, but in the historical period—the period in which virtually all the objects that are known to us as Egyptian art were made—this form of the afterlife myth had been subsumed within and largely replaced by a more complex myth in which the selfhood of the deceased breaks up into fragments which go various ways. Most of the tomb objects have magical functions involved in the reconstitution of the fragmented self for wanderings beyond the tomb. The self, when ritually reconstituted, does not continue to inhabit the tomb and enjoy the grave goods, but goes on to the Field of Reeds and the Court of Osiris, and finally, converted into Re, achieves an eternal life among the circumpolar stars. The tomb objects, meanwhile, lie in the tomb as a kind of magical support system. There are various forms of this myth, and none of them provides a whole self living on in the tomb and enjoying its furnishings. Rubin's views here are like those of the anonymous Greek tourist who entered an Egyptian tomb in about 600 B.C., and wrote on the wall, "I have seen these things and I understand none of them."

Well, big bear, that about wraps up the news from here. It's getting late. You might feel that I have abstracted this topic from a more concrete array. But the force and power of your show, its scale, its time and place—all these things have made it historic, because it raised questions. It made us ask exactly how and why

it was deficient. I thought it was, above all, inadequate because the relationship was all one way.

I'd like to read you some choruses of Aeschylus and show you my favorite poems. We could both bring a friend. We could explain to our friends that we have shared something special together, you and I. Take care of kitty. I don't think I'll be writing to you much anymore, but I want to say that I hope the future profits from what we have done. And that we do not drink the black milk of morning, you and I, for doing it.

On the Claims and Critics of the "Primitivism" Show

(ART IN AMERICA, MAY 1985)

KIRK VARNEDOE

"PRIMITIVISM" IN TWENTIETH-CENTURY ART: AFFINITY OF THE TRIBAL AND THE MODERN sought not only to present art of exceptional quality, but through that art to address intellectual issues of great density and importance. Even beyond the popular and critical acclaim the show enjoyed, another index of its impact is the serious debate surrounding those issues that has been established in several recent reviews—especially those of Thomas McEvilley, Hilton Kramer, James Clifford, and Yve-Alain Bois [for the last two, see *Art in America,* April 1985].[1] Of course the show was hardly flawless, as its own organizers would readily concur; and these critics have been correct to cite lapses and uneven aspects within it. But in considering the more basic criticisms voiced in these commentaries (and parallel critiques that were aired at the museum's two-day symposium for anthropologists and art historians last November), I want to suggest how they may reveal, not so much putative flaws in the exhibition and its accompanying publication, but problems in critical positions, and broader dilemmas in contemporary intellectual life.

The prime purpose of the show was to illuminate an aspect of Western modernism: its contact with and inspiration from tribal art of Africa, Oceania, and North America. Nonetheless, the disclaimer that the show was not about tribal art per se—only about modern artists' responses to it—did not ward off accusations

of a "formalist," "decontextualizing," and thereby deforming ethnocentrism. In some instances the objections seemed directed as much against the way history happened (since ethnocentrism is endemic to modernist primitivism by any account) as against the way the show represented it. But on the whole, critics claimed to indict actions taken by the curators rather than those reported by the exhibition, and blame not the limitations of the modern artist's viewpoint but the curators' violation of those limits. Thus they pointed out that the majority of tribal objects were *not* selected on strict documentary principles, but according to contemporary standards of quality. And, they asserted, we *did* make claims about the tribal objects per se, by imputing formal concerns to their makers in order to suggest elements that linked modern and tribal creation.

Now admittedly, high standards of quality weren't licensed by the show's documentary premises (which were amply fulfilled all the while). But even hostile visitors concurred that the show's presentation of tribal art was powerful precisely because it was discriminating; and no one has seriously argued that it would have been more virtuous to have shown shoddier pieces.

It is instead the other accusations, about allegedly imposing our values on tribesmen, that are the real sticking points. They were at the heart of Thomas McEvilley's objections to the show, as well as of James Clifford's attack on the "Affinities" section (the part of the show where comparisons sought to illuminate "common denominators" shared by modern and tribal objects that were historically unconnected). These objections are crucial because they open onto broader critical positions against "formalism" and "decontextualization"; and because they provide the launch zone from which charges of cultural imperialism and autistic reflexiveness have been flung not just at the show, but through it at the Museum of Modern Art, modernism, and Western society in general.

* * *

Such reactions confirm what was a given before the outset: that the show treads on highly sensitive territory, especially in regard to cross-cultural comparisons. Certainly from a curatorial point of view it would have been safer to have stuck to documenting specific influences of tribal art, and to have left the whole area of "Affinities" out of the project. Safer, but far less interesting and provocative. Similarly, it would be judicious now to beg off the attacks, either by wearily reinsisting that the show was not really about tribal art or by saying (as is true) that

the idea of "Affinity" was initially conceived in the narrower sense of the one-way kinship modern artists felt with tribal art, imputing nothing about reciprocity. Judicious, but less interesting or useful. Whatever the local weaknesses in our particular presentation, I think there remains more value in the basic notions of "Affinities" and "common denominators" than James Clifford would allow; and that there are sound reasons to allow the accompanying "formalism"—and, yes, even "decontextualization"—that he and others have rejected. Let me thus be the devil's advocate (or MoMA's, which for many will be the same) and stand up a bit for these much-maligned ideas.

We allegedly "decontextualized" the tribal objects in the show by dealing with them outside the context of their original use. But, in fact, we simultaneously "recontextualized"—shifted the focus of inquiry to see the pieces not just in some emptied-out void, but as part of a separate set of considerations. We wanted to deal with the questions raised by the forms of the objects, rather than with the other kinds of questions that could only be answered by supporting texts about their origins or functions. This way of looking at things is the standard condition under which all museums show Western art, but it is held by many to be more problematic with regard to tribal art; and by our critics to be especially unfair with regard to the tribal objects shown in *"Primitivism."* The show should have been more informative, critics insisted, as to the original purposes and societal context of those works—by adding labels with anthropological information, for example.

In a sense, this is just an argument about one kind of exhibition as opposed to another—a full-dress ethnographically oriented display, which we were not out to do, versus the show about primitivism we did do. But, in fact, the critics' call for context suggests some more basic disagreements about the ways art can be understood. The little argument about label texts opens into something fundamental about the way art works, and about the way we get knowledge. At issue are a constellation of basic intellectual positions—contextualism, holism, and relativism—that are dominant credos in much of contemporary thought.

The contextualist position here, as elsewhere, starts from the basic laudable premise that the things people make or do should be understood in terms of their circumstances of origin. The problem arises when this position hardens, as it seems to have for some of the critics of *"Primitivism,"* into the insistence that all valid meanings of a work of art are delimited by those founding contingencies. You can't know anything true or meaningful about an Igbo yam mask, such a con-

textualist would say, unless you know all about the Igbo rituals for which it was made. The idea that circumstances shape art leads in this fashion fatally to the conclusion that it is circumstances, not art, that finally most merit our attention. This hard version of contextualism then dovetails with the larger belief in holism.

Holism also begins impeccably, with the sympathetic ecological plea that all activities are interrelated; but it can then lead inexorably to the noxious conclusion that you really can't know any one thing unless you know everything. Under this light, all divisions are artificial, therefore harmful: To wit, not only is the notion of tribal *art* wrong because it isolates one activity from others, but also the idea of the tribe itself is just a jury-rigged grouping for our convenience; and furthermore the focus of the *"Primitivism"* show on three cultures is invalidated because it leaves out the other interrelated aspects of modern primitivism's taste for the Pre-Columbian, the infantile, the naïve, perhaps eventually the Egyptian, the archaic Greek, etc. In larger terms, the holist credo inevitably favors general over specific modes of investigation, since in its view the truths that count can only be snared by maximum extension of the widest nets of intellectual abstraction. You can't know anything true or meaningful about the Igbo yam mask, this view would hold, unless you comprehend everything about the Igbo worldview. From this position, one arrives at the logic of the larger label, in a corollary devotion to historical texts at the expense of historical objects. Here, too, lie the roots of the ever-more-familiar imperative to discuss the work of art in terms of what's not there rather than what is. In the politics of professions as well as in these methodological concepts, one consequence of the holist revulsion against divisions is disavowal of the separateness of disciplines, and thence the urge to merge: The study of tribal art must be dissolved into anthropology, the study of art history into history. More on this anon.

<p style="text-align:center">* * *</p>

Now we can begin to understand what the critics mean when they accuse us of "formalism." Evidently they don't mean simply that we adhere to some theory associated with Clement Greenberg or Viktor Šklovskij; the objection is more basic. For them, real and useful knowledge apparently can only proceed from examining whole contexts through texts, while knowledge gained from visual analysis of the way representations are made is assumed to be devoid of guiding ideas and doomed to yield only falsehoods. The implication is that all we care

about is the way things look—as if looking were the opposite of thinking, and the evidence of form were evidence for nothing.

Specifically, the antiformalist critics hold that the comparisons we set up between modern and tribal objects were mere "look-alikes": trivial resemblances based on morphology without regard to meaning, and therefore empty. Now obviously there *were* some instances of banal resemblance, but these were among the comparisons that demonstrated provable influences. This common, lesser strain of primitivism we felt obliged to present, but not to defend against charges of superficiality. The more speculative juxtapositions we made of historically unconnected works were however (like the more arresting instances of influence) based *not* on mere surface resemblance but on concordances of structure and apparent strategy. The concern was precisely *not* with the self-sufficiency of appearances, but with the idea that visible isomorphisms—in the structuring of volumes, in the sequence and variety of parts, in strategies of transposing natural orders—might suggest that underlying approaches to the construction of ideographic, nonnaturalistic systems of representation (usually of the human face or form) were in some instances parallel in tribal and modern Western art.[2] In that sense, we did focus on form, not because it excludes meaning but because it points to, or more simply *is* meaning. It is a kind of meaning—one very consequential significance among many to be found in the objects, separately or together—which an exhibition is especially good at making vivid and immediate. The way our exhibition proceeded to isolate this meaning was not by any conspiratorial denial of other possible truths, but simply by an act of comparative focusing, of the kind anthropologists frequently use when they study the organizational forms of a range of tribal dance patterns, or barter systems, or kinship myths. Indeed, this kind of selective matching is an essential aspect of human thought on all levels from the scientific to the everyday.

It might help, for example, to think of the basic notion of the useful analogy. Any worthwhile analogy contains a gap of difference and a leap of similarity, and perforce involves accepting a selective focus. Saying "an orange is like a tangerine" is fine but doesn't get us terribly far. Saying "the universe is like a gas bubble" is outrageous but may be immensely helpful, even though—or because—there are millions of obvious differences between the two terms. Similarly, if we say an Igbo yam mask is like a Picasso painting of a head, we focus on the modular repetition that both use to denote facial features—not finally to deny or suppress the objects'

countless differing particularities, visible or invisible, but operationally in order to understand something about them, and possibly about a larger system to which they may both belong.[3] The problem addressed is anything but trivial. It concerns parallel ways humans may construct separate visual languages to say different things; and in order to focus on it, we allow for the kind of comparative thinking that involves strategic departure from both works' separate integrities (for not only the Igbo mask but also the Picasso is denatured in the process; both connect to a world of complexities held provisorily aside).

Perhaps some of the "Affinities" have *only* the force of an analogy, without bespeaking deeper linkages. Perhaps, on the other hand, they may indicate congruities on the level of shared cognitive structures in human representational systems; or they may say something about the rule-bound nature of image making as a human game. Almost certainly they vary in implication, since some of the concordances are more subtle than others. We did not pretend to provide final answers that explain why these parallel representational structures appear in these particular situations. And clearly one thing we were not arguing for was some Jungian notion of "aesthetic universals." To the contrary, written into the selection of the comparisons is the idea that they are relatively rare and specific, that they illuminate structures especially pertinent to tribal and twentieth-century Western art and not to the art of other periods or cultures. The tribal-modern relationship is not a hypothesis that emerges from thin air, but one obviously suggested by the special, pervasive and consequential importance these particular forms of tribal art have had for twentieth-century Western artists.

* * *

We have not yet reached, however, the roots of the critics' disagreement; for they have objected not just to the methods used in "Affinities" but to the basic validity of the inquiry itself, to the premise that underlies everything we have just discussed. The premise in question, which our critics seem to find highly suspect, is that there exist real things worth knowing about human beings as culture makers, beyond the local facts of their particular and various cultures. The corollary notion is that there is value in studying the ways people may be alike, rather than just emphasizing the ways they're different.

These curatorial heresies seem to run directly against the grain of further credos, of pluralism and relativism, that are also found hypertrophied in contempo-

rary thought. As with contextualism and holism, these lines of thought start out unimpeachably well. They begin with premises liberating and morally sound, honoring the Otherness of different cultures or epochs, and abstaining from any hierarchies of dominance in which our limited viewpoint might claim power over theirs. Alas, when yoked with a certain brand of holism, these ideas do a very different kind of work. The separate integrity of the age or the culture becomes conceived in terms of abstractions variously labeled as epistemes, paradigms, et al., which are held to be all-pervasive and all-powerful in their local dominance, and wholly incommensurable with the worldviews of other cultures and ages.

A part of this kind of zeitgeist determinism is the ostensibly liberating vision that everything we know—ourselves, our institutions, our ideas—is only a set of artificial constructs built into us by the systems of our society. And if it's true for us—who at least have some glimmer of despairing awareness of this—it's triply true for tribesmen, who are seen by critics like McEvilley as deeply bunkered into an inability to do anything that isn't inscribed in the "texts" of their economic-religious structure and their language. On this account, it is a grave error for us to pretend to know anything about them in terms like *art*, which are fit for our local use only, made only to adorn the wall of conventions that imprison and isolate us.

Of course, respect for human pluralism deservedly commands moral and intellectual force. However, the evidence is not clear that we should congeal it into a rigid doctrine of the inescapable, atomized separatism of all human experience in separate cultures. When stated in these harsh exclusionary terms, the credo tends to blur the line between opinion and fact, and to disallow the contradictions it generates internally. That is to say, the argument is open-ended as an empirical question and faulty as a logical position. Empirically, on the evidence of field reports, psychological studies, etc., ironclad cultural relativism certainly does not stand as the only legitimate way in which to think about human production and communication. For each of the authorities one might marshal in its defense—as, for example, the dubious Whorf-Sapir hypothesis on the total constraints languages allegedly impose—there are other respected sources of evidence and interpretation that point to different conclusions: that there can be significant common denominators among the different ways humans perceive and represent; that cultural frameworks aren't as wholly binding as they may appear; and that the way meanings derive from context is the motor nerve of communication rather than its Achilles' heel.

It would be pointless, though, to reduce the debate over *"Primitivism"* to a battle of bibliographies on language acquisition, perceptual psychology, and so on—not least because the court is still out on these matters, lots of new findings are as yet unevaluated, and there will likely never be any crisp, one-sided permanent consensus. It can be suggested, though, that the evidence of the critics' own arguments show that their positions don't hold logically, just on the level of common sense and personal practice; and that their results tend to go against the grain of their own initial strengths.

* * *

If there's really *no* commensurability between epistemes, and no way to know the Other in our own language, then that is that, and we close the book and hunker down at home. But it seems that no one believes this, and least of all those who urge more anthropology—more scientific anthropology, the quintessentially modern-Western construct based in all our contingent myths of evidence and objectivity—as the remedy for MoMA's allegedly deforming vision of tribal objects as art. Our critics not only believe that it is possible to have knowledge of the Other; they sometimes allow that it *is* possible for artists as well as ethnologists to have it. At that point we are in a position of deciding among contending anthropological viewpoints (which is precisely what we did not feel obliged or qualified to do in *"Primitivism"*); and we find ourselves tussling about which artist's vision is more compelling. These are evidently disagreements on particulars, not principles; but it seems the former (matters of taste and opinion) travel under guise of the latter (issues of science and philosophy) in some of the attacks on *"Primitivism."*

Clearly McEvilley, for example, thinks it *is* possible for the Western mind to understand meaning in tribal representations, and to have that understanding in various ways. Thus he defends both the science of anthropology and the possibility of shared worldviews among tribal and modern artists. He just doesn't think I have the *correct* understanding, or that the artists I focused on in the exhibition have the *true* community of spirit. Clearly, too, he knows that what people do may be different, in effect and substance, from what they think they're doing; and thus accepts that an outside observer may read meaning, or even impute motivation, from appearances without regard to documented indigenous expressions of context or purpose. On this principle he, like Bois, insists that, in itself, the very fact of my selection of several contemporary women artists for *"Primitivism" shows* I

subscribe to an earth-mother cliché—even though I explicitly reject this idea in my catalogue essay, and offer wholly different reasons for my choices. But he won't allow this familiar practice of outside judgment and analysis to extend to assessments of artistic aspects in tribal objects, because he knows in advance that this is a *wrong* meaning.

For those who subscribe to these critics' basic principles, such distances from practice and conflations with preference may seem irrelevant. But I find disturbing the progress from the theoretical high ground of cautionary admonitions against hegemony, toward practicing claims of exclusive access to indisputable truths. It suggests a familiar recent pattern in which, by the assertion that all knowledge is but the masquerade of power, fervent attitude is licensed to parade as firm authority.

On a far more general level, these disparities between principles and practices also bring to mind one of the tales that the history of primitivism has to tell, in which ideals of respect for the Other have been fatefully interwoven with an urge to the authoritarian. This latter tale is worth sketching, for it not only suggests how modernist primitivism might connect to other parts of intellectual history, but also "contextualizes" our current debate. The history of primitivist thought in the West since the eighteenth century has seen a recurrent oscillation between (in rough-cut terms) rationalism and romanticism. The rationalist current of the Enlightenment posited some faculty of reason that was held to be a human birthright regardless of race or society. The belief that this birthright only got smothered by civilization tended, theoretically, to favor the noble savage; but in practice it was used to justify imposing the Enlightenment's brand of "universal" reason over all the "contingent" differences of non-Enlightened civilizations. The notion of universal mental structures came to be seen both as a tyrannical political premise and as an impediment to genuinely scientific investigation of the rich variety of appearances, customs, languages, and beliefs that flourished in the world.

Enter romanticism, with its empirical devotion to variety and its regard for the significance of differences—and with it, new ethnologies of folk song and folk art, and systematic philology. The problem arose when this "primitivism," too, with its investment in the separate organic integrity of cultures and in comparative thinking, led to an equally sinister form of tyranny equating culture with nature (especially race), and ranking peoples on rigid ladders of destiny. The proliferation of useful differences became confused with the fetishization of categories and fed

the intolerance it seemed destined to banish. At this point, a partial return of the despised "universalism"—the notion that humans share something important regardless of differences—could have salutary and innovative consequences.

* * *

There's a great deal to be said—far too much for here—about the way these two inheritances interact in modern views of the primitive, from Gauguin and Franz Boas right on through. But for the moment it's worth underlining the particular way in which the romantic rebellion has been replayed in recent years, in the reaction against structuralist thinking that has conditioned some of the negative views of our exhibition. Claude Lévi-Strauss's view of tribal society, so influential in the 1960s, linked up with an essentially rationalist current that looked for common or comparable mental structures beneath heterogeneous appearances. Now this once-provocative slant of thought, regarded in its day as an assault on Western humanism, is lately painted as the established seat of all that tradition's logocentric evils. It is the recoil from the lofty structuralist brand of analysis that has brought a sharp corrective pendulum-swing back toward a professedly empirical insistence on individual cultures as incomparable singularities, impervious to Western constructs of rationality. It is easy to see how this flows into the larger current of epistemes and paradigms we examined earlier, and not too hard to find some familiar landmarks in the new intellectual landscape they jointly nourish.

One of the most salient of these features is a twin investment: belief in the impenetrable separateness of cultural worldviews, paired with a veneration of the irrational or antirational current in Western thought. The idea is roughly that if culture is both artificial and all-constraining, then the only way to achieve access to the true Other, or to truth of any kind, is by a radical rejection of, and escape from, one's cultural prison. In the Western tradition, this squares with the idea that the energy of great art, from romanticism through surrealism and beyond, is to be measured in its distance of escape from the shackling conventions of an ever-more-rationalized worldview. (The recent wrinkle is that the mantle of the true fugitive has passed from the artist, child, and madman to the theorizing critic—who deconstructs the entrapments of Power, and attains Ideas while all others have only ideology. Art thus approaches correctness as it aspires to the condition of criticism, but that is a subject for another day.)

Of course this story of flight from Western civilization has been the founda-

tion narrative of modernist primitivism, beginning with Gauguin in Tahiti as its archetype. It should stand to reason that those who are enchanted by this romance of escape would extol the history of artistic primitivism as one of the nobler episodes in modern art's noble struggle to abandon or destroy Western values. But, in fact, what has happened to modernist primitivism follows roughly the pattern of what happened to structuralism: Once seen as the *bête noire* of the Western tradition, it is now recognized as a lapdog. In this holist view, Picasso's revolution was merely of the palace kind, and the *big* picture shows that there's little to choose between him and the colonialists who fired the guns in Africa, except styles of imperialism. And if that isn't bad enough, to present a *history* of primitivism is worse, for it compounds the initial ethnocentrism with still another overlay of logocentrism, in the benighted desire to organize and clarify a record.

Leave aside yet again the internal contradictions in such arguments (in this case the plea—by those who scorn the idea of history—that fuller history would improve the situation). Focus instead again on what I think is the crux of most of the debates, the difference between the hypothetical exhibition that some critics desired, or would have done themselves, and the one that was in fact presented.

* * *

In detail, the missing dream-shows don't always come together; they may even be self-canceling. For example, Bois feels that a conceptually based involvement with the primitive, like Robert Smithson's, should have been more to the fore; while Clifford, though he shares a mistrust of the merely visible, finds the diffuse conceptual linkages of recent primitivism unworthily incoherent. Some, like McEvilley, want more documentation of the origin-history of the tribal objects themselves (not the record of their coming to Europe, which we fully covered); while Clifford wants more post-facto Western cultural history, such as a picture of Josephine Baker on the walls to speak for *négrophilie* (I suppose that for the confirmed holist there's something inherently false and incomplete in anything we can understand about the primitivism of, say, *Les Demoiselles d'Avignon*, without reference to this vogue for American black culture, which got going about a decade behind artists' first involvement with African objects). In the main, though, those who have most disliked MoMA's exhibition do share one reasonably similar vision, of a truly radical primitivism that MoMA's show and book allegedly conspired to exclude.

Let's sketch it caricaturally as follows: MoMA's version of primitivism is allegedly false consciousness, enslaved to the market for tribal objects and to the myths of individual creativity that support the same; and, in its urge to validate modernist aesthetics, is blind to the solipsism of its own attempts to "know" (an evil word obviously synonymous with *collect*) the Other. The true primitivism is something else again. It isn't superficial because it can't be seen, and can't be bought because it doesn't depend on objects (theirs or ours). It's not Eurocentric because it relies on anthropology, and it can't be implicated in the crimes of the West because it states right out loud that it doesn't like Western values. It believes the Other is irrevocably Other, and it knows this is so because it can wholly identify with and understand what that Other is all about. What the Other is all about is an enthralled submersion in darkly anti-Cartesian "intentionalities" that free tribespeople from such Western fallacies as self-consciousness, doubt, cynicism, humor, and (god forbid) aesthetic appraisals—and that remove from their individual consciousness any distracting decisions about form or materials, so as not to pollute their object making in its "collective" formation, or in its singular focus on the shadowy violence of blood religion.

Now I am instantly ready to admit that this caricature may lump too many people's ideas into a monolithic construction and that it dismissively fails to do justice to the intellectual integrity, evidential bases, and honorable purposes of the arguments most critics have advanced. I am equally quick to note that I model these overstatements on the similar excesses of those reviews that posit *"Primitivism"* as the whole-cloth emblem of some conspiratorial plot, authorial and institutional; and try to convince their readers that the only real story of the exhibition and book is a negative one, to be unmasked in terms of the truths it concealed, repressed, censored, denied, etc. To call a spade a spade, this latter way of arguing is just a paranoid style, usually involving a set of predisposed feelings about the Museum of Modern Art so complex and deep-seated as to preclude reasonable debate on the issues at hand.

If we look at the exhibition that took place instead of the ones that didn't, I believe we will find that it neither concealed nor censored the conflicting points of view I've previously outlined. Instead it did something positive, and stronger: It offered an alternative vision that speaks on the same matters in very different terms. On the matter of individual creativity within tribal traditions, for example, it offered not only individual objects of tremendous power and sophistication, but

also the opportunity to compare objects of identical format from the same tradi-
tions—as, for example, the two Grebo masks in the first vitrine. For the hard con-
textualists, the differences between these objects—between Picasso's Grebo mask
and the one from the Metropolitan Museum—cannot exist in any meaningful
way, as both were conceived to have the same function within the same society.
For the hard cultural relativist, the whole comparison is a sham, since to call these
objects "art" and to see quality distinctions between them is only to mount a mas-
querade based on arbitrary Western conventions. Yet there *is* a difference between
them, which is not a figment of anyone's imagination, but present and demon-
strable; and that difference suggests to me that in these objects is vested evidence
of a variety of dialogue between individual decision and traditional tribal model—
an aspect of the makers' existence (or of the Grebo worldview, if you will) that
may well escape any other form of record.

Is it hopelessly superficial and ethnocentric to recognize this, and find it worth
reflecting on? Or should we rule this evidence of our experience out of court,
and—as the critics would have us doing with their points—"repress" it and "deny
its existence"? I think the show did in the end tell us something about tribal art
itself; and furthermore that what it told us—about the differences and similarities
in the way three tribal cultures made representations, about the range of sophis-
tication and achievement possible within those representational systems—was
true, valuable to know, and not knowable except through this kind of examina-
tion of the art.

* * *

The primary focus of the exhibition was not on the primitive, however, but on
primitivism; and here, too, positive positions were taken that seem to me as valu-
able as they are unfashionable. Modernist primitivism is obviously a complex
human phenomenon, partaking of several different and even contradictory
strands that interweave boldness and fear, wit and anger, creativity and destruc-
tiveness. It is replete with aspects trivial, mediocre, and sinister as well as with
high achievements and positive power (a heterogeneity brought into relief by the
differing viewpoints of the book's numerous authors). But among the most pow-
erful lessons it has to offer are some I believe the exhibition and book amply illu-
minate; and these are lessons that cannot easily be assimilated by the credos of
contextualism and relativism I mentioned earlier. Among these lessons are the

following: The things people make can communicate powerfully far beyond the confines of their original purposes and cultural contexts (we might have already guessed this from, say, Shakespeare's popularity in China). Acknowledging the interdependence of meaning and context entails not just insisting on the subservience of human creations to their original purposes; but also respecting their hidden strengths, and multifaceted capacity to reveal different powers in different places. Furthermore, in likening representational systems to languages, we need not only use Saussure nihilistically, to posit an arbitrary hollowness and solipsism of words as analogues for images. We can look as well, and more tellingly, at all there is to learn about the rogue generative power of such systems from the creative "misunderstandings," the hybrid "dialects," and the neologistic inventiveness that arise in the modernist encounter with the tribal.

Modern artistic primitivism has, in its broadest implications, a lot to say about the way humans can use their cultural conventions to change themselves and to understand new things—how Giotto and Daumier prepared Gauguin to value Marquesan carving, or how Gauguin's art in turn joined with the very different lessons of Cézanne to help prepare Picasso for his encounter with African and Oceanic sculpture. And it has more to say, too, about how this process works in reverse, so that African sculpture became not a simple "source" for Picasso, but a catalytic agent that allowed him to reimagine the possibilities of what he had at hand, in such a way that Rousseau and Cézanne could be pulled together on one canvas across a gap that might have seemed unbridgeable.

Picasso, like most pioneer modernists, encountered tribal art not just "out of context," but embedded in a context of general ignorance or misunderstanding about the objects' original functions or societal meanings. This necessitated a willful forgetting or setting-aside. What took place was an aggressive recontextualization of tribal objects, out of the (by now largely discredited) web of contextual "knowledge" that had held them distant and in significant senses invisible, into the volatile taxonomic category of art, then in upheaval. The eventual shift in Western frameworks for tribal art was from the natural history museum to the art museum; but the crucial way station was the artist's studio, where not only the constraints of the ethnological context but also the constraints of the inherited artistic tradition were tactically set aside for a new kind of thinking to emerge, which would challenge the parameters of both. It's too simple to say Picasso suddenly saw tribal objects as art. A changing definition of art readied him to see how

something formerly excluded could be included—and would further transform the category in the process. The resources and limits of Western art weren't inert and closed boundaries that had to be broken, but varied and malleable things that he realized he could use to build a window to the outside, and with that action also see the house he lived in by a whole new light.

This creative use of existing forms as a way of gaining knowledge about the new and unfamiliar, and this way of then using that knowledge to reorder one's own tradition so as to make new meanings expressible, are central to the compelling character of twentieth-century Western art—as central as is its uncommon openness to the art of radically different societies, or to change in general. Some of our critics read the gains from primitive art only as sycophantic "appropriations," and assimilate into European colonialism the openness to unfamiliar modes of seeing and feeling that characterize modernism. But this openness so obviously contradicts the one-sidedness of colonial exploitation that the critics' acts of selective focus—comparable to their willful blindness before the Grebo vitrine—evidence a simplifying partiality more extreme than any of which we've been accused. They tend not only to obscure the local facts of the way primitivism worked, but also to preclude reflection on some of the things the history may have to tell us about the way communication and innovation happen across and within cultural frontiers.

* * *

Both the history of modernist primitivism and the way it was presented at MoMA converge on some broader lessons about knowing things, and about knowing art in particular. Contextualism notwithstanding, there's a serious need for fields of inquiry that study representations in the transcultural context of other representations. And holism notwithstanding, circumscribing these fields of inquiry can bring into relief as much truth as it suppresses. The general and rather simple proposition touched on above—that cultural conventions can be not just chains of confinement but also tools of discovery—has a particular relevance to the debate at hand, as it relates to other current disputes between artificially polarized notions of "formalism" and "contextualism" in the study of art.

The study of the history of art is felt to be in crisis, and lament is heard for the eras when thinkers such as Riegl or Wölfflin radiated influence outward from art's study to other fields of inquiry. Yet is a remedy to be found, as is commonly now

argued, only in breaking down the "arbitrary cultural conventions" that have isolated art history, and thereby dissolving this field and others into one holistic interdisciplinary conception of historico-sociology? Or should we hold, to the contrary, that the term *art*, in however imperfect and changing a way (indeed, *because* of its flexibility and lack of closure), is a useful convention rather than merely an onerous one—that it helps us understand a set of human activities and aspirations that merit study as phenomena related across the barriers of time and cultures?

If to do so is considered proper only for a "mere connoisseur," a superficial "formalist," and an enemy of history, then we have a crisis that is not to be solved by dissolving the discipline. For it is powerful questions about how and why art has a history that have characterized the admired thinkers; and to respond only that art is an epiphenomenal pawn of other histories is inadequate to their measure. Not less distinct, but sharper and more challenging boundaries, which define better, more on-point questions about art and its history—might these not be an alternative way to change art history from a discipline of patchwork borrowing into one of greater generative value to human inquiry writ large?

As an art historian, I am more than aware of what can be gained from contextualism, holism, and cultural pluralism; I frequently defend one or the other approach. Can I then ask the critics of *"Primitivism"* to take a hard look—as they should be predisposed to do—at the other side, at the limitations that these contingent, culturally derived paradigms of thought can, when rigidified, impose on seeing and understanding important things that do not fit their rule?

NOTES

1. See Thomas McEvilley, "Doctor Lawyer Indian Chief: *'Primitivism' in Twentieth-Century Art* at the Museum of Modern Art in 1984," *Artforum* (November 1984); Hilton Kramer, "'The *'Primitivism'* Conundrum," *The New Criterion* (December 1984); Yve-Alain Bois, *"La Pensée Sauvage,"* Art in America (April 1985); James Clifford "Histories of the Tribal and the Modern," *Art in America* (April 1985). See also the exchange between myself, William Rubin, and Thomas McEvilley in *Artforum* (February 1985); and William Rubin's further response in *Artforum* (May 1985).

2. Yve-Alain Bois seems to have misunderstood, for instance, the point of the comparison between a Giacometti figure and the elongated body of a Nyamwezi dance baton. The comparison was shown

in the "Concepts" section of the show, immediately adjacent to two Fang masks, one highly attenuated and the other very squat. The point being made here was not just that the Giacometti looked like the dance baton, or that he was influenced by such a piece (in fact, in the book and on the label other possible models for Giacometti's stylization were stressed). The point of the whole vitrine—for which the pieces were demonstrative evidence—was that the radical reformulations of body proportions one finds in twentieth-century art are parallel to similarly drastic compressions and elongations in certain areas of tribal art. In thinking back over the show, it would seem that a great many of the comparisons made—between a Henry Moore and a New Ireland Malanggan, between an Alexander Calder and a New Guinea Imunu, between a Baranoff-Rossiné and a Baga headdress, and so on—were demonstrating not surface similarities but just the kind of structural parallels in conception that Bois believes valuable, and claims are missing. Of course there may also exist important structural parallels that are not so accessible; the linkage of Picasso's Guitar to the Grebo mask he owned is just such a "conceptual" match, as Bois correctly notes. But one of the points of that comparison (made clear in the label) was that some of the most telling influences and connections in this field are doubtless "invisible"—covert and subtle in such a way that they are retrievable only through the kind of guiding affirmation Picasso provided in this case. In twentieth-century primitivism there are lots of obvious connections that finally aren't worth looking at; and there are undoubtedly countless instances of rapport that are profound but unknown, "invisible," and/or undemonstrable. The show generally tried to find a middle ground: connections that were telling and could be demonstrated to the public through the objects.

3. My thanks to Leo Steinberg for his suggestion of the analogy as analogous model for the "Affinities" comparisons. I am also grateful to Adam Gopnik for suggestions both substantive and structural that helped shape this essay as a whole.

4. A word about the pool from which we drew the "Affinities" comparisons: James Clifford feels that if one takes any three cultures and cross-references them with the limited possibilities for stylistic encoding of human features, resemblances are predictably inevitable. Thus he concludes that those we find have no special status and boil down to similarities only of exclusion—shared departures from naturalism common to many other styles as well. I have some very basic disagreements. The concentration on these three groups follows not our whim but the lead of modern artists, who consistently picked these kinds of objects, in preference to other nonnaturalistic styles, because they felt these were more specially relevant to what they were doing.

I take it that by Clifford's "nothing-new-under-the-sun" account, it's spurious to see anything really innovative in modern Western art, and doubly spurious to believe the latter has anything credibly special to do with tribal art in particular. He would seem thus to feel that there's no substantive distinction to be made between Japonism and modernist primitivism; and that Buddhist or Egyptian

art would hold just as many telling matchups with innovative works of twentieth-century modernism as do Oceanic and American Indian art. I doubt that many artists or art historians would subscribe to those views, or, for that matter, buy the proposition that the options for representing human form constitute as narrow and as dormantly closed a set as he contends.

The possibilities humans invent and will continue to invent for representation are vastly diverse, and the point of our juxtapositions was precisely not to promote the vague notion of some universal "family of art," but to zero in on exceptional cases—specific parallelisms shared by these particular objects from these particular cultures and not shared to anything near the same degree with other traditions. Admittedly there were degrees of success in what we attempted. The Kenneth Noland tondo painting, as Bois correctly pointed out, was a weak moment—since the similarity was too broadly shared with too many other art forms to be specially meaningful in our context.

A final point about Clifford's notion of a connection between imperialist hegemony and primitivist influence. Primitivism is not a natural result of imperialism. This cause-and-effect linkage is weaker in its explanatory power than the frailest of our matchups; for there have been numerous cultures colonized by the West that have had virtually no effect on Western art—and, one might add, countless conquests that have brought together vastly different cultures throughout history and around the globe, without the phenomenon we observe in modernist response to the three tribal cultures we cite.

III.

PRACTICE

The Practice of Beauty

James Hillman

I. The Repression of Beauty

By calling this talk this morning "The Practice of Beauty," my desire is to show why an idea of beauty is useful, functional, practical. Too often and for too long when the words *Bella* and *La Belleza* appear, they raise us to lofty thoughts. This high style, of course, has been declared to be a function of beauty: It inspires, reminds us of our wings as Plato would say, lifting the mind to permanent values and eternal truths. This higher idea of beauty, shown immediately by the effect it has on our rhetoric the moment we begin to enter into discourse on aesthetics, would not be disputed by either Classics or Romantics. And it is also this higher idea and lofty rhetoric that often makes the discussion of beauty, finally, stupefying, *nuoso,* narcoleptic.

The narcoleptic effect of the usual discussions of aesthetics, the disguised moralism that beauty is "good for you," in fact, is Good itself, have turned an entire century against anything to do with beauty, classic and romantic, and have banned beauty from painting, music, architecture, and poetry, and from criticism too, so that the arts, whose task once was considered to be that of manifesting the beautiful, will discuss the idea only to dismiss it, regarding beauty only as the pretty, the simple, the pleasing, the mindless, and the easy. Because beauty is con-

ceived so naïvely, it appears as merely naïve, and can be tolerated only if complicated by discord, shock, violence, and harsh terrestrial realities.

I therefore feel justified in speaking of the repression of beauty, and am immensely appreciative of this opportunity afforded by this event. It demonstrates that we are here today engaged in a profound question, not only regarding the arts, psychology, and the theory of aesthetics, but as I intend to show, regarding the world we live in and the condition of its soul and ours.

To speak of beauty today with this Gulf War in the air, this apocalyptic devastation going on right now as we sit here, could seem precious, elitist, even fascist. I assure you this is not the case. Discussions of beauty during most of this century have been perverted by the fascist appropriation of the subject too often neglected by the humanist and existential concern for democratic social improvement. The political Right took over fields left untilled by the political Left. If we do not boldly open this question, it remains not only repressed, but worse: subject to fascist misuse. So, what I am hoping to do today is to make one small step toward reclaiming for the democratic tradition some of the abandoned terrain—much as I have tried on previous occasions regarding Greek myths and romantic thinkers. For, let us be quite clear, fascism today is not where it was fifty years ago; nor is it here in our reclamation of this theme. Today, fascism is on television, its glorification of war equipment, the technology of destruction, the suppression of human feeling with uniform language, and the mass patriotism stirred by the letting of blood.

Psychology—by which I mean of course a psychology that is true to its name, *psyche logos,* the study of the soul, psyche, anima—has been influenced by theories derived from scientific medicine, from physics, chemistry, physiology and pharmacology, from anthropology and linguistics. Psychology has been influenced, however, also by aesthetics, particularly by the very denial of beauty that appears in psychological discourse as an absence, a repression. Beauty is not a category in psychotherapy or a factor in considering the language used, the style of the patient, the taste displayed by the therapist, the preferences in the arts of the patient, or that we all live, one way or another, within aesthetic ideals: imagining ourselves in terms of the lives of dead artists or as figures in their works, or in present films, or enacting moments in our lives that consciously repeat in recollection leitmotivs from painting, music, novels. We choose fashions, decorate our rooms, search for restaurants, and judge our friends.

This curious refusal to admit beauty in psychological discourse occurs even though each of us knows that nothing so affects the soul, so transports it, as moments of beauty—in nature, a face, a song, an action or dream. And, we feel that these moments are therapeutic in the truest sense: make us aware of soul and make us care for its value. We have been touched by beauty. Yet, as I say, therapy never discusses this fact in its theories, and the aesthetic plays no role whatsoever in therapeutic practice, in developmental theory, in transference, in the notions of successful treatment or failed treatment, and the termination of therapy. Are we afraid of its power?

To conclude from this fact in my own field, and in the field of my colleagues here today who I hope will enter the discussion as we proceed, I shall claim that the most significant unconscious today, the factor that is most important but most unrecognized in the work of our psychological culture, could be defined as "beauty," for that is what is ignored, omitted, absent. The repressed therefore is not what we usually suppose: violence, misogyny, sexuality, child-hood, emotions and feeling, or even the spirit, which receives its due in med-itation practice. All these themes are common in daily conversation. No, the repressed today is beauty.

With this in mind, let us attempt now to show how beauty affects our con-temporary practical concerns beyond both psychology (my field) and the arts (yours). You notice of course that I am postponing any sort of definition of beauty, any move to make it clear what beauty *is*. I ask you to hold this question in abeyance, and to feel instead whatever idea of beauty you have, letting what I say resonate with the recollections of beauty and feelings of beauty that have estab-lished themselves in your way of life.

The first of these concerns is the world itself: ecology. Our approach, in gen-eral, today has turned to the mythical figure of Gaia. The Gaia hypothesis of deep ecology holds that the world is a living and breathing organism; even the magma and rocks at the earth's core, Gaia's basic stuff, shall be imagined organically. This hypothesis that interconnects all the world is the triumph of feminism and organicism. The hypothesis that the world is alive represents a complete reversal of values, an *enantiodromia* from the paternalism of God the Father and his instru-ment on earth, the Pope, as well as the doctrines of higher spiritualism, which see the world as an act of *creatio ex nihilo* and the matter of this earth as merely dead, Cartesian *res extensa*.

Nonetheless, the Gaia hypothesis of deep ecology reduces the puzzles of the world to interacting functionalism—Darwin up-to-date—so that our wonder in the face of the world's complex magnificence attends less to its sensate presence than to its subtle interactionism: microorganisms, ozone layers, virus strains, methane, tropic heat, evaporation, chlorophyll, gene pools, interdependency of species. Our ecological wonder remains scientific—as it should be since the Gaia hypothesis was formulated by Lovelock and Margulis, both physical scientists. The world of deep ecology remains *physis*. But is this vision enough to draw us toward the world? That we must do it is clear enough. Great Mother Nature no longer provides our support; we are now obliged to care for her.

Nature today is on dialysis, slowly expiring, kept alive only by advanced technology. What can stir our depths equal to the depths of ecological need? Duty, wonder, respect, guilt, and the fear of extinction are not enough. Only love can keep the patient alive—a desire for the world that affords the vitality, the passionate interest on which all other efforts rest.

We want the world because it is beautiful, its sounds and smells and textures, the sensate presence of the world as body. In short, below the ecological crisis lies the deeper crisis of love, that our love has left the world. That the world is loveless results directly from the repression of beauty, its beauty and our sensitivity to beauty. For love to return to the world, beauty must first return, else we love the world only as a moral duty: Clean it up, preserve its nature, exploit it less. If love depends on beauty, then beauty comes first, a priority that accords with pagan philosophy rather than Christian. Beauty before love also accords with the all-too-human experience of being driven to love by the allure of beauty.

The second of our major concerns that calls for a practice of beauty is economic. This may seem surprising. For usually beauty is imagined as an accessory, a luxury, beyond the scope of economics. If, for instance, a public plaza is to be constructed, town planners first arrange the traffic question, then the accessibility for shopping and other commercial uses, last comes the "look" of the place: a commissioned sculpture, a fountain, a little grove of trees and flower beds, special lights. The artist is brought in last and is first to be eliminated when the project begins to go over budget. Beautification costs too much. It's uneconomical.

Contrary to this usual view, ugliness costs more. What are the economics of ugliness: What is the cost to physical well-being and psychological balance of careless design, of cheap dyes, of inane sounds, structures, and spaces? To pass a day in

an office under direct glaring light, in bad chairs, victim of the constant monotonous hum of machine noise, looking down at a worn, splotched floor cover, among artificial plants, making motions that are unidirectional, push-button, sagittal in and out that repress the gestures of the body—and then, at day's end, to enter the traffic system or the public transport system, fast food, project housing—what does this cost? What does it cost in absenteeism; in sexual obsession, school drop-out rates, overeating and short attention span; in pharmaceutical remedies and the gigantic escapism industries of wasteful shopping, chemical dependency, sports violence, and the disguised colonialism of tourism? Could the causes of major social, political, and economic issues of our time also be found in the repression of beauty?

The third repression of beauty we find at home, in depth psychology. Today, our field is characterized by an intense subjectivity of self-reflection. Introspection, reminiscence, reconstruction, feelings—the cultivation of personal interiority. The mirror has become a favorite metaphor, adolescence and childhood the major topos, resulting in a contemporary syndrome, a character disorder, relatively unnoticed in the first seventy-five years of psychoanalysis: I am of course referring to the diagnosis, "narcissism."

Narcissism had classically been described by Freud in 1922 as an absence or disturbance of "object libido," that desire reaching into the world "out there." Instead, desire flows inward, activating one's isolated subjectivity. The beauty of the world holds no allure, no echo that draws our noticing. Because the world's beauty does not call, I seek and find that beauty in a self-concentrated gaze. This is narcissism and, as the word itself betrays from its origin in the Ovid tale, narcissism is a *beauty disorder*, the face of the world unattended, the libido objectless, turned toward the narcissistic subject, disordering his character. Narcissus was captivated not by himself, not by reflection, but by beauty.

If we wish to be practical and therapeutic in regard to this, supposedly the most prevalent syndrome affecting the younger population of Western society, this narcissism that prevents relationship and citizenship, displaying itself as self-centered immature escapism in alcohol, gambling, drugs, consumerism, and celebrity worship, then we may do better considering the syndrome a disorder in the realm of beauty, a result of its repression, rather than a disorder in the realm of individual patients. For the soul of the individual cannot be separated and treated apart from the soul of the world and its zeitgeist.

There is yet one more arena where the restoration of beauty could be practically valuable. I am thinking of contemporary philosophy.

Generally, philosophy has never been noted for its passion or compassion in regard to the actualities of life lived; but today it seems more cold and callous—shall we say anesthetized—to the plight of the soul in the shipwreck of the world than ever before. I recall a conference a few years ago entitled "Philosophy—Where Are You When We Need You Most!?"

This anesthesia, what Robert Lifton calls "psychic numbing," shows in philosophy in several ways: in cosmogony, where speculation of the origin of the cosmos invents big bangs, black holes, and gas storms without a thought about its stupendous beauty visible, for instance, each night in the sky. Anesthesia shows, also, in death-of-God theology and in the disguised apocalyptics of chaos theory. It shows in postmodern deconstructionism, which relies on the semantics that have severed the signifying gift of the human spirit from the significance of the world within which it moves. We are left with the fractals and wittily named particles (by definition nonsensate) of theoretical physics, the puns and parodies of architecture, and the language games of philosophical analysis resulting in a severe dissociation between what is thought, said, and written and what the senses see, the heart feels, and the world suffers.

II. Display of Beauty

But wait: We have not yet said what beauty is. We have gone on and on using the word yet evading its definition; simply begging the question. This evasion is deliberate: We want to enter into the heart of the subject before we are snared by the rational defenses against the subject. We must beg the question because a major part of the repression of beauty has always been an inability to find for it a rational definition, which implies that we should not talk about beauty since we cannot define what we are talking about.

The usual definitions fall into the usual subject/object dispute. The subjectivists, Hume for example, say beauty is in the eye of the beholder. *De gustibus non disputandum est.* If there are conflicting judgments about the beauty of a painting, each viewer perceiving beauty in his and her own light, the resolution lies in acquiescence to superior enlightened taste cultivated by those who are experts. Eventually the expert person of cultivated taste becomes the influential art critic, the academy judge, the museum director, the gallery owner, so that subjectivism

finally degenerates, as in our time, to commercialism, where market-price determines taste and substitutes for value. Beauty for sale at the auction house.

The objectivists maintain that beauty is not in the eye of the beholder, or if so, then only because of the formal properties of the artwork, there in the object: composition, variation in unity, color, line, contrast, complexity, finish, tension, subtlety, resolution of internal conflict, proportion, accomplishment of intention, balance. Beauty is reduced to conceptual formalisms.

Instead of these dilemmas, suppose we were to imagine that beauty is permanently given, inherent to the world in its data, there on display always, a display that evokes an aesthetic response. This inherent radiance lights up more translucently, more intensively within certain events, particularly those events that aim to seize it and reveal it, such as artworks.

If we use mythological language for this inherent radiance, we would speak of Aphrodite, the golden one, the smiling one, whose smile made the world pleasurable and lovely. She was more than an aesthetic joy; she was an epistemological necessity, for without her, all the other gods would remain hidden, like the abstractions of mathematics and theology, but never palpable realities. (Abstractions, by the way, require proof and belief; they must be made convincing by argument or believed in by faith; whereas gods that manifest their qualities to the senses require no such mediation.) Owing to her, the divine could be seen and heard, smelled, tasted and touched. She made manifest the divine mind. And we respond to her radiant presence in things with words like *divine, marvelous, gorgeous, superb, wonderful, amazing, heavenly, delightful, out-of-this-world*—words that attest to the divine enhancement of any ordinary thing, whether the feel of a fabric, the fall of a woman's hair, the taste of a wine.

Just here, a passage from Plotinus (iv.4.37) will be useful, for it has to do with the power of ordinary things. After all, is that not the great puzzle: that ordinary things—the *objet trouvé*, the collage of newsprint, wallpaper, and postage stamps, the light glinting off the icicle—can exhibit the invisible power of beauty? Plotinus argues that "We do not habitually examine or in any way question ordinary things, but we set to doubting when confronted with any display of powers which are out of the ordinary, and encounter the extraordinary with astonishment, though we should be astonished at these ordinary things too if we were unfamiliar with them and someone presented a detailed account of them and explained their powers."

Plotinus is saying that we take ordinary things for granted, and that they are "ordinary" precisely because we do not examine them carefully enough in detail, which does not allow the power of their aesthetic smile to appear. The artist, of course, does indeed reveal the extraordinary in the ordinary. That is the job—not to distinguish and separate the ordinary and the extraordinary, but to view the ordinary with the extraordinary eye of divine enhancement. Is this not the intention of pop art? For, as Plotinus goes on to say in the same passage: "We must admit, then, that each particular thing has an unreasoned power . . . has share of soul. . . ."

This sense of the world as the presence of Aphrodite is already given in the Greek word *kosmos* from which our *cosmology* and *cosmonaut* derive. *Kosmos,* when translated from the Greek into Latin, became *universum,* betraying the Roman penchant for general laws, the whole world turning around one (*unus-verto*). *Kosmos,* however, does not mean an all-embracing system; it is an aesthetic term, best translated into English as fitting order—appropriate, right arrangement, so that attention to particulars takes precedent over universals. *Kosmos* is also a moral term, as for instance *kata kosmon* ("disordered") in the *Iliad* (8:179) means "shamefully." *Kosmos* embraces meanings such as "becomingly, decently, honorably." The aesthetic and the moral blend, as in our everyday language of craft where *straight, true, right, sound* imply both the good and the beautiful. Another group of connotations are "discipline, form, fashion." *Kosmos* was used especially for women in respect to their embellishments, decorations, ornaments, dress, and the word is descriptive of sweet songs and speech. *Cosmetics* is actually closer to the original than *cosmic,* which tends to mean "vacant, gaseous, vast." The Stoics used *kosmos* for the *anima mundi,* soul of the world—quite different indeed from universe, which has no aesthetic implications. Plotinus (1.6.2), because he was immersed in the Greek implications of *kosmos,* or fitting order, could therefore state as a definition that "an ugly thing is something that has not been entirely mastered by pattern."

If the cosmos itself implies beauty, if we live in an aesthetic world, then the primary mode of adjustment to the cosmos would be through the sense of beauty, the aesthetic response. For this reason alone, the repression of beauty has cosmic proportions. No wonder civilization is in disarray, and no wonder the terrible burden on the individual artist to find his or her way back to the innate demand that the cosmos places on an individual talent. We are each out of order and in need of therapy because we have forgotten that life is essentially aesthetic, cos-

mologically so. In Whitehead's words: "The teleology of the universe is directed to the production of Beauty."

The Aphroditic notion of beauty as sense perception or *aisthesis* raises display to the primary mode of knowledge and replaces faith in the invisible to trust in the visible. Rather than analysis into the microbits of science or abstraction into the comprehensive laws of mathematics and theology, *display* of the world reveals its truth.

Moreover, by shifting back from the Roman universe to the Greek cosmos, beauty, too, shifts its locus from the universal to the particular. We hardly realize how *universe* has favored science, mathematics, theology, and law and has disfavored the arts, which are concerned with each, particular, bodily made event in a painting, a dance, or a song. The arts are no more general than is nature. Even if in nature there may be panoramas and *bellavistas*, these remain particular images. Each star in a galaxy of billions has its locus and magnitude.

Cosmos does not present itself as an all-embracing whole, but as the appearance of fittingness of each thing as and where it is; how well, how decorously, how appropriately it displays. And its beauty is that very display; cosmos in each, as each, grain of sand. Different indeed from the idea of beauty in a universe where artworks are signified by a whole beyond themselves—Church art being a prime example—becoming representations of abstract symbol systems, thereby devaluing the immediacy of the thing at hand and its sheer decorativeness, which does not have to gain its power by pointing to a larger conceptual significance.

Animals bear the most apparent witness to the cosmological importance of display. Adolf Portmann, the genius Swiss zoologist who died some ten years ago, gave evidence in many publications for the primacy of display. According to Portmann, the exterior coat of the different species is laid down in its genetic structure and develops prior to the eye that can see the coat. Moreover, there are small oceanic creatures living in the interiors of the larger deep-sea creatures, or living below where light can penetrate, yet which present vivid colorings and symmetrical markings that can never be perceived in their habitat nor by their own species, which have no optical perceptive organs. These patterns bear no useful purpose, neither for camouflage against enemies, attractions for breeding, signaling messages, staking territory, nor lures for prey. This is "sheer appearance for its own sake," or what Portmann calls "unaddressed phenomena." Animal life is biologically aesthetic: each species showing itself in coats, tails, feathers, furs,

curls, claws, tusks, horns, hues, sheens, shells, scales, wings, dances, songs—if for "its own sake," how similar to the aesthetic idea of "art for art"; and if "unaddressed" and therefore nonfunctional, how similar to Kant's idea of the aesthetic as "purposiveness without purpose."

To conclude with these theoretical reflections derived from the idea of cosmos and the idea of animal display, I hope I have been able to suggest to you that we can consider beauty from a vantage point altogether outside the dilemmas of subject and object, altogether outside of the human restrictions on the theoretical imagination. If life itself is biologically aesthetic and if the cosmos itself is primarily an aesthetic event, then beauty is not merely a cultural accessory, a philosophic category, a province of the arts, or even a prerogative of the human spirit. It has always remained indefinable because it bears sensate witness to what is fundamentally beyond human comprehension.

III. The Road to Beauty

Following from what we have already said, we ought now to be able to find ways to lift the repression and invite the return of beauty.

But one caution before we can begin: Lifting the repression cannot be done directly, as if solely by making a beautiful thing, by beautifying, by applying what we believe to be beauty directly with our hands, bodies, or voices. This direct road does not lead there because the very repressing function, that which denies, refuses, ignores, would be the very instrument we would employ. We would still be relying upon the power of the personal rational will, what psychology now calls "ego," to do the job, whereas it is this very same ego that is the instrument of the repression. It would first itself have to become beautiful, that is, affected by beauty. Only likes can affect likes, *similia similibus curantur*.

To escape from this dilemma—that the repressor of beauty in its attempt to make beauty will only make more repression—we must move indirectly. The road to beauty means for the ego to enter conditions like those of beauty.

The first of these is *pleasure*. George Santayana—who belongs among the great Mediterranean forefathers, like Plotinus, Ficino, Vico, Ortega—Santayana, who passed his aging years in Rome where he died some forty years ago, defined beauty as "pleasure objectified." "Beauty," he said, "is pleasure regarded as the quality of a thing. . . ." We do not see beauty as such; we perceive pleasingness, delight, sensual joy. Pleasure subjectively is a psychological experience; pleasure objectively is

what we call beauty. To me there seems little doubt that the innate link Santayana proposes between beauty and pleasure indicates that Santayana's thought is informed by Venus, that his theory is not Apollonic (i.e., formal qualities, such as we find in the classic aesthetics of Winckelmann), but rather Aphroditic.

For us it means that the road to beauty begins in pleasure, opening the soul's body to delight, which anyway is what is implied by that sensate word *taste*. So, the lifting of the repression necessitates a prior lifting of repression from puritanism and its denial of pleasure.

The second indirect road derives from the familiar idea that beauty arrests motion. For example: You see a hawk soaring and diving, a fox peering at you in the forest, the playful leap of a dolphin in the bow-wave. You draw in your breath and stop still. This quick intake of breath, this little gasp—*hshshs* as the Japanese draw between their teeth when they see something beautiful in a garden—this *ahhhh* reaction is the aesthetic response just as certain, inevitable, objective, and ubiquitous as wincing in pain and moaning in pleasure. Moreover, this quick intake of breath is also the very root of the word *aisthesis* in Greek, meaning "sense perception." *Aisthesis* goes back to the Homeric *aiou* and *aisthou*, which means both "I perceive" as well as "I gasp, struggle for breath," and *aisthomai, aisthanomai,* "I breathe in."

Does this not suggest that if beauty is to appear, we must be stopped still; the eye's roving perceptions, the body's habitual forward thrust, the mind's ceaseless associations arrested? The arresting of motion has long been consciously used in painting, for instance in the static riveting gaze of Coptic portraits and Greek orthodox icons, in the still life or *nature morte*, in which the very name of the genre states the arrest of organic motion; in photography where the still shot frames and holds a moment as if in eternal presence; and in the gigantic color field paintings of the 1960s, which completely immerse the viewer stopped before them, embraced within them. By stopping the forward motion of the mind, body, and spirit, the soul may become receptive, as in the Annunciation painting where Maria is surprised by an angel, startled, suspended.

The moment of attention does not last; it breaks the flow of time for an instant, but time returns. Continuity seems stronger than eternity. So, Yoga and Zen disciplines attempt to extend the grace of the aesthetic moment described in T. S. Eliot's words: "The stillness, as a Chinese jar still/ Moves perpetually in its stillness./ Not the stillness of the violin, while the note lasts." . . . "or music heard

so deeply/ That it is not heard at all, but you are the music/ While the music lasts."
Like Rilke's line, "Rose O Rose:" that the "O" is the arrested moment; not the rose
as such, that customary symbol, is beautiful. It is beautiful because of the stopping
"O," and then the repeating, respecting, going back to see again, as the only
motion possible, the motion to recapture the evanescent epiphany.

At the end now I want merely to list briefly other suggestions that lift the
repression. I shall not go down these roads at length, only suggest them as key
phrases for our consideration, and with an invitation to you to make further sug-
gestions—for one thing is certain, lifting the repression requires all our attention,
and the more the better since there is surely no limit on the number of roads.

One is the courage to abandon irony. Another is the courage to be afraid. If
beauty does have to do with naked power of imagination, the divine power of
Venus and of Mars, then there will be mortal fear in closing with the beautiful.
Defenses against beauty are often defenses against the fear of its power, and
these defenses are some we saw: wit and parody, appeal to the mind before the
senses, sentimental literalism, sweetness, slickness without complexity, surface
without depth.

A third road comes from Plotinus (1.6.2): He defined the ugly as that which
makes the soul "shrink within itself, denies the thing, turns away from it, resent-
ful and alienated from it." Does this not suggest that whatever we turn from and
deny becomes thereby ugly? And does this not as well suggest that what we turn
toward may become beautiful? The painting of this century especially has fol-
lowed Plotinus on this road. It turned toward frightening masks and distorted
sculpture in the twenties, toward old chairs and old shoes, toward machines,
toward rusty steel and plastic, toward slabs of dead meat and dismembered human
bodies, toward ordinary manufactured objects, warplanes, celebrity cheapness,
toward crude matter of mud and barbed wire and broken glass, and with such suc-
cess that today we hardly can imagine that once these materials and these subjects
were not always the focus of painting. The turn toward and not shrinking from is
quite clearly a way to beauty: Think of what Constable did for the disapproved
topos of landscape, of what Goya did for images of war's horror, and of what
Toulouse-Lautrec, George Grosz, and Otto Dix did for the ruined discards of soci-
ety, what Mapplethorpe did for the sexually outcast. The work of art allows
repressed districts of the world and the soul to leave the ugly and enter into beauty.

Another requirement that I urge is to risk gorgeous or exquisite intensity, that

is, to risk excess. Whether this is a baroque, romantic, or eccentric prejudice of my own you may decide, but let us bear in mind the value of prejudices, for if allowed to go to extremes, that is, if we drive the prejudice for excess to become excessive, then it may show its final intention. The violent prejudices of Blake, of Mondrian, of Cézanne, too, perhaps, is what drove them to their extreme limits, and not their search for idealized beauty.

Also on my little list is this thought from the Platonists: Do not neglect or forget the gods. This was the essential commandment of the Hellenic world. We humans were not asked to have faith as with the Christians or to obey the law as with the Hebrews. We were asked not to forget or neglect the gods. Surely this caution has some relation with the role of beauty in Hellenic culture. But how? Perhaps it means that art, as anything else we humans do, remembers the non-human and immortal powers—as the gods were defined in antiquity.

Then, we could lift repression from beauty by anchoring the mind in nonhuman values. For surely the humanist program is not enough: Social protest and political concern, the exploration of self-expression and the full exploitation of the materials, the reaction of one school or movement to another school or movement, to say nothing of the drive for fame, career, and money, are not satisfactory anchors of the mind's intention in the making of art. Beauty cannot enter art unless the mind in the work is anchored beyond itself so that in some way the finished work reflects the sacred and the doing of the work, ritual.

Perhaps ritual is the best way of grasping Kant's phrase that the aesthetic shows "purposiveness without purpose." We perform ritual with cool concentration, a "disinterestedness" that is anything but diffident, and yet, at the same time, with intensely passionate devotion. The timeless repetitious character of ritual lifts repression from beauty. Ritual suspends the forward motion of will and ego toward some fixed purpose; instead, a dedication to the powers served by the ritual.

If there is time for one last reflection, let it be this. That gasp of which I spoke comes from the chest, which in the Kundalini Yoga is the place of the heart chakra. There, the sudden unexpected comings and goings of feelings are imaged by the fleeting gazelle glimpsed only rarely in its quick, startling movements and its absolute frozen stillness as it stands watching and listening, senses acute. Unless this chakra comes to life, unless the heart is opened and the gazelle awake, we remain deaf and blind, repressing despite our best intentions, simply because

the organ that perceives beauty, that emits the gasp of the aesthetic response has not been stirred. The gazelle hides in the dense thickets of the soul or sleeps in innocence. So, above all else I have said—and I have said far too much too fast and too crudely—let the heart be stirred. It is with the thought of the heart that I hope you will look at the images on the screen this afternoon, for they have been selected to catch the gazelle. I thank you for your attention.

Ode to Willem de Kooning

FRANK O'HARA

Beyond the sunrise
where the black begins

an enormous city
is sending up its shutters

and just before the last lapse of nerve which I am already sorry for,
that friends describe as "just this once" in a temporary hell, I hope

I try to seize upon greatness
which is available to me

through generosity and
lavishness of spirit, yours

not to be inimitably weak
and picturesque, my self

but to be standing clearly
alone in the orange wind

while our days tumble and rant through Gotham and the Easter narrows
and I have not the courage to convict myself of cowardice or care

for now a long history slinks over the sill, or patent absurdities
and the fathomless miseries of a small person upset by personality

and I look to the flags
in your eyes as they go up

 on the enormous walls
 as the brave must always ascend
into the air, always the musts
like banderillas dangling

and jingling jewellike amidst the red drops on the shoulders of men
who lead us not forward or backward, but on as we must go on

 out into the mesmerized world
 of inanimate voices like traffic
noises, hewing a clearing
in the crowded abyss of the West

2
Stars of all passing sights,
language, thought and reality,
"I am assuming that one knows
what it is to be ashamed"
and that the light we seek
is broad and pure, not winking
and that the evil inside us
now and then strolls into a field
and sits down like a forgotten rock
while we walk on to a horizon
line that's beautifully keen,

precarious and doesn't sag
beneath our variable weight

In this dawn as in the first
it's the Homeric rose, its scent
that leads us up the rocky path
into the pass where death
can disappear or where the face
of future senses may appear
in a white night that opens
after the embattled hours of day

And the wind tears up the rose
fountains of prehistoric light
falling upon the blinded heroes
who did not see enough or were not
mad enough or felt too little
when the blood began to pour down
the rocky slopes into pink seas

3
Dawn must always recur
 to blot out stars and the terrible systems
of belief
 Dawn, which dries out the web so the wind can blow it,
 spider and all, away
Dawn,
 erasing blindness from an eye inflamed,
 reaching for its
morning cigarette in Promethean inflection
 after the blames
and desperate conclusions of the dark
 where messages were intercepted

by an ignorant horde of thoughts

 and all simplicities perished in desire

A bus crashes into a milk truck

 and the girl goes skating up the avenue

with streaming hair

 roaring through fluttering newspapers

and their Athenian contradictions

 for democracy is joined

with stunning collapsible savages, all natural and relaxed and free

as the day zooms into space and only darkness lights our lives,
with few flags flaming, imperishable courage and the gentle will
which is the individual dawn of genius rising from its bed

"maybe they're wounds, but maybe they are rubies"

 each painful as a sun

Venus Unveiled: De Kooning's Melodrama of Vulgarity

Donald Kuspit

I always seem to be wrapped in the melodrama of vulgarity.

—Willem de Kooning

Well, yes, we must face it: the little woman—or, more specifically, her body—has, throughout history though to varying degrees, been considered dirty, diseased, putrid—the more so, perhaps, as she is actually desirable.

—Wolfgang Lederer, "Frau Welt, or the Perfume of Decay," *The Fear of Woman*

Occasionally neurotic men speak of the female genital as "uncanny." Yet this uncanny place is nothing but the entrance to the old home of mankind, to that abode where every one of us was once and first at home. "Love is homesickness," as the saying goes; "and if a dreamer, seeing a landscape or a certain place, thinks in his very dream:" I know this, I have been there . . ." then it is proper to substitute therefore, in the interpretation, his mother's genitals or body.

—Sigmund Freud, *The Uncanny*

I

FOR MUCH OF HIS CAREER, WILLEM DE KOONING'S FAVORITE SUBJECT MATTER WAS the female figure. But less has been said about the meaning with which he invests the image of woman than about the powerful painterly gestures that render it, as if those gestures had an independent meaning—made purely stylistic sense. But the gestures are not autonomous; they define an attitude to subject matter, a complex attitude to a complexly experienced subject matter. It is as if there is embarrassment about the way de Kooning's attitude impinges upon this subject matter. One would rather attend to the stylistically comprehensible paint—the innovative expressionistic handling—than to the psychologically disturbing image of woman.

Harold Rosenberg has stated that "de Kooning willed the spontaneous appearance of a female figure through the unguided discharge of energy in paint." For Rosenberg, the paint is primary, the female figure secondary. It is no more than a sign of de Kooning's will, mastering his own willless energy. The will to the figure brings the power in the paint under control, giving it form and direction. The figure is a necessary traditional constraint on an unexpected modern energy, focusing and concentrating it without any loss of power. The figure in Rosenberg's terms is even conceivable as an afterthought, a dubious "afterimage" loosely associated with the ejaculatory paint. But can't we then go one step further and say that the female figure is the dream image that evoked the discharge, and appears in the picture provocatively veiled by it? For if woman's image makes little sense apart from the discharge of paint, then she exists only in terms of the warped vision whose agent is the energized paint.

Describing *Woman I* (1950–52) as a monster, Rosenberg argues that "What makes monsters is the irreconcilability of the forces that produce them, and this ordains that every monster shall also be a cripple." But if the monster is de Kooning's creation, the crippling conflict of forces must also be his. In a less dramatic formulation, separating de Kooning's style from his subject matter—the standard false dichotomy of the aesthetic approach—Thomas Hess declared that "de Kooning's paintings are based on contradictions kept contradictory in order to reveal the clarity of ambiguities." Hess reduces Rosenberg's profound irreconcilability of forces to simplistic contradiction of forms. Nonetheless, the effect remains the same: a sense of disturbance, of some kind of impassioned disharmony, in de Kooning's pictures. I want to suggest that this is psychological in origin, not simply the latest strategy in a developing abstract expressionism.

Rosenberg tilts his analysis toward de Kooning's expressionism, Hess works hard to make him a purely abstract artist, as if abstraction and expressionism were fundamentally irreconcilable—fraudulently reconcilable. Both ignore—play down—his subject matter, which allows each a freer hand in stylistically labeling him.

I intend to argue that the disturbances in de Kooning's pictures—just those tensions that make them exciting—register the ambivalence of his attitude to his subject matter. I want to go so far as to assert that de Kooning is a failure when, as in the later landscape paintings, woman is no longer his explicit subject matter. His gesture becomes dry, and seems more invented than driven, and his spatial ambiguities seem altogether without psychological tone—emotional significance. Without woman as obsession, his pictures often seem solemnly pure painting, as in the recently exhibited untitled works of 1982–83—works with an altogether unoffensive, neutralized, dully dignified painterliness. However, one can, through a deliberate effort of perceptual will, read the streamlined, attenuated biomorphic curves as traces of female bodiliness, or as generally feminine in connotation. Then the works come more forcefully alive, and seem more than virtuoso manipulations of the Wölfflinean opposites—painterly/linear, open/closed form, clear/obscure shape, etc. Then the created ambiguities, standing like dumb idols in a stylistic pantheon, become vigorously lived memories of a subject matter, a radical transformation and original conception of an eternal theme.

It is the offensive fantasy—the unconscious factor—that one must recover in a de Kooning painting, and that makes it convincing. An old-fashioned kind of psychoanalysis seems appropriate for understanding de Kooning's images of woman, each a desperate approximation of an absolute imago. Quoted in the *New York Times Magazine* on the occasion of de Kooning's Whitney Museum retrospective, his wife Elaine de Kooning observed that the famous fifties pictures of women were essentially of one rather tough woman: Willem's mother—the one essential woman in his life. This is enough to steer us toward a Freudian interpretation. But there are also art-historical reasons to make one. De Kooning acknowledges at least two images of Venus as influences: the Willendorf Venus and the generally Venus-like—fleshy, voluptuous—women of Rubens. An influence is something an artist is competitive with as well as assimilates. De Kooning subsumes—transcends—both by synthesizing what they connote. Their symbolic value is as great as their visual value: They are mother and beloved as well as raw and refined flesh. Moreover, the pregnant Willendorf Venus, symbolizing sacred mother love—

nourishing, idealized love—is crudely carved, making her lithic heaviness all the more inseparable from the primitive earth. In contrast, Rubens's Venus, a type of Luxuria, symbolizes profane love; her beauty is an announcement of her perfect eroticism, an invitation to vulgar sexual use of her body.

Paradoxes and reversals abound: The sacred, motherly woman seems more overtly physical not to say grossly material—and ugly—than the sensual, profane woman, who has the tender beauty appropriate to the ideal. De Kooning is not simply fascinated by contradictions, but trapped by them—unable to break out of or resolve them—which is one definition of neurosis. De Kooning's art is fraught with a neurotic experience of contradiction: a neurotic experience of woman. Ostensibly an effort to combine contradictory views of woman in hopes of neutralizing both, his painting is in fact stuck on the horns of the dilemma that woman is for him. Indeed, it is at its irritating best when it exacerbates contradictoriness—whether formal or female—rather than conquers it. Harmony is a mistake for de Kooning, not a triumph.

All of de Kooning's contradictoriness is embodied in his gestures. Their ritualized intensity and ambivalence—they are orgasmic, but also destructive—suggests that they are deliberate motions in a ceremony of intercourse with woman, more broadly, in a relationship ritualized to keep its emotions under control. In other words, for all their apparent spontaneity, de Kooning's paintings are as stylized as Kabuki performances. For all their demonstrativeness and forcefulness, his gestures are calculated, indeed, preordained: careful steps in a male mating dance—a kind of psychobiological strutting—designed to attract and engage the female body with their display of visceral energy while emotionally disengaging from her person. She must be kept at a safe distance, for she is dangerous, however alluring. The gestures initiate de Kooning into the Dionysian mystery of woman—explore the space of her body, participate in her being—even as they enact his fate while struggling to avoid it: He is doomed to be torn to pieces by her. Ironically, his painterly hand is hers as much as his, and has a contradictory purpose: to re-create her in all her splendor, and, unwittingly, to destroy himself in the process.

De Kooning courts both Venuses; he is their attentive Adonis, acknowledging their power while trying to appease it. His gestures stroke and soothe as well as excite and manhandle: They are as subliminally full of fear as they are overtly passionate. Their apparent uncontrollability represents the secret insatiability of the goddesses: They sacrifice every man they love to themselves. But they let the man

sacrifice himself—tear himself to pieces—through the very intensity of his desire for them. The gestures show de Kooning attempting to control himself, to give himself shape—many of the gestures become contours, eccentrically fusing to form a self-contained space—yet invariably losing control under the spell of the Venuses, or rather of his lust for them and need of their love and tenderness. Sometimes the gestures seem tightfisted, as though de Kooning had a hold on himself, but they often seem to be made in a blind fury, as though de Kooning had sacrificed his sight to (and insight into) the object—woman—to which it was devoting itself. Clearly, he is conflicted about woman: He is obsessed with—possessed by—her, as his lavish, not to say slavish gestures toward her suggests, but also struggling to liberate himself from her by sheer force of will, which is also visible in their often harsh heroism. In short, they are at once a defense against his desire for her, and the instrument of that desire. The gestures are aggressive and loving—hostile and caressing—at the same time, not simply in the fusion of aggression and libido characteristic of sexual excitement and intercourse, but to signal a split attitude toward woman: De Kooning hates her as much as he desires her. Indeed, the greater the desire, the greater the hatred.

At the very moment man accepts the maternal care he needs, or sexually consummates his relationship with the woman he loves, he acknowledges his helplessness and loses his independence. He submits to her power. His attempt to control his conflicted feelings for her plays into her hands, for they confirm her power over him. Thus, de Kooning's gestures can be understood as a neurotic assertion of independence in the face of his dependence on his "divine" subject matter. They are a futile defiance of her power that ends up embodying it. Their futility—de Kooning's gestures quickly lose their energy, and often trail off inconsequently, or form amorphous, impotent shapes—not only acknowledges her power but makes it seem absolute. They are not simply acts of homage, which is a form of identificatory merger with its object, but sacrifices to an idol: De Kooning's gestural discharge on the body of woman is as much self-castration as self-assertion.

But de Kooning castrates woman—the omnipotent phallic woman the goddess always is, whether she appears as mother or beloved—as well himself: His gestures undermine and destroy her substance as much as they seem to create and mystify her image. Over time, de Kooning slowly but surely shreds woman—tears her to gestural pieces, which eventually evaporate into amorphous fragments of a

bodily landscape—in the very act of idolizing her. Endlessly repeated, in a compulsive delirium, she loses her reality. She disappears from his pictures, however many traces of her presence continue to haunt them. Rebellious resistance to his primary subject matter wins out over his lurid desire for her. But the pictures in which he finally succeeds in painting her out—metamorphosizing her into a shadowy landscape—are secondary. They lack the substance of his paintings of woman in all her perverse glory: When woman dwindled, in a dubious mastery of her presence, de Kooning's paintings dwindled and became dubious. His gesture plays itself out when it no longer toys, belligerently or fondly, with woman's body. Thus his profound ambivalence toward woman made his paintings tragic in more ways than one.

De Kooning's gestures—intense and supple not only because of their energy, but because they are indecisive and inconclusive—seem to bear the weight of a Freudian interpretation, not only because they are impulsive, and as such signify psychic energy, but because the numerous "accidents" their impulsiveness invariably leads them into suggests the raging conflicts in his psyche. Nonetheless, his gestures are too material and particular, not to say idiosyncratic, to readily lend themselves to metaphoric use and generalization; they resist interpretation. But the way they inform his image of woman does not. One must go to that image— one must trace its history to the decadent end—to understand the bitter meaning of de Kooning's art, for the gestures have their ultimate validity in the way they constitute the image not in their assertiveness, which creates the illusion of their autonomy. It is only insofar as de Kooning's gestures function as descriptive details of woman's body that they acquire recognizable if uncanny meaning—deep psychodynamic significance.

II

For me, the key image in de Kooning's art is not of woman but of her genitals— the most uncanny part of her body. He strives to render it independently of the female body that possesses it, perhaps never completely succeeding, but always on the verge of presenting it as the raw, direct reality of femaleness, whether understood as sign or fact. De Kooning's drive to make manifest the uncanniness of the female genital is erratic, even haphazard, and while dominant in the fifties recurs throughout his career. Increasingly, the rendering of female flesh becomes a context for the representation of the female genital: a representation of the source of

female power and mystery. For from it issues man, which is exactly what makes it "uncanny." De Kooning's increased "surrealization" of the female figure occurs in the name of a greater, more urgent revelation of the essence of the female genital. Where Courbet's *The Origin of the World* represents the female genital realistically and unemotionally—from the outside—de Kooning struggles to represent it from the inside, that is, in terms of its uncanny emotional effect on man. Its uncanniness—uncanny power—is the issue for him, not its surface appearance. De Kooning is not just painting flesh (he once said oil painting was invented to do so), but the uncanniness of flesh—flesh that is uncanny because it is woman's, and, as such, imbued with her creative power, that is, the power to give birth that makes her body as a whole uncanny. The female genital symbolizes creativity and de Kooning, in painting woman, is painting creativity, and when he can no longer paint woman, he loses his creativity, or else goes through the motions of being creative: His postwoman works are pseudocreative rather than authentically creative.

When the female genital becomes totally manifest—oppressively evident, confronting and overwhelming the viewer with the self-evidently female—the female body has almost completely disappeared: The female figure has itself been almost completely overwhelmed by the sign of itself—the most vital fact of its authenticity, the smallest but most significant part of its femaleness. Totally exhibitionistic, the female body dissolves—into its roots, as it were. One can understand this as an example of locker-room irony, and there is no doubt such a vengeful element in de Kooning's attitude to woman, but one can also view it as an unflinching disclosure of the usually obscure "mystery of life," and even more heroically as a militant, fearless, in-your-face revelation of the unconsciously terrifying intimate reality of the female body. De Kooning is a Perseus who uses painting as a mirror in which to stare at the Medusa—the female genital, surrounded by its snaky roots—and not turn to stone.

Yet, after all, the female genital is commonplace; but psychoanalysis teaches us that the commonplace facts of bodily life are the most repressed—"neglected" but emotionally charged and "fantastic"—realities. De Kooning wants to unrepress—"liberate"—the female genital, so that we can understand both its banality and its power. The same combative, audacious, grandiose gestures that release, aggrandize, and articulate female creativity in a process of identification, caricature—defensively debunk and trivialize—it. On one level, his whole aggressive

project of painting is to de-idealize the female body, which has been overidealized in traditional art. He goes against the grain of the standard mythologization of woman, defamiliarizing her appearance and making it freshly uncanny—but this demystification of woman tends to reduce her to a hollow figure of fun. Sardonically treating woman's body, he resists what is supposedly irresistible, reminding us that its attractiveness has more to do with our desire than with its beauty. Recognizing the tragedy of male desire—his own tragedy—de Kooning reduces woman to a deceiving clown, a kind of perverse figure of fun. The more self-conscious he becomes about his own tragic flaw of desire, that is, the greater insight he has into his own "senseless" desire for woman, so that it becomes less and less blind, the more matter of fact, indeed, offhand, he becomes about woman, until he finally comes to regard her attempt to make herself attractive to man as a kind of cheesy vaudeville act—a cheap spectacle à la Marilyn Monroe, whom he paints several times. From being a femme fatale, she becomes an absurd ideal—a cosmetic construction deconstructed by angry, increasingly self-aware gestures, which decathect in the very act of molesting.

De Kooning's satiric early paintings—they are the modern visual equivalent of Juvenal's enraged admiration of woman—are a lesson in the basic irony of love: a painterly enactment of the truth of the cliché that one destroys what one loves— with the addition of the insight that one does so in order to extract its essence from it. One does so out of one's own inner creative necessity—out of one's own will to live and work creatively, however much, after the short fling with the creativity one has appropriated from the beloved muse, one ends up destitute, which is to be as destroyed as she is, if in a different way. We see that subliminally bitter if superficially sublime dead end in de Kooning's subsequent treatment of woman as vapid landscape. She has become a kind of empty cosmos, or, more pointedly, an exhausted, abandoned mine, which suggests that her creativity has been completely scooped out by his envy, leaving both him and her barren and purposeless—without the tense dialectic of their relationship, neither has a raison d'être. The gestures of de Kooning's woman-as-landscape paintings are less intense, passionate, irregular—more inhibited, predictable, judicious—than those of his woman-as-flesh paintings, which is to say that the former do less hard creative work (strip-mining of woman). They not only have a weaker will to creative power and dominance—whatever the ambivalence of such a will, that is, its unholy mix of destructive hatred and re-creative love—but suggest a loss of

appetite for woman. In a sense, the passive, peculiarly anhedonic landscape paintings re-idealize and simplify the female figure he struggled so hard to de-idealize. Woman, who had been alien and overfamiliar, threatening and seductive, impossible to live with or without, was neutralized into a cosmic platitude.

In the best of the landscape paintings, woman is no longer the obscene creation of de Kooning's anxious wet dreams, but rather a mystical presence, not unlike Lucretius's invisible Venus, the final cause who made matter—in de Kooning's case paint—"swerve" in a "lively" way. Creation is an intensification of movement—creativity seems to occur spontaneously when one is running at one's fastest emotionally and intellectually—and for Lucretius, Venus is the power that presides over creative movement, intensifying the ordinary motion of matter until it generates life, just as she does for de Kooning, whose paint flows faster and faster—becomes increasingly impulsive, particular, alive—at the urging of the goddess. But when she is codified as cosmic landscape she loses the disgusting attractiveness that made her alluring in the first place. No longer "Frau Welt," she no longer has substance or power. She is no longer the Mephistophelian phallic woman who gratifies de Kooning's every perverse wish—allows him to imagine every emotional and physical liberty and experience—in exchange for his artistic soul, but a peculiarly listless, amorphous atmosphere in which there are no wishes, perverse or otherwise. Venus has finally been subdued—castrated—but so has de Kooning. His probing gestures, finally unveiling her essence, lose their urgency, and discover there is nothing there—woman has no essence. In apotheosizing her genital—experiencing its "cosmic" character or universality and centrality—de Kooning uncovers its emptiness. There is nothing at woman's center, which is disillusioning. De Kooning's landscapes are the bitter climax of his struggle to possess yet not be possessed by woman, to be creatively moved while not being dominated by the goddess: total disillusionment with her, and with himself. He too has become stagnant and shallow, compulsively repeating old gestures, which become more and more refined and ritualistic—what little energy he has left becomes an aesthetic formula—for he is no longer able to find his old impulsive self in her. Unexpectedly, he discovers his own limitations, the limitation of living off inner conflict and energy, and experiences the bankruptcy of his inner landscape: Returning to an undifferentiated Mother Nature, de Kooning's paintings lose their power and subtlety—heroic ambiguity—and become entropic reprises. Left with little but his memories, he paints the ghost of the self he once

was: He paints his self-defeat. Woman finally disappears: All that is left is the sterile act of painting.

In the end, de Kooning's narcissism, which competed with woman's narcissism, even as it attempted to exploit and live off it—an effort that was doomed to fail, because of Venus's lack of empathy for her lovers—created a "narcissistic imbalance" in him.[1] He lost more self-esteem than he gained; he regulated his self-esteem by regulating his impulsiveness toward woman, whom he elevated into an icon. The reality of woman is repressed by it; his impulsiveness gives us a perverse glimpse of its "content," to paraphrase de Kooning, but this "slippery content" only epitomizes his ambivalence toward her. She remains elusive, a contradictory, duplicitous presence, oscillating between primitive sacred mother and sophisticated profane lover, emblematic of Being and Becoming. Her slipperiness—inherent ungraspability—frustrates and finally narcissistically wounds de Kooning, as both artist and man, for the whole effort of his art is to "know" her in a single consummate act that reconciles her different sides, and that "knowledge" is impossible if the sides are irreconcilable, so that one aspect of her always escapes understanding. One can grasp her as one or the other, but never both at once: The synthesis of opposites is unworkable and incomprehensible in woman's case; it makes her all the more mysterious. To take one's mother as one's lover is to violate the incest barrier, or to make one's beloved into one's mother is to regress to infantilism. Nonetheless, de Kooning's impulsiveness becomes an instrument of self-healing, in that so long as his instincts are strong, he feels integrated, however much woman remains "disintegrated." But they must fade, as the landscape paintings show, for if they cannot accomplish their mission of integrating her—a truly heroic task—they lose their inner necessity and reason for being.

III

According to Freud, women have "a greater amount of narcissism" than men, "vanity" that is "partly a further effect of penis envy, for they are driven to rate their physical charms more highly as a belated compensation for their original sexual inferiority." The female genital is the site of that inferiority. For Freud, "modesty . . . originally [was] designed to hide the deficiency in her genitals."[2] De Kooning is obsessed with that deficient organ, which woman has made into a source of strength. He tends to depict woman as a narcissistic mix of aggressive

glamour and gross physicality, as if to assertively compensate for, as well as disguise, genital deficiency. *Woman I* (1950–52) strikes me as an especially straightforward rendering of this kind of phallic female. But there are a large number of pictures in which de Kooning shows woman in all her genital vulnerability—aggressively flaunting her deficiency, as if taking ironic pride in it, no doubt in recognition of its power over men, its use as an instrument of dominance, subtler in form than man's erect penis, which it can absorb. De Kooning's woman often appears in the "mythical" primitive position in which she can give birth, "in a sitting or squatting position, her thighs spread wide, her vulva plainly displayed."[3] In this position of ritual self-exhibition (self-excitation?), made emphatic by de Kooning's fusion of the cleft of the vulva with the cleft between the buttocks, as if extending the division, woman shows her genital in all its glory, an open passageway between outer world and inner body.

A similar squatting figure occurs in Picasso's *Les Demoiselles d'Avignon* (1907); scholars have generally regarded de Kooning as being in great debt to Picasso, a master of the representation of the two-sided—double-edged—woman. But de Kooning's representation of the squatting figure is more manic and visceral; in Picasso the figure is schematic. Picasso does violence to her; in de Kooning she seems inherently violent and disturbed—at odds with herself. Both Picasso and de Kooning are in debt to paleolithic antiquity, when the squatting figure was the cult image of the goddess of the fertile womb. It is as if she was displaying her fertile womb, belying the deficient—nonphallic—appearance of her surface genital. This display of the female genital is unquestionably revolting—threatening and disgusting—to man, for it not only demonstrates physical castration but suggests spiritual castration at the hands of the child in the fertile womb, who will supersede him. At the same time, the female genital is offered for worship, reminding us, as Lederer writes, that "the revolting, of course, was once the sacred."[4] De Kooning often shows the squatting figure doubled—fetishized—indicating his obsession with it, which is more than enough compensation for its apparent deficiency. The doubling makes clear that he is dealing with the female imago, the mother of us all, however much a particular woman may have been his starting point.

The buttock-buttressed female genital appears in various early drawings, at least as early as 1951. It is conspicuously evident in *Woman III* (1952–53). The squatting female figure appears as early as *Billy-Lee's Delight* (1946). I would argue, perhaps all too speculatively, that it is abstracted, along with the double-breast

configuration—the breasts are also "split" or divided—in such landscape paintings as *Fire Island* (1946), an untitled 1947 work, and various "black" landscapes, including *Dark Pond* (1948). De Kooning reconstitutes the female figure in landscape terms, using biomorphicized female parts, making the landscape one huge erogenous zone. The biomorphic planar shapes in these paintings seem less eccentric when they are deciphered as "transfigured" squatting figure or breast configurations, sometimes perversely coupled, resulting in a monstrous hybrid shape. It is physically confusing and chaotic, but emotionally consummate—a comprehensive symbolic rendering of the equally desirable mother and beloved, mysteriously unified by art. Only in it can the hard-learned rules for self-preservation implanted in the unconscious be safely violated. Only in art can the fantasy of unity of emotionally irreconcilable opposites be achieved.

De Kooning's obvious breast fixation gives way to a less obvious genital fixation. If we want to push the issue, we can say that de Kooning grows up. No longer are the breasts, to use Melanie Klein's ideas, the object of his hungry, aggressive, infantile attention, the slashes rendering—and rending—them, functioning as signs of de Kooning's hate-filled lust. Now he fixates on the genital, which can satisfy desire by offering temporary union with woman: Penetration of it affords a temporary, symbolic, consoling return to the womb. During the 1950s, de Kooning is equally attentive to both breasts and genital. But already in *Woman* (circa 1959), woman is more genital than breast, and also faceless, making her less of a particular person and more of a general symbol. In an untitled caricature-like drawing of 1968, her face returns, made modest by sunglasses, but she is almost all genital.

The landscape transfigurations of the female body are important stages on the way to its reduction to pure genital, all the more uncanny for being abstract and confrontational. The cleft is a major feature in such works as *Ruth's Zowie* (1957)—presumably the same Ruth Klingman who was with Jackson Pollock in the automobile accident that killed him, and who exclaimed "zowie!" in appreciation of various paintings—and *Suburb in Havana* (1958). In these works, the cleft appears as the abstract horizon—the "upshot"—of the erotic painterly events, with their aura of accidental, transient encounter. Similarly, in the series of paintings beginning with *Two Women* (1964) and continuing through *Woman, Sag Harbor* (1964) to *Woman in the Water* (1967), *Woman on a Sign II* (1967), and *Woman on the Dune* (1967), all the action revolves around the exhibited genital, which is revoltingly thrust forward—defiantly confronts the viewer. The latter three works show

squatting female figures with buttock-buttressed clefts—de Kooning's vaulting Gothic arch, symbol of the natural transcendence of sexuality, more particularly of female sexuality, which symbolizes spontaneous, driven, nature-given creativity. No wonder that de Kooning's 1967 image of a priapic man shows him emulating woman, his erection becoming a cleft. His genital has become female—readable as both male and female. He has become as dynamically defective as woman. A kind of psychic androgyny is disclosed, inevitable in disordered male narcissism, where man finds himself envious of woman's selfhood, identified with her power to give birth, and thus envious of her vagina. In the last group of pictures mentioned, her genital is so dominant that it is possible to describe her as one of the "vagina girls" of the New Mexico Jicarilia Apaches, girls who "had the form of women, but they were in reality vaginas."[5] De Kooning did not necessarily know of the Apache conception of the vagina girl, but his pictorial conceptualization of woman in these works is equally primitive.

De Kooning's early approximations to the vagina girl often had prominent teeth, announcing her threatening—castrating—character. But the vagina, for all the cases of vagina dentata that afflicted it, remained alluring, and from the start, de Kooning eagerly sought a glimpse of it. In *Seated Woman* (circa 1940), he could not help but notice, and make abstractly evident, the sign of the female genital. When de Kooning describes content as "a glimpse of something, an encounter like a flash," he announces the full desperation of his voyeurism, his absorption in the vision of a forbidden sight. He seats the woman cross-legged in a way she would only unconsciously sit in reality, revealing that secret part of herself that neurotically fascinates the male unconscious even more than her far-from-secret breasts. De Kooning has here begun the process of abstracting and idealizing, yet at the same time isolating and amputating—aesthetically castrating, as it were—the most dangerous yet desirable part of a woman's body. Analyzing that body into its constituent parts, he neutralizes it as a whole. Abstraction makes it assimilable and harmless; its erotic reality is dissipated in the "formal" interest one takes in it. Aesthetic disinterestedness displaces dangerous interestingness, transposing compulsion into the more comfortable, manageable aesthetic realm. The aesthetic is in emotional fact the realm where sense and erotic experiences—experiences of involuntary connection—are brought under control, that is, treated as though they were voluntary. What makes de Kooning's art seductive is that it hovers on the border between aesthetic (self-) control and impulsive loss and lack of control.

IV

A good deal of modern art is motivated by the pursuit of spontaneity, understood as the ultimate liberation from society. Modern art claims to offer the spontaneity one can never have in the "iron cage" of the modern world, as Max Weber called it. To be spontaneous is to feel unconstrained and vitally alive, if only for a moment. It is to be energized and integrated in a way that is ordinarily impossible in daily life. Indeed, it is to be indifferent to dailiness, and to transcend it. Modern art has often examined a familiar, everyday content through the filter of a quick furtive glance, making it seem mysterious and spontaneous. The "vibrating sensations" of the impressionists epitomize the mysterious moment of spontaneity. In their different ways, Monet and Cézanne cast furtive glances at the familiar world, seeking the elusive moment when it comes mysteriously alive, and thus becomes altogether unfamiliar. They made spontaneity seem miraculous, because it is so rare. Spontaneity and immediacy go together, and the impressionists were able to experience nature with an immediacy that made it seem spontaneous. Or rather, they were able to feel spontaneous in its presence—come alive and feel complete as they were unable to in everyday life—because they were able to absorb themselves in it to the exclusion of all else, which made it seem all the more immediately given. Their furtive glance filtered out the everyday understanding of reality, allowing it to appear spontaneously. Attentive to the nuances of nature, they undid the ritualized perception that prevails in everyday life, giving them the emotional freedom necessary to be spontaneous.

De Kooning is part of this modern history of spontaneity. He brings to fruition what blossomed with Degas: the furtive glance at woman, which liberated her from the ideological trappings in which tradition had smothered her living presence.[6] In the city, that living presence was more necessary than ever: Woman was substitute nature, less vitalizing than the real thing but also an alternative to everydayness, and thus authentic in a way it could never be. The reason for painting her was the same as the reason for painting nature: to absorb oneself in her presence until it overwhelmed one with its immediacy, which positioned one to be saved by the grace of spontaneity. Picasso refined the process: He realized that abstraction had a more immediate emotional effect than representation, and so afforded more of an opportunity for spontaneity. Representation mediated a more or less habitual version of reality; free of the necessity of doing so, abstraction could establish a sense of immediate presence that seemed spontaneous.

Picasso's abstract renderings make woman seem all the more vital, immediate, spontaneous. He in effect uses his own spontaneity to bring her to "transcendental" life. Immediacy—an apotheosis of givenness—becomes impossible without a subjective expression of spontaneity, and spontaneity—an apotheosis of energy—becomes impossible without an objective experience of immediacy. Picasso synthesized personal spontaneity and objective immediacy to create an effect of abstract presence, something the impressionists had only begun to do.

The dialectic of immediacy and spontaneity, in relation to a catalytic content, and as ways of investing in a vital content—giving it artistic life, in exchange for the life in it—informs modern creativity. It reaches a climax in de Kooning's abstract paintings of women. Pollock abandoned content, which in the end led to his loss of creativity. His last works show him struggling to recover content, but unable to do so because of his "purification"—"radicalization"—of painting. Paradoxically, the allover paintings had become too immediate and spontaneous to "hold" any content, but the immediacy and spontaneity of the post-allover paintings is problematic—unconvincing—because they lack an obsessive content to "bind" their energy. In contrast, de Kooning remained creative for a long time, because of his long obsession with woman. It eventually collapsed under the weight of its own redundancy, and de Kooning—like Pollock—became narcissistically absorbed in the pure act of painting. He began to make paintings that had no emotional meaning—that were no longer a revelation of inner content. They were simply art-historical artifacts, that is, of technical interest in the history of modern art. Of course, they retained narcissistic significance, that is, they revealed de Kooning's bankrupt sense of self. His retreat to pure painting, which began with the landscape paintings, acknowledged his defeat by woman. She—the unsolvable conundrum she always was for him—had wounded him, to the extent that he could never recover an adequate sense of self—however much the act of pure painting was an attempt to do so.

What remained was material, and, in his later years, de Kooning's strong sense of material is at its most explicit in his sculpture rather than his painting. His sculptures return us to the pre-geometric origins of sculpture in the sensation of elemental bodiliness—the sensation that is more fundamental to the Willendorf Venus than her pregnancy. "Geometric shapes are not necessarily clear," he said, meaning that they are not as fundamental as bodily shapes. Mondrian "had nothing left over," he said, and what is left over—material—is

more fundamental than geometry, because it is evocative of the body. Geometry imposes itself on bodily material; the issue is to articulate the profound emotional meaning of such material. It is a female task; to impose geometrical control is a male task. De Kooning's art remains female-identified to its material roots, for all its abandonment of woman's image.

I think de Kooning abandoned the male image—after painting a number of male portraits during the Depression, and making a few sculptures of male figures in the seventies—because, for him, the male body was less emotionally engaging and spatially interesting than the female body, which made it a more authentic material. For him, the contrast between the convexity and projection of the breasts and the concavity and recession of the vagina is a spatial metaphor for subjective tension. There is no equivalent contrast in the male body. De Kooning projects his subjective tension into the objective tension built into woman's body. The latter becomes the expression of the former, however unconsciously. Woman's body took its form from de Kooning's subjective tension, changing shape according to its dictates. Within the confines of its contradictoriness, woman's body was as protean as de Kooning's moods; while always tense, they were not always intense and wild. His male figures, for example, *Glazier* and *Seated Figure (Classic Male)* (both circa 1940), are nowhere near as protean—and playful—as his female figures. He is not as emotionally invested in them, or rather they have a different emotional meaning for him. The male figures represent his split-off, tragic sense of himself—his sense of himself as defeated by fate. In contrast, woman represents the sense of possibility and openness, and with it the comic sense of life, that struggles against fate, which is the struggle of creativity and fantasy. For de Kooning, subjective tension is more bearable—and fruitful—than tragic finality and fatalism.

A comparison between female *Clam Diggers* (1964) and a male *Clam Digger* (1972) makes the point clearly. The male strikes an old heroic yet peculiarly morbid pose. His erection, tragically, cannot last. Echoing Rodin's *Balzac*—Rodin muffled the erection he originally gave Balzac with a tragic cloak—de Kooning's heroic male is an absurd, futile figure. In contrast, the female clam diggers are buoyantly exuberant. Their bodies joyously spread over the picture space, while the male figure seems inwardly constricted. Women understand *joie de vivre,* man is stupidly tragic and self-defeating—self-punishing—which is why he resents woman. If, as Lacan wrote, "splitting reveals, right down to the depths of his

being," man's "neurosis of self-punishment, with its derealizations of others and of the world,"[7] then de Kooning's attempt to impose his neurosis on woman and derealize her—turn her into a vulgar melodrama—ultimately fails. This is perhaps why he finally gave her up: His slippery glimpse of the paradise she is—it was slippery because of his ambivalence toward her—did not mean he could enter it. His landscapes show a slackening of his subjective tension, but they are too melancholy to be paradise.

NOTES

1. Heinz Kohut, *An Analysis of the Self* (New York: International Universities Press, 1971), 20–21.

2. Sigmund Freud, *New Introductory Lectures on Psycho-Analysis* (New York: Norton, 1933), 180–81.

3. Wolfgang Lederer, *The Fear of Woman* (New York: Harcourt Brace Jovanovich, 1969), 42.

4. Ibid.

5. Ibid., 45.

6. Manet's *Olympia* is generally thought to begin the process of liberation from tradition, all the more so because of its spontaneous touches, but it remains charged with moral significance, suggesting that it is more traditional than it seems underneath its brave effrontery, a fact confirmed by its acknowledged debt to Titian's *Venus of Urbino*. Moreover, Olympia is not a living presence, but an object lesson in demystification—Venus turned into a banal mannequin. Such banalization—debunking, profaning—of what was once held sacred (love, woman) is as typically modern as the pursuit of spontaneity (the new sacredness), but it has the opposite purpose: to deaden everything living—to break its spirit, or to show that it is spiritless—so that it fits in the iron cage. There the prevailing principle is that individuals are social instruments—that they get their entire identity from their use value to society. Olympia, a prostitute, is indeed a social instrument, of value only for her sexual use. Her room is a kind of cage, and her spiritless presence that of a cunning but ultimately entrapped animal.

7. Jacques Lacan, "Aggressivity in Psychoanalysis," *Écrits: A Selection* (New York: Norton, 1977), 28.

The Mind and Body of the Dreamer

John Yau

In the spring of 1965, Jasper Johns published "Sketchbook Notes"[1] in a quarterly magazine, *Art and Literature*,[2] of which the poet John Ashbery was an editor.[3] It remains Johns's most public attempt to develop a set of flexible propositions that describe not only the shifting relationship between the mind and the body, but also their relationship to the world. Because this is one of the few public statements made by an artist who has repeatedly been characterized as "hermetic," it should be read for the light it can shed on his work. Certainly someone who writes and publishes is likely to be interested in both meaning and disclosure.

Rather than seek asylum in a previously established discourse and align himself with tradition, Johns took it upon himself to develop terms—at once limited and expansive—that possess the power to name the states he felt constituted his being, the randomness of his sensations and wildness of his thinking. Such terms would help him understand something more about the ways he comprehended reality, help him glimpse the order it possesses. This is very different from imposing a preexisting order upon reality, and it is Johns's attentiveness to the world that links him to Leonardo and Cézanne, artists for whom he has professed admiration.

Johns knew that if he was truly isolated from others, and to some degree from himself, he had to construct a language that could suitably account for that isola-

tion, make him secure within its boundaries while further connecting him to the actual. It had to be a language without blame, as calm and as obdurately matter-of-fact as *Flag*. Otherwise, his isolation would be a pose, and the real force motivating his actions would be dependence and the need for approval. At the same time, Johns knew that by articulating such terms he would be reinforcing the likely permanence of his solitude. For while the terms might help him understand his predicament, they also would stand between him and others.

Johns's terms propose something about his relationship to what Wittgenstein called a "state of affairs." Like *Flag* and *Map*, "Sketchbook Notes" is his analysis of the way he perceives his existence in the world as well as understands his changing relationship to time's unfolding. Although "Sketchbook Notes" consists of three dense paragraphs followed by a list, I want to focus on the middle paragraph, which is simultaneously poetic and theoretical, and far more narrative than either the first or the last paragraph.

> The watchman falls "into" the "trap" of looking. The "spy" is a different person. "Looking" is and is not "eating" and "being eaten." (Cézanne?—each object reflecting the other.) That is, there is a continuity of some sort among the watchman, the space, the objects. The spy must be ready to "move," must be aware of his entrances and exits. The watchman leaves his job and takes away no information. The spy must remember and must remember himself and his remembering. The spy designs himself to be overlooked. The watchman "serves" as a warning. Will the spy and watchman ever meet? In a painting named *SPY*, will he be present? The spy stations himself to observe the watchman. If the spy is a foreign object, why is the eye not irritated? Is he invisible? When the spy irritates, we try to remove him. "Not spying, just looking"—Watchman.

The first and last paragraphs consist mostly of ideas and methods. The writing is largely a list of materials and methodologies. Thus, the first paragraph says:

> Put a lot of paint & a wooden ball or other object on a board. Push to the other end of board. Use this in a painting. Dish with photo & color names.

Along with this kind of writing, Johns makes two observations worth noting: "encaustic (flesh?)" and "Beware of the body and the mind. Avoid a polar situa-

tion." In addition to Cézanne, he mentions Duchamp, whose own writings may have been one of the inspirations for "Sketchbook Notes." However, in the middle paragraph Johns introduces two figures that leave the reader wondering, who are the watchman and the spy? What do they have to do with Johns and his work?

The "watchman" is Johns's term for the body, while the "spy" is his term for the mind. As he has already stated, he must "avoid a polar situation." Typically, a watchman guards things that do not belong to him, and a spy is someone whose true identity remains a secret. "The watchman," Johns tells us, "falls 'into' the 'trap' of looking." That is, he becomes the article he is looking at, the flag or map. The reason this transposition occurs is because "'looking' is and is not 'eating' and 'being eaten.'" In the first paragraph Johns considered the possibility that "encaustic" is "flesh." He understood that by dipping the pieces of newspaper into encaustic, he was inducing the hot wax to both eat and not eat a foreign substance. The encaustic (or body) both consumed and preserved a foreign object. The newspaper is comprehended by the mind rather than the body. "If the spy is a foreign object," Johns wrote, "why is the eye not irritated? Is he invisible? When the spy irritates, we try to remove him."

Among other things, Johns is alluding to *Flag*, which because it must be both looked at and read, conjoins aspects of the body (watchman) and mind (spy). Thus, within the reality proposed by his terms, the combination of encaustic and collage is Johns's equivalent of the body and the mind; they are a "united states" in which each maintains its own identity. At the same time, looking is paired with eating (a form of consumption) and not eating (a form of preservation); and this dualism is paired with encaustic's ability to consume and preserve an object. In order to be true to flux, as well as to the body and mind, encaustic must consume and preserve objects that engage aspects of both looking (the body) and reading (the mind). Common to his paintings and sculptures is their engagement with these two aspects of our perceptions. Had Johns used encaustic to consume an object that disregarded either the body or the mind, he would not have avoided a "polar situation." This is why Johns has never been interested in becoming either a pure abstract artist or a conceptual artist who eschews the use of paint; he does not want to privilege body over mind or vice versa.

Underlying all the writing in this paragraph is the possibility of reciprocity, of one thing or gesture both becoming another and being preserved by it. At the same time, by linking looking and eating, Johns acknowledges that the cycle of

consumption and waste is an integral part of art, which makes the enterprise impure and material rather than pure or spiritual. Johns's conjunctions also make it clear that his art arises out of an attempt to reconstruct a perceptual process, embody the moment he passed from the realm of seeing to the act of looking or what he terms "spying." Thus, when he says of Cézanne, "each object reflecting the other," he is suggesting something about his own work. The objects of his art (flag, map, bathroom wall, or blueprint) mirror his perception of them, as his materials (newspaper and encaustic) mirror each other. In the 1980s, expanding upon his understanding of Cézanne, Johns began arranging objects (Mona Lisa poster, faucets, highway warning sign, empty rectangle of a bathroom wall) so that they purposefully mirrored each other, manifesting his resonant perception of being caught in time.

"Sketchbook Notes" is not the first time Johns paired "looking" and "eating." *Painting Bitten by a Man* (1961, encaustic on canvas, 9½ × 6⅛ inches, collection of the artist) is a vertical rectangle covered with a thick layer of encaustic. In the middle of the upper third is a bite mark, where Johns sank his teeth into the painting.[4] By preserving this tellingly ruthless gesture, the encaustic has eaten (taken into itself) and not eaten (not transformed it into waste) his bite. Johns has used encaustic to transform an action into an object. In the sculptural object, *The Critic Sees* (1961, sculptmetal on plastic on glass, 3¼ × 6¼ × 2⅛ inches, private collection, New York), Johns, in the Magritte tradition, placed an open mouth full of teeth behind each aperture of a pair of glasses. His antipathy toward critics is clear; they eat art for their own needs and, in doing so, turn it into shit. For Johns, seeing is not looking; it is blind consumption.

Why is looking a "trap"? Probably because it is the body (or one's eyes) that connects the individual to reality but the mind that makes the realization. After all, it was not until Johns made *Flag* that he gained insight into an entity he had seen many times before. For while the "watchman falls 'into' the 'trap' of looking," the "'spy' must be ready to 'move,' must be aware of his entrances and exits." The body sees, but the mind conceives of how to reconstruct that act. The "watchman" (body) is the one who brings Johns in contact with reality, while the "spy" (the mind) discovers something about their relationship to each other and to the world. The "watchman falls 'into' the 'trap' of looking" because the act of looking, a bodily function, is what must be preserved by art; it must be eaten and not eaten by Johns's materials. The task of the spy

is to find a way to resurrect the trapped body, thus earning it another, albeit temporary, guise.

When Johns wrote, "The spy designs himself to be overlooked," he was letting us know that art is finally not measured by the artist's intelligence. Yet, while the mind's ability to be self-reflective, to "remember" and "remember himself and his remembering," is a constant, often threatening attribute that can cut one off from the world of sensations, the mind is invisible. "I think," Descartes observed, "therefore I am," failing to take the body into account. "Beware of the body and the mind," Johns warned himself. "Avoid a polar situation." By Johns's measure, a work of art that doesn't take into account the body, its production of waste, claims to exist outside the realm of human affairs, as if such a thing were possible.

When Johns wrote, "The watchman 'serves' as a warning," he proposed that the body will make the mind aware of time passing because it most likely will register time's effects before the mind does. "The watchman leaves his job and takes away no information," that is to say, the mind rather than the body remembers. If the body did the remembering, then the memory of the various pains we all have endured would be unbearable. But because the mind remembers, it must acknowledge the body's transformations. However, Johns also knows that the mind's capacity to remember can interfere with the body's ability to experience, that this is the polar situation which must be avoided.

Johns's figures of the watchman and spy enabled him to begin examining both his previous work and the present from another perspective; they formed a framework through which he could examine experience. These figures were both personae and alter egos; they had lives of their own. Beyond Johns's wanting to come up with a language that would adequately describe his experience, his primary reason for constructing these figures stemmed from a threefold desire: He wanted to remove himself as much as possible from the sphere of aesthetic considerations; he felt he had to give himself further permission to be true to what was "helpless" in his behavior; and he wanted to contextualize the behavioral properties of encaustic and bronze, materials with which he felt a deep affinity. The two most obvious inspirations behind Johns's personae are the writings of Ludwig Wittgenstein and Marcel Duchamp, both of which he had read closely by the early 1960s.

In *Philosophical Investigations*, which was published posthumously in 1953, Wittgenstein examined, among a range of topics, the relationship between subjective and objective experience. He was concerned with discovering the basis of

knowledge; how does one know what one knows? In one passage he proposed the example of a man trying to corroborate his memory of the time a train departs by calling to mind an image of the timetable. Wittgenstein used this example to point out the fallacies such solipsistic thinking might lead to. He then reinforced his point with a metaphor: "As if someone were to buy several copies of the morning paper to assure himself what it said was true." Through these examples, Wittgenstein was able to demonstrate that neither subjective nor objective truths are adequate measures of experience, and that one cannot rely on such measures to determine what one knows.

In his four-panel painting 4 *the News* (1962, encaustic and collage on canvas with objects, 65 × 50¼ inches, private collection), which alludes to Wittgenstein's metaphor of the newspaper, Johns wedged a rolled-up newspaper between two panels and stenciled the painting's title and "Peto Johns" along the bottom. Paired with the so-called objective experience of the newspaper, Johns has registered one measure of subjective experience, a left handprint (he is right-handed). To the left of the handprint and above the title, Johns has stenciled the word *THE* twice,[5] superimposing the smaller version over the larger one.

The doubling of the word *the* may have been inspired by the last line of Wallace Stevens's poem "The Man on the Dump":

Where was it one first heard of the truth. The the.

As in Stevens's poem, Johns's doubling of *the* proposes that there is no such thing as the truth, just "The the." Johns first read Stevens's poems when he was a teenager and made an etching more than three decades later in response to them.[6] The handprint embodies the limits of direct human experience, as opposed to the domain of consensus and ideals, which to some extent is embodied by the newspaper. By separating handprint and newspaper, Johns underscored his observation that neither the body nor the mind alone can arrive at the truth; they must be made to work in tandem.

"Peto" alludes to the American *trompe l'oeil* artist John F. Peto (1854–1907), while 4 *the News* is the first of a number of Johns's works to acknowledge Peto's painting *The Cup We All Race 4* (1900).[7] Peto's painting depicts a *trompe l'oeil* dented tin cup hanging from a hook affixed to a "wooden panel." The title is painted as letters someone has gouged out of the "wooden frame" with a knife. Above the

cup, and in the top section of the wooden frame, Peto depicted a *trompe l'oeil* brass plate with his name stamped on it. The tin cup, wooden frame, brass nameplate, gouged letters—all the objects and surfaces in the composition—have been rendered into paint. For Johns, who had lavished equal care on his two sculptures titled *Painted Bronze* (both 1960), Peto's work must have come as a welcome revelation. By stenciling "Peto Johns" on the painting, Johns was defining the creator of the work as a synthesis of two different people. He and Peto are alter egos who made *4 the News*. In the guise of Peto, Johns, who had not yet written "Sketchbook Notes," found another way to contextualize a newspaper.

* * *

Although Duchamp's name comes at the end of a list in "Sketchbook Notes," his importance to Johns in both his art and his writing cannot be underestimated. In "The Creative Act," a talk given in 1957, Duchamp proposed:

> Let us consider two important factors, the two poles of the creation of art: the artist on the one hand, and on the other the spectator who becomes posterity.
>
> To all appearances, the artist acts like a mediumistic being who, from the labyrinth beyond time and space, seeks his way to a clearing.
>
> If we give the attributes of a medium to the artist, we must deny him the state of consciousness on the aesthetic plane about what he is doing or why he is doing. All his decisions in the artistic execution of the work rest with pure intuition and cannot be translated into a self-analysis, spoken or written, or even thought out.
>
> T. S. Eliot, in his essay "Tradition and Individual Talent" writes: "The more perfect the artist, the more completely separate in him will be the man who suffers and the mind which creates; the more perfectly will the mind digest and transmute the passions which are its materials."[8]

Certainly there is an affinity between Johns's "watchman" and Eliot's "man who suffers," and between the "spy" and the "mind which creates." Also, Johns's pairing of "eating" and not "eating" echoes Eliot's "digest" and "transmute." Johns's figures are a way of rejecting the unified "I" as the origin of his art; they exist in the third person and make art which comes from that place. Consequently, they are neither subjective nor objective in their intention but an unfixed, unpredictable combination of the two. At the same time, Johns's figures can be seen as the counterparts

of Duchamp's "artist" and "spectator," not the one who becomes "posterity," but the one who lives in time, amid change, the one who eats and is eaten.

The questions Johns tried to resolve in "Sketchbook Notes" are these: How do you define your existence in the world when your experience of it isolates you from others? How do you remain true to that fact of your existence, particularly when your work is placed before the public and is discussed by critics? How do you continue to focus on the actual when others claim you are not doing so? How do you remove yourself from the realm of aesthetic ideals, social pressures, and the audience's expectations, and go your own way? It is not Johns but the "watchman" who "falls 'into' the 'trap' of looking." And it is not Johns but the "spy" who "must remember and must remember himself and his remembering."[9]

By locating the origins of his art in the reciprocal relationship that arises in certain moments of looking, Johns was able to define himself as both spectator (watchman) and creator/destroyer (spy). In doing so, he completed a circle between himself as maker and himself as viewer, which enabled him to jettison any residual dependency he might have on external standards of aesthetics and accomplishment.[10] Moreover, by connecting looking to eating and the cycle of consumption and waste, Johns not only further de-aestheticized looking and art making but also underscored art's connection to the body's passage toward dissolution.

The questions Johns resolved in "Sketchbook Notes" led to others, one of them being: Where do the spy and watchman exist? Until the early 1980s, the "continuity" underlying the "watchman," "the space," and "the objects" was more literal than pictorial, the connections existing within a narrower domain of experience. In *Map*, for example, Johns achieved a continuity among the collage fragments, the rectangles of primary color, the stenciled words, and the states' irregularly shaped rectangles, but all of them are derived from more closely related categories of existence. It was not until paintings such as *Racing Thoughts* (1983) that Johns achieved the desired "continuity" in a layered pictorial space occupied by items as diverse as a bathtub faucet, a jigsaw puzzle of his dealer (Leo Castelli), a reproduction of the Mona Lisa, a pair of corduroy pants, a highway warning in German and French, various pots, a laundry hamper, and a lithograph by Barnett Newman. In making images, Johns switched from his unconventional method of applying encaustic to a more conventional one, a move he had been determined to complete since the beginning of his career.

For while it is clear that Johns achieved a continuity in early paintings such as *Flag*, where he collapsed a "flag" and collage fragments together, it was only after 1983 that he was able to bring a more unlikely and wider array of items together within the same layered pictorial space. The continuity he began achieving in *Racing Thoughts*, across the entire surface as well as from the front layers to the back, is more extensive and adept than at any previous point in his career.

If Johns was concerned with received knowledge, he would not have started working in a mode considered antimodernist and thus obsolete: the depiction of space. After all, Johns is the artist who single-handedly introduced representation back into painting, while completely emptying out the pictorial space. A flag, a surface, and an object became one. Now, instead of making airless, self-contained, autonomous paintings and objects, he works in a mode that is considered old-fashioned, if not *outré*. In doing so, Johns challenges us to dispense with our aesthetic standards. At the same time, he doesn't try to shock or titillate the viewers so much as to engage them, to compel them to look and examine. Reality rather than social or aesthetic codes is what he wants to touch; the rest is appearances. Reality will forever elude the individual who is satisfied with achieving fame in the social or aesthetic realm.

NOTES

1. Jasper Johns, "Sketchbook Notes," *Art and Literature* 4 (Lausanne, Switzerland: Spring 1965): 191–92; reprinted in Suzi Gablik, *Pop Art Redefined* (New York: Praeger, 1969), 84–85; reprinted in Kristine Stiles and Peter Selz, *Theories and Documents of Contemporary Art: A Sourcebook of Artists' Writings* (Berkeley: University of California Press, 1996), 325–26. Johns also published two other selections of "Sketchbook Notes." One appeared in *Julliard*, edited and published by Trevor Winkfield (Leeds, England: Winter 1968–69): 25–27, the other in *Art Now: New York*, vol. 1, no. 4 (April 1969).

2. The first English translation of Maurice Merleau-Ponty's essay "Cézanne's Doubt" appeared in the same issue of *Art and Literature*. Work by Frank O'Hara and Ted Berrigan also appeared in this issue; Johns would allude to both poets in his work long before they became well known.

3. The editorial board consisted of John Ashbery, Ann Dunn, Rodrigo Moynihan, and Sonia Orwell.

4. In a conversation with the author, Johns revealed that he found it necessary to fold the painting before taking a bite so that only his teeth marks would be evident. He pointed out, "You sometimes have to cheat a little in order to make something work."

5. Johns embedded the word *the* once before, in *The* (1957, encaustic on canvas, 24 × 20 inches, private collection).

6. In a conversation with the author, Johns said that he was given a book of Stevens's poetry in 1947 or 1948. This suggests that the book was *Transport to Summer,* which was published in 1947. A third edition of *Harmonium,* Stevens's first book, which included "The Man on the Dump," was published in 1937. In 1985, the Arion Press published a limited edition of Stevens's poems on the thirtieth anniversary of his death. The poems were selected by Helen Vendler, who also wrote the introduction. Johns provided an etching for the frontispiece. Beginning early in his career with a drawing, *Tennyson* (1958, ink on paper, 11⅝ × 8¾ inches, collection of the artist), Johns has alluded in his work to a number of poets and their work, among them Ted Berrigan, Hart Crane, and Frank O'Hara.

7. Johns learned of Peto's work from a reproduction that Ileana Sonnabend sent to him in the early 1960s. Among other things, he would have noticed a number of affinities between paintings by Peto and Magritte; both men worked in a relatively straightforward, somewhat homely style, preferred a muted palette, and used *trompe l'oeil* devices to call reality into question.

8. Reprinted in Robert Lebel, *Marcel Duchamp,* trans. George Heard Hamilton (New York: Grove Press, 1959), 77–78. Although Johns probably had read the writings of Eliot before he saw Duchamp's work, it would have been in Lebel's book that he read Duchamp's reference to Eliot's theory of the "perfect artist" who exists seperately from the individual.

9. In a conversation with Johns, I once mentioned that when people came up to me after a poetry reading and commented on poems I had read, I felt as if they were talking about someone else and someone else's work. He responded, "They are."

10. Although Johns was influenced by Duchamp's writings and art, in "Sketchbook Notes" he directly challenged Duchamp's belief that an individual's "decisions in the artistic execution of his work rest with pure intuition and cannot be translated into a self-analysis, spoken or written, or even thought out." Thus, rather than aligning himself with the avant-garde tradition that mystifies the artist's thinking, as Duchamp did, Johns attempts to demystify it without becoming reactionary, Newtonian, didactic, or simplistic.

Mondrian's Secret

DAVID SHAPIRO

LET US BEGIN WITH *BLUE CHRYSANTHEMUM*, A SINGLE FLOWER IN INK AND WATER-color with a stem that nearly disintegrates at the bottom of the page or is simply occluded. The flower, standing in a light-blue mist, is outlined in simple, dignified ink as if in dry prose. But the petals are full of a very painterly brushwork in white and light blue, and one has to strain to make out the very tiny cross-hatchings that also bind and define them. The scholars inform us that it is from the early 1920s but that the dating is a most difficult problem. The signature bears the double *A* of his early orthography, but the Dutchman in Paris used this spelling through the 1920s for works destined for Holland.[1]

The artist told his friends he hated meadows and fled trees.[2] Is *Blue Chrysanthemum* a work of commerce? Is it a work of kitsch, an appeal to popular taste and painted for money, as Mondrian himself confessed? But the work itself, we think, does not look like a betrayal of any abstract or intransigent dogma, and we find it hard to believe that the artist, as we learn of his nature, would have betrayed his ideals through his own art. Perhaps he was betraying, in a different sense, a part of himself; the sensuality that one finds throughout this lyrical, snowy work.

The more one looks at the chrysanthemum, the more it seems to give us back

the gaze that others have found in Dutch portraits. The more we think about its singularity and its centripetal force, the more we place it as a work of a geometrical master. What makes this work so provocative is that it subverts our notion of the relationship between natural lyricism and geometrical abstraction within painting. Perhaps that is what led the artist both to renounce his flowers publicly in statements and keep them on a secret wall in New York City to show to friends.[3]

Mondrian made few important statements about his flowers. In one "trialogue" concerning the natural, he is very suggestive about his renunciation of nature: "Naturalistic flowers are for children and the feminine spirit. Flowers best express the outward, the female. [In abstract art] the feminine is expressed more inwardly."[4] In this and other essays written during his so-called de Stijl years of 1917–24, we get an echo of Mondrian's intense devotion to nature, and also his decisive tone in transforming himself into a devotee of pure essence. (Ironically, his flowers do express an inwardness through their centripetal patterns and Symbolist devices.) In a rare autobiographical fragment of 1941, he wrote: "I never painted . . . romantically; but from the very beginning, I was always a realist. Even at this time I disliked particular movement, such as people in action. I enjoyed painting flowers, not bouquets, but a single flower at a time, in order that I might better express its plastic structure."[5] He speaks of his deviation from likeness and natural color and underlines his slowly developing opposition to curves and the "tragic" in the dualities of nature. But all of the late quotations lack the symbolist passion that we hear in a letter of 1909, where Mondrian speaks to a critic of the real meaning of his painting *Devotion* and says: "I had rather intended, as I said, to convey the very deepest sources of the act of prayer. . . . I try to obtain occult knowledge for myself in order to gain a better understanding of things."[6] Thus, the early Mondrian rebukes an interpreter.

Of course, Mondrian's statements must be taken with more than a usual sense of how artists conceal themselves. Mondrian speaks of a taste for singleness, and here he is correct, but he gives no real appreciation of how much that lonely sign of bachelorhood might express. He also speaks of a detestation for movement, but as Agnes Mongan and David Sylvester have underscored, his own flowers are full of flight and inwardness and even the pathos of dying. He seems to be typecasting himself as the chaste empiricist, but the truth of the works is that they are much more romantic and moonlit and dangerous

than this pure priest is willing to admit. The meanings of the flowers cannot be sought from the artist himself.

Meyer Schapiro has written profoundly and subtly concerning the meaning of still lifes. In his canonic essay on Cézanne's apples, he finds in the very choice of subjects, in Baudelaire's phrase, the poetic of the painter. He reminds us that artists are not neutral recording machines and that particular objects become, under the pressure of art, physiognomic and personal. The apples of Cézanne become signs, partly for the sensual in his own nature agitated almost beyond control. Schapiro restores our sense that an artist is deeply invested in his usual constellation of images. He amusingly perceives, for example, that we cannot imagine Cézanne painting the sunflowers or old shoes of van Gogh.[7]

We must import this sense to Mondrian's single flowers, that galaxy of obsessive images. We find in them the portents of a whole sensibility. In Mondrian, the empiricist and the symbolist combine to give us uneasy "figure-studies" of the feminine. Schapiro has found the overlapping planes of the city in Mondrian's abstract work.[8] His flowers offer personal metaphors of his isolation and attempts to control an image of the feminine. He himself decoded this when he referred to the tulip in his studio as a sign for woman.

David Sylvester sees Mondrian as dividing himself between centripetal figure-studies (including the flowers), which show inwardness and an involvement in suffering and the nature of death, and late abstractions, which are centrifugal and burst outward into infinity. This analysis reminds us of what we have come to prize in the tormented flowers of Mondrian.[9] It is emphasis on the flower in a state of decay or a transitory fullness. Mongan, another perceptive critic, speaks of this theme of death and of how a dying chrysanthemum begins to be a veritable *memento mori*.[10] Like his lonely towers and windmills, dunes, piers, and trees, Mondrian's flowers are hypnotizing because they are encounters with suffering. They speak of the human in trouble, as the "late, elated" pictures of New York speak of acceptance and, even, ecstasy in movement.[11]

Piet Mondrian's development was influenced early by the fact that his father taught drawing and languages. We even possess a collaborative work done by father and son.[12] The father was not as professionally successful as the elder uncle Frits Mondrian, who took pains later to dissociate himself from his modernist nephew, going so far as to write a public proclamation of his distance from Piet's aesthetic.[13] But Frits's decent Hague School landscapes are at least part of Piet's

early heritage. Beginning in the late 1890s, with its fairly academic realism, Mondrian's art underwent an astonishing development. From the turn inward remarked by friend, foe, and family critic alike at the turn of the century, he marched rapidly toward an exclamatory use of pointillist, fauve, and expressionist modes, all synthesized by a young man who grew up under the aegis of a truth-telling pastoralism. Mondrian's early work may be called a development of Dutch realism, but what we see by the turn of the century, and certainly in the studies of single flowers that he begins to make about 1907, might have been influenced by the Swiss symbolist Ferdinand Hodler, whose works seem to have been exhibited in the Netherlands around this time. Henkels has shown how strange and unique these single flowers really are, despite all still-life antecedents. In art nouveau, the cliché is the female form surrounded by nature, whereas Mondrian employs his flowers as figures already. This "anthropomorphic" device is a deviation from the conventional; a hallucinatory turn. Henkels also emphasizes the staring eyes in the self-portraits and elsewhere in this period of inwardness, when Mondrian was learning from Theosophical texts.[14]

In 1905, Mondrian made a little money by doing scientific drawings of an anonymous character. This work is thought to have continued, astonishingly enough, but as a sign of poverty and duress, for years![15] I would place, moreover, the conjunction of science and Symbolism as the advantage of Mondrian. Kafka learned from legalese, and Mondrian makes his profit from precision. What is also astounding is how quickly, as Henkels and others have noted, Mondrian becomes Mondrian and seems to become obsessed with geometric—to the exclusion of other—problems. Already the flowers reveal evidence of the kind of painterly adjustment and readjustment that we find in Mondrian's constant scrutiny of the masking tape that he used to mark out areas of color in the late works, when art and geometry were measured in fractions of an inch in revisions. The single flower, which we represent often as the artist's symbol of the body and its "interiority," becomes for Mondrian the site for a series of aesthetic investigations that are as constructive as they are allegorical. The richness of Mondrian, which lies in part in his combination of fact and dream, is heightened by his sheer will to aesthetic assimilation and analysis. This, as much as politics, drove him to the Paris of the cubists, whom he had already seen in the Netherlands by 1911, and to London, and to his beloved New York, a tour that is not just an exile but a willful expatriate's conquest of space.

Every student of Mondrian's flower studies, and anyone who has a passing acquaintance with the tradition of scientific illustration in the nineteenth century, will note how much they are filled with the detailed botanical discursiveness that is the virtue of scientific expositions. But what is so extraordinary is that Mondrian is a scientific illustrator exactly at a period in his life (circa 1907) when he is drained of all fervor for the external world. His symbolist period initiates a turning away from the positivist identification of the world with reality, a road that Mondrian—with his Platonizing and search for essences—traveled until the end of his life. What is, therefore, extraordinary is that this Platonist had the equipment of a prose realist and began to use it to describe, with subversive charm, the pleasures and dangers of the unreal. The flowers of Mondrian are parables of unreality, often disintegrating, like the *Blue Rose*, before our eyes. But this disintegration and pathos are made much more haunting by the possibilities of a "legal" precision, a canniness that defines and shapes the uncanny.

The tension between the empirical and the symbolic is seen throughout the early flower studies. Welsh quotes an early critic of Mondrian as praising his "symbolic direction," to which the artist replied: "I too find flowers beautiful in their exterior beauty; yet there is hidden within a deeper beauty."[16] In his studies of flowers and of nudes, there is a curious contradiction between Mondrian's resolve to go further in the symbolic direction and his native unwillingness to sacrifice the quotidian and the observed.

Let us try to use a tolerant pluralism to understand the radiant and largely unrepressed naturalism of the younger Mondrian. We find in his diverse flowers—and in his great melancholy towers, windmills, and trees—an untrammeled Mondrian with much more libido expressed and much less theoretical self-censorship. It is important to note that this was not a young man warbling his wood-notes wild. A man who had received a degree in drawing in his late teens, a man who worked ceaselessly throughout his earliest youth in a family of amateur and professional artists, Mondrian was a mature artist when he deviated from the Hague School into symbolist and expressionist work in the first decade of the century. It is only a dogmatic historicism that betrays our own provincial or narrow sense of "modernity" that leads us to speak of him as mature only after the taste of cubism. The flowers of Mondrian have been an open secret, like the violently sensual "early" Cézanne. Though in many cases artists grow by the avoidance of libidinal temptations and sensual sentimental-

ities, in Mondrian it is well to recover some sense of his sensuality to evaluate later spiritualities.

Furthermore, the painting of flowers survived Mondrian's encounter with cubism. If the earlier flowers can be dated only with difficulty, the later flowers often appear to be inherently problematic, as if the very secret of Mondrian were to leave them undated in order to reveal something "beyond time" about himself and his relations to others. But it is reasonable, psychoanalytically, for the origin of erotic works to be concealed. More than one scholar and painter have felt that the secret loves of Mondrian are exhibited here, like the tulip in his studio that so entranced André Kertész. Though Mondrian rebuked himself for his commercial work, we see the repetition of the flowers as something much different than, say, the stylistic hoax of de Chirico, who mocked his early work and lost his own sense of it. Mondrian was more confessional, one might say, than opportunistic. Or, to put it in psychological terms, he seizes on the opportunity to conceal a truth in these flowers, a truth in pleasure that was all "too natural" for Mondrian. No one wants to dabble in armchair psychoanalysis, and there is no subtle biographical study of Mondrian extant, but it is not difficult to agree with Robert Welsh that the signs of an inhibition are present in Mondrian.[17] For Mondrian, self-repression was a compulsion. The mystery, as Freud said of the artistic, remains: that Mondrian, capable of working at a level of realism approaching scientific illustration and drawn toward both Theosophical and sexual symbolism of a romantic order, could make out of dissonant psychic forces powerful flowers, like the blue *Calla Lily* and the horrifying *Dying Chrysanthemum*.

* * *

Yasunari Kawabata, in his poignant Nobel Prize address, spoke of the Oriental taste for the single flower and his remarks are an explication of some of the values seen in Mondrian: "The single flower contains more brightness than a hundred flowers."[18] One does not want to emphasize the Oriental and Theosophical connotations of Mondrian's flowers too much, but one might keep in mind, as with Eastern influences on the impressionists, the grace sought in concentration that is part of the power of these pictures. The thematic reduction to singleness seems to speak often as a rhetorical device: the flower for the body.

We are used to thinking that the mood and even mode of fragility and frangibility in the early flowers of Mondrian are an artifact of his youthful sensibility.

One thinks of Picasso, whose adolescent, self-absorbed Blue Period figures gave way to the tectonic constructive angles and remorseless affirmations of the later works.[19] What we should keep in mind with Mondrian is the possibility that themes of fragility are not necessarily mawkish self-lacerations and are kept alive as late as his flowers of the 1920s, not for mere private self-indulgence or public kitsch, but as a continuing meditation on flux itself. He gives us early self-portraits whose hypnotic, trancelike stare seems fixed on an ideal of stability. On the other hand, his impressionist and Hague School heritage lead him, again and again, to be involved with the joy of flux, as in his enduring love of the dance, the boogie-woogie of the real. The themes of fragility, chance, the biomorphic, and the fluctuations of the real are constant pressures in Mondrian, both early and late.

The best of the tree studies (circa 1908–1909), give us this magisterial sense of a self meditating on stability and movement. Mondrian has not given up the nineteenth-century love of the instant and immediacy, and somehow persuades us even in his more abstracted trees that movement is the virtue of line. The great late tree studies of 1912, sometimes in crayon and sometimes in oil, insist on a triumphant arc in which horizontal and vertical are balanced. I know artists who prefer the fullness of the tree studies and their cinematic slope into abstraction to the flower studies with what seems like their relative diminutiveness. But I would suggest that the glorious tree studies could not have emerged without the patient analysis and attention to detail of the flowers. The focus and tactfulness of the centripetal flower studies are what is needed to take the trees into their abstract geometrical flourish. Some would say that it is only cubism that has transformed the trees to this extremity, but I would also insist that the meticulous morphological formalism of the flower studies is what makes such a work as *Tree II*, the great drawing of 1912 at The Hague, into something that magically enforces an equilibrium between the organic and the schematic. The flower studies forced upon Mondrian an analysis of botanical movement in the close-up, and afterward he was able to direct this power to the macroscopic world of the trees. Even in the earliest chrysanthemums one may say that the vertical power of the trees is being born. And the pathos that is so marked in the dying flowers (circa 1907–1908) must not be thought of merely as a nullity. That the flourishing trees overcome this pathos is evident, but *The Gray Tree* of 1912 (Haags Gemeentemuseum) recalls Hague School atmospherics. Even in his cubist glory, Mondrian maintains the silvery

search for melancholy that was a famous aspect of the Dutch naturalists, sometimes referred to as a school of gray.[20]

When the flowers and the trees are seen together, they make, I think, for one of the most sustained serial groups in the history of modern art. So, for example, the psychological force of the dying chrysanthemums, with all their unrestrained pathos, is balanced by the later flowering apple trees. I would suggest that the flowers and other flora resemble a spiritual autobiography in symbolist terms and can be seen as a collected poem with a romantic unity. Certainly, the early flowers do not all lack the powerful vivacity of the trees. An early *Sunflower* is striking for its van Gogh–like refulgence, and Kermit Champa and others have spoken of the appreciation for van Gogh in Amsterdam and the inclusiveness in exhibitions in that city of fairly advanced French art. The watercolor *Chrysanthemum* of circa 1909 in The Hague should overcome the idea that the flowers convey only a mood of fin-de-siècle fragility or Mallarméan absence. There is explosive red and white in the head of this showy flower; the theme is profusion itself, and calligraphic swiftness marks the execution as what another age would call "virile." The scale (28½ × 15 ⅛ inches) reinforces the sense of the flower as something as explosive and immense as a person. It is not a pathetic fallacy, moreover, but a romantic analogy with states of being that is earnest and convincing.

Kermit Champa has asserted that the flowers of 1908 are "at their worst, somewhat literary and effeminate reminiscences of van Gogh."[21] But these flowers convey an obsessiveness, a Poe-like darkness, and not a mood of lyricism or even commercial sweetness. The early *Expressionist Self-Portrait* of 1908–1909 shares an obsessive theme with the *Dying Sunflower* of 1907–1908. It is not, moreover, a morbid or moribund theme of death, but one radiant with the objective tone of the great symbolists. The dying flowers of Mondrian permit him some very sunny tones of blue and gold. Even the muddiest tone of the dying *Sunflower I* sings next to a primary by sudden contrast. And the very schema of certain dying flowers, with drastic diagonals gently balanced by a broad abstract panel to the left, is one of equilibrium and precarious harmony, not mawkish collapse. The dying is all an activity of agitated color and geometry. Thus, Mondrian avoids the sodden flowers of a hypertrophied Romantic and the equally sterile flowers of a mere botanical illustrator.

Interestingly enough, Champa speaks of Theosophy's "retrograde" effect on Mondrian's paintings, even though he beautifully underscores the fact that it is

Theosophy's insistence on "the pregnant simplicity of carriers of deep spiritual meaning" that leads Mondrian to studies of single objects: windmill, tower, dune, and tree.[22] Champa seems to find "Symbolist" concerns an entrancing delusion for Mondrian. Instead, we might concentrate on how much this "dialectical alternative" had to offer to the student of the Hague School. Symbolism forced Mondrian to adopt a kind of wariness in the face of the real, which led him to see "meaning" in abstract forms in a way that remained his constructivist forte and defense for life. Symbolism provided him with a spiritual refuge from an obsession with the mere facts of vision that permitted him to engulf cubism without being engulfed himself. One can easily imagine a Mondrian without symbolism for whom the encounter with cubism would have been overwhelming. Theosophy, the syncretistic mystical sect originating around 1875 that claims Mondrian as a sometime initiate, was nurturing for the artist in a variety of ways, and its aesthetic effects were too consequential merely to deplore.[23] How, indeed, can one disentangle Mondrian the priest and mendicant from Mondrian the aesthete? In many of the flowers, for example the great amaryllis group where Mondrian uses scale to strike us with a flower as solid as a church facade, the religious symbolism inflects the naturalism but does not detract from the vigilant dignity of the image.

Still, there are early drawings—the *Amaryllis* and the *Chrysanthemum*, for example—that have an empirical quality. The *Amaryllis* was a gift from Mondrian to Charmion von Wiegand; it is a sign of the intense relationship between them and of the generosity of the guru-artist, who also gave her important abstractions. This drawing may well be thought of as preparatory for *Red Amaryllis with Blue Background*, but for itself, it seems less a Theosophical symbol or anthropomorphic trope than an observed reality. Throughout this drawing, the lines and traces of lines are allied to what Alberto Giacometti once called the true method of observation by short lines, as opposed to the false generalizations in Cocteau's and Picasso's single-line drawings. In the chrysanthemum drawing, the architectural volumetrics become the theme of the work, which is made vivid by an insistence on tectonics as well as by theatrical highlighting. An architectural flower, it reminds one of Mondrian's desire to create, if much later, a new environment on canvas and his delight in using colored rectangles throughout his studio. Both *Amaryllis* and *Chrysanthemum* have this glorious geometry, a grammar as intuitively precise as that of any Barnett Newman.

Against these "empirical" works, we must consider the many early works, like the *Golden Lily* of circa 1908, that near invisibility. These works have an intense hush and chromaticism that is their symbolist heritage.[24] Thus, the so-called realism of these pieces often loses itself in an atmosphere of the unreal or relatively irreal. (One might understand the rapture of the woman in *Passion Flower* as much by analogue with early Schönberg or Scriabin as by anything Dutch, chaste, and solid.) Christopher Ricks has written a book on the "embarrassment" we often feel with the lush romanticism of Keats and even on the theme of embarrassment. Certainly, these attenuated studies often embarrass us with their sense of deliquescence. The poignant *White Rose in a Tumbler*, dated as late as 1921, is lost in a yellow field. This rose is a delicate and, one might say, phonological study after Verlaine, as it were "une vaste et tendre apaisement." Jasper Johns has said that art might be an appeasement or a complaint.[25] This rose, with its lonely suspension in space, is as interiorized a cultural symbol as a flag in a field or a coat hanger in darkness. It is an adequate statement about inadequacies and fragility. *The Blue Rose* is a Mallarméan exercise in disintegration and watery flux. One ink wash of a dying chrysanthemum seems more of a wisp of smoke than the punctilious punctuation one expects from this grammatic master. Each flower has its own physiognomic pull and not all are so ravished or ravishing, but it is fair to say that our own embarrassment with this symbolism is not too far from the artist's own, and his few nudes seem less sensual than the flowers. We might think of the flowers, then, as the real nudes in the oeuvre of Mondrian and place our embarrassment as a fear of desire. Mondrian returns again and again to them because he is so troubled by the enigma of private sensations.

How many of these flowers seem to be about the libidinous presence of woman. The Theosophical *Devotion* from 1908 makes the antithetical point by placing the flower as a hovering symbol of purity above the radiant epigone. And the strangely alienated *Evolution* shows a diagrammatic progression from flower to geometry in a wild transmogrification in honor of philosophical idealism. But one should not forget, as Sidney Janis once reported to me, that "women were important to Mondrian" and that Michel Seuphor and others were quite aware of the unhappy love affair that inflected his life and that seemed to indicate that the artificial tulip in his studio was a feminine presence. Janis recounted to me how a typical art party in New York would end with everyone drunk except Mondrian, who would be "surrounded by six or seven

women, all listening to him." The priest in Mondrian seems to have become the whole myth. But remember that this was the man who started to kiss Peggy Guggenheim passionately when she leaned her head against his shoulder. When she remonstrated coyly that he was so pure in reputation, Harry Holtzman suggests that Mondrian beamed with healthy appetites.[26] Seuphor and Holtzman both allude to a healthy sexual appetite on the part of Mondrian—whatever healthy may be—but there is a suggestion and more than a suggestion in both of the obvious trouble Mondrian was in throughout his life. While the flowers are always acts of attention and observation, the suggestive and the allegorized feminine is another pole of this art. A flower, one might say, is both a geometrical demonstration of nature's logic and an escape from the "tragic" element of sexual imagery into delicacy.

There are a few flower stories that are significant, hilarious, and melancholy. There are letters from 1921–22 in which Mondrian tells a friend that he has rendered commissions for flowers "(naturalistic)" for one hundred francs, and that if this kind of success continues he will stop painting![27] In this mode, we also have a letter (dated 1931!) to a friend, the great collector S. B. Slijper, for whom he says he will paint "another farmhouse," but he will have to buy some tubes of muddy colors, since he no longer keeps those colors in his studio.[28] Mondrian in more than a few anecdotes tells friends that he must sit with his back to the trees outside because he hates nature. He also tells a reporter who visits his studio in Paris that the tulip in his atelier is artificial and that he has even "whitewashed" the leaves to avoid that hideous green of nature. Mondrian, on the other hand, once told his New York dealer Sidney Janis that an abstract composition "was like a rose."[29] Perhaps the most touching anecdote about Mondrian and his naturalistic works is that told by Charmion von Wiegand in simply relating that many of his single-flower studies were present with him in New York City on a special wall, and that he made a tour of these early works when she came to his studio. Throughout his life, Mondrian betrays an obsession with the natural, first in his attention toward the real and then in his manic sacrifice of it in pursuit of the essential. One must compare it with his much remarked-upon asceticism in a life pierced with some grand passions (requited or not and relatively undocumented but alluded to by Seuphor and others).

Seuphor's vision of Mondrian is incisive: a man formed partially in a tug-of-war with a moralistic father and a mother so weak and stiff she is hardly repre-

sented by her son. The uncle, Frits, fosters his art a little and then renounces him publicly, as if for moral laxity. His life becomes a story of renunciations, finally even the renunciation of nature itself. And yet Mondrian is a man who loved Walt Disney's animated cartoons, dancing, and jazz, and once said firmly that he would renounce any country that banned the Charleston, his beloved dance step. But Seuphor assumes that the "distance" enforced in dancing the Charleston presupposes the sublimation of sex. And he writes of the turmoil of Mondrian in making these dissociations and sublimations.[30]

Kurt Badt speaks of the degrees of loneliness in painting, and in his decisive study of Cézanne, he calls attention to the theme of loneliness in Cézanne's seemingly veristic work. One must say that at some point Piet Mondrian also experienced a comparable conversion to loneliness.[31] One might add that Mondrian's sexual melancholy is something he learns to control, like Cézanne, with great difficulty, but that it exerts a constant pressure on his art. Just as the rigid trees of the late "Bathers" have been said to speak of Cézanne's fear of desire—here I am paraphrasing Meyer Schapiro's famous analysis—so we might think of Mondrian's abstractions as forms of a gigantic controlling mechanism. But the flower is not entirely cast out by Mondrian, who returns to it in times of need. He traces it, as Mongan has shown, permits it to proliferate, and details it with a botanical zeal, which Kant appealed to as one of the truest ways to understand the flower's beauty. Mondrian's long bachelorhood conjures up this sign of desire's pathos. Perhaps we may be permitted to see an unextinguished melancholy in the black bars and grays of his abstractions.

* * *

Mondrian's flowers are poignant and precise works of a human order that link him to two other masters of twentieth-century art, Picasso and Matisse. In these works, Mondrian was willing to express an uncertain sensuality and a bent for pragmatic analysis that betrays theory and dogma. They are flowers of the symbolist and expressionist tradition, though they may be said to be flowers of good and not of evil. The most turbulent of the charcoal drawings suggest untapped libidinal energy that was obviously a burden for this genial ascetic throughout his life. While we would not want to break his flora like butterflies on a theoretical wheel, they deserve and demand a scrutiny and can widen our sympathies for the late works. We learn from them not to disdain the representational in all acts of

abstraction, as Meyer Schapiro encouraged in his essays on Mondrian and other masters of seemingly impersonal geometry.

Throughout my study of individual flowers of Mondrian, I have been aware of the problem of kitsch. Is it possible that Mondrian, at least in the later flowers of the 1920s, was complaisantly playing to popular taste for his subject? Clearly, I think not. Still, we must add to all those who call the figurative Mondrian kitsch, that Meyer Schapiro found, with fecund irony, that there was a kind of abstract painting that had become the kitsch of our time.[32] Perhaps this insistence on the flowers of Mondrian is a resistance to the fetishism of abstraction in the last forty years. Fairfield Porter once remarked to me that he had opposed Clement Greenberg ferociously because of the implied loss of liberty in a dogmatic abstractionism.

Perhaps it is for the love of liberty that we may return to the flowers of Mondrian, early and late, including the flowers rendered in the 1920s for commercial reasons. They all represent an undogmatic, experimental, experiential Mondrian that contrasts, even in journalistic humanity, with his theoretical Platonizing. In the flowers we find a "resistance to theory" that is perhaps more beautifully negative than anything in the theory. Bizarrely enough, in the single-flower studies, as in the watercolors of Cézanne, modesty produces a rare completeness.

Mondrian's search for a perfect language in geometry is analogous to the rigorous approach to language of his near contemporary Ludwig Wittgenstein. The philosopher may be thought of as a troubled symbolist who reduced the pressure of his pessimism by a swerve toward the logic and engineering of an absolute linguistics. Both Wittgenstein and Mondrian, troubled by different sensual problems, defended themselves against a nature and a naturalism that early on looked like a bewildering wilderness. In his maturity, Wittgenstein began to accept this wilderness of forms and to become a kind of anthropologist of the everyday. This might be compared to Mondrian's late acceptance of the profusion of signs in the city of jazz. Both men enjoyed geometry and grammar as a relentless defense against what seemed the whimsical cheapness of disorder. But, secretly, Wittgenstein turned for pleasure to Fred Astaire, Mondrian to Disney movies and other entertainments, and both avoided this beloved humor in their severe works. A way to understand both is to sense that their brand of impersonality concealed imperfectly their horror of their own frailties.

The painter-critic Fairfield Porter mistrusted and resented this impersonality in Mondrian. Porter mocked him for the puritanical repressions he found throughout his late works. He speaks of the white paint of the abstractions as beginning to crack because, he thought, Mondrian had forgotten the element of time in his painting. Porter believed in diversity and felt that the black dividing lines of Mondrian's late paintings were little more than prison bars. He felt Mondrian wanted to be sheltered "from the dangerous mystery of fact," which is exactly present in the flowers.[33] The flowers should also lead us to see elements of diversity, change, and time throughout the master's work.

Thus, we may even reinterpret the abstract works in the light of the representational pieces. Mondrian was willing in his forties to learn from the younger masters Picasso and Braque, those two mountain climbers, but we must note how he had already prepared himself for this cubist experiment by his whole assimilating career. In many ways, cubism was the perfect vessel for him because he had already used moonlight and other devices to attain disintegrating and planar effects.[34] He needed cubism and its patient analysis of the object. He could not accept collage, it is true, nor did he follow Picasso into excesses of wit and zeal in aggressive texturing of the literal, but Mondrian was already a cubist, one might say, in his analytic flora. And his voyage into his own "neoplasticism" is an audacious strategy but of a continuous adventure.

The melancholy of the abstractions should not be overlooked either. After a time with Mondrian's symbolist pieces, we note how often a blue-gray ground in the later work succeeds in conveying a delicate, naturalistic connotation. The abstractions are too often viewed as "joyful décor," a perfectly wrought happiness of primaries. After reckoning with the darkest of the flowers, we begin to sense the darkness and even skepticism of Mondrian's opaque grids. These systems no longer seem so harmonized, formal, or pure. They now begin to show us something of the pathos of the flowers, and their vertical bands create metaphorical stems. The late, seemingly nonreferential abstractions do, after all, and with a little poetic justice, take on the tabooed and secret meaning of a native tongue. In Mondrian, we find an embarrassment with the riches of the libido, and yet there is an air in the late abstractions of a coming to terms with the "New York" of sensual pleasure.

Are there any conclusions to be drawn from a study of Mondrian's flowers, these seemingly too-delicate creatures of a doubled time, a turn-of-the-century

wistfulness and a 1920s classicism? We might say that Mondrian reveals himself first to be primarily part of the symbolist tradition, and that therefore his "nature" studies, so poised, so unnatural, so cutoff, so cultural, never really had to be rejected by him, except that he had difficulty in accepting his own body and the flesh that finally is what these flowers express. The flowers, again and again, state conclusively that Mondrian was a libidinous poet, that the single flower is a partner or double in an erotic dance. This fine dancer made of his flowers a form of very subtle gift-giving, a generosity grown, however, distinctly inward. These are letters to a world that never wrote to him.

There is, in the flowers, observation, tact, and reserve; there is architecture and geometry; and there is also the memory of a dream. This multiplicity, what we might call the radiant pluralism of these images, is perhaps the meaning of Mondrian's serialism. The flowers are not simply a grouping born of financial need. Mondrian returned to them, as to his self-portrait, because of a great need that had not been resolved by the abstractions. They remained with their emotional curves a powerful force to trouble him. In a sense, these works confirm Mondrian in his own self-impression, that he was the true surrealist. They speak of mad love, in tones as rare and yet as direct as any incantation of those poets of the unconscious and of self-consciousness itself.

NOTES

1. See Robert P. Welsh, *Piet Mondrian's Early Career: The "Naturalistic" Periods* (New York: Garland, 1977), n. 98, 22, and Michel Seuphor, *Piet Mondrian: Life and Work* (New York: Harry N. Abrams, Inc., 1956), 407.

2. One must weigh against the many anecdotes relating to Mondrian's antipathy to nature Seuphor's report that his last wish was to see the ocean, *Mondrian*, 114.

3. See Charmion von Wiegand, "Mondrian: A Memoir of His New York Period," *Arts Yearbook* 4 (1961): 57–67.

4. Piet Mondrian, *The New Art, The New Life: The Collected Writings of Piet Mondrian*, eds. Harry Holtzman and Martin James (Boston: G. K. Hall & Co., 1986), 118.

5. Ibid., 338.

6. Ibid., 13–14. See Welsh's subtle analysis of this letter in *Early Career*, 158–61.

7. Meyer Schapiro, "The Apples of Cézanne: An Essay on the Meaning of Still Life," in *Modern Art*,

Nineteenth and Twentieth Centuries: Selected Papers (New York: George Braziller, 1978), 1–41.

8. See Schapiro's fascinating analysis of Mondrian's relationship with postimpressionist space in "Mondrian," *Modern Art* (New York: George Braziller, 1990), 233–61.

9. David Sylvester, "A Tulip with White Leaves," *Studio* (December 1966): 295.

10. Agnes Mongan, "Mondrian's Flowers," *Miscellanea* 16 (1969): 229.

11. Schapiro, "Mondrian," 257–58.

12. Haags Gemeentemuseum, *Mondrian, from Figuration to Abstraction*, texts by Herbert Henkels, H. Overduin, and Piet Mondrian (Tokyo: The Tokyo Shimbun, 1987), 166.

13. Seuphor, *Mondrian*, 45.

14. Herbert Henkels in Haags Gemeentemuseum, *Figuration to Abstraction*, 37–38.

15. Herbert Henkels, letter to the author, November 1989. Henkels dates the work through 1913, although others believe it lasted up to the end of the war.

16. Welsh, *Early Career*, 54.

17. Ibid., 171. See also Seuphor, *Mondrian*, 86, on "Mondrian and Women."

18. Yasunari Kawabata, *Japan, the Beautiful and Myself*, trans. by Edward Seidensticker (Tokyo: Kodansha International, 1969), 18.

19. See Schapiro, *Modern Art*, 111–20.

20. Mondrian's predilection for painting in the evening and its effect on his art is discussed by Welsh, *Early Career*, 107, and Seuphor, *Mondrian*, 60, 401.

21. Kermit Champa, *Mondrian Studies* (Chicago: University of Chicago Press, 1985), 12.

22. Ibid., 14.

23. See Robert P. Welsh, "Mondrian and Theosophy," in the Solomon R. Guggenheim Museum, *Piet Mondrian: Centennial Exhibition*, texts by M. Bill, N. van Doesburg, J. Joosten, T. M. Messer, M. Rowell, R. P. Welsh, and L. J. F. Wijsenbeek (New York: Solomon R. Guggenheim Foundation, 1971).

24. See Martin S. James, "Mondrian and the Dutch Symbolists," *The Art Journal* XXIII, no. 2 (Winter 1963–64): 102–11.

25. Roberta Bernstein, "Things the Mind Already Knows: Jasper Johns's Paintings and Sculptures, 1954–1974," Ph.D. dissertation, Columbia University, 1975, 240.

26. Sidney Janis, conversation with the author, 1985; Mondrian, *The New Art*, 6.

27. Henkels in Haags Gemeentemuseum, *Figuration to Abstraction*, 207.

28. Ibid., 219.

29. Sidney Janis, conversation with the author, 1985; also cited in Welsh, "The Hortus Conclusus of Piet Mondrian," *The Connoisseur* 161 (February 1966).

30. Seuphor, *Mondrian*, 169–70; see also the delightful "Mondrian in Disneyland" by Els Hoek, *Art in America*, no. 2 (February 1989): 136–43, 181, in which Mondrian refers to himself in a letter as "Sleepy."

31. Compare Mondrian with Badt's Cézanne in his penetrating study *The Art of Cézanne* (Berkeley and Los Angeles: University of California Press, 1965).

32. Schapiro, "Mondrian," 252–54.

33. Fairfield Porter, *Art in Its Own Terms, Selected Criticism, 1935-1975*, ed. Rackstrawe Downes (New York: Taplinger Publishing Co., 1979), 74–75.

34. See Welsh, *Early Career*, 107–08, and Seuphor, *Mondrian*, 60.

A Conversation between Julia Kristeva
and Ariane Lopez-Huici

(ILE DE RÉ, FRANCE, SEPTEMBER 1990)

Ariane Lopez-Huici: Julia, you've just published your first novel, *Les Samouraïs* (*The Samurai*). It's an autobiographical novel and a personal account of a generation of intellectuals. Can you elaborate on the way that you, as an analyst, wrote this book with the awareness that you risked compromising yourself, somewhat in the same manner that Freud, for example, opened himself up to criticism from other psychiatrists by becoming interested in sexuality?

Julia Kristeva: Indeed. First of all, I want to say that I took great pleasure in writing this book. As opposed to theoretical writing, which demands great mastery and a sort of intellectual asceticism, fiction allows one to renew contact with one's memories, in other words, with childhood and the body. It involves having recourse to one's imagination, the fact of showing oneself intimately, speaking of one's sensations, one's manner of living the sexual act, a sunset, maternity, all these phenomena that in principle are never foregrounded because they are held to pose a potential danger for the analysis and lead to a sort of reinforcement of what is referred to as transference. In other words, it risks creating a situation in which the patient intensifies either the love or the hatred he or she feels for the analyst, and in which, in any case, the

relation becomes more powerful. One runs a risk in attempting to master this intensity, but if you want to get to the bottom of these things, it is necessary to stir up the entirety of the patient's psychic life, and this implies, reciprocally, that the analyst too is stripped bare. In a way, this is a manner of enriching my analytic technique. This writing is not only a pleasure, but also takes its place within my professional activity as an analyst.

I've often been asked why I didn't write memoirs instead. One of the lessons analysis teaches us is that we can't tell all; not only because many contemporaries are still alive and still close to us, because our modesty makes us unwilling to reveal certain relations that link us to them, but also in a more fundamental and absolute sense, because a human being cannot tell all about what makes us go. Writing memoirs in the name of some absolute truth, one says less than ever. This became quite clear recently in the memoirs of Simone de Beauvoir, when her correspondences were published. In comparison to her letters, her memoirs seem over-polished, frosty, embroidered. One shouldn't believe that the genre of memoirs involves any direct truth. The deformation presupposed by fiction bears the mark of the author and is the only possible truth; thus I did not pretend to the truth as such, but tried to speak a subjective truth that seems to me to be truer than so-called objective accounts.

ALH: The second question that interests me—and that affects both of us, since you're married to the writer Philippe Sollers and I'm married to the sculptor Alain Kirili— is to know if you find that there is room in a couple for two individualities, for I sense that there is a veritable allergy to this possibility. Obviously, I'm thinking of that most famous couple, Sartre/de Beauvoir, but also of the American sculptor Carl André and his wife Ana Mendieta, whose marriage ended in tragedy, or of Althusser in France, who strangled his wife. The question is about the couple in general, and whether or not it is viable.

JK: Yes, this is a complex question. I'll try to approach it from several angles. We should not underestimate what the feminist movement has achieved in recent years by attempting to clarify the particularity of female sexuality, which was simply crushed in the ostensibly harmonious classical marriage. Yet feminism also emphasizes a notion that seems difficult, if not impossible, to admit: the war between the sexes. Lately we have gone backwards with regard to all this, and, per-

sonally, I think it's a matter of civilization to attempt to go beyond this war of the sexes and constitute a harmony.

Nevertheless, there is an element of truth revealed by this feminist gesture: The antagonism between the sexual interests of man and of woman leads to tensions and conflicts that can be stimulating, but also very mortifying. This much said, one obviously shouldn't fall back into the trap of the sort of idyll one sees in today's women's magazines, which consists in singing the return to harmony in the family, how everyone is kind, everyone is adorable, etc. This tension is constitutive of the sexual relation between men and women, and it undoubtedly becomes all the more problematic when the two partners try not only to be sexual partners, but also individuals in the fullest sense. For while a sort of equality or even a dramaturgy is admissible in bed, perhaps provoking the man's humiliation but also his pleasure, this genre of play in the social and public arena is very difficult to tolerate for both parties, and principally for men. The fact that women achieve a social role supposes that, to their traditional characteristics such as seduction, maternity, and a certain passivity, they add that of being active. And activity, in our culture, has a phallic connotation. This phallicism nonetheless seems to me an absolute necessity for feminine creativity of any sort, even giving one's children a good education. As a relation to power and to the law, the woman's identification with this phallic power—as distinct from the penile organ—is a necessity. And this identification must be assumed by every woman who wants to create something. Her difficulty consists in woman's process of psychosexual maturation: There is a long path to travel, which, schematically, consists in tearing oneself away from symbiosis with the mother. This is where we all come from, but women are held within it more powerfully because they are of the same sex as the mother.

Of this transition toward the world of abstraction, rules, and activity, I would say that many are called but few are chosen, for many women remain prisoners of this maternal embrace, and this imprisonment directs them toward either passivity or melancholy. Others break this relation brutally, returning to their male, virile identifications, and thereby censure their female particularity. That the path of female autonomy is extremely complex explains the difficulties confronting female accomplishment; but when this path is traveled, it produces individuals who are especially complex and mature.

When the woman accedes to creativity, then, how is this perceived by her

partner? The competition that exists between two creative individuals, which itself is grafted on the already fragile terrain of sexual partnership, makes the life of the couple extremely problematic unless a great maturity—both sexual and psychic—permits a recognition of the other. The case of Sartre/de Beauvoir is quite exceptional, and it's Simone de Beauvoir who said that there may be room for two in a couple, but only when one deploys all of that sort of finesse and sexual maturity that has nothing to do with wisdom and renunciation—for if there's only mere politeness and restraint, everything breaks down.

ALH: I'd like to return to the difference you made between phallicism and the penis.

JK: This distinction doesn't originate with me. Lacan insisted on it, referring to Greek mysteries and to the entire sacred tradition of humanity. On the one hand there is the organ, which is a physical appendage, and on the other there is what the organ represents, that is, an agency of power and authority: the law. Phallicism is symbolic.

ALH: Recently I made a series of photographs that I entitled *De Viris, 1989*, that deal with erotic fragmentation, principally in sculptures of nude men. I'm amused by the reaction of the public, who seem to be surprised that a woman should deal with this subject, whereas the question never arises when a man deals with the female sex. Now, if the creative act is first and always a sexual act, the variety of possible subjects is multiple. In terms of contemporary artists, I think of Louise Bourgeois who deals with the phallus, of de Kooning's women, of Robert Mapplethorpe's homosexuality, or of Cindy Sherman's androgyny. Personally, I have a certain type of comfortable relation, an ease, with regard to sexuality, a relation without morbidity, that probably comes from a Latin tradition. I have no problem in dealing with the male sex or, for that matter, with the female sex; but the difference is always very clear and any amalgam strikes me as dubious.

JK: I would first of all say that I am very seduced by your work and that you have told me that many people, confronted with so many male sexes, interpret these photos as an unacknowledged or complex relation to the paternal figure or the phallic power of men. In point of fact, this relation is not at all unavowed, nor is

it complex. Rather, it is entirely apparent, frank, and jovial. There is nothing surreptitious or ashamed about your work, quite to the contrary, and this points in the direction we mentioned earlier, suggesting that an affirmation of women in the domain of creativity passes through a confrontation with the phallic element. But I think it would be a mistake to reduce your work to this sexual aspect, which is subjacent, visible, and important, but which is less central than several other connotations. When you choose to photograph Greek sculptures like the Laocoön, works of the Italian Renaissance, or of the baroque in Bernini, it seems to me that this is an attempt to render homage to a cultural tradition. It's a cult of memory that strikes me as an important dimension of experience arrayed against a certain crushing, a certain flatness or platitude of formalism that wanted to have done with content. This relation to representation, not just to any representation but to carefully chosen works, indicates that one is situating oneself in relation to history and marking one's place in a continuity.

As concerns androgyny, sexual difference was replaced in the 1970s and 1980s by a sort of incantation of bisexuality. This is to say that insofar as sexual difference demands great efforts—psychic, sexual, and mental efforts—toward acknowledging the other, one simply gets rid of the problem by becoming oneself both the one and the other. One becomes everything in this totality, neither man nor woman while believing oneself both man and woman. There are excellent studies on transvestites and transsexuals which show that, contrary to certain ambitions maintained in their phantasms and thus in their truth, they are of neither sex: They take themselves to be angelic.

This is a manner of getting rid of sexuality that may appear paradoxical, paradoxical because they pretend to taste every sexual pleasure, while in fact it's a matter of neutralizing them and thus of arriving at a sort of homeostasis that is a very good representation of the myth of Aristophanes in the *Symposium*: Beings are spherical because they comprise the two sexual elements, and everyone knows that one sphere doesn't communicate with another.

What about the presence of the female in the works of male artists? Proust, for example, whom I have been reading in the context of my teachings for several years now and who remains for me the summit of the French novel, is an enigma. Clearly he is someone whose homosexual sexuality was sometimes timid, sometimes violently affirmed, notably in his penchant for brothels and sadomasochistic practices on animals and humans; his fascination with whips and blood. Yet he

had a highly developed sensitivity to the female body, and to his female friends. The simple fact that the character who is the narrator's companion, Albertine, is a woman allows Proust to overturn the homosexual relation and love for a man into a relation with a woman, and to produce a description of her sensibility that many heterosexual men have difficulty perceiving. This reveals an extremely intense identification with the feminine, if only on the level of the phantasm and even if it doesn't involve entering into sexual relations with women.

For Matisse, a fascination and a veritable passion for the female body takes the form of a consecration consisting in the staging of harmony and an intimate, I would say almost gustatory, relation. For Picasso and de Kooning, this passion takes the form of a violence that seems intended to release them from a power of the feminine that is perceived as threatening. This confrontation with the feminine is also a confrontation with the feminine part of oneself. If this dimension weren't there, some aspect of the artist's universal message would be absent. Men are often less at ease in speaking of the female universe, which has connotations of passivity and castration. Nevertheless, this female presence in their work is a guarantee of its complexity.

Sunday Afternoons: A Conversation and a Remark on Beauty

LOUISE BOURGEOIS

I. A Conversation

(My conversation with Louise Bourgeois took place in her home in the Chelsea area of Manhattan on three Sundays in the summer of 1997: July 20, July 27, and August 10. We sat at a little table in a back room filled with books that opened to a garden. —Bill Beckley)

Louise Bourgeois: Beauty? It seems to me that beauty is an example of what the philosopher's call reification, to regard an abstraction as a thing. Beauty is a series of experiences. It is not a noun. People have experiences. If they feel an intense aesthetic pleasure, they take that experience and project it into the object. They experience the idea of beauty, but beauty in and of itself does not exist. To put it another way, experiences are sorts of pleasures that involve verbs. The fallacy occurs in taking the experience "I like X" and referring to "X" as beauty. The process is similar to what T. S. Eliot said of Wordsworth, "Wordsworth found in stones the sermons he had planted there." In fact, beauty is only a mystified expression of our own emotion.

Bill Beckley: That's very well said.

I.B: You don't have to thank me, because it was said by art historian Jean-Louis Bourgeois. But the thanks is justified, in any case.

I have here a demonstration, a visual, tangible demonstration that beauty is learning, understanding, solving problems, and a reward of effort. So I am going to show it. That is to say, it is to transform chaos into harmony. Obviously we have no visual record, so I will have to. . . .

(The phone rings.)

LB: Hello. So we had a telephone appointment. Thank you for being on time. . . . So beauty is what stirs the heart? Could you be a little more explicit and give examples? Examples please. . . . A beautiful woman, a beautiful building, a beautiful cloud. . . . But this is only visual, you might say that I am much more moved by music. . . . So, can you say a little bit more? That is, what does it have to do with sensual pleasures? . . . They are not pleasures of the senses, they are pleasures of the soul. . . . All right then, a definition of *soul* will be needed. . . . Well, you are putting the woman on the clouds—a beautiful idea, but this is a different theory. . . . It is butterflies in the stomach? . . . Intellectual satisfaction? Intellectual satisfaction may be satisfying, but it is not beautiful. I have to say that if I see a beautiful woman on the street, it doesn't mean that there is much effort on my part. . . . So you convinced me, but to convince somebody is not necessarily beautiful. However, the expenditure of your efforts was successful.

(Click.)

BB: Who was that?

LB: His name is Alain.

BB: If you want, I can take a photo of the letters.

LB: That would be good. They have to be seen without anything else. (She arranges the letters slowly.) This is an *L* . . . this is an *O* . . . this is a *U* . . . this is an *I* . . . this is an *S* . . . this is an *E*. It spells, Louise. So there is meaning in this pile of letters. It has a symbolic value and it is a re-creation of the past. You see that it says Louise, but it first spelled, in fact, Louis. It was something that was important in my childhood, because these letters formed the name of my father, and

they were put on the door—Louis Bourgeois. This is not Louise it is Louis. And every time you wanted to talk to my father, you would see this on the door.

BB: Do you remember the address of this door?

LB: Yes, 174 Boulevard St. Germain, which is next to Les Deux Magots and the Café de Flore, right there. This a reconstructed past. So you see, when they are all together they mean something, and they have to find their own place. For me, it shows that beauty is an intellectual thing, but it is also very visual. So you cannot say that when all this is mixed it is only a mess. It has the possibility of meaning.

Proust said on Sunday mornings, when eating a madeleine, memories came back to him. It was the smell, the sweet smell and the taste of the madeleine (the little scallop-shell of pastry, so sensual under its severe, religious folds) that made them come back.

But, of course, music is terribly important also. In hearing, there is also the sense of touching, in the sense that the piano player touches the keys. Hearing has the most power. A king of Spain, who was a little insane, could only be brought to reason by listening to the very high voice of a certain male singer—a castrato. Beauty of the ear kept him sane; well, perhaps not really sane, but at least not dangerous.

But, for me, it is the visual that counts most. In the visual you have the symmetrical and the asymmetrical—very important. Color comes later. I make a drawing and then I discover what I meant in the drawing. It is the opposite of imitation. You don't have a conscious intent when you start out. No, it is totally unconscious. I am a sculptor. You can have blind sculptors because touch is so important.

BB: At the Brooklyn museum you did some very large boxes.

LB: They were reconstructions of the past, of past experience. Yesterday we were shooting a film with some actors replaying some scenes of my infancy and my relationship with my father, through which I learned so much. The recollection was so vivid. By reconstructing these things, I worked with memories. Memory is not one of the five senses. Memory includes all of them. The movie is a reconstruction of a whole life.

BB: You were born in France, but you have lived a long time in the United States. What is the difference between the aesthetics of the two countries?

LB: I'll tell you a story about my mother. When I was a little girl, growing up in France, my mother worked sewing tapestries. Some of the tapestries were exported to America. The only problem was that many of the images on the tapestries were of naked people. My mother's job was to cut out the, what do you call it?

BB: The genitals?

LB: Yes, the genitals of the men and women, and replace these parts with pictures of flowers so they could be sold to Americans. My mother saved all the pictures of the genitals over the years, and one day she sewed them together as a quilt and then she gave the quilt to me. That's the difference between French and American aesthetics.

* * *

Here the beautiful changes for me from day to day and I am divided between the rational and the emotional. I am a total rational person, but prone to ecstasy, like religious ecstasy. I forgive people their religious ecstasy, but I feel sorry for them. Are you a religious person?

BB: We baptized our son Tristan on the Epiphany, January 6, 1996. It started to snow, the greatest snowstorm in New York. My Uncle Bob, a retired Air Force chaplain, flew in from Alabama for the service. He was stranded at my house for three days. We sent him off in a cab at three o'clock in the morning. Newark Airport was deserted at that time of night; there were only three other men there, three Episcopal bishops who had just returned from Bethlehem. . . .

LB: We are not talking about religion.

BB: There is also the darker side of life where perversity plays a part. Is there a connection between perversity and beauty?

LB: No, no, this is not my idea. Beauty is a positive thing.

BB: The surrealists were interested in perversity, weren't they?

LB: I cannot talk about surrealism, because it is not my period. I cannot spend my time talking about people who have nothing to do with me. If I talk about André Breton and the surrealists that I knew very well, since they were in New York, I would not talk about them because I do not have much positive to say.

BB: There is quote from Breton, "Beauty will be convulsive, or will not be."

LB: I consider this remark a pun, or in any case, not serious.

BB: You have used sexual metaphor in you work, haven't you? You have used imagery that is very phallic. I mean this in a positive sense, though there has been much suspicion of the phallic as of late. You claimed it as *your* territory, in your sculpture as well as that beautiful portrait by Robert Mapplethorpe where you are holding a hairy black phallus.

LB: This is an unconscious part of me. I don't know it well, but my unconscious is pretty wild. And that is why at a conscious level I am so much in love with rationality. That is the economics.

BB: I was criticized for photographing faucets next to a drain, because of their phallic nature. Maybe it's easier at the moment for a woman to use phallic imagery than for a man to use it.

LB: That I know, but since I am a woman, I am not going to answer a question about how men feel. I cannot answer that. I am not qualified. This is not my cup of tea. I have enough of a time being a woman without being something else on top of it.

BB: On the cover of your new book of drawings there is something very feminine, a rainbow-colored oval.

LB: Are you asking what the metaphor of the oval is? I never had a chance to say that. An oval means a lot of things—very important to me. The circle is a one-centered thing, but the oval is my favorite image because it involves two centers. An oval is two. An oval from the beginning is a metaphor for a twosome. Two centers, two entities.

* * *

BB: We met briefly in 1974 at the 112 Greene Street Gallery. You did this incredible piece called *The Destruction of the Father*.

LB: Yes, that's right. It upsets people because it's aggressive. If you look at that piece, you see that the children are devouring the father. Usually, in antiquity, it is the father that devours the children. This time it is the other way around. I reversed it and it is a revenge. It is the children who are devouring the father. I like my father, but I still like that piece very much.

BB: Some people might have seen it in the context of minimalism, which is very cool—masculine. *The Destruction of the Father* was really crazy, a rebellion against minimalism—Dionysian.

LB: But of course; any work of art worth its soul is subject to many interpretations. It is important if it arouses people in very different ways. This is the richness of interpretation. I don't mind.

BB: At that point, in the early seventies, the question of making something beautiful really didn't come up very much. Beauty was the by-product of an activity, the result of a tension between the classical and the contemporary. I remember Gordon Matta's tray of mold, and Raffael Ferrer's piles of leaves—beautiful.

LB: Yes, Gordon was the center of that group, wasn't he? What did you think of Fluxus?

BB: I liked Fluxus.

LB: Did you know them?

BB: I didn't know them personally.

LB: They say that Fluxus had something to do with surrealism.

BB: Well, I was afraid to mention it, after your previous reaction to surrealism.

LB: I knew the Fluxus here, personally.

BB: They certainly were antivisual.

LB: Yes, certainly. They were smart alecks. Absolutely ridiculous. Smart alecks. You are not a smart aleck. You know my English is not very good.

BB: Fluxus was before my time. The first person I met in New York was Vito Acconci.

LB: Yes, he is very ambitious; he will do anything to be interesting. He is something quite special.

<p style="text-align:center">* * *</p>

BB: What would a feminist have to say about beauty?

LB: First I must ask *you* some questions. What do you mean? Do you mean passive or active beauty? There is a difference between the two—being looked at because you are beautiful is one thing, but as an artist, you must create beauty.

BB: Perhaps we have been under the mistaken perception that if you are beautiful it is difficult to *make* beauty.

LB: Sure, that's a problem. Just look at Cyrano de Bergerac. He was ugly as sin. But he had the talent to write all those beautiful love letters. Ugly as sin—that's probably a very puritanical concept. But I will give you another example: Beauty is the ability, through your talent, to please the man you love. But it depends on a very important condition. That condition is that the talent exists. I had a friend, I can't remember his name at the moment, but it will come to me. He said he took an art class with thirty other students. All his life he had wanted to make a dif-

ference. After a while he realized that some of the students in the class were much better than he was. When he came to this conclusion, he decided to take another path. He became an art dealer. And here is another example, *le désir de plaire,* the desire to please. And what about your child? He wants to please you to show that he loves you. If he knows you like the color blue, he will put the color blue all over his drawings.

BB: I guess part of the confusion is that beauty can describe both art and people. Some people don't want to be thought of as *objets d'art.*

LB: Yes, and you can have a beautiful dog too.

BB: What about the influence of so-called primitive art in your work?

LB: What are you talking about? You changed the subject. I thought we were talking about beauty, not the primitive. The primitive is irrelevant to our discussion. In any case, there is no influence. To call something primitive has moral implications. "I am civilized, you are primitive." As I said, I am not concerned with the moral, I am concerned only with the visual. What would it mean to have a primitive smell, to have smells that you thought were primitive? Do we have musicians that we call primitive? Do we have music that is primitive? If it is strange to have *primitive* sounds and smells, why use the word for art? In any case, if you have an artist who likes the primitive, it doesn't mean he has to *be* primitive.

BB: I'm sorry, maybe we did get off the subject. I guess I was thinking about it because of the debate in the book between McEvilley, Rubin, Varnedoe. You like Bill Rubin don't you?

LB: Of course I like him, he gave me a show at the Museum of Modern Art, didn't he?

BB: You were also in the *"Primitivism"* show at the Museum of Modern Art in 1984 too, weren't you?

LB: Yes.

* * *

BB: Keats wrote of "Beauty and Truth." Thomas Mann linked beauty with death. With what do you associate beauty?

LB: Well, first it is much bigger than that. It goes back to Shakespeare doesn't it? Even further? You should get the quotes from Shakespeare. What about *Romeo and Juliet*, and all the others?

BB: Do you associate sex with death?

LB: Never. I associate *that* idea with repression and guilt. Beauty is associated with love, isn't it? Maybe it's a religious thing. Christ died because of his love. Perhaps it is a religious tragedy.

BB: My friend David Shapiro said that you are the greatest living artist. The first time I had dinner with my wife Laurie, who is a sculptor, she brought along the catalogue from your show at the Museum of Modern Art. My students at the School of Visual Arts (SVA) regard you as a goddess in the way that we regard Andy Warhol as a god. Young people look up to you. What would you say to them about the possibilities for art?

LB: What age?

BB: Seventeen, eighteen, nineteen, twenty, twenty-one. . . .

LB: That young? They should know that they can make a living without the burden of selling their work. That they can put their work away, the way that I put my sculptures away in Long Island. It took twenty years to show this work. I would say that they have to be ready to wait twenty years without selling their work. They need to have a way of making a living. Indispensable. I would say to the girls, go to school, and insure yourself a modest but steady living. It's very difficult to live in New York, but people like to stay here. I taught at SVA in the print department in 1973. Things were different then, I traded copper etching plates for pot. SVA means a lot to me.

BB: When did you come here from France?

LB: In 1939.

BB: Do you want to go back?

LB: I am not interested in going back. I am not interested in traveling. I am only interested in remembering.

BB: I liked the part about the fallacy and the phallic.

LB: Yes, that's very good. They are similar in many ways. And the madeleine, don't forget the madeleine.

II. A Remark on Beauty

In my sculpture, it's not an image I'm seeking, it's not an idea. My goal is to relive a past emotion. My art is an exorcism, and beauty is something I never talk about.

My sculpture allows me to reexperience fear, to give it a physicality, so that I am able to hack away at it. I am saying in my sculpture today what I could not make out in the past. It allows me to reexperience the past, to see the past in its objective and realistic proportions.

Fear is a passive state, and the goal is to be active and take control, to be alive here and today. The move is from the passive to the active, for if the past is not negated in the present, you do not live. Since the fears of the past are connected with functions of the body, they reappear through the body. For me, sculpture is the body. My body is my sculpture.

In relation to viewing as opposed to creating, I experience beauty in an oscillating manner. First, I see beauty in the intellectual operations of the mind—perfection in logic, learning, understanding, and convincing. Second, the pleasure principle can produce beauty through the body, the heart, and our five senses. For example, the flirtatious gaze or the touching of the skin can generate an almost electric current. There is also the smell of the garden in rain. In music or in someone's voice, an echo may reenact an emotion of a distant past. These rare memories may also be beauty.

As my brain experiences the duality of subjective and objective, my sense of beauty swings between the two. I refuse to choose. I am a woman of emotion who still pines to be a woman of rationality. I am torn between the two, and I have learned to accept them both.

To seduce is a harmonious merger of the two, and it is the greatest art of all. Sculpture, which is my *raison d'être*, is motivated by my obsessive, unsuccessful attempts to seduce. Uncontrollable beauty is in the effort to seduce one through my sculpture. It is *le désir de plaire*. Art comes from the inability to seduce. I am unable to make myself loved. I am still motivated by an attraction to "the Other," which is a mysterious beauty. Seduction is a form of convincing. I am the indefatigable seducer. Beauty is the pursuit of "the Other."

LOUISE BOURGEOIS
August 23, 1997

Sentences on the House and Other Sentences

John Hejduk

1. A woman lives in the house; she has taken its name.
2. A house knows who loves it.
3. An empty house is one that metamorphoses into vacant space.
4. The breath of a house is the sound of voices within.
5. I sense I am leaving you.
6. I loved you in/a/way.
7. Forever is everfor.
8. Maze Gods the soul.
9. Maze guards the body.
10. The house is a nocturnal thing, this is seen from the outside, when the lights are turned off.
11. The house is like a black cat at night, only a silhouette.
12. A house roams at night, when its occupants sleep.
13. Night dreams are accelerated in fixed rooms.
14. Day dreams blank out light.
15. The yawning of a house comes from the excessive sound of its inhabitants.
16. The house likes the weaver, it remembers its early construction.
17. The sister of a house is its garden.

18. When a house is sad its glazing clouds over and there is no movement of air.

19. The house never forgets the sound of its original occupants.

20. A house's ghosts stay inside, if they leave and go outside they disappear.

21. A house is only afraid of gods, fire, wind, and silence.

22. A house's blood is the moving people within, when they still-stop.

23. A house is seen crying when it sheds its rain waters.

24. The gods are jealous of the house, because the house cannot fly.

25. The stairs of a house are mysterious because they move up and down simultaneously at the same time.

26. Snow is female, icicles male.

27. A house fears the wind and is afraid of trees.

28. A house carries its own weight, also the sorrows within.

29. Lightning is the house's direct connection to the heavens.

30. God gave man two houses, his body and his soul.

31. All souls implode when a woman dies. It is then when man's heart disappears.

32. The sanctuary of a house is the closed room.

33. Man gave names to rooms, God gave the space.

34. The sound of a house is its distant lament.

35. The furniture of a house is the silent witness of man.

36. The house doorknob inverts time.

37. The aroma of a room is defined by woman's presence and by her absence.

38. A house's shadow proves its dark two-dimensionality.

39. A house's calendar is its internal falling leaves.

40. Crawling vines on a house hints at its agelessness.

41. When a woman's dress falls on the floor of a room God hears it.

42. The birth of a house is from a female.

43. To dance in a house is forbidden fruit.

44. A house awaits letters.

45. A house's windows yearn for the sun.

46. Frosted windows are the drawing boards of a house.

47. The porch of a house mediates between nature and building.

48. A house lies in state during wars.

49. Flowered wallpaper within a house makes the house feel an unease.

50. Locked doors within a house mean either joy or horror.

51. The stone floors of a house in winter send a chill to all extremities.

52. The thoughts of a private house should be kept secret.

53. Heat rises in a house in order to return to mother sun.

54. God named house.

55. The soul of a house is its soul.

56. The awnings of a house indicate a house's sorrow.

57. Moonlight within a house is the darkest light imaginable.

58. A house wakes up in the morning and smiles at the bird feeder.

59. Night stars are an indication that it is snowing in the universe.

60. A red dawn makes the house drowsy.

61. A house plays with the lake through its reflections.

62. The wind blows the leaves off a tree because it wants to see it naked.

63. Moonlight reveals to the house that other houses have souls.

64. A house closes its eyes when it is being renovated.

65. A house knows that there is inevitable surgery in store for it.

66. Tree roots are relatives of a house's foundation.

67. Illuminated clouds are God's quiet thoughts reflected.

68. A woman unfolds as a house of many rooms.

69. A woman moves through the house as angels move through the air.

70. When a woman combs her hair a house becomes entirely silent.

71. The carpets of a house are the slippers of a house.

72. A woman washes her body as moonlight washes a house . . . softly.

73. A woman's voice is as varied as a long day's light in a room.

74. When a woman washes the glass of a window she washes away God's discarded thoughts.

75. A woman's lips close as the curtains of a house close to be opened in the dawn.

76. A cat in the house is the silent surveyor.

77. The books in the library of a house age with the inhabitants of the house.

78. When two lovers speak in a room the air listens.

79. The bookshelves of a house store past and present loves and wait for future volumes.

80. A bowl of fruit on a table in a room adds a touch of volumetric pigment.

81. She wrapped her arms around the round wood column and imagined the earlier tree.

82. A thatched roof is the house's shawl.
83. A woman's eyes looking through an open slat of a shutter make the peacock's eyes plausible.
84. The hands of the old painter gripped the wood handrail in order to support his solid vision.
85. The studio of a painter is for painting and other things too.
86. The painter embalms death.
87. When a woman rocks a child in her arms death becomes bewildered.
88. When a woman blows a kiss in a house . . . it lingers. . . .
89. The eyes of the players of a string quartet meet in a room and exchange themselves and their hearts.
90. A house is born, lives, and dies and is named house.
91. The house gains immortality when it becomes only a thought that ceases to exist.
92. God punishes the house by withdrawing its time.
93. Snakes enter a house in order to escape God's wrath.
94. Wild geese fly in a triangle to puncture the clouds.
95. The heaviness of the granite stones of a house comes from the stone's absorption of the house's melancholy.
96. Moisture on the stones of a house forms from the house's fear of fog.
97. Curtains of a house are its veils, when removed a glimpse of a house's nakedness is revealed.
98. A house is a woman's sexual collaborator, filled with private thoughts.
99. Air is invited in when a woman opens a window.
100. Books are female, a mysterious ritual are within them.
101. The sound of books can only be heard internally.
102. An abandoned house is God's warning and death's forsakeness.
103. A woman moving down a stair in a house is slow-determined.
104. The earrings of a house are the suspended flowerpots on a porch.
105. The spider webs on a house are the cataracts of the house.
106. The tablecloth is thrilled by the touch of plates and awaits further violations.
107. The china closet senses all the lips that have touched its inhabitants.
108. The house acts as the recovery room for broken cups and soiled antiques.
109. The cellar is the bowels of a house, it collects all wastes and discarded time.
110. The bed in a house promises future joys and remembers past sorrows.

111. A forlorn house is a house without a woman.

112. A woman moves her fingers over the surface of a pewter jug and thinks of man.

113. A house is suspicious when an armoire is introduced to an unfulfilled room.

114. A sudden draft in a room is from the sigh of the house.

115. A house wants to be alone with a woman intimately.

116. A house contemplates the internal thickness of the fruit in a bowl.

117. Candlelight is the house's passing thought.

118. Hail falling on the glass windows of a house is the suicide's afterthoughts.

119. Angels carry soulfilaments on their wings.

120. The house searches for its lost occupants.

121. The house objects to the sea's fluidity.

122. The sea coaxes the house into its undertow.

123. God created house to contain man's sins.

124. A wall anticipates nails being driven into it—paintings cover the punctures.

125. The knife and fork distanced man's tactility.

126. A floor carries all the house's vanished footprints.

127. The sudden appearance of a woman in a door frame takes the breath away.

128. The bowl receives the soup as a celebration to all concavities.

129. Milk flowing from a pewter pitcher hints at a woman's thought . . . fluid, metallic, opaque, rich, silent movement.

130. When a woman wraps a long scarf around her neck the nineteenth century comes into view.

131. A woman reading a book is different from a man reading a book.

132. Dusk is woman's possession of the house.

133. A house blushes when a woman pins up her hair.

134. Wallpaper is the house's internal dress.

135. The house receives hidden letters, photographs, and secret thoughts.

136. Drawers containing silk garments are the coffins of past sins.

137. Clothes hanging in a closet are collapsed volumes.

138. A woman writing at a desk is the house's three-dimensional painting.

139. The rulers of a house are its mirrors, time is measured and judged.

140. A polished marble table feels like the skin of a plum and of other skins too.

141. A ceiling fan keeps angels from entering a room.

142. A house feels pleasure when a woman ties a ribbon in her hair.

143. Curtains blowing in a room are caused by the kiss of the wind.

144. Moldings hide the wounds of a house.

145. The leaves of the mimosa tree close their eyes at night.

146. A woman bites at the sewing thread as a cat bites at the neck of a bird, ferocious joy.

147. A woman hums day's soul away, and welcomes night's silences.

148. The painter is God's photographer.

149. The buds of spring push up through the earth as fingers of dead life.

150. God flattens three dimensions into the surface of a canvas to still life.

Sentences on the House and Other Sentences II

1. Death waits living on our time.

2. Our death is outside of us.

3. The death of a house in announced by the only standing structure; the brick chimney.

4. The attic of a house is where children go and where death hides.

5. The roof shingles of a house absorb God's heat during the day and death's chill during the night.

6. The height of a door of a house is for man's entry, the width of a door of a house is for man's exit. One dimension for life, the other dimension for death.

7. Death demands that houses have windows so that he can see simultaneously day and night.

8. Death is pleased when man cuts flowers; he sees the act as a premonition.

9. Death is nothing compared to life.

10. Death hates film negatives.

11. We never see the last card of death until it is over.

12. Death inculcates us with dread, then erases the r.

13. Death argues with God about the vertical while man lies horizontal.

14. Death's favorite color is the rose.

15. The poet's words are incomprehensible to death.

16. The house welcomes death after it has lived its life.

17. Death asked God for his house.

18. Death glides on the hinges of house doors.

19. Death covers his bones with wet plaster in order to lubricate his dryness.
20. The closets of the house enclose the cloth of death.
21. Death is monochromatic, as Hawthorne's soul.
22. The noise of death is the whispers in other rooms.
23. Death knocks on the entry door of a house when the sound is not to be heard.
24. Death is always jealous of woman.
25. Death rests under the footings of the house.
26. The mirrors of a house are covered by death.
27. Death is disliked because he takes away breath.
28. White walls of a house make death vague when death is naked.
29. Death's laugh becomes man's cry.
30. The threshold of a house makes death pause.
31. A house is preparation for death in that it encloses.
32. The floors of a house are washed and polished in order to make death's blood soft.
33. Skylights are built for winter flowers which death cultivates.
34. Flowers in a room have two purposes, to sweeten life and death.
35. The windowsill prevents man's fall and assists death's entry.
36. A drapery is the shroud of a window.
37. The window shade is death's sign.
38. When dogs bark at a corner in a room they provoke death's triangle.
39. Mirrors become opaque at the moment of death.
40. To live with death is possible, to live in death impossible.
41. With a death a house changes forever.
42. A wreath on a house door announces Christmas and death.
43. Death perches on the peak of a house's roof.
44. The shutters of a house of a suicide are always closed.
45. Cold air slips under the door of a house as a sense of future deaths.
46. Singing within a house arouses angels and makes death wait for a moment.
47. Death implores the house to open its doors.
48. The house can hear death by its total silence.
49. The sun is a friend of death in that it bleaches the color out of a house's paintings.
50. When a woman smiles in a house, death tries to imitate her.

51. Death's painting in a house is a still life.

52. A sudden death shows death's impatience.

53. A rocking chair in a house induces death to be quiet.

54. The sighing of a house makes death change direction.

55. The first nail driven into a wood post of a house makes death rejoice.

56. A house waits for daylight as death waits for darkness.

57. Moonlight and death are the sisters of the afterglow.

58. The bird of death flies through the wallpaper of a plum-colored room.

59. When death sleeps the earth dances.

60. God banished death from his house in order to see the light.

61. Death's skull is the house of black birds. They enter the house through the eye sockets.

62. Death brought the color of black to earth's houses.

63. Death needed black cloth to cover the whiteness of his bone.

64. White is the undercoat of death's house.

65. Death builds his city underneath.

66. Death scrubs the body until it looks like him.

67. God takes everything above the earth. Death takes everything below the earth.

68. A flower vase becomes life. A funeral urn becomes death.

69. When it snows, Death requests his black cloak, he believes in the extreme condition.

70. God threatens the fires of hell when he becomes sad with the earth.

71. When a man builds a house God overwatches, when a man destroys a house death undersees.

72. Death is only structure.

73. Death wants the skin of the house.

74. Death's lifelong workshop is man's body, God's man's soul.

75. A woman stares at death's skull until the eye sockets of death are filled with blood.

76. A woman holds death's skull to her breasts until death softens.

77. A woman invites death into the house then proceeds to break his bones.

78. A woman puts death's cloak on in order to whiten her skin and darken her eyes.

79. A woman forces death's teeth open with the stem of a rose.

80. Death makes a wreath of roses and rose stems . . . blood red.
81. Death watches the wild geese trapped within the arabesque of the wallpaper.
82. Death's dimension is one.

Aunts

MAX FIERST

> tell us, can't you, are there any
> stars, inside your black fedora?
>
> —Elizabeth Bishop, "Exchanging Hats"

Thumbing through role models, I suddenly knew
I would never, in a googolplex of millennia, wish
To be either of my aunts, and knowing
Who I will not be, who I am became new,
Baptized like a window scrubbed for spring.
Still, I am not done with you, weird ladies, I've new
Cells every seven years, but problems don't turn new.
As we age, we boil down but stay the same-
Type stew. Dear aunts, dissimilar, am I the same
As you? Inescapably the self I never knew?
Two American women, strange to be
Each other's in-laws, Xs in the math of who I am,

When I slid out, easy as a fish, and was
In the doctor's hands, a creamy lump, brand new
In rubber gloves, crying my own tune, it seemed I was
A putty replica of my Aunt Sandy. I was
"Just like her," everybody said, as wishes
Are like prayers, or to mirror is to be.
Or for a sliver of a nanosecond, I *was*
Her perfect doppelgänger, my clockwork springing
With a whir the same pitch as hers: clone buds in spring
Who unfold in summer, destined to be
Different as operas of notes, from operas of soap. The same
Atoms woven as grass in us no longer seems the same,

And I no longer feel a bit the same
As you or the Play-Doh effigy I was.
You're sweet and kind, but plain as potatoes, the same
Day after day after day, like reading the same
Times, until one's eyes are dyed black and white by the news.
I switch opinions like exchanging hats—the same
Kango of dogma I treasured on Monday, by the same
Time next week, will be traded for a crown of wishes
Or a laurel of doubts. I could only wish
To be as sure as you—ethics always fitting the same.
But life is like a double dream, and spring
The moss upon the rock. If from the rock's red core a spring

Would gush to quench my thirst, I could have faith like you and spring
Into action, lotus from Vishnu's navel. All the same,
I would never write a poem. Doubt is the spring
In my gears, the foul-mouthed fountain from which springs
Dreams and tears. Sadly, to be or not to be
Is an anthem which hoarsens the throat and dries the spring.

But my other aunt is a snob *sans* taste (winter judging spring
As being unseasonably warm, brilliant, and new).

Draconic, she judges without justice. When I was new
In my crib, her now ex-husband, a Barbie doctor, sprung
It on my mom that if (*like hell!*) she wished,
With a nip here, a tuck there, I could be pretty as a wish.

Aesthetics without empathy is like the obscene wish
Of a child who craves eternal spring.
His hopes dashed, he spends his life ruining others' wishes.
Dear aunt, you're cruel and cold as pennies in a wishing
Well, if you don't feel a pang upon your heart—the same
For others' spoiled hopes as for your own moldy wishes.
I too can be a snob, but I have no wish
To end like you, judging people's souls upon their teeth. To be
The sort of fool who values time by surface is
To be the fool who wakes to find life a foiled tinny wish.
Dear aunt, we all suffer as you do. I know
Life is disappointing, but hope and kindness make each day new.

Thumbing through role models, I suddenly knew
My aunts and, knowing them, knew my wishes,
The wishy-washy and the changeless, reliable as crocuses in spring.
In the spring of my life, I found I was not the same
As those two autumn ladies, and that I was the same,
 knowing I am that I am.

———————————

On Beauty

KENNETH KOCH

Beauty is sometimes personified
As a beautiful woman, and this personification is satisfying
In that, probably, of all the beautiful things one sees
A beautiful person is the most inspiring, because, in looking at her,
One is swept by desires, as the sails are swept in the bay, and when the body
 is excited
Beauty is more evident, whether one is awake or asleep.
A beautiful person also suggests a way
To be at one with beauty, to be united with it, physically, with more than our eyes,
And strange it is, this tactile experience
Of beauty, and the subject of many other works. The first beauty one sees
That one is conscious of as "beauty," what is that? Some say
"The mother's face"—but I do not think
The baby is conscious of anything as "beauty"—perhaps years after
When he looks at Carpaccio's Saint Ursula, he thinks of "mother"
Subconsciously, and that is why he finds her *"bella—*
Poi anche bellissima," as he says in Italian
To the guard or fellow-viewer at his side. The guard smokes a cigarette

Later, on the steps of the palazzo, and he gazes at the blue sky,
And for him that is *bellissima*. Perhaps the sky reminds him
Of someone's eyes. But why is that, this human reminder,
If that is what accounts for beauty, so enchanting? Like a thigh, the island of Kos
Is extremely lovely, as are many other Greek islands—Lemnos,
Poros, and Charybdis. We could sail among them, happy, fortunate
To be in such places, yet tormented by an inner sense
Of anxiety and guilt, beleaguered by a feeling we had torn
Ourselves from what is really important, simply for this
Devious experiencing of "beauty," which may be nothing but a clumsy substitute
For seeing our mothers again. But it is not that,
Not a substitute, but something else. There is no going backwards in
Pleasure, as Hemingway wrote, in *Death in the Afternoon,* speaking of Manolete
Who changed the art of bullfighting around, and there is
No going backwards, either, in beauty. Mother may still be there,
In dimity or in nakedness even, but once you have seen Lemnos
It is all over for mother, and Samos and Chios and Kos, and
Once you have seen the girls of your own time. Perhaps one's earliest experience
Of beauty is a sort of concentrate, with which one begins,
And adds the water of a life of one's own; then
Flavors come, and colors, and flowers (if one's
Mother is Japanese, perhaps), mountains covered with flowers, and clouds
 which are the
Colors of blossoming trees. One cannot go back to a
Nightingale in the hope of getting a "more fundamental
Experience" of it than one has gotten from Keats's poem. This
Schema is not impoverishing but enriching. One does
Not have the Ode instead of the bird, one has them both. And so
With mother (although mother dies), and so with the people
We love, and with the other things of this world. What, in
Fact, is probably the case is that the thigh
And nose and forehead of a person have an interchangeable
Relationship with landscape; we see
The person first: as babies we aren't tourists, and our new-flung eyes
Are not accustomed to looking at mountains, although

Soon we see breasts—and later see the Catskills, the
Berkshires and the Alps. And as we were moved by breasts before
We are moved by mountains now. Does that mean the
World is for us to eat? that our lives are a constant re-
Gression? Or "Plato inside-out"? Or might it not mean, as
I have suggested, that we are born to love either or both?

Beautiful, Charybdis, are your arms, and beautiful your hands;
Beautiful in the clear blue water are the swift white-tinted waves;
Beautiful is the "starlight" (is there any light there,
Really? We may come to the question in a while of whether
Beauty is a reflection); beautiful is the copy
Of Michelangelo's David, and the original; beautiful the regatta
Of happy days one receives, and beautiful the haymow
From which the birds have just flown away. If they
Have left some eggs there, let us go and look at them
To see if they are beautiful as well.

If all these things are carryovers from mother,
Then mother is everywhere, she completes our consciousness
On every side and of every sight we see. We thank you, mother,
If that is so, and we will leave you there at the beginning of it all, with dad.

It is always a possibility that beauty does not exist
In the realest sense, but that is just as true of everything else,
So in a way it does not modify this poem but actually strengthens it
By being a part of the awareness that puts it together.

Beauty suggests endlessness and timelessness, but beauty
Is fleeting in individual instances, though a person's
Or a landscape's beauty may last for quite a long while.
It is worth preserving, by exercise, good diet, and other
Ways of keeping in good health, and in the case of
Landscape, careful gardening, and good, enforceable zoning and
Antipollution laws. Even though it may cause desperation

In the abstract, the thought that "beauty is only for a day,"
So to speak, in individual instances it need not. A good
Night's sleep and wake up happy at all that is beautiful now
Is the best remedy. It is just a quality of beauty that
It comes and it goes. We are contented with the ocean's
Being that way, and summer, winter, fall, and
Spring also leave and return. If beauty does not return
In all cases to the same objects, we must simply be alert and
Find it where it has gone. Every good artist knows
This, and every person should know it as well, its being
One thing one can learn from art, and of course as I said
From close study of nature—though art is sometimes easier
To learn from, whether one is viewing it or creating it.
People, of course, are often depressed,
Despite philosophy and art, about the loss of their own
Beauty, and it is a fact that once one has something
To no longer have it is a sorrow, and there is nothing
This poem can do about that. On the other hand,
You participated in it for a while (for twenty or for
Forty years) and that is pretty good. And there it is,
Shining in the world. Your own exterior is, after
All, just a tiny part of that.

Beauty quite naturally seems as if it would be beautiful
No matter how we looked at it, but this is not always true. Take a microscope to
Many varieties of beauty and they are gone. A young girl's
Lovely complexion, for example, reveals gigantic pores, hideously, gapingly
Embedded in her, as Gulliver among the Brobdingnagians observed. And
Put some of her golden hair under the microscope: huge,
Portentous, menacing tubes. But since
Our eyes aren't microscopic, who cares? To have an
Operation to make them so would be insane. A certain
Sanity is necessary for life, and even our deepest studies need not
Carry us beyond a certain place, i.e. right here, the place
Where we would get microscopic eyes. Nor is it necessary to

Pluck out the eyes of an animal (a dog, say) and
Transplant them for our own, so we can see
Beauty as a dog sees it, or as a kangaroo or as a rhinoceros.
We do not know if animals see beauty at all, or if
They merely see convenience and sex, a certain useful log here or there a
Loyalty-retaining moving creature. I do not think we need to know,
Physically, in our own bodies. To give up our human eyes,
And indeed our human brain, for those of a horse or lion might
Be fantastic to write a book about, but then we would
Never know anything else. I suggest, instead,
Walking around beautiful objects, if one can, for that
Is sometimes very pleasant and reveals newer and, if
That is possible, even more beautiful views. One's first view
Of the Bay of Baia, for example, may be improved
Sharply by the view from a boat coming into the harbor or
From the Hotel Shamrock on the mountain's peak. First sight of a girl
Is often one of best ones, but later, sighing above her in bed,
She is even more beautiful. And then in A.M. waking you up
With a happy alarm. Who would want microscopic eyes at
Such a moment? or macroscopic ones, for that matter, which would make
Your girl look extremely tiny, almost invisible, like an insect
You might swat, if you weren't careful; and you would feel
Funny, wondering how someone so small
Could make you feel so happy; and it would be so hallucinatory, to
Go to bed with her and hold her in your arms, for unless you had
Macrotactile arm and hand nerves as well, she would
Feel as large as you are, almost, and yet be so small! You
Would think you were stoned on something monstrous. I think
The proportion between eye and nature, then, is, as
Far as beauty goes, the most important proportion of all.

Like your own eyes, it is probably best to accept your own culture
In responding to what is beautiful. To try to transform yourself
To an Ancient Mesopotamian or a Navajo priest
In order to decide on the beauty of a stallion or a

Stone jar could end up being an impediment to actually seeing anything. Some
Knowledge is helpful, but you should exercise reason and control.

In general, any sort of artificial aids
To looking at something may be an impediment to beauty
Unless you are so thoroughly accustomed to them that
You do not know they are there. So a telescope,
When looking at the Valley of the Arno for the first time, may not
Give the pleasure you might get from your naked eye,
Even if your eye did not enable you to see things in
So much detail. Eyeglasses can be annoying at first, as
Well, and even such a slight thing as a map, looked at
Too closely, can keep you from enjoying the landscape it explicates.

Naturalness, important in the looking at beauty, is also esteemed
A main characteristic of the beauty of what is seen.
"Naturalness" is difficult to define, though one knows what it is
When one sees it. Greek statues, for example,
Are both more beautiful and more natural-seeming
Than the people in the harbor of Lemnos, or more natural in
A certain way. One says of a certain statue
"How natural it is!" but does not praise Astrovapoulos the butcher
Or Axanthe the waitress in the same way. It may be
It is because it would seem foolish to praise a living
Human creature for being "natural," but we do praise some—usually children,
Or famous or prestigious people one would not expect
To behave like everyone else, or great beauties who do not
"Put on airs"—those we'd expect to be stiff, but
Who are not, except in the case of children, but
Them we seem to be comparing to our stiffer selves. Statues,
Which are expected to be rigid, may have a strange appearance of motion
And ease. And in dancers one admires the same contrast
Between rigidity and movement. Where does this leave us
As we look at the ocean, then? It too is both frozen and mobile. Without the tides
It would probably be a great mess. And in a girl

Naturalness is real breasts and a warm, attempting smile,
Combined with bone structure and a good complexion. Pimples, however
Natural they may be, are rarely praised as such. Nor are
Snoring people or the deaf, though both conditions are
Natural. At the opposite, or not quite the opposite, pole from naturalness
Is strangeness, though strange need not be unnatural. Beauty seems a combination
Of natural and strange, which is one thing that makes it so complex
To talk about to some people, who want it to be one
Or the other: avant-garde people wishing for it always to
Be strange, "traditionalists" wanting it always to be
Natural—neither really understanding what those words mean
Or how they are related to things, since
The world is naturally strange, i.e. what seems to us natural
Is really bizarre—the composition of a human face, for
Example, or the splendors of the sun. Though strange as
Well as natural, dependent on our culture and on our vision,
Beauty is a good companion, trustworthy and cheerful.
People are right to look for a beautiful mate and to
Put windows where the beauty is outside.

Animals, though natural and strange, I do not usually find beautiful,
Or fish or insects either. I do not know why this is. Many
People feel otherwise. Birds make me think uncomfortably of color
(Except when they whiz past by surprise) and the idea of feathers
I find disturbing. Whatever its cause, a strong feeling of discomfort
Makes hard the perception of beauty. You should not worry
If some people find some things beautiful that you do not
Find so. There is probably something that seems ugly to others
Which gives you the pleasure that beauty brings
Into our lives. Such strong feelings as physical
Discomfort, or deprivation, or a terror of disease or
Death, can make beauty unlikely to get through to you. It may be
That seeing birds in a more natural, everyday way would
Make them seem more beautiful to me. I do not know
Since this has not happened. Birds are something I was told

Were "beautiful" when I was a child. Flowers also were, and
Especially roses. I am still slightly uncomfortable with
Roses. The moon and the stars were also on my parents' and
Teachers' list of what was beautiful. It has been
Hard for me to love them (stars and moon, I mean) but I have,
Despite this early "training," which may be injurious to beauty
In some cases, in others not. In raising your child,
You should share your feeling with him of what is beautiful,
But do not expect a child to respond to it that way.
He or she is likely to respond more like a poet or an artist,
By wanting to do something with it—to run
Through it, or eat it or tear it apart. It is in later life perhaps
Precisely the suppression of these feelings, or some of these feelings,
That results in our feeling of beauty, which we are merely to contemplate.
Contemplation seemed to Aristotle the superior mode, to others may seem
 an unnatural mode
Of life. Most people still feel in the presence of beauty that old wish
To do something, whether it is to make love
To the beautiful person, in the case it is a person, or if
It is a landscape or a seemingly billion stars, or a
Light blue scarcely rippling bay, to run through it, get out a
Telescope, or dive in and swim or build a boat or buy a piece of
Property adjoining it. Sometimes it is merely an impulse to
Jump up and down, or to scream, or to call people up on the telephone to
Tell them about what one has seen. In any case, nothing satisfies
The impulse but merely exhausts it. The perception of beauty wears out
After a while, speeded up by activity, and then one is all right again or
Not all right again, depending on how you look at it. Remembered beauty,
On the other hand, if protected properly, can be a source of light and
Heat to one's imagination and one's sense of life, like
The sun shining in on one's shoulder. It is difficult to make
The impression of beauty last as it is difficult to make the pleasure of love-
Making last for days, but it can sometimes happen. The length of time
 one stays with

Something one thinks is beautiful can help it to stay
With one, so going back through the gallery is often a good idea.
In these cases, contemplation itself is a form of activity
The object of beauty incites. But children, told to contemplate
In this way, are likely to dislike what they see
Because they cannot contemplate and thus can do nothing
With it. Beauty, along with seeming strange, natural, and being temporal
And adapted to the size of human eyes and being a concentrate
With time added, must also seem like something of one's own.
Roses and birds belonged to my mother and her friends. I loved
Tulips, daisies, daffodils, and the white
Tiny flowers whose name I don't know which grew in
The woods in back of my house, which was used as a dump (the
Woods, I mean) and which were so small they were useless for the decoration
 of homes.

One reaction beauty sometimes causes, in the absence
Of other responses, is that it makes one cry, perhaps
Because of seeming a possibility of happiness projected
Into the past, as it is, in fact, in space, which one
Can never again reach, because irrevocably behind one. It may be
That there was never any chance of the kind of happiness
Beauty suggests, and thus that our tears are
In vain, but it is hard to imagine what "useful" tears would be
After one is an adult. Crying is crying, and
Blossoming plum and cherry trees may make one cry
A good deal, as may rocky coastlines and Renaissance art.
The tears in such cases are probably caused by the conflict
Beauty sends up of "Too much! There is no way to
Deal with me!" And the presence of beauty may make
Tears easier and seem safer, too, since it seems, also, to warrant and protect.

If none of the actions we take in regard to beauty
Seems completely satisfactory, and if we go on feeling

An impulse to do, to finally do something when we are in its presence, then
It may be either that beauty is a front for something else or that
It has a purpose our minds have not penetrated yet—or both. Many people
Say that it is all a trick of "Nature." "Nature" makes people
Beautiful, so people will make love to each other and the
Human race will go on, which "Nature" apparently desires.
Others, and sometimes some of these same ones, assume there is
A God, a Divine Being, with absolute power, who also wishes
The human race to go on, as well as to remind them
By the beauty of mountains, lakes, and trees (as well as of human features)
Of how bountiful He is, so that they will do His Will. The
Human features are lovely, also, to remind them
Of what God Himself looks like (approximately). I believe
All this is too simple to be correct, but you are free to believe what you will.
Nor can I subscribe to the "Analogy Theory" of beauty,
That beautiful things exist to show us how to behave
To ourselves and to each other. For one thing, the correspondence
Is insufficiently clear—just how that blue sky, for example, can
Help me to do what is right. It is true that clarity and harmony
May be the result of an ethical action, but it is also
True, often, that such actions involve pain and deprivation
Which seem inimical to beauty, and which I cannot see up there at all.

The beauty of many things does seem to show
They are good for us (or good for our descendants), but
What about poison flowers and berries? Treacherous bays? Beautiful
Wolf women who simply wish to devour us? What about Blake's Tyger?
My own view is that we are in a situation
That is not under our control (or anyone's, for that matter) but
Which we can handle, if we are wise about it, fairly well.
Temper your admiration for beauty with whatever
Else you know of the particular example you are looking at. Do not
Leap into a reflection in a lake, or take up with a bad woman
Because her breasts are beautiful, or commit
Suicide because Botticelli's Venus (it is not a real

Situation) reminds you of what your life has not been. These are times to let the
"Enchantment" wear off for a while—for it is an
Enchantment, and it will go away. You will feel driven
To act on your feeling immediately, and—
Perhaps you should go ahead and do it, even though you will be destroyed.
Not every man can die for beauty. Perhaps there is some kind of List
On which your name will be recorded. I don't know. I don't know if I
 approve of that.
However, my approval may not be that which you are after.
As a young man myself I felt I would do anything for
Beauty, but actually I was fairly cautious and did
Nothing that seemed likely to result in the destruction of my ability
To stay around and have these ideas and put them into words.
I would go forward one step, and back another, in regard to
Beauty, but beauty of course was mingled with other things. I don't
Propose myself as a model. Far from that. Since I am still the
Same way, I am interested, though, in if how I am
Makes sense to me in the light of these other things I am saying.

One thing I notice I have done which does seem right to me
Is to think about beauty a good deal and see many examples
Of it, which has helped me to have what is called "good taste"
In it, so I am able to enjoy a great many things
That I otherwise could not have. Discriminating taste does not
Decrease the amount of beauty you perceive, but adds to it.
If you notice an opposite effect, you are "improving" in
The wrong way. Go visit a lot of foreign places
Where ordinary things have an extraordinary aspect and thus
Invite you to see them aesthetically. Travel with someone
Else, and travel alone. Stand in front of a beautiful object until you
Are just about to feel tired of being there, then stop
And turn away. Vary your experience of what you see.
In variety is refreshment of the senses. A great painting, a
Mountain, and a person are a good combination for one day.
Sometimes, sameness increases beauty, or, rather,

Variety within sameness, as when looking at beautiful twins,
Triplets, or quadruplets, or in climbing a lot of staircases in Genoa,
A city famed for the beautiful structure of its stairways.

The impulse to "do something" about beauty
Can be acted on, as we have seen, by making love or, sometimes,
Even by marrying. Man is capable of improving
The beauty of nature in numerous ways, of which planting
Huge long rows of beautiful flowers is not the least. The
Cannas are nodding, the roses are asleep. And here's a
Tiny or medium-sized bumblebee, no it's a great big one!
And the oleanders are planted, they are standing
Next to the palms. You feel a surge of unaccountable delight. The wind moves
 them. And
Extraordinary cities may also be tucked together by
Human imaginations and hands. And other works of art as well.
Beauty is perceived in a curious way in poems,
Like the ocean seen through a partially knocked-down wall.
In music, beauty is "engaged in," as in sculpture and dance.

"I am beautiful, O mortals, like a dream of stone," says
Beauty, in Baudelaire's sonnet "La Beauté," where Baudelaire, in
Fewer words than I, has set down his ideas on the subject. Essentially he
Sees Beauty as eternal and pure, an enslaver of poets.
Rilke says that we love beauty because it "so serenely
Disdains to destroy us." In making works of art, then,
Is the excitement we feel that of being close to the elements of
Destruction? I do not want any mystery in this poem, so I will
Let that go. Or, rather, I want the mystery to be that it is clear
But says nothing which will satisfy completely but instead stirs to action
 (or contemplation)
As beauty does—that is, I wish it to be beautiful. But why I want that,
Even, I do not entirely know. Well, it would put it in a class of things
That seems the highest, and for one lifetime that should be enough.

Beauty is sometimes spoken of
As if it were a "special occasion," like going to the ballet
If one does that only once a year, or like going to
Church, if one does that only on religious holidays. Ex-
Perienced in this peripheral fashion, beauty cannot be
Sufficiently understood so as to be as valuable
To us as it should be, even if we do not understand it
Completely. Some understanding will rub off from frequent
Contact with it in both physical and intellectual ways,
And this understanding will do us some good. Of course,
It is possible to live without ever having seen mountains
Or the ocean, but it is not possible to live without having seen some
Beauty, and once one has seen something and
Liked it, one wants to have something more to do with
It, even to the point of having it inextricably tangled
Up with one's life, which beauty may be, anyway, whether we
Want it to be or not. It is a pleasure to be on top of things,
Even if only for a moment. Beauty may be an unsatisfiable
Appetite inducer, the clue to an infinite mystery, or a hoax,
Or perhaps a simple luxury for those with enough money and time
To go in pursuit of it, like château vintages. Or it may be the whole works (see
Keats). It may simply be a bloom which is followed by
Fruition and not supposed to last and we have perversely arranged things
So in many cases it does, the way we force-feed geese
And pigs, and now we are simply stuck with it, grunting and
Cackling all around us, from which we try to make music.
Or it may be that beauty is an invitation
To a party that doesn't exist (Whitman thinks the party exists).
In any case, you will probably want as much
Of it as you can take with you, because it is, in spite of
All the doubts expressed above, certainly one of the sweetest things
In life. Of course, this is not the end of the subject, but it is
As far as I now can see, which in regard to beauty is
All we have, and one thing it seems to be about.

An Aesthetic of the Cool

Robert Farris Thompson

THE AIM OF THIS STUDY IS TO DEEPEN THE UNDERSTANDING OF A BASIC WEST African/Afro-American metaphor of moral aesthetic accomplishment, the concept *cool*. The primary metaphorical extension of this term in most of these cultures seems to be *control*, having the value of *composure* in the individual context, *social stability* in the context of the group.[1] These concepts are often linked to the sacred usage of water and chalk (and other substances drenched with associations of coolness and cleanliness) as powers that purify men and women by return to freshness, to immaculate concentration of mind, to the artistic shaping of matter and societal happening. Coolness in these senses is therefore the purifying means by which worlds are taken out of contingency and raised to the level of aspiration.

Put another way, coolness has to do with *transcendental balance*, as in Manding divination, where good outcomes are signaled by one kola half up, one down, and this is called "cool." But, before we move to the consideration of detailed instances of the concept in social context, let us review what is known about the linguistic and historical background of the notion.

The Lexicon of the Cool

Language in Europe and in tropical Africa equally reveals in the term *cool* a basic reference to moderation in coldness extended metaphorically to include composure under fire. Thus, in English:

Cool, composed, collected, unruffled, nonchalant, imperturbable, detached [are] adjectives [which] apply to persons to indicate calmness, especially in time of stress. *Cool* has the widest application. Usually it implies merely a high degree of self-control, though it may also indicate aloofness.[2]

Now compare a West African definition, from the Gola of Liberia:

Ability to be nonchalant at the right moment . . . to reveal no emotion in situations where excitement and sentimentality are acceptable—in other words, to act as though one's mind were in another world. It is particularly admirable to do difficult tasks with an air of ease and silent disdain. Women are admired for a surly detached expression, and somnambulistic movement and attitude during the dance or other performance is considered very attractive.[3]

The telling point is that the "mask" of coolness is worn not only in time of stress but also of pleasure, in fields of expressive performance and the dance. Control, stability, and composure under the African rubric of the cool seem to constitute elements of an all-embracing aesthetic attitude. Struck by the reoccurrence of this vital notion elsewhere in tropical Africa and in the black Americas, I have come to term the attitude "an aesthetic of the cool" in the sense of a deeply and complexly motivated, consciously artistic, interweaving of elements serious and pleasurable, of responsibility and of play.

Manifest within this philosophy of the cool is the belief that the purer, the cooler a person becomes, the more ancestral he becomes. In other words, mastery of self enables a person to transcend time and elude preoccupation. He or she can concentrate on truly important matters of social balance and aesthetic substance, creative matters, full of motion and brilliance. Quite logically, such gifted men and women are, in some West and Central African cultures, compared in their coolness to the strong, moving, pure waters of the river.[4] A number of languages

in West and Central Africa provide a further basis for these remarks (see the table at the end of this piece).

According to these sources, coolness is achieved where one person restores another to serenity ("cools his heart"), where group calms group, or where an entire nation has been set in order ("this land is cool"). The phrase, "this country is cool" (*di konde koto*)[5], is used with the same valence and the same suggestiveness by the descendants of runaway African slaves on the Piki Lio in the interior of Surinam, in northern South America.

Idioms of cool heart and cool territory do not, to my knowledge, communicate in Western languages the same sorts of meanings of composure and social stability unless the phrasing is used by, or has been influenced by, the presence of black people of African heritage. I think that the African definition of metaphorical or mystical coolness is more complicated, more variously expressed than Western notions of *sang-froid,* cooling off, or even icy determination. It is a special kind of cool. Perhaps the most convenient way of suggesting its specialness and complexity is to allude immediately to further nuances within African usages in addition to valences just discussed of composure, self-control, and social equilibrium. Comparison of terms meaning "cool" in a variety of West, Central, and even East African languages reveals further nuances of (1) discretion, (2) healing, (3) rebirth, and (4) newness or purity. Compare Yoruba nuances (raw, green, wet, silent)[6] with Kaonde, from Rhodesia (raw, green, wet, silent).[7] Wetness is an inevitable extension of coolness. But silence is not. "Cool mouth" (*enun tutu,* in Yoruba) or "cool tongue" (*kanua kahoro,*[8] in Kikuyu) reflect the intelligent withholding of speech for the purposes of higher deliberation in the metaphor of the cool. This is not the stony silence of anger. This is the mask of mind itself.

Remarkable pursed-lipped forms of African figural sculpture are sometimes formed in this mirror of discretion. Where the teeth are bared, the instance is exceptional and can take the form of a leader or a spirit or a leader-spirit who shows special power in order to confront negative powers of witchcraft and war.[9] The idea of freshness in the cool intersects with visual art, too, in the sense that traditional artists sometimes (not always) impart a luminous quality of vital firm flesh to the representation of the elders and the ancient gods. Such images thus become ideally strong within their poise, suggesting, within depth of dignity and insight, commanding powers of mind and body.

The blending of muscular force and respectability leads to the appreciation of the fit human body in the cool, a right earned, however, by demonstration of character and right living. I once complimented the elders of Tinto-Mbu in the Banyang portion of the United Republic of Cameroon on the fine appearance of their chief, whereupon they immediately corrected me: "We say people are not judged by physical beauty but by the quality of their heart and soul; the survival of our chief is a matter of his character, not his looks."[10] However, no matter how ordinary his face, it is important for the chief to dress as beautifully as possible in order to attest his fineness of position in appropriate visual impact. He must consequently prove that he knows and controls the forces of beauty as much as the forces of polity and social pressure. Beauty, the full embodiment of manly power, or the power of women, in feminine contexts, is mandatory where it is necessary to clarify social relations. It would not make sense, in African terms of the aesthetic of the cool, to strike balances between opposing factions without aesthetic elaboration.

Coolness therefore imparts order not through ascetic subtraction of body from mind, or brightness of cloth from seriousness of endeavor, but, quite the contrary, by means of ecstatic unions of sensuous pleasure and moral responsibility. We are, in a sense, describing ordinary lives raised to the level of idealized chieftaincy. The harmony of the marriage or the lineage ideally reflects the expected first-magnitude harmony imparted by the properly functioning ruler to the province or nation at large. Men and women have the responsibility to meet the special challenge of their lives with the reserve and beauty of mind characteristic of the finest chiefs or kings.

More than the benefit of the doubt is extended to mankind in his natural state by this philosophy. Man starts not from a premise of original sin but from the divine spark of equilibrium in the soul, which enters the flesh at birth from the world of the gods. To act in foolish anger or petty selfishness is to depart from this original gift of interiorized nobility and conscience. This means a person has quite literally lost his soul. He has "departed from himself"[11] and is in serious danger. The Gã of southern Ghana even say that a person out of harmony with his ideal self can only win back his soul by means of extraordinary aesthetic persuasion: wearing brilliant cloth, eating cool, sumptuous food, keeping important company.[12]

If, therefore, in the cool, wild upsurges of animal vitality are tempered by

metaphoric calm, such is the elegance of this symbolically phrased reconciliation that humor and ecstasy are not necessarily denied. Nor is physical beauty itself, a force that brings persons together via saturated expressions of sexual attractiveness and deliberately attractive behavior and charm, excluded from this moral vision. Being charming is also being cool, as is suggested by the following interlude among black folk in Florida: "I wouldn't let you fix me no breakfast. I get up and fix my own and then, what make it so *cool*, I'd fix *you* some and set it on the back of the cook-stove . . ."[13] This man was flirting. But a whole ponderation lies concealed within his phrasing. He had cited the cool in an African sense, in a diagram of continuity. He had promised to assume the role of another person in order to earn her love. He had promised to dissolve a difference that lay between them. The charm of what "made it so cool" in these senses suggests he knew, in Zen-like simplicity, the divine source of the power to heal, love. He had thereby identified the center from which all harmony comes.

This highly cultivated, yet deceptively simple, idiom of social symmetrization clearly seems ancestral. Philip Curtin shows that perhaps a fourth of the total eighteenth-century slave imports into the United States derived from the area of the Bantu language groups, principally in the region of Angola.[14] Now when we examine a number of Bantu roots (viz., *-talala*, *-zizira*[15]) combining both the literal and the socially assuaging valences of the African usage of the term *cool*, we seem to touch basic roots of black social wisdom. Part of the power of the cool is undoubtedly rooted in just this quality of referral to ancestral custom. The presence of structurally similar idioms of coolness in Central African languages separated by great distances implies their antiquity. As another demonstration of historical depth for the concept, we have seen that descendants of seventeenth- and eighteenth-century slaves in Surinam use the expression to "cool his heart" (*koto di háti f'en*)[16] as an image of restored social tranquility. The precise idiom is used by Akan, Cross River, and some Bantu peoples. Indeed, there are other suggestions of the ancientness of the concept.

The Antiquity of the Cool

Praise names for ancient African kings provide evidence for the presence of this intellectual principle at a time that might otherwise have seemed inaccessible. During the first half of the fifteenth century, a certain leader was crowned king of the famous Nigerian empire, Benin. He took the title *Ewuare*, meaning, literally,

"it is cool."[17] This referred perhaps to a conclusion of a period of disorder. In the same century, a Yoruba ruler was crowned with the title Cool-and-Peaceful-as-the-Native-Herb-Osun (*oba ti o tutu bi osun*) at Ilobi, in what is today southern Egbado country.[18] The same title was awarded a sixteenth-century Ijebu Yoruba king.[19] Undoubtedly, a wider currency of the concept in ancient Yoruba ruling circles remains to be established.

Nigeria seems a fountainhead of the concept cool. Art-historical evidence supports this. Superb sculptured heads of important personages at Igbo-Ukwu, Ile-Ife, and Benin, respectively dated to around the ninth century, around the eleventh to fifteenth centuries[20] (for the so-called Lajuwa head), and the 1500s, suggest abiding interest in facial serenity as the sign, in the company of kings, by which certainty and calm from the past is transferred to the present and, as a phenomenon of mirrored order, from this world to the next. But it is surely more useful to pass from these speculations on origin[21] to the concretely documented instances of the cool concept in certain modern traditional societies in West Africa.

The Contexts of the Cool

I am attempting identification of some main contexts of cool aesthetic happening in certain West African civilizations and their corresponding, historically related, African counterparts. When these strategies of aesthetic assuagement (what we might term the rites of the cool) are compared, point by point, certain elements of conceptual articulation seem clearly mirrored, suggesting, to this writer, the continuity in change of indelible cultural code.

Let us pursue this possibility with transoceanic pairs—Cross River and lower Niger/western Cuba, Dahomey/Haiti, Akan and neighbors/Surinam. The basis for this pairing is the proof of contact through the Atlantic slave trade.[22] Thus, for a brief illustration, slaves from the region of Calabar on the west coast of Africa in southeastern modern Nigeria were brought in considerable numbers to the provinces of Havana and Matanzas in Cuba during the first half of the nineteenth century. Scraps of Efik and Ejagham, two languages of the Calabar area, are still spoken in these parts of Cuba to this day.

Cross River and Lower Niger Cool/Western Cuba

The civilizations of the Cross River, where the United Republic of Cameroon and the Republic of Nigeria come together, and the Igbo-speaking people farther west

in the Niger Delta, both form an interesting province of the cool. There is, for example, a reference to the ceremony known as "cooling the village" (*lopon lawa*) in Daryll Forde's study of a lower Cross River society, the Yakö: "Where questioning had elicited specific acts of hostility, obstruction, or other failures affecting rights and duties between patient and a spouse, relative, or neighbor, the loss of supernatural protection would be implicitly attributed to this and the prescriptions then included an explicit moralizing element. In such cases a 'cooling' rite was also enjoined at one or more shrines."[23]

The offending person therefore restored social equilibrium by ritual gifts of money and sacrifice (material amends) or the performance of entire ceremonies (behavioral amends). Diviners were crucial in such instances, for they were what might be phrased specialists in cool, whose own initiation had, significantly, combined prolonged staring at the sun with training in the lore of soothing herbs and cooling, sacred water. The concern with herbs (green) and the disk of the sun (orange) immediately suggests a vivid sense of contrast in nature harnessed for a higher order. (Yoruba diviners sometimes wear beads of alternating green and yellow color,[24] symbolizing the mystic complementarity of heat and coolness, chaos and order, in the world of divination.)

Richard N. Henderson has written of coolness in traditional Onitsha Igbo culture. The classic example is homicide. The moment that a murder has been committed, the land is said to become "hot" and is believed not to be properly assuaged until warriors from the immediate patrilineage of the victim attack the premises of the murderer's ancestral home, driving off all occupants (who take refuge with their mother's parents), burning or destroying the house, crops, and animals, and, quite symbolically, cutting down all the shade trees so that the land about the house becomes, in actuality, a "fiery surface."[25]

The heating up of the land illustrates how the lineage is caused to share responsibility for the transgression of a single member. The killer, if innocent, may later return with his lineage segment to recover the land. But first the lineage must provide compensatory transfer of one of the members of their own family segment to the family of the victim, in order to "cover the abomination and cool the land." The "fiery surface" then cools down to habitable temperature, after the parties involved have bound their lives and reestablished social purity and coolness in reconciliation.

A person in traditional Onitsha society can acquire a sense of coolness through

the learning of appropriate ancient lore. Thus, a senior daughter of the patrilineage tests every pubescent child's knowledge of basic ancestral customs, to cleanse him of "strangeness" to lineage affairs.[26] Purification by conscious acquisition of ancestral lore relates to the purification of the self that pervades the whole notion of mystic coolness in the West African sense.

Personal purity cannot, however, be inherited. Personal purity is achieved. This is done through ceremonial rites in which the individual communes with his ancestors, becoming, in the process, more ancestral.[27] Other sources of ritual coolness, in the quest for purity, include learning to speak with words that bear evidence of diplomacy and high character, learning the "deep" uses of the fan, to enforce peace on disputing nontitled men by fanning them when they begin to argue, and, ideally, to transcend arrogance and revenge in favor of situations in which men may move in whole concert with one another.

The essential Onitsha Igbo image of ritual coolness includes permanent luster or luminosity, that state which, like the eagle feather, "does not tarnish."[28] People in this society take pains to maintain special neatness and brilliance in their personal appearance, and clay walls are carefully rubbed and polished. Purification of the self also elevates the individual beyond sorrow, close to the divine order of things, if only at the level of performance. Thus, a chief confronted with news of death within the lineage indicates his status by absence of facial expression. He appoints others to mourn for him.

There are certain senior women in Onitsha Igbo society who are armed with extraordinary powers to restore coolness. When a person has committed an act that contaminates his compound, the senior priestess of the patrilineage must perform an oath to "quench the fire which makes his presence dangerous." She beats a fowl around the body of the malfeasor, in order that the bird absorb the "heat" of his morally dangerous condition, thus restoring equilibrium and social order.[29]

The quest of the cool in ritual purity reappears among the blacks of western Cuba who are of Cross River and Igbo extraction. Here, too, a rooster is passed, fluttering and still alive, about the torso of an initiate into the famous all-male, Cross River–derived Abakuá society (compare the Abakpa Ejagham of the Calabar area). This act is said to absorb impurity from his body. Another form of mystic coolness in the Afro-Cuban Abakuá society dramatically emerges during the funeral of a cult elder:

We arrive at the supreme moment, separating the soul of the member from the sacred skin of the drum [it is believed the spirit of the departed elder momentarily rests within the skin of a sacred friction drum, *Ekpe,* before leaving this world forever]. Next to the high priest, Isué, stands his helper, Mbakara, who carries a vessel half-filled with water. Isué chants and the soul of the departed member abandons the skin of the drum and travels into the vessel . . . "It is going to seek the water. . . . Because water has the power of sustaining, within itself, the spirits of the dead and dominating them. Water attracts the souls of the dead; its coolness clarifies them, lends them tranquility. . . ."

The spirit of the departed brother is [thus] dispatched to the mystic river . . . the priest . . . lights the gunpowder sprinkled over the chalked representation of an arrow leading from a circle drawn around the base of the drum within the secret chamber to a point beyond the door. The gunpowder is ignited. It burns immediately along the length of the drawing, expelling, in this way the soul of the dead man [from the drum to the water] . . . the carrier of the vessel of water then chants: May your soul arrive cool at the sacred river, cool as it once existed in union with our sacred drum![30]

We shall see shortly that in Dahomey, broken pottery at a funeral signifies the shattering of life by death, the anguish of which is eased by pouring soothing liquid on the earth and by speaking beautiful phrases and words. By the same token, it seems to me, the use of gunpowder explosions in the Abakuá funeral in Cuba equals the breaking of the pots as a symbolic means of severing death from life. At the same time, the use of cool water in the same ritual confronts, as it were, the heat of the explosion and the glitter of its traveling fire. Clearly, the river of the ancestors is attained in Cuba by means of the most dramatically orchestrated equilibrium.

The sign of the arrow as emblem of spiritual transition almost unquestionably derives from the great graphic traditions of the Cross River. In the latter territory there is a kind of pictographic script (*nsibidi*) of which the more public and secular manifestations have to do with love and social unity and the deeper signs with initiation, death, and punishment. This is, we might say, "cool writing," scripts whose coolness is a function of abiding concern with social purity and reconciliation. Sultan Njoya of the Cameroon Grasslands was influenced by the signs of this script. At the beginning of this century, when he elaborated a new, syllabic form of writing, largely based on *nsibidi,* the old concerns remained:

When an oral civilization moves to become literate the first items recorded are the texts felt to be important, just as the first printed book in Europe was the Bible. When Sultan Njoya of the Bamun in the Cameroons invented a script, the first materials written down were the royal chronicle and a code of the customary law and the local pharmacopeia.[31]

What Njoya attempted to make indelible—history, law, and the use of the leaves—combined aspects of leadership with herbalism. We think of the frequent correlation, linking good government with healing, in the concept, cool. Insight into the sorts of custom that bind together individuals and social groups, and that keep them alive and well, also characterizes the corresponding Afro-Cuban script, *anaforuana,* but we will not consider this fascinating continuity here.

Dahomey/Haiti

Comparison of funerals in Dahomey and Haiti elicits strongly related ritual strategies of dealing with the end of life. Death in Dahomey is heralded by metaphor, "fire has fallen heavily upon the family roof,"[32] communicating annihilation by heat, and is reminiscent of the Igbo concept of the "fiery surface." The funeral follows. Water is sprinkled three times near the corpse on the ground, there is continuous percussion, and finally comes the moment when the man who digs the grave finishes his work:

> Coming out of the grave, the eldest son gives the grave-digger (a small pot) filled with . . . the residue of the fruit of the palm-tree when oil is made . . . the digger takes the (pot), breaks it, and throws it and its contents into it . . . he re-enters the excavation, gathers up the pieces and takes them away. This ceremony . . . is intended to "cool the earth," that is, to cause it to allow the dead to lie peacefully in it.[33]

On the one hand, irrevocable loss has been symbolized by smashing pottery. This is widespread as a funeral custom in tropical Africa, and Afro-Americans in coastal Georgia questioned on this point have answered that broken pottery is deposited on their graves to ensure that ties between the living and the dead are definitively broken, so that the dead will not return to haunt the house of the living.[34] On the other hand, the pouring of oil metaphorically eases the dead into the

realm beyond. The soothing oil possibly also eases the return of the living to their normal concerns. The reestablishment of tranquility is underscored by the pouring of cool lubricant (the oil) at the point of intersection.

There is a partial echo of this rite in the culture of the north of Haiti. The custom of *casser-canari*[35] (smash the earthenware jar) marks the formal end of the funeral. When the jar is reduced to fragments, the vodun priest makes a libation of rum (water equivalent) over the shards and dust. The Dahomean synthesis of smashing and soothing, of making the transition both definitive yet easy, remains.

There is another transoceanic relationship to consider here, one that suggests that great heat is sublimated and controlled in Haitian mystic coolness. This relationship is especially manifest in rites of initiation or rebirth.

In Dahomey and Yorubaland, a person sworn into the cult of the thunder-god, patron of warriors and lord of lightning, must prove upon initiation special mastery of the pain of heat. He must dance with a fire burning in a vessel on his head. He must literally balance heat with ease. He must also thrust his hands into a vessel containing boiling gruel without flinching.[36] He thus proves, by tasting heat with nonchalance, that his control is derived from his god, a possession actual and not feigned. This splendidly dramatic test apparently came to Haiti from the Dahomean and Yoruba cults of thunder to become the means of entrance into the entire vodun religion of the black folk of that important Caribbean black republic:

> She smeared her hands with cold oil, took the novice's left hand from beneath the sheet and smeared that, too. Scooping a handful of the now seething mixture, she pressed it into the novice's hand and closed the fingers on it, for four or five seconds . . . This is the central moment of initiation, when the novice is made to grasp heat without flinching—a heat which will sear the flesh only if the (gods) are displeased through some lapse on the novice's part . . .[37]

Thus we come back, at the beginning, as at the end, of life to the purity of self that is an imperative of the cool.

Akan and Neighbors/Surinam

Akan and the Akan-related ritual patterns, from the old Gold Coast, helped shape the aesthetic of the blacks of the interior of Surinam in South America.

The link was forged in slavery, when blacks from the Gold Coast, including Akan, Gā, and other peoples, were brought to Surinam in the seventeenth and eighteenth centuries.

A source for the understanding of the nature of this influence is the study of the making of a shrine for a northern Akan god: A brass bowl is filled with water and sacred ingredients. The particular objects immersed within the water, and the incantations that accompany the ritual, serve as cultural preparation for the reader:

> A spirit may take possession of a man and he may appear to have gone mad . . . it is some spirit which had come upon the man . . . The one upon whom the spirit has come is now bidden to prepare a brass pan, and collect water, leaves, and "medicine" of specific kinds. The possessed one will dance, sometimes two days, with short intervals for rest, to the accompaniment of drums and singing. Quite suddenly he will leap into the air and catch something in both his hands (or he may plunge into the river and emerge holding something he has brought up).
>
> He will, in either case, hold this thing to his breast, and water will be at once sprinkled upon it to cool it, when it will be thrust into the roots pan and quickly covered up.
>
> The following ingredients are now prepared: clay from one of the more sacred rivers, like the Tano, and . . . medicinal plants and other objects . . . any root that crosses a path, a projecting stump in a path over which passers-by would be likely to trip, also roots and stumps from under water, leaves of a tree called *aya* . . . seen to be quivering on the tree even though no wind is shaking them—the leaves, bark, and roots of . . . the wizard's tree, a nugget of virgin gold . . . (an) . . . aggrey bead, and a long white bead called *gyanie*. The whole of these are pounded and placed in the pan, along (with) the original objects already inside, while (an) incantation . . . is repeated . . . [38]

The incantation establishes the meaning of the substance-enriched water: magic intelligence, to be addressed as a virtual person—"If a man be ill in the night or in the daytime, and we raise you aloft and place you upon the head, and we inquire of you, saying 'Is so-and-so about to die?' let the cause of the misfortune, which you tell him has come, be the real cause and not lies."[39]

Divinatory power, activated by placement upon the head, applies to another

Akan custom, whereby men carrying a dead man in a coffin on their heads can be magically directed by the corpse to halt at the house of the witch responsible for his death. When the shrine of the initiate, therefore, is lifted, like a coffin, to the head of the initiate, then to "speak" through him of sources of disorder, the shrine acquires the aura of a living watchful presence, come from the world of the dead. This again communicates what lies within the water: intelligence. A gloss upon this fundamental concept is provided in incantation, repeated after the initiate has placed the various objects that make up his shrine within the water: "O tree, we call Odum Abena, we are calling upon you . . . that we place in this shrine the thoughts that are in our head."[40]

Water as a metaphor for mind is present in the lore of the Gã of Accra. The Gã traditionally believe that mediation serves right living and that water is its sign. They also maintain that rain establishes balance and communication between heaven and earth, hence water in a vessel is also divine presence in shared moisture. God appears in water. And from this medium carefully kept in vessels, He reveals his messages to the priestess who relays his words to the world at large.[41]

In Surinam, where the custom of detecting witches by the corpse carried on the head exists as a hardy Akanism, we find that beliefs from the old Gold Coast about the connection between the purity of water and the world of the spirits have also taken root:

> In Saramaka when a person is in serious danger or has a sudden fright, his *akaa* ("soul") immediately goes out of him into the river, from which it must later be called or summoned and, after interrogation (divination) about the cause of the problem, ritually reinstalled in the head of the person.[42]

This custom recalls Akan, Gã, and neighboring sources. The Saramaka summoning of the errant soul from the river recalls in particular an aspect of a Gã healing ritual in Ghana. Gã traditional healers coax the soul of an ailing person back into his person by means of offering that person an especially cool diet, particularly mushrooms, redolent of shade, coolness, and rain.[43]

Shade can equal coolness in a mystical sense of healing and the assuagement of sorcerous elements of disease and dissension in other African cultures. We have seen how Igbo correlate ritual coolness with the adequate presence of shade trees.[44] In the Americas, Saramaka bracket coolness and shade under a single term, *koto*.[45]

There is probably more to the frequency of umbrellas at the courts of African kings than mere prestige or physical comfort. In Surinam, where the most important of the black chiefs of the Piki Lio sits under an umbrella, shade in the council house distinctly symbolizes the cool of early morning and, by extension, good judgment: "Cool was their image for peace and health and fairness and deliberation and justice. Inside the council house, then, was a light which 'cooled the heart,' for heart and head are synonymous to the Bush Negro when he speaks of emotional states."[46]

There is another aspect of old Gold Coast ritual that has a bearing on custom in interior Surinam. Among the Brong of the northern Akan there is the *apo* festival, lasting eight days, in which ill health caused by harbored hatred is healed by sanctioned expressions of utter frankness. The *apo* rite is a time "when every man and woman, free man and slave, should have freedom to speak out just what was in their head, to tell their neighbors just what they thought of them, and of their actions, and not only their neighbors, but also the king or chief." This was the rationale: "When a man has spoken freely thus, he will feel his *sunsum* (soul or spirit) cool and quieted, and the *sunsum* of the other person against whom he has now openly spoken will be quieted also."[47] This sophisticated grasp of the consequences of repression was not lost in transit from the Gold Coast to Surinam.

Herskovits has recorded one coastal form of the same ceremony among the blacks of Surinam, but the Saramaka and the Djuka of the interior have, Price shows, a more abstract version, called *púu fiúfiú* (remove the poison of the hate), which seems close to the original African custom:

> In Saramaka *fiúfiú* is a state of masked hostility between two people—where people act cordial and friendly but harbor resentment, hurt, or jealousy; it is when people pretend friendship but speak badly of each other in private. The existence of such a state is revealed through divination, when someone, who may be a third party, falls ill.[48]

Clearly, Price adds, this is in part a social mechanism to keep people in line and prevent bad feelings from building up within a community. Then he says:

> Once discovered, *fiúfiú* must be removed by a rite which has many different technical variations, ranging from a simple procedure to expensive complex

ritual. In simplest form, a ritual specialist simply takes a calabash of water plus kaolin (*keéti*), prays that the *fiúfiú* leave, has the two protagonists spray with the ritual solution from their mouths, on the idea that "what is caused by mouth can be cleansed or removed by mouth." Some such rites are very complex, with involved symbolism. But all are ceremonies of social purification, or reconciliation.[49]

The striking thing here, I think, is that the spirit or interior spark of divinity within every man, when angered by involvement in hatred or jealousy, can strike down even third parties with illness. Impurity of intent and false cordiality angers the god within. Social purification, bringing matters into the open, is mandatory.

This great concern with the purity of self can be related not only to Akan sources but, of course, Cross River and Lower Niger custom. In the old Gold Coast, the mighty Odwira Festival seems to have projected a thirst for purity in strength to the highest level of national concern. The king takes a golden sword, moistens it with sheep blood and water from the sacred rivers Tano, Abrotia, Akoba, and Apomesu, and says: "I sprinkle you with water in order that your power rise up again." He salutes the mighty Golden Stool with similar incantation: "I sprinkle water upon you, may our power return sharp and fierce."[50]

There is more than a symbolic reconciliation of the living with the dead. This is an aesthetic activation, turning ancient objects of thought into fresh sources of guidance and illumination. It is possible to argue, although this paper is not the place, that such was the importance of the sword and the throne, as emblems of renewed power in the cooling and purifying of the human royal soul in traditional Akan culture, that their embodied modes of characteristic decorative patterning, widely shared among the Akan and their northern and eastern neighbors, were to influence, partially but deeply, the art of Surinam.

In conclusion, the data, as a whole, communicate their own insight, a notion of black cool *as* antiquity, for as Ralph Ellison has put it, "We were older than they, in the sense of what it took to live in the world with others."[51]

The Concept "Cool" in Select West and Central African Languages

SOCIETY	TERM	SEMANTIC RANGE
1. Abakpa	*tebede*[52]	in a cool manner; unrushed; not harsh

2.	Baguirmien	*kulu*[53]	to be cold, calm, tranquil
3.	Bamana	*súma*[54]	to cool; to calm
4.	Bobangi	*tilima*[55]	to be cool; to be allayed; become still; be eased; to settle (a quarrel); be sober
5.	Bushman	*kwerre*[56]	to cool; to be cool
		//koin an kwerre, !gwa ɛxukan //khou /kai:n	the sun cooled, the sky turned green
6.	Diola	*ma-kunkul*[57]	coolness; beauty
7.	Edo	*Ewuare* (a title)[58]	it is cool; trouble has ceased
		ofure ekhaor[59]	"cool heart" (tranquility of mind; reconciliation)
8.	Efik	*suk*[60]	to cool; exorcise; reduce to quietude and reason; to moderate the strength of anything
9.	Ejagham	*ekwen*	to cool
		ki etok ekwen	may the town be cool (peaceful)
		ki ntea akwen[61]	make your heart cool (be composed; do not be rough; do not make trouble)
10.	Fongbe	*fifa*[62]	cool (water); coolness; peace; tranquility; calm; placidity; gentleness
11.	Gã	(vernacular not given)	to cool; to heal by prescribing a diet of cool food and drink[63]
12.	Onitsha Igbo	(vernacular not given)	to cool; to render the land safe[64]
13.	Kaonde	*tarala*[65]	be cold, wet, green, raw, unripe; be silent; placid, untroubled (as the surface of water); be serene; cease to pain
14.	Kenyang	*bekwen*[66]	to cool; to restore order
15.	KiKongo	*zizika*	to make cool
		zizila[67]	calm, patient, tolerant, faithful, brave, firm, courageous, imperturbable

16. Kikuyu	-horo[68]	inactive, calm, at peace, cool (water), soft (in the sense of cushion or silk)
	mundu wa kanua kahoro	a smooth-tongued person
	horoha	to be reconciled with; be settled
	horohia	atone, pacify, restore to state of ritual well-being
17. Kisongye	kutaala[69]	to be cool; to be calm; to be like the river; to be beautiful (excluding music)
18. Kitabwa	kutalala	to be cool (water); to be silent; to calm oneself
	kyalo kyatalala[70]	the land is cool (at peace)
19. Kuba	hio[71]	coolness; wetness
20. Lala	talala[72]	be cool, silent, still
21. Lomongo	cicimya[73]	to cool; moderate; assuage; calm; compose; pacify; set at case; soothe; tranquilize
	cicimyeefe	to ease pain
	kutsa	to cool
22. Lodagaa	(vernacular not given)	to make cool; render safe to inherit; to lessen social danger in crisis situations (e.g., death)[74]
23. Luo	mokue[75]	cool, quiet, peaceful
24. Manganja	kuzirira[76]	to be at peace; to be calm; pacify; appease (quarrel, a child crying); to ease pain; to be cool; to cool; to lack savor, be insipid; to be loose-limbed
	mtsikidzi wina wo-zizira	sweet taste of water from a fresh pot
	lero kwa-zizira	it is calm (cool) today
	chironda changa chaleka cha-zizira	my wound is cool (better)
	mtu wanga wa-zizira	the pain in my head is cool (my headache has stopped)
	Mpinjika ikutuniska zawe	the Cross cools (settles) quarrels
25. Runyakore	kuhoza[77]	to cool; to plead a case

26. Sesuto	phola[78]	make cool
	pholiso	healing; making cool
27. Songhai	yenendi[79]	to "make cool" (provide spiritually ensured calm; to cool men by the flash and roar of the thundergod; to cool the spirits by the promises made by men)
28. Tshi-luba	talala[80]	to cool; pacify; to be cool; humid; become calm; be at peace
	muntu mutalale bu mayi	person cool (peaceful) as water
	mukele mutalale	sweet salt (not biting, not hot)
	kutalala mpala	to lose coolness from his face (through illness)
	kutuya munda kutalala	the heart is entirely cool (at peace)
29. Tumbuka	kutuna[81]	to cool down (anger or inflammation)
30. Twi	dwo[82]	to cool; to be calmed; to relax from a state of excitement; to make quiet, tame; humble (not proud); to come to rest, feel comfortable
31. Xhosa	phola[83]	cool; calm down; heal
32. Woloff	(vernacular not given)	cool; free from quarrels[84]
33. Yakö	lopon fawa[85]	"cooling the village" (ceremony of social purification and reconciliation)
34. Yoruba	tútù[86]	cool, green, raw, wet, damp
	enun è tútù[87]	silence (his mouth is cool)
	ile yii tútù	verdancy (this land is cool)
	ilé tútù	peace (cool house)
	ó finuntútù ba mi soro	he spoke to me pleasantly (lit. made my mind cool by speaking to me)
35. Zulu	phola[88]	heal; be cool; be calm

NOTES

There are a number of scholars who were kind enough to read and criticize an early draft of this paper: Charles Bird, Leonard Doob, Joseph Greenberg, Richard Henderson, Sidney Mintz, Paul Newman, Richard Price, Jan Vansina, and Frank Willett. I thank them all most warmly, while excepting them from remaining errors, all of which are mine. In addition, Robert Armstrong was kind enough to write a reaction which was so thoughtful that I have decided to incorporate his suggestions as the beginning of another book, *African Art in Motion*. An early version of this paper was read at a symposium, "The Ethnography of Speaking: African and Afro-America" at Burlington, Vermont, on 27 April 1973. At this meeting, I profited by further reaction and comments from Karl Riesman, Dan Rose, Dan Ben-Amos, and, most especially, James and Renata Fernandez. They are all to be thanked most cordially. And I am most pleasurably in debt to Roger Abrahams, John Povey, Alice McGaughey, John Szwed, and Nancy Gaylord Thompson for encouragement and inspiration at the right hour and the apposite place.

1. Prof. Charles Bird, personal communication, 3 April 1973.

2. William Morris, ed., *The American Heritage Dictionary* (New York: American Heritage Publishing Co. and Houghton Mifflin, 1969), 293.

3. Warren D'Azevedo, "The Artist Archetype in Gola Culture" (Paper presented at the Conference on the Traditional Artist in African Society, 28–30 May 1965, Tahoe Alumni Center, Lake Tahoe, California), Preprint No. 14, Desert Research Institute, University of Nevada, Reno, 31-32.

4. For a good discussion of this concept in Songye culture, Zaire, see Alan P. Merriam, *The Anthropology of Music* (Evanston: Northwestern University Press, 1964), 267-68.

5. Prof. Richard Price, personal communication, 28 November 1972.

6. Rev. Samuel Crowther, *A Vocabulary of the Yoruba Language* (London: Seeleys, 1852), 278.

7. R. E. Broughall Woods, *A Short Introductory Dictionary of the Kaonde Language* (London: Religious Tract Society, 1924), 159: *tarala* v. be cold, wet, green, raw, unripe: be silent, placid, untroubled (as the surface of the water), be serene, cease to pain, be tranquil.

8. T. G. Benson, *Kikuyu-English Dictionary* (Oxford: Clarendon Press, 1964), 164.

9. For a Yoruba example, see Robert Farris Thompson, "Aesthetics in Traditional Africa" in Carol Jopling's *Art and Aesthetics in Primitive Societies* (New York: Dutton, 1971), 377.

10. See Table.

11. The first time I heard this phrase in context was in Butuo (Western Dan), Liberia, Spring 1967.

12. Leith Mullings, personal communication, 21 October 1972.

13. Zora Neal Hurston, *Mules and Men* (New York: Harper & Row, reprint, 1970), 90. Italicization of the word *cool* is mine.

14. Philip Curtin, *The Atlantic Slave Trade: A Census* (Madison: University of Wisconsin, 1969), 144.

15. See Table.

16. Price, op. cit.

17. Jacob Egharevba, *A Short History of Benin*, 3d ed. (Ibadan University Press, 1960), 14.

18. A. I. Ogunbiyi, T. O. Adebowale, and other petitioners, *Petition from the Ilobi Tribes of Oke-Odan District, Ilaro Division, Abeokuta Province, to His Excellency the Governor-in-Council, Lagos* (Lagos: Samadu Press, 1931), par. 12. According to this "authorized version," Ilobi was founded by Adekanbi, surnamed Oba-ti-o-tutu, in 1483. This date cannot be substantiated. By 1553, it is also alleged, the third king of Ilobi was reigning. It would appear that the concept "cool" is at least several centuries old in this district.

19. King Owa-Otutu-bi-Osun, king of Idowa, in Ijebu Yorubaland, is believed to have reigned in the six-teenth century. For details, see Oyin Ogunba, "Crowns and Okute at Idowa," *Nigeria*, No. 83 (December 1964): 249–50.

20. I am grateful to Professor Frank Willett for the photographs that illustrate this point. (The pho-tographs that accompanied this article when it was originally published in *African Arts* are not repro-duced in the present volume.)

21. It is tempting to postulate a partially pygmy origin for cool aesthetics in Africa. For reasons why, see Alan Lomax and Edwin E. Erickson, "The World Song Style Map," in *Folk Song Style and Culture* by Alan Lomax (Washington, D.C.: American Association for the Advancement of Science, Publication No. 88, 1968), 95.

22. Curtin, op. cit.

23. Daryll Forde, *Yakö Studies* (London: Oxford University Press, 1984), 232. There is a wealth of data about "cool" in Forde's excellent set of essays, from which I excerpt another particularly striking example (p. 251): "Later the Diviners prepare a new supply of chopped leaves and roots which are essential ritual ingredients in the cooling and healing water that they use. The Head of the Diviners then provides a supply of this sacred water, with which is mixed sacred water of *Korta*, and with this the whole village is ritually cooled, after the other ceremonies, in rites of asperging at every patriclan house and at every matriclan shrine . . . The power of healing and cooling bestowed by Obasi (God Almighty, the Creator) is in these final rites represented as effective and necessary for all the other cults. The final rites connected with Obasi not only as is expressly stated, 'cool the village,' that is, remove the implicit danger from the ritual power of the other cults that have been activated; they also place the patriclans, the matriclans, the Council of Village Priests, the *Korta* and *Okenka* cults, and the women's cults, under the ultimate ritual power of Obasi the Supreme Being, and support the role of the Diviners as the source of ultimate knowledge of the causes of sickness and of the origins of the human souls that are reincarnated in every generation . . ." This suggests an unsuspected power within the mastery of the arts of ritual coolness: ultimate knowledge of the roots of illness and the origin of human souls. For details, see Forde's "First Fruits Rituals," 234–53.

24. Or opaque tan and light green beads, as reported by William Bascom, *The Yoruba of Southwestern Nigeria* (New York: Holt, Rinehart & Winston, 1969), 80.

25. Richard Henderson, *The King in Every Man: Evolutionary Trends in Onitsha Ibo Society and Culture* (New Haven: Yale University Press, 1972), 151.

26. Ibid., 155.

27. Ibid., 251. Henderson elaborates: "In Onitsha the color white is the essence of purity . . . white cloth is a prime symbol of purification. Purity or 'whiteness' also entails both the absence of the 'heat' of anger and aggression." Henderson shows, I think, that sexual "heat" is a quality that a man "loses" in old age only to gain the exalted level of ancestorhood. The elder thus eventually assumes the essential attitudes of his patrilineal ancestors: the physical color of whiteness and the avoidance of the contaminating qualities of women. At the end of this process, he will don white cloth, the raiment of the ancestors; his body will be covered with white clay, thus assuming the white appearance of the ancestors themselves. In other words, only a person who has spiritually "died" and then come back in ancestral purity, can act as the priest of the patrilineage.

28. Ibid., 263.

29. Ibid., 155.

30. Lydia Cabrera, *La Sociedad Secreta Abakuá* (Miami: Ediciones CR, reprint, 1970), 274–76. Translation mine.

31. Jan Vansina, "Once upon a Time: Oral Traditions as History in Africa." *Daedalus* (Spring 1971), 443.

32. Melville J. Herskovits, *Dahomey: An Ancient African Kingdom,* vol. I (Evanston: Northwestern University Press, reprint, 1967), 354 ff.

33. Ibid., 357.

34. Quoted in Robert Farris Thompson, "African Influence on the Art of the United States," ed. Armstead L. Robinson, *Black Studies in the University* (New Haven: Yale University Press, 1969), 151.

35. Alfred Métraux, *Voodoo in Haiti* (New York: Schocken Books, 1972), 252–55.

36. Pierre Verger, *Notes sur le Culte des Orisa et Vodun* (Dakar: I FAN. Mémoires de l'Institut Français d'Afrique Noire, 1957), 305.

37. Francis Huxley, *The Invisibles* (London: Rupert Hart-Davis, 1966), 139. The vodun gods of Haiti test, in fire, the coolness and spiritual commitment of their devotees. For further details, see Maya Deren, *Divine Horsemen* (New York: Chelsea House Publishers, reprint, 1970), 220–24; Louis Maxmilien, *Le Vodou Haitien* (Port-au-Prince: Imprimerie de l'Etat, 1945), 110.

38. Capt. R. S. Rattray, *Ashanti* (Oxford: Clarendon Press, 1923), 147.

39. Ibid., 149.

40. Ibid., 148. For the custom of "carrying the corpse," see Rattray, *Religion and Art in Ashanti* (Oxford: Clarendon Press, 1927), 167.

41. Marion Kilson, *Kpele Lala: Gã Religious Songs and Symbols* (Cambridge: Harvard University Press, 1971), 69.

42. Richard Price, personal communication, 18 September 1972.

43. Leith Mullings, personal communication, 21 October 1972.

44. Henderson, op. cit., 151.

45. Richard Price, personal communication, 28 November 1972.

46. Melville J. and Frances S. Herskovits, *Rebel Destiny: Among the Bush Negroes of Dutch Guiana* (New York: McGraw Hill, 1934), 177.

47. Rattray, *Ashanti*, 148.

48. Price, op. cit. See also W. F. Van Lier, *Aanteekeningen over het geestelijk leven en de samenleving der Djoeka's in Suriname, Bijdragen Tot De Taal-, Land- en Volkenkunde Van Nederlandsch-Indie*, Deel 99 ('s-Gravenhage: Nijhoff, 1940), 179–80.

49. Ibid.

50. Rattray, *Religion and Art in Ashanti*, 137–38.

51. Ralph Ellison, *Invisible Man*, 1952 ed., 497.

52. Informant: the *Nididem* of Big Qua Town, Calabar, 14 January 1972.

53. H. Gaden, *Essai de Grammaire de la Langue Baguirmienne* (Paris: Ernest Leroux, 1909), 93.

54. Moussa Travele, *Petit Dictionnaire Français-Bambara et Bambara-Français* (Paris: Librairie Paul Geuthner, 1913), 242; Charles Bird, personal communication.

55. John Whitehead, *Grammar and Dictionary of the Bobangi Language* (London: Kegan, Paul, Trench, Trubner, and Co., 1899), 236.

56. Dorothea F. Bleek, *A Bushman Dictionary* (New Haven: American Oriental Society, 1956), 113

57. L.-V. Thomas and P. Fougeyrollas, *L'Art Africain et la Société Senegalaise* (Dakar: Publications de la Faculté des Lettres et Sciences Humaines, 1967), 34. There is an alternate term, *mahululen*.

58. Egharevba, op. cit., 14.

59. I am indebted to Professor Paula Ben-Amos, Temple University, for this term.

60. Rev. Hugh Goldie, *Dictionary of the Efik language* (Ridgewood: Gregg Press, reprint, 1964), 279.

61. Informant (for the three phrases in Ejagham): Andreas Ako, of Mfoni, Cameroon, near Mamfe, 8 January 1972.

62. Maxmilien Quénum, *Au Pays des Fon*, 2d ed. (Paris: Larose Editeurs, 1938), 149.

63. I am indebted to Leith Mullings, Yale University, for this information.

64. Henderson, op. cit., 151.

65. R. E. Broughall Woods, op. cit., 159.

66. Informants: the elders of the Ngbe house, Tinto, Banyang country, West Cameroon, 8 January 1972. Their precise phrasing was: "all Ekpe Societies 'cool'—because they are *government*."

67. K. E. Laman, *Dictionnaire Kikongo-Français, M-Z* (Hants: Gregg Press, reprint, 1964), 1168.

68. T. G. Benson, ed., *Kikuysi-English Dictionary* (Oxford: Clarendon Press, 1964), 164.

69. Merriam, op. cit., 267.

70. R. P. Aug. Van Acker, *Dictionnaire Kitabwa-Français et Français-Kitabwa* (Publication de l'Etat Independent du Congo, 1907), 214.

71. Althea Brown Edmiston, *Grammar and Dictionary of the Bushongo or Bakuba Language* (Luébo: J. L. Wilson Press, n.d.), 522.

72. A. C. Madan, *Lala-Lamba-Wisa and English/English and Lala-Lamba-Wisa Dictionary* (Oxford: Clarendon Press, 1913), 238.

73. E. A. and L. Ruskin, *Dictionary of the Lomongo Language* (London: Christian Literature Society, 1928), 78.

74. Jack Goody, *Death, Property and the Ancestors,* 231. There are further references to the symbolic cooling of objects pertaining to the dead, viz., on 69, 89, and 339.

75. R. L. Stafford, *An Elementary Luo Grammar* (Nairobi: Oxford University Press, 1967), 116.

76. Rev. David Clement Scott, *A Cyclopaedic Dictionary of the Mang'anja Language* (Edinburgh: Foreign Mission Committee of the Church of Scotland, 1892), 679.

77. C. Taylor, *A Simplified Runyankore-Rukiga-English Dictionary* (Nairobi: Eagle Press, 1959), 58.

78. A. Mabille, *Sesuto-English Dictionary* (Morija: Sesuto Book Depot, 1911), 349.

79. Jean Rouch, *La Religion et la Magie Songhai* (Paris: Presses Universitaires de France, 1960), 223.

80. Em. Willems, ed., *Dictionnaire Tshiluba-Français* (Leopoldville: Imprimerie de la Société Missionnaire de St. Paul, 1960), 309.

81. Rev. William Y. Turner, *Tumbuka-Tonga English Dictionary* (Blantyre: Hetherwick Press, 1952), 148.

82. Rev. J. G. Christaller, *Dictionary of the Asante and Fante Language* (Basel: Basel Evangelical Missionary Society, 1903), 107.

83. Rev. William J. Davis, *A Dictionary of the Kaffir Language, Part I: Kaffir-English* (London: Wesleyan Mission House, 1872), 170–71.

84. David P. Gamble, *The Wolof of Senegambia* (London: International African Institute, 1957), 67.

85. Forde, op. cit., 247.

86. Crowther, op. cit., 278. See also 166: *itu*, ease, comfort; *tu-ara*, ease, refreshment of a cool breeze; *ituno*, consolation.

87. R. C. Abraham, *Dictionary of Modern Yoruba* (London: University of London Press, 1958), 655, *tù*; 658, *tútù*.

88. C. L. S. Nyembezi, ed., *Compact Zulu Dictionary* (Pietermarzburg: Shuter and Shooter, 2d ed., 1962), 128.

The Violet Hour: An Essay on Beauty

CARTER RATCLIFF

OH, BEAUTY, WHAT ARE YOU? YOU ARE SO ELUSIVE AND SO ALLURING. YOU SEEM to justify a life of doing nothing but wondering about you and a life of struggling, desperately, to forget you, and even a life of trying to account for you, a life that trudges drearily from one decade to the next and is eventually lost to the quiet demands of career. Is there any way of life you cannot be thought to justify? For isn't it in the hope of attracting you that the gangster in *Red Harvest* refuses to talk, to explain anything, even his silence, as his life flows away, drop by drop, from the gunshot wound in his stomach? Of course his silence is imperfect, like that of a minimalist box, which says, after all, I have nothing to say.

In the simple geometry of contradiction many have sought you, Beauty, yet they find only themselves. Does this mean that you are an aspect of the subjective mind? Maybe you are just an attitude, of which all are capable. If so, why do you seem so utterly alien, no more so than in those moments illuminated by the aesthetic attitude?

To domesticate you, let's say that you are a quality, and therefore detectable by methods the most phlegmatic empiricist can employ with the skill of the liveliest connoisseur. Let us establish a bureau and charge it with the task of defining you and setting standards. For the bureaucratic mind is inclined to suppose that you

are only on rare occasions entirely present—or entirely absent, for that matter, Beauty—so there is an apparent need for a grading system. Inspectors would have the responsibility of affixing a rating to every nuance of our experience.

As the bureau finds its legs, shakes out the bugs, and begins humming along like a well-oiled machine, enforcement capabilities could be added. Given regulatory definition as an empirically detectable quality, you could be required as a matter of public policy to be present more fully and more often in the lives of a steadily increasing percentage of the populace. And how could you register an objection, Beauty? For the coercive nature of this program would have banished you beyond the reach of even the most powerful imagination, and a citizenry content with a standardized image of Beauty would never feel your absence.

But I feel it and that is why I feel suspicious of myself. Because who am I to look for Beauty when I see so many admirable intellects vanishing into the fog of a practical concern for those who are thwarted and, to be more specific, the even denser fog of a theoretical interest in the taxi throbbing with the indifference that evolves into a woodenness wreathed by the unreality of a job well done, or not. It is for the individual to decide, about the job and about reality. And what does Beauty have to do with all that?

Less than nothing, for individuality owes its powers of decision to your willingness, Beauty, to be eclipsed by newer models. The Sublime, the Picturesque, the Grotesque—theirs were the fresh and interesting faces that launched the vessels of modernity, the ships that supply the options we find so useful in deciding who we are.

We miss you, Beauty. Our individualities miss you and wish you could join our discussions of autonomy versus determinism. Yet we don't want to turn the clock back to the time when you were self-evident and the existence of people like us was inconceivable. At most, we are willing to turn it back to the time when somebody might be expected to insist, from the heart of a labyrinthine isolation, that he or she has seen you, Beauty, in the pleading, somehow arrogant smile of the Grotesque. We feel a dim nostalgia for this mandarin paradox.

And, going forward, we feel indulgent toward the stupidity of taking the crush as a sign of Beauty's presence. This error is widespread and thus admirable, for it is the only error with enough clout to rescue large portions of the populace from the clutches of Beauty standardized. So let us, by all means, encourage the crush and its myriad errors, for they are glamorous. They generate the delusions of style.

They sponsor hipness and sometimes go so far as to inspire the hip to talk of Beauty—I mean, of Beauty as the most coercive of fads, which is marginally better than Beauty standardized, don't you think?

I do, because margins are all there is to live on in modern times, even if you spend every waking hour on the sixteen-lane highway of standardization. But you'd never do that, would you, Beauty? Refusing at the birth of time to be in the least bit marginal, you occupied the center of existence. We exist, yet you are absent, so thoroughly that we now and again turn in upon ourselves, austerely, and take absence itself for a sign of the beautiful.

So it is that, at the violet hour, one of us will stand on the sidewalk and look up at the line of yellow windows. Whoever you are will be in the apartment, as well, familiar enough with all that you could never know, in principle, about events transpiring there. Having mislaid that principle in the rush of modern life, you are simultaneously within and without. So even if it goes unnoticed by the apartment's inhabitants, even if it is overlooked by you, as you stand there, your presence at street level will contribute its share of absence to that unmoored and overlit space.

Turning away, you stroll from one conical splash of light to the next. You feel the truancy of your being but not the usual sadness, for it occurs to you that you have a resemblance to the only Beauty we feel we know, Beauty as a spook in the theoretical machine. Perhaps you and Beauty have something in common. Possibly—and you are beginning to feel exhilarated now—the great burden of your buoyancy, the flimsiness of self you have spent your adulthood deploring, is beautiful.

Beautiful after all! And beautiful in a modern way that gives the kiss-off to those dowdy ideologies of the postmodern, and has something to give you, too: a oneness with the moment. The very texture of your being is meshing now with the flow of moments, and your crush on the night, on its grainy dazzle, feels like a crush on yourself. This is fabulous, this resolution of disparities, this unity so perfect you never knew to yearn for it. All is Beauty and there is nothing you need yearn for now, for all of it is yours, it is all you—insofar as it exists, and I'd just as soon not be the one who eventually gets around to explaining that your being is now a membrane a single molecule thick and you take it for the universe only because it is swamped by light. You are glamorous, not beautiful. Beauty fled from your eagerness not to know the difference.

Beauty, where are you?

The minimalist box, it turns out, really did have nothing to reveal. The apartment, of which the box was the distillate, broke up with its uninflected surfaces. Able to maintain only an on-again–off-again relationship with the right angles that gave it a provisional stability, the place has become unrentable—like so many others. Consequently, housing costs have risen, creating a ripple effect that expands with a certain elegance. And there's a sort of symmetry—an earnest spoof of symmetry, let us say—to the occasional solution to one of our myriad other problems. Overworked, we find that days off can be poignant and filled with perspicuity.

These are all attractive qualities, and it has been argued that if they and a few others were stitched together and draped over a suitable armature, the result might possibly be beautiful. Think again, though I suppose this new Frankenstein would be preferable to the totalitarian regime I mentioned earlier, the one dedicated to the proposition that Beauty is a gradable substance like gold or meat.

Don't worry if you can't remember what I said. Just try to remember what you were before you defined yourself as Sublime. Or are you Picturesque? Anyway, the ideal was visible in those shining days, long ago, because you didn't try to embody it. Remember the saddle shoes that Beauty wore, and the ankle socks? Beauty's skirt was pleated, as you must remember. I do, and I remember that she wore a short-sleeved sweater, and over it a long-sleeved cardigan of identical color. Truly modern spirits would say that her gaze was eternal, the rest ephemeral—the saddle shoes, the socks, the pleats of her skirt, the notebook she hugged flat against her body.

The notebook was blue, the sunlight blonde.

Truly modern spirits are half right. They are right about the eternal steadiness of Beauty's gaze. As for the ephemeral, they should look for that in the need to know what you saw when you looked at me. That need went away. So did you, Beauty; then you came back. But I didn't notice. I was too busy defining myself. To convince myself that I had succeeded, I moved on, to the task of defining you. Looking up from my work, I saw that you had vanished absolutely. My subsequent idleness has not brought you back, and my need to know what you saw when you looked at me is unrelenting. It is eternal.

Beauty Is the Mystery of Life

AGNES MARTIN

WHEN I THINK OF ART, I THINK OF BEAUTY. BEAUTY IS THE MYSTERY OF LIFE. IT IS not in the eye, it is in the mind. In our minds there is awareness of perfection.

We respond to beauty with emotion. Beauty speaks a message to us. We are confused about this message because of distractions. Sometimes we even think that it is in the mail. The message is about different kinds of happiness and joy. Joy is most successfully represented in Beethoven's *Ninth Symphony* and by the Parthenon.

All artwork is about beauty; all positive work represents it and celebrates it. All negative art protests the lack of beauty in our lives. When a beautiful rose dies, beauty does not die because it is not really in the rose. Beauty is an awareness in the mind. It is a mental and emotional response that we make. We respond to life as though it were perfect. When we go into a forest we do not see the fallen rotting trees. We are inspired by a multitude of uprising trees. We even hear a silence when it is not really silent. When we see a newborn baby we say it is beautiful—perfect.

The goal of life is happiness and to respond to life as though it were perfect is the way to happiness. It is also the way to positive artwork.

It is not in the role of an artist to worry about life—to feel responsible for creating a better world. This is a very serious distraction. All your conditioning has been directed toward intellectual living. This is useless in artwork. All human

knowledge is useless in artwork. Concepts, relationships, categories, classifications, deductions are distractions of mind that we wish to hold free for inspiration.

There are two parts of the mind. The outer mind that records facts and the inner mind that says "yes" and "no." When you think of something that you should do, the inner mind says "yes" and you feel elated. We call this inspiration.

For an artist this is the only way. There is no help anywhere. He must listen to his own mind.

The way of an artist is an entirely different way. It is a way of surrender. He must surrender to his own mind.

When you look in your mind you find it covered with a lot of rubbishy thoughts. You have to penetrate these and hear what your mind is telling you to do. Such work is original work. All other work made from ideas is not inspired and it is not artwork.

Artwork is responded to with happy emotions. Work about ideas is responded to with other ideas. There is so much written about art that it is mistaken for an intellectual pursuit.

It is quite commonly thought that the intellect is responsible for everything that is made and done. It is commonly thought that everything that is can be put into words. But there is a wide range of emotional response that we make that cannot be put into words. We are so used to making these emotional responses that we are not consciously aware of them until they are represented in artwork.

Our emotional life is really dominant over our intellectual life, but we do not realize it.

You must discover the artwork that you like, and realize the response that you make to it. You must especially know the response that you make to your own work. It is in this way that you discover your direction and the truth about yourself. If you do not discover your response to your own work, you miss the reward. You must look at the work and know how it makes you feel.

If you are not an artist, you can make discoveries about yourself by knowing your response to work that you like.

Ask yourself, What kind of happiness do I feel with this music or this picture?

There is happiness that we feel without any material stimulation. We may wake up in the morning feeling happy for no reason. Abstract or nonobjective feelings are a very important part of our lives. Personal emotions and sentimentality are anti-art.

We make artwork as something that we have to do, not knowing how it will work out. When it is finished we have to see if it is effective. Even if we obey inspiration we cannot expect all the work to be successful. An artist is a person who can recognize failure.

If you were a composer you would not expect everything you played to be a composition. It is the same in the graphic arts. There are many failures.

Artwork is the only work in the world that is unmaterialistic. All other work contributes to human welfare and comfort. You can see from this that human welfare and comfort are not the interests of the artist. He is irresponsible because his life goes in a different direction. His mind will be involved with beauty and happiness. It is possible to work at something other than art and maintain this state of mind and be moving ahead as an artist. The unmaterial interest is essential.

The newest trend and the art scene are unnecessary distractions for a serious artist. He will be much more rewarded responding to art of all times and places—not as art history but considering each piece and its value to him.

You can't think, My life is more important than the work, and get the work. You have to think the work is paramount in your life. An artist's life is adventurous: one new thing after another.

I have been talking directly to artists, but it applies to all. Take advantage of the awareness of perfection in your mind. See perfection in everything around you. See if you can discover your true feelings when listening to music. Make happiness your goal. The way to discover the truth about this life is to discover yourself. Say to yourself, What do I like and what do I want? Find out exactly what you want in life. Ask your mind for inspiration about everything.

Beauty illustrates happiness: the wind in the grass, the glistening waves following each other, the flight of birds—all speak of happiness.

The clear blue sky illustrates a different kind of happiness, and the soft dark night a different kind. There are an infinite number of different kinds of happiness.

The response is the same for the observer as it is for the artist. The response to art is the real art field.

Composition is an absolute mystery. It is dictated by the mind. The artist searches for certain sounds or lines that are acceptable to the mind and finally an arrangement of them that is acceptable. The acceptable compositions arouse certain feelings of appreciation in the observer. Some compositions appeal to some, and some to others.

But if they are not accepted by the artist's mind, they will not appeal to any-one. Composition and acceptance by mind are essential to artwork. Commercial art is consciously made to appeal to the senses, which is quite different. Artwork is very valuable and it is also very scarce. It takes a great deal of application to make a composition that is totally acceptable. Beethoven's symphonies, with every note composed, represent a titanic human effort.

To progress in life you must give up the things that you do not like. Give up doing the things that you do not like to do. You must find the things that you do like—the things that are acceptable to your mind.

You can see that you will have to have time to yourself to find out what appeals to your mind. While you go along with others, you are not really living your life. To rebel against others is just as futile. You must find your way.

Happiness is being on the beam with life—to feel the pull of life.

Contributors

JOHN ASHBERY has written many volumes of poetry, including *Some Trees*, *The Tennis Court Oath*, *Rivers and Mountains*, *The Double Dream of Spring*, *Self-Portrait in a Convex Mirror*, *April Galleons*, *Flow Chart*, and *And the Stars Were Shining*. Winner of the Pulitzer Prize, the National Book Award, and the National Book Critics Award, he is a professor at Bard College.

BILL BECKLEY is an artist who lives with his wife Laurie Johenning and sons Tristan and Liam in New York City. His work represented the United States at the Venice Biennale and has been exhibited in the Whitney Biennial and Documenta; at numerous galleries in the United States and Europe, including the Hans Meyer Gallery in Düsseldorf, Daniel Templon Gallery in Paris, Galeria Milano in Milan, and Galleria Pasquale Trisorio in Naples; and in solo exhibitions at the International Center for Photography and the Projects room of the Museum of Modern Art in New York, the Städtisches Museum Abteiberg in Mönchengladbach, Germany, and Fondation Château de Jau in France.

LOUISE BOURGEOIS was born in Paris in 1911 and moved to New York in 1939. She has had solo exhibitions at the Museum of Modern Art, New York; Contemporary

Arts Museum, Houston; Museum of Contemporary Art, Chicago; Frankfurter Kunstverien, Frankfurt; Kunst Museum, Berne; Kröller-Muller Museum, Otterlo; and in many other galleries and museums, in the United States and internationally.

HUBERT DAMISCH is an art historian and philosopher, and director of studies at l'École des hautes études en sciences sociales in Paris. His most recent book is *The Judgment of Paris*.

ARTHUR C. DANTO is the Johnsonian Professor of Philosophy Emeritus at Columbia University. His many books include *Mysticism and Morality*, *The Transfiguration of the Commonplace*, *Beyond the Brillo Box*, *The State of the Art*, and *Encounters and Reflections*, which won the National Book Critics Circle Award for criticism in 1990.

MAX FIERST's poems have appeared in *Mudfish*, and his first play, *Gnarled Mac*, was produced in New Haven in 1997. He has studied with Harold Bloom at Yale.

DAVID FREEDBERG, professor of art history at Columbia University, is the author of *Iconoclasm and Painting in the Revolt of the Netherlands, 1566–1609*, *Dutch Landscape Prints of the Seventeenth Century*, *Rubens: The Life of Christ After the Passion*, and *The Power of Images: Studies in the History and Theory of Response*.

JEREMY GILBERT-ROLFE, a painter as well as an art critic, was awarded a Guggenheim Fellowship in Painting for 1997–98. His recent publications include *Beyond Piety: Critical Essays on the Visual Arts 1986–1993* and *Das Schöne und das Erhabene von heute*. He teaches in the M.F.A. and M.A. programs at Art Center in Pasadena, California.

JOHN HEJDUK is dean of the Channin School of Architecture of the Cooper Union. He has created architectural works in Prague, Oslo, Berlin, London, Georgia, Milan, and New York, and his books on architecture include *Mask of the Medusa* and *The Collapse of Time*, *Architectures in Love* and *Adjusting Foundations*. His selected poems with a foreword by David Shapiro will appear in the spring of 1998.

DAVE HICKEY has served as the executive editor for *Art in America* and as arts edi-

tor for the *Fort Worth Star-Telegram*. His publications include *Prior Convictions* (1989), *The Invisible Dragon: Four Essays on Beauty* (1993), and *Air Guitar* (1997). He is currently associate professor of art criticism and theory at the University of Nevada in Las Vegas.

JAMES HILLMAN was for ten years director of the C. G. Jung Institute in Zurich. He is a Founding Fellow of the Dallas Institute of Humanities and Culture, publisher of Spring Publications, and editor of *Spring: A Journal of Archetype and Culture*.

KENNETH KOCH was born in 1925 in Cincinnati, and educated at Harvard and Columbia, where he has taught for thirty years. A winner of the Bollingen Prize for poetry and the Shelley Memorial Award, he has published major works in every genre, including his novel *The Red Robins*, essays in *The Art of Poetry*, and many collections of poetry, from the early *Thank You* to the recent *Selected Poems*.

JULIA KRISTEVA is a psychoanalyst, critic, and chief proponent of Semanalyse, a term she coined to name the discipline that blends semiotics with psychoanalysis. She is the author of numerous books, including *Strangers to Ourselves, New Maladies of the Soul,* and *Time and Sense*.

DONALD KUSPIT is a contributing editor at *Artforum, Sculpture,* and *New Art Examiner* magazines, and the editor of *Art Criticism*. He is professor of art history and philosophy at the State University of New York, Stonybrook, and A. D. White Professor-at-Large at Cornell University. His most recent books are *Health and Happiness in Twentieth-Century Avant-Garde Art* (with Lynn Gamwell, 1996), *Idiosyncratic Identities: Artists at the End of the Avant-Garde* (1996), and *Chihuly* (1997).

JACQUELINE LICHTENSTEIN is associate professor of French at the University of California, Berkeley. Her most recent book, *The Eloquence of Color: Rhetoric and Painting in the French Classical Age,* was originally published in French as *La Couleur éloquente: rhétorique et peinture à l'age classique*.

ARIANE LOPEZ-HUICI was born in Biarritz and lives and works in New York and Paris. In *Solo Absolu,* an exhibiton at the AC Projectroom in 1994, she showed a series of black-and-white photographs of a man masturbating, the close-up nature

of which emphasized the intimacy of the act. In her focus on beauty and erotic expression, she locates herself in the tradition of the south, the *Mediteranée*.

AGNES MARTIN was born in 1912 in Canada, and has resided in the United States since 1931. Her work has been exhibited at the Betty Parsons, Robert Elkon, and Pace galleries in New York, and she has had solo shows in many venues, including Kunstraum, Munich; Hayward Gallery, London; and Stedelijk Museum, Amsterdam.

THOMAS MCEVILLEY has taught at Rice University since 1969. He has written hundreds of articles, catalogue essays, and reviews in the field of contemporary art, as well as monographs on Yves Klein, Jannis Kounellis, and Pat Steir. His recent books include *Art and Discontent*, *Art and Otherness*, and *The Exile's Return Toward a Redefinition of Painting for the Post-Modern Era*.

ROBERT C. MORGAN is a critic, artist, art historian, curator, and poet. His recent books include *Art into Ideas: Essays on Conceptual Art* (1996), and *Between Modernism and Conceptual Art* (1997). He is professor of art at Rochester Institute of Technology and at Pratt Institute. Morgan's works have been shown in New York City at the Whitney Museum of American Art, Anthology Film Archives, and the Museum of Modern Art.

FRANK O'HARA published six books of poetry, including *A City Winter* and *Mediations in an Emergency*. His *Collected Poems*, edited by Donald Allen and published posthumously, won the National Book Award in poetry in 1971. As a curator at the Museum of Modern Art, he wrote a series of art essays on such figures as Motherwell, Pollock, and Nakian. His work was cut short by his accidental death in 1966 on Fire Island.

CARTER RATCLIFF is a contributing editor of *Art in America*. His writings include *Andy Warhol* (1983), "Barnett Newman: Citizen of the Infinitely Large Small Republic" (1991), *The Fate of a Gesture: Jackson Pollock and Postwar American Art* (1996), and "Alex Katz's Hobbesian Portraiture," in *Alex Katz: Twenty-five Years of Painting* (1997).

WILLIAM S. RUBIN was appointed Director Emeritus of the Department of Painting and Sculpture at the Museum of Modern Art in 1988, after serving as director of that department for fifteen years. In addition to his position at MoMA, he serves as adjunct professor of art history at the Institute of Fine Arts, New York University.

MEYER SCHAPIRO was Professor Emeritus of Art History at Columbia University, where he was a student and teacher for over fifty years. His publications include *Van Gogh; Cézanne;* and *Modern Art* (Selected Papers Vol. II), which won the National Book Critics Circle Award (1978) and the Mitchell Prize for Art History (1979).

PETER SCHJELDAHL was born in North Dakota in 1942 and has lived in New York since 1964. He is a columnist for the *Village Voice* and a contributing editor of *Art in America.* He has worked as a regular art critic for the Sunday *New York Times, Vanity Fair,* and *7 DAYS.* His books include *The Hydrogen Jukebox: Selected Writings 1978–1991* and *The 7 DAYS Art Columns* (1990).

DAVID SHAPIRO, poet and art historian, has written many volumes of poetry and literary and art criticism, including *January, Poems from Deal, A Man Holding an Acoustic Panel, The Page-turner, Lateness, To an Idea, After a Lost Original,* and monographs on John Ashbery's poetry, Jasper Johns's drawings, and Modrian's flower studies.

ROBERT FARRIS THOMPSON is Colonel John Trumbell Professor of the History of Art at Yale University. He is the author of many books, including *Black Gods and Kings, African Art in Motion, Flash of the Spirit,* and *Mbuti Design.* He writes for *Artforum,* and contributed a chapter on the impact of down-rocking, electric boogie, house, and other black dancing of the eighties to the catalog for the Keith Haring retrospective at the Whitney Museum in 1997.

KIRK VARNEDOE has been affiliated with the Museum of Modern Art since 1984, and has been the Chief Curator of MoMA's Department of Painting and Sculpture since 1988. From 1980 to 1988, he was professor at the Institute of Fine Arts, New

York University, where he continues to hold an adjunct teaching post. In 1984, he received the MacArthur Foundation Fellowship, which resulted in his book, *A Fine Disregard: What Makes Modern Art Modern* (1990).

MARJORIE WELISH has taught at Brown University and Pratt Institute. In 1997, she received Pollock-Krasner Foundation and Trust for Mutual Understanding grants. Her most recent book of poems is *Casting Sequences* (1993).

JOHN YAU has published articles and reviews in *Amerasia Journal*, *American Poetry Review*, *Artforum*, *Art in America*, *Interview*, and *Vogue*. Recent books include *The United States of Jasper Johns* (1996), *Ed Moses: A Retrospective of the Paintings and Drawings, 1951–1996* (1996), and *Forbidden Entries* (1996). He is on the faculty at the Maryland Institute, College of Art.

Acknowledgments

Thanks to the School of Visual Arts and the Pollock Krasner Foundation for the sabbatical and the support that allowed me to undertake this project.

BILL BECKLEY

Thanks to both the Foundation for Contemporary Performance Arts and the Graham Foundation for grants recently and in the past that have permitted me to work on the idea of a maximal poetic. Much of my thinking on art has been inflected by collaboration and conversations with the late Fairfield Porter, Lucio Pozzi, John Hejduk, and many poets and friends by whom I have been influenced, more in joy than in anxiety.

DAVID JOEL SHAPIRO

Credits

6. "Notes on Beauty," by Peter Schjeldahl. © 1994 Peter Schjeldahl. Originally published in *Art issues. Press* #33, May/June 1994. Reprinted with permission of the author.

7. "Contratemplates" by Marjorie Welish. © 1998 Marjorie Welish.

8. "A Sign of Beauty" by Robert C. Morgan. © 1998 Robert C. Morgan. This essay is based on a paper delivered at the Seoul National University, Korea, November 21, 1997.

9. "On Beauty and Platonic Cosmetics," from *Eloquence of Color: Rhetoric and Painting in the French Classical Age*, by Jacqueline Lichtenstein, translated/edited by Emily McVarish. © 1993 The Regents of the University of California. Reprinted by permission of University of California Press.

10. "Freud with Kant? The Enigma of Pleasure," from *The Judgment of Paris*, by Hubert Damisch, translated by John Goodman (Chicago: University of Chicago Press). © 1996 by The University of Chicago. Reprinted with permission of the publisher.

11. "Arousal by Image," from *The Power of Images*, by David Feedberg. © 1989 University of Chicago Press. Reprinted with permission of the publisher.

12. "Doctor Lawyer Indian Chief: *'Primitivism' in Twentieth-Century Art* at the Museum of Modern Art in 1984," by Thomas McEvilley. © 1985 Artforum. Originally published in *Artforum*, November 1985. Reprinted with permission of the author.

13. "On 'Doctor Lawyer Indian Chief: *"Primitivism" in Twentieth-Century Art* at the Museum of Modern Art in 1984,'" Letters to the Editor by William Rubin and Kirk Varnedoe, with a response by Thomas McEvilley. Originally published in *Artforum*, February 1985. Reprinted with permission of the authors.

14. "On 'Doctor Lawyer Indian Chief': Part II," Letter to the Editor by William Rubin, with a response by Thomas McEvilley. Originally published in *Artforum*, May 1985. Reprinted with permission of the authors.

15. "On the Claims and Critics of the *'Primitivism'* Show," by Kirk Varnedoe. © 1985 Art in America. Originally published in *Art in America*, Brant Publications, Inc., May 1985. Reprinted by permission of *Art in America*.

16. "The Practice of Beauty," by James Hillman. © 1991 James Hillman. Reprinted with permission of the author and with thanks to Spring Publications. This piece was presented as a talk at the Museum of Contemporary Art at Prato, near Florence, in February 1991, and published in *Archivo* #2, 1994, by the Museo Pecci, Prato and Amalthea, Fiesole; it appeared as well in *Tema Celeste–Art Magazine*, International Edition #31, May/June 1991, Siracusa, Italy; and in *Sphinx: A Journal for Archetypal Psychology and the Arts* #4, 1992, London.

17. "Ode to Willem de Kooning," by Frank O'Hara, in *The Collected Poems of Frank O'Hara*, Donald Allen, editor (Berkeley: University of California Press, 1950). Reprinted by permission of Maureen Granville-Smith, the Estate of Frank O'Hara.

Index

Books from Allworth Press

Sticky Sublime *edited by Bill Beckley* (hardcover, 6¾ × 9⅞, 256 pages, $24.95)

Out of the Box: The Reinvention of Art, 1965–1975 *by Carter Ratcliff*
(paperback with flaps, 6 × 9, 312 pages, $19.95)

Redeeming Art: Critical Reveries *by Donald Kuspit*
(paperback with flaps, 6 × 9, 352 pages, $24.95)

The Dialectic of Decadence *by Donald Kuspit* (paperback with flaps, 6 × 9, 128 pages, $18.95)

Beauty and the Contemporary Sublime *by Jeremy Gilbert-Rolfe*
(paperback with flaps, 6 × 9, 208 pages, $18.95)

Sculpture in the Age of Doubt *by Thomas McEvilley*
(paperback with flaps, 6¾ × 9⅞, 448 pages, $24.95)

The Shape of Ancient Thought *by Thomas McEvilley* (hardcover, 6¾ × 9⅞, 816 pages, $35.00)

The End of the Art World *by Robert C. Morgan* (paperback with flaps, 6 × 9, 256 pages, $18.95)

Looking Closer 3: Classic Writings on Graphic Design *edited by Michael Bierut, Jessica Helfand, Steven Heller, and Rick Poynor* (paperback, 6¾ × 9⅞, 304 pages, $18.95)

Education of a Graphic Designer *edited by Steven Heller* (paperback, 6¾ × 9⅞, 288 pages, $18.95)

Education of an Illustrator *edited by Steven Heller and Marshall Arisman*
(paperback, 6¾ × 9⅞, 288 pages, $19.95)

Please write to request our free catalog. To order by credit card, call 1-800-491-2808 or send a check or money order to Allworth Press, 10 East 23rd Street, Suite 510, New York, NY 10010. Include $5 for shipping and handling for the first book ordered and $1 for each additional book. Ten dollars plus $1 for each additional book if ordering from Canada. New York State residents must add sales tax.

To see our complete catalog on the World Wide Web, or to order online, you can find us at *www.allworth.com.*